CLASSICAL BRONZES

ALSO BY CAROL C. MATTUSCH

Bronzeworkers in the Athenian Agora

The Fire of Hephaistos: Large Classical Bronzes from North American Collections (ed.)

Greek Bronze Statuary: From the Beginnings through the Fifth Century B.C.

CLASSICAL BRONZES

THE ART AND CRAFT OF GREEK AND ROMAN STATUARY

Carol C. Mattusch

Cornell University Press | ITHACA AND LONDON

Published with the assistance of the Getty Grant Program.

First published 1996 by Cornell University Press.

Printed in the United States of America

♾ The paper in this book meets the minimum requirements
of the American National Standard for Information Sciences—
Permanence of Paper for Printed Library Materials, ANSI Z39.48-1984.

Color plates printed in Hong Kong.

Library of Congress Cataloging-in-Publication Data

Mattusch, Carol C.
 Classical bronzes : the art and craft of Greek and Roman statuary / Carol C. Mattusch.
 p. cm.
 Includes index.
 ISBN 0-8014-3182-4 (cloth : alk. paper)
 1. Bronze sculpture, Classical. 2. Bronze figurines, Classical. I. Title.
NB135.M38 1996
733—dc20 95-36843

For H. C. M.

A good mother is hard to better.

CONTENTS

PREFACE

In our study of the freestanding sculpture of antiquity, we have traditionally pursued questions of style and of iconography. Even today, an author may pay little attention to medium or to the technology needed to work a medium, glossing over the materials of sculpture as if they were all somehow equal. And yet the technical differences called for in working various media have a major effect on how a finished sculpture is achieved and how it looks. We could even argue that the appearance of a statue depends a great deal more on the technician's manipulation of the medium than it does on the artist's original idea. Once we recognize the importance of adding this dimension to our consideration of antique sculpture, we can return to the actual contribution of the artist and to the collaborative skills that were developed by artists and artisans working together.

If we consider the group of surviving Geometric bronze statuettes from any given sanctuary, we inevitably see a certain amount of repetition. Bronze was well suited to the production of many small-scale votive offerings for worshipers to buy on arrival at a sanctuary. Some of these bronzes were no doubt hand-modeled one after another, and then cast. Others were based on a single model, and they were serially produced. That is, after all, the nature of the medium. Various forms of serial production were also used to make the groups of bronze protomes that would ornament the shoulders of cauldrons dedicated during the Orientalizing period.

Little evidence survives for large-scale bronze sculpture in the Mediterranean world until the fifth century B.C. Even then we have little to go on, except for the certainty that the types represented in public sculpture were limited. Above all, public sculptures had to be clearly recognizable to the passerby. A viewer would not have needed to read the inscription on a statue base to know which ones in the row of bronzes were humans and which were gods. In the same way, the viewer would immediately distinguish between an attacking Athena and a presiding Zeus. The two surviving Riace bronzes were surely produced for a dedication of a good deal more than two images. And many of the images would have

looked essentially the same—standing heroes with attributes. The best way to make such a commission was, of course, by serial production, to which the Riace Bronzes testify. If we look carefully at these two statues, however, we can pick out a wealth of subtle differences between the two images. Such differences do not depend on the original models for the statues, for those models were incomplete, serving primarily to set the precise scale, dimensions, poses, and general attitudes of the images. Instead, the final features are the result of intervention by the artist(s) or artisan(s) who finished the wax working models for the two statues. It was in this final phase, just before casting, that one or more highly skilled workers or artists gave each statue its unique characteristics, making each one an "original."

The limitations or strengths of a particular medium did not entirely govern the appearances of freestanding sculpture. Style, not the medium used, was the first consideration: sculptures had to meet accepted stylistic conventions. Indeed, the medium seems to have been a matter of choice, by the artist, the artisan, or the buyer, depending upon the context or the use intended for the work. In public, only certain types of images for particular kinds of monuments and dedications were allowed. But when it became possible for a buyer to choose an image for his or her own private use, the choices were far more varied. If, for example, one chose the exotic Dionysos herm, one might purchase a freestanding bronze or a marble herm for the garden, or a marble plaque to hang on a wall, or a gem that one could carry around. All of these versions represented the same type of image: some might come from a single series made from the same model; others might best be called variations on a theme. Although all were recognizable as the same Dionysos, they differed with respect to scale, medium, and the contribution of the maker. Indeed, the maker of a particular example might well sign his handiwork.

It is important to remember that once the scale and the medium were chosen, then the maker had to create the work, even though the original idea for a particular image might not have been directed to any particular medium. Thus, once an artisan took over the idea for an image, he had control of the finished product. Depending on the extent of that control, the skill required, the changes made, and the like, the artisan might sign the work. In sculpture, then, the maker's name might appear alongside that of an artist, or it might appear alone, even though the image itself is one we can attribute with certainty to someone else.

But what if we do not know the name of the "artist"? What has usually happened is that we have sought to assign the name of an artist, using literary testimonia, stylistic features, and the subject matter of the work. Certain types, like the sleeping Eros, were so familiar, and could be designed to fit so many possible iconographic functions, that many individuals produced their own versions of that type. Nonetheless, we continue to assume that surviving works reflect famous "originals," from which all the others derived or are "copies"— even though there may be no two surviving examples that are very much alike, and a wide range of differences exists within the type. Our need to identify an artist, someone whose name and dates we know from the literary testimonia, does not bring us closer to under-

standing the original context of a work. To fulfill its purpose in its own time, a popular image—an Eros or a Hypnos who appears again and again in literature and in the visual arts—did not require an artist's name, nor is any necessarily mentioned in connection with such popular images.

In the following chapters, I have used the term "Classical" to refer broadly to the Greek and Roman periods. I have used the widely accepted classifications for the early periods: Geometric, Orientalizing, and Archaic. For works assigned to later periods, I have avoided using dates that are based on stylistic analysis except to illustrate the difficulties inherent in stylistic chronology. Instead, wherever possible, I have given dates of discovery and of excavated context. In the following pages, these will serve us better than dates based on style.

This book deals with a few selected works and with specific problems. I do not devote equal attention to all the works mentioned; nor do I attempt to be exhaustive in my coverage. If I have not looked at a bronze myself, for example, I do not discuss its technique. Some of the works covered are very well known but can benefit, I think, from a new look. Others I have considered before, but with different emphases. Above all, I have tried simply to state the facts that are known about particular works, in the hope that those facts will lead us to ask new questions and to see the works in a new light. Perhaps we can still learn not to deal too subjectively with ancient sculpture, and not to take the evidence where we think we want to go with it; instead, we can let the facts lead us, objectively, toward new and perhaps unexpected conclusions.

I have not provided exhaustive bibliographic references but have instead referred to readily accessible general works where full bibliographies can be found. I have tried primarily to cite basic works that are available to most readers, keeping in mind those readers who may not have ready access to good library facilities. All translations of the literary testimonia are my own, unless indicated otherwise.

An earlier version of part of chapter 2 originally appeared in my essay "The Eponymous Heroes: The Idea of Sculptural Groups," in *The Archaeology of Athens and Attica under the Democracy*, Oxbow Monograph 37, ed. O. Palagia and W. D. E. Coulson (Oxford, 1994), pp. 73–82. Similarly, earlier versions of portions of chapter 5 have appeared in my "Bronze Herm of Dionysos," in *Das Wrack: Der antike Schiffsfund von Mahdia*, ed. G. Hellenkemper Salies et al. (Cologne, 1994), 1:431–50, and "Two Bronze Herms: Questions of Mass Production in Antiquity," *Art Journal* 54.2 (1995): 53–59. And an early version of part of chapter 6 appeared in my article "The Bronze Torso in Florence: An Exact Copy of a Fifth-Century B.C. Greek Original," *AJA* 82 (1978): 101–4.

My work on this book has been supported by fellowships and grants from the Center for Advanced Study in the Visual Arts at the National Gallery of Art, the Deutsches Archäologisches Institut in Berlin, George Mason University, and the National Endowment for the Humanities.

I am grateful for the resources and the friendly surroundings of the institutions in whose

libraries I conducted much of my study and research and where I tried out many of the ideas presented in this book: the American School of Classical Studies in Athens; the Center for Advanced Study in the Visual Arts at the National Gallery of Art, Washington; the Deutsches Archäologisches Institut in Berlin; and the American Academy in Rome. In the Washington, D.C., area I have benefited from the interlibrary loan offices of George Mason University and of the National Gallery of Art, and from the libraries of Johns Hopkins University and of the Center for Hellenic Studies.

The collections and the staff members of the following museums and excavations have been especially generous in supplying resources and assistance: the Agora Excavations and the Corinth Excavations, both of the American School of Classical Studies at Athens; the National Archaeological Museum in Athens; the Antikensammlung of the Staatliche Museen in Berlin; the Rheinisches Landesmuseum in Bonn; the J. Paul Getty Museum in Malibu, California; and the Metropolitan Museum of Art in New York.

The contents of the chapters that follow have been presented in the form of lectures or seminars, and have been enhanced by discussions with students and colleagues. The following persons have provided ideas, information, access, and assistance that have been valuable in the research and writing of this book: Maxwell L. Anderson, Beryl Barr-Sharrar, Elizabeth Bartman, Arthur Beale, Malcolm Bell III, Susanne Bennet, Luigi Beschi, John Boardman, Nancy Bookidis, Stella Bouzaki, Robert A. Bridges Jr., Peter Brunette, Lawrence Butler, John M. Camp, Beth Cohen, David Davis, Paul Denis, Charles M. Edwards, Helen Fellows, Sheila ffolliott, Edilberto Formigli, Jiri Frel, Elaine K. Gazda, Wilfred Geominy, Robert Haber, Kenneth Hamma, Evelyn B. Harrison, Denys Haynes, Wolf-Dieter Heilmeyer, John J. Herrmann Jr., Shannon Holcomb, Caroline M. Houser, Jeffrey M. Hurwit, Sara A. Immerwahr, Marit Jentoft-Nilson, Jan Jordan, Raymond Kaskey, Gerhard M. Koeppel, John Kurtich, Christa Landwehr, Neda Leipen, Henry Lie, Kurt T. Luckner, William L. MacDonald, Steven A. Mansbach, Sheila Marson, Miranda Marvin, Douglas Matthews, Margaret E. Mayo, John A. McIntire, Joan R. Mertens, Henry A. Millon, David Gordon Mitten, John E. Moore, Sarah P. Morris, W. Andrew Oddy, Therese O'Malley, George Ortiz, John Papadopoulos, Christopher Parslow, Elizabeth G. Pemberton, Carlos A. Picón, Robert L. Pounder, Rosa Proskinitopoulou, Ellen D. Reeder, Emeline H. Richardson, Peter Rockwell, Sherrie L. Rook, Susan I. Rotroff, Uwe Rundstock, Jocelyn P. Small, Richard E. Spear, Susan Stock, Richard E. Stone, Mary C. Sturgeon, Homer A. Thompson, Michail Yu. Treister, Ismini Trianti, Jennifer Trimble, Marion True, Olga Tsachou-Alexandri, Gocha Tsetskhladze, Zita E. Tyer, Catherine DeG. Vanderpool, Cornelius C. Vermeule III, Susan Walker, Frank Willer, Charles K. Williams II, Nancy A. Winter.

Once a week during the fall of 1993, I enjoyed lively and thought-provoking discussions about the material in this book with Sally Schultz and Kathleen Lynch, graduate students at the University of Virginia. The students at George Mason University who participated in my seminar during the spring of 1994 provided additional insights, critical responses,

and enthusiasm: Roya Abedi, Jaime Bierds, Abby Chough, Lara Cox, Raymond Czaster, Michele Ehrenfeld, Stephanie Guthrie, Hillary Hutcheon, Hania Khuri, Tina McPherson, William Nevitsky, Kim Su Giang Nguyen, Melanie Packer, Maria Tsodoulou, and Scott Van Ness.

I owe special thanks to Amy Brauer, Diana Buitron-Oliver, Elizabeth Cropper, Charles Dempsey, Richard Daniel De Puma, A. A. Donohue, Gisela Hellenkemper Salies, Mary B. Hollinshead, George L. Huxley, Michael Koortbojian, Jeffrey Maish, Lida Miräj, Andrew Oliver, Olga Palagia, Jerry Podany, Hans-Hoyer von Prittwitz und Gaffron, Charles Purrenhage, Nancy H. Ramage, Antony E. Raubitschek, Brunilde Sismondo Ridgway, Diana F. Smith, Alice Taylor, George Varoufakis, Gerhard Zimmer, and to Bernhard Kendler at Cornell University Press. Most of all, I am grateful to Richard S. Mason and Harriet C. Mattusch for all sorts of ideas, help, and support.

CAROL C. MATTUSCH

Clifton, Virginia

ABBREVIATIONS

AA	*Archäologischer Anzeiger*
Agora	*The Athenian Agora*
AJA	*American Journal of Archaeology*
AM	*Mitteilungen des Deutschen Archäologischen Instituts, Athenische Abteilung*
Archäologische Bronzen	*Archäologische Bronzen: Antike Kunst, Moderne Technik*, ed. H. Born (Berlin, 1985)
ArchEph	*Archaiologike Ephemeris*
*ARV*²	J. D. Beazley, *Attic Red-Figure Vase-Painters*, 2d ed. (Oxford, 1963)
AttiPal	*Atti della Accademia di Scienze, Lettere e Arti di Palermo*
BCH	*Bulletin de Correspondance Hellénique*
BdA	*Bollettino d'Arte*
Bieber, *Ancient Copies*	M. Bieber, *Ancient Copies: Contributions to the History of Greek and Roman Art* (New York, 1977)
Bieber, *Hellenistic*	M. Bieber, *The Sculpture of the Hellenistic Age*, rev. ed. (New York, 1961; rpt. 1967)
BJb	*Bonner Jahrbücher des Rheinischen Landesmuseums in Bonn und des Vereins von Altertumsfreunden im Rheinlande*
BMMA	*Bulletin of the Metropolitan Museum of Art*
Boardman/Dörig/Fuchs	J. Boardman, J. Dörig, W. Fuchs, and M. Hirmer, *The Art and Architecture of Ancient Greece* (London, 1967)
Bober/Rubinstein	P. P. Bober and R. Rubinstein, *Renaissance Artists and Antique Sculpture: A Handbook of Sources* (New York, 1986)
Bol, *Antikythera*	P. C. Bol, *Die Skulpturen des Schiffsfundes von Antikythera. AM* suppl. 2 (1972)
Bol, *Bronzetechnik*	P. C. Bol, *Antike Bronzetechnik: Kunst und Handwerk antiker Erzbildner* (Munich, 1985)
Bol, *Grossplastik*	P. C. Bol, *Grossplastik aus Bronze in Olympia*, OF 9 (Berlin, 1978)
BSA	*Annual of the British School at Athens*
Camp, *Agora*	J. M. Camp, *The Athenian Agora: Excavations in the Heart of Classical Athens* (London, 1986)

CRAI	*Comptes Rendus de l'Académie des Inscriptions et Belles Lettres*
CVA	*Corpus Vasorum Antiquorum*
Deltion	*Archaiologikon Deltion*
diam.	diameter
dim.	dimension(s)
EAA	Istituto della Enciclopedia italiana, *Enciclopedia dell'arte antica, classica e orientale* (Rome, 1958–1966)
Finn/Houser, 1983	D. Finn and C. Houser, *Greek Monumental Bronze Sculpture* (New York, 1983)
Furtwängler, *AG*	A. Furtwängler, *Die Antike Gemmen* (Leipzig, 1900)
Furtwängler, *Bronzen*	A. Furtwängler, *Die Bronzen*, Olympia 4 (Berlin, 1890)
H	height
Harrison, Agora 11	E. B. Harrison, *Archaic and Archaistic Sculpture*, The Athenian Agora 11 (Princeton, 1965)
Haskell/Penny	F. Haskell and N. Penny, *Taste and the Antique* (New Haven, 1990)
Helbig, *Führer*	W. Helbig, *Führer durch die öffentlichen Sammlungen klassischer Altertümer in Rom*, 2d ed. (Leipzig, 1899; rpt. Tübingen, 1966)
Houser, 1987	C. Houser, *Greek Monumental Bronze Sculpture of the Fifth and Fourth Centuries B.C.* (New York, 1987)
HSCP	*Harvard Studies in Classical Philology*
IG	*Inscriptiones Graecae*
JAS	*Journal of Archaeological Science*
JdI	*Jahrbuch des deutschen archäologischen Instituts*
JHS	*Journal of Hellenic Studies*
JöaI	*Jahrbuch des österreichischen archäologischen Instituts*
JRS	*Journal of Roman Studies*
JWarb	*Journal of the Warburg and Courtauld Institutes*
L	length
Laurenzi	L. Laurenzi, *Ritratti Greci* (Florence, 1941)
LIMC	*Lexicon Iconographicum Mythologiae Classicae* (Zurich, 1974–).
Lullies/Hirmer	R. Lullies and M. Hirmer, *Greek Sculpture*, rev. ed. (New York, 1960)
Mattusch, *GBS*	C. C. Mattusch, *Greek Bronze Statuary: From the Beginnings through the Fifth Century B.C.* (Ithaca, 1988)
max. dim.	maximum dimension(s)
max. pres. dim.	maximum preserved dimension(s)
Mem.	Xenophon, *Memorabilia*
MonPiot	*Monuments et mémoires publiés par l'Académie des Inscriptions et Belles Lettres,* Fondation Piot
Morrow, *Footwear*	K. D. Morrow, *Greek Footwear and the Dating of Sculpture* (Madison, 1985)
NH	Pliny, *Natural History*
OF	Olympische Forschungen
OJA	*Oxford Journal of Archaeology*
ÖJh	*Jahreshefte des österreichischen archäologischen Instituts in Wien*
Overbeck	J. Overbeck, *Die antiken Schriftquellen zur Geschichte der bildenden Künste bei den Griechen* (Leipzig, 1868)

Pollitt, *Greece*	J. J. Pollitt, *The Art of Ancient Greece: Sources and Documents* (Cambridge, 1990)
Pollitt, *Hellenistic Age*	J. J. Pollitt, *Art in the Hellenistic Age* (Cambridge, 1986)
pres.	preserved
RA	*Revue Archéologique*
REA	*Revue des Etudes Anciennes*
Richter, *Portraits*	G. M. A. Richter, *The Portraits of the Greeks*, rev. ed. (Ithaca, 1984)
Richter, *SSG*	G. M. A. Richter, *The Sculpture and Sculptors of the Greeks*, 4th ed. (New Haven, 1970)
Ridgway, *HS* 1	B. S. Ridgway, *Hellenistic Sculpture*, vol. 1: *The Styles of ca. 331–200 B.C.* (Madison, 1990)
Ridgway, *RC*	B. S. Ridgway, *Roman Copies of Greek Sculpture: The Problem of the Originals* (Ann Arbor, 1984)
RM	*Mitteilungen des deutschen archäologischen Instituts, Römische Abteilung*
Robertson, *HGA*	M. Robertson, *A History of Greek Art* (Cambridge, 1975)
Rolley, *BG*	C. Rolley, *Les bronzes grecs* (Fribourg, 1983)
Small Bronze Sculpture	*Small Bronze Sculpture from the Ancient World*, ed. M. True and J. Podany (Malibu, Calif., 1990)
Smith, *HS*	R. R. R. Smith, *Hellenistic Sculpture: A Handbook* (New York, 1991)
Stewart, *Greek Sculpture*	A. Stewart, *Greek Sculpture: An Exploration* (New Haven, 1990)
th	thickness
W	width
Walters, *Catalogue*	H. B. Walters, *Catalogue of Bronzes, Greek, Roman, and Etruscan, in the Department of Greek and Roman Antiquities, British Museum* (London, 1899)
Walters, *Select Bronzes*	H. B. Walters, *Select Bronzes* (London, 1915)
Wojcik	M. R. Wojcik, *La Villa dei Papiri ad Ercolano* (Rome, 1986)
Das Wrack	*Das Wrack: Der antike Schiffsfund von Mahdia*, ed. G. Hellenkemper Salies et al. (Cologne, 1994)
Wycherley, *Agora* 3	R. E. Wycherley, *Literary and Epigraphical Testimonia*, The Athenian Agora 3 (Princeton, 1957)
Zimmer, *Bronzegusswerkstätten*	G. Zimmer, *Griechische Bronzegusswerkstätten: Zur Technologieentwicklung eines antiken Kunsthandwerkes* (Mainz, 1990)

CLASSICAL BRONZES

ART, MARKET, AND PRODUCT

Before the Greeks did much traveling, and before they fell prey to foreign influ-
ences, they seem to have confined their visual expression to relatively small-
scale objects. If some of the pots they made were large, the decorations re-
mained small. Repetition of standardized ornament—simple horizontal lines,
zigzags, meanders, dots, swastikas, chevrons, and the like—was an integral part of this
tradition. When figures appear on Geometric pottery, they are in perfect consonance with
the overall decorative patterns surrounding them, for they too are formulaic, and they
repeat themselves. There may be a row of birds, of deer, or of chariots, or dozens of
mourners, all alike, as if they are part of a huge and never-ending procession. Sometimes,
like figures are represented facing each other, mirror images separated by repetitious de-
signs, perhaps by a row of birds (fig. 1.1).

 The earliest three-dimensional figures are also small, and they too are repetitious, there
being large numbers of birds, cows, deer, horses, and human figures. Most of them are
simply standing figures. Many, even those whose production is of high quality, are so much
alike that they can best be described as generic images (fig. 1.2). We need only count the
seventeen hundred bronze statuettes of horses that have been cataloged from some seventy
sites to get a sense of the vast extent of the bronze-casting industry during the Geometric
period.[1] The similarity among these bronzes, particularly those that come from a single
site, is astounding. A close adherence to types was, of course, necessitated by the votive
functions of most figures, and was thereby related to the market demand. When the
concept and methods of monumental work in stone and in metal were imported to Greece
during the seventh century B.C., the traditions shifted to accommodate this new environ-
ment. The custom of repetition, however, was already in place, and this remained a part of
the artistic tradition. In bronze, the practical need for repetition was closely linked to the

[1] See Jean-Louis Zimmermann, *Les chevaux de bronze dans l'art géometrique grec* (Mainz, 1989).

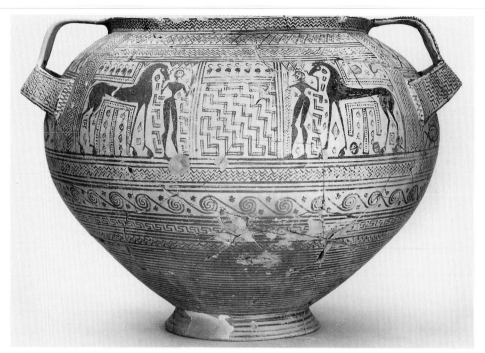

1.1. Argive Geometric clay krater, late eighth century B.C. H 0.47 m. Argos Museum. Courtesy of Ecole Française d'Archéologie, Athens.

technical tradition, for the essential nature of the bronze medium is reproduction; that is to say, the product is actually a "copy" of the "original" wax working model.

Although the Greeks had settled abroad in Egypt by the middle of the seventh century B.C., it was not until Herodotos, two centuries later, that a Greek gave a good account of the kinds of things that impressed him, a Greek, in Egypt. Herodotos was primarily interested in the land, in the wildlife, and in the people, and his stories about them occupy much of book 2 of the *Histories*. He describes very few of the works of humankind in Egypt, but those that he does mention are usually both large in scale and made of the materials with which the Greeks had become familiar in Egypt. Herodotos pays most attention to the great pyramids at Gizeh, but he also makes reference to a few stone temples, tombs, and architectural complexes, and he does so primarily because of their size. Herodotos mentions other monuments only occasionally; those attracting his interest include obelisks, colossal stone statues, and relief carvings, and he reports at some length on a huge gilded wooden cow in which he says the daughter of Mycerinus was interred, then notes as well twenty colossal wooden statues of that same king's concubines. No doubt earlier travelers to Egypt had also been impressed by such wonders.

Greeks were living in the Nile Delta by about 650 B.C. Their trading colony at Naukratis was an important one, and Herodotos reports that at one time it was the only approved

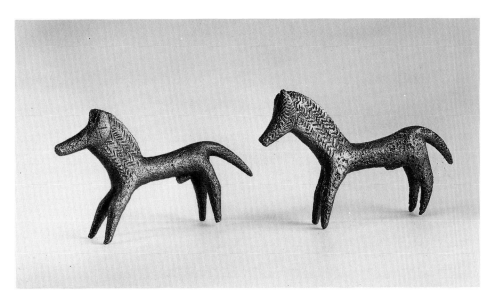

1.2. Two Geometric bronze statuettes of horses, decorated with chevrons, eighth century B.C. L 0.069 m. and 0.070 m. Olympia Museum Br. 10028 and Br. 9451. Courtesy of Deutsches Archäologisches Institut, Athens, neg. no. 69/439. Photo by E. F. Gehnen.

port of entry to Egypt through the Nile Delta.[2] When the Greeks settled at Naukratis, Egypt's Third Intermediate period (ca. 1070–656 B.C.) was in its last years. This period has yielded great numbers of cast-metal objects, including large bronzes, many of which are richly inlaid or sheathed in gold or silver.[3]

Early in the twenty-sixth dynasty, after the Third Intermediate period, King Psammetichos I (664–610 B.C.) encouraged intercourse between the Greek colonists and the Egyptians. The success of his endeavor is evident from the passage in which Herodotos reports that when these first foreigners came to Egypt, Psammetichos gave them land and sent Egyptian boys to learn Greek from them; Herodotos adds that the Greeks had an accurate record of Egyptian history from the reign of this king onward.[4]

The Greeks saw monumental stone architecture and sculpture for the first time while they were living in Egypt. Like Herodotos, they must have marveled at statues sheathed in gold, and at the rich and multicolored inlays in such materials as gold, silver, lapis lazuli, and carnelian. These works and their decorations were part of a long and flourishing tradition, one that was subject to very little change in style or technique.[5] By the seventh

[2] Herodotos 2.179.

[3] See C. Ziegler, "Les arts du métal à la Troisième Période Intermédiaire," in *Tanis: L'or des pharaons* (Paris, 1987), pp. 85–101, and R. Bianchi, "Egyptian Metal Statuary of the Third Intermediate Period (circa 1070–656 B.C.), from Its Egyptian Antecedents to Its Samian Examples," in *Small Bronze Sculpture*, pp. 61–84.

[4] Herodotos 2.154.

[5] John Boardman, summarizing the evidence for the Greeks in Egypt, states that living in Naukratis "opened Greek eyes to the works of a great civilization, more impressive even then in its 'antiquities' than in its contemporary arts and crafts" (*The Greeks Overseas* [London, 1980; rpt. 1988], p. 131).

century B.C., the Egyptians had been using the same basic formulas for representing large-scale figures of gods and of humans, as well as the same methods of carving them, for nearly two thousand years. They had also been using the lost-wax process to cast bronze statues in the same stylistic tradition for well over eleven hundred years. Whether a statue was made of stone, of wood, or of bronze, and whether it was standing, walking, or seated, it was invariably blocklike, frontal, and carefully proportioned according to the standard. Thus Egyptian sculpture was, by nature, repetitious. It was within this context that the Greeks learned how to make large-scale sculptures.

By the end of the seventh century B.C., the Greeks had started making large sculptures: the same general types as Egyptian statues, but with a few changes as they adapted Egyptian models to fit their own needs. At first, Greek statues were produced primarily as religious dedications. One of the most common types for Archaic Greek images is the nude standing youth, or kouros, whose formulaic style was repeated over and over, with few changes from the late seventh century through the Archaic period and into the early fifth century B.C. The kouroi were made individually or in pairs, which could be the same, like the colossal statues of Kleobis and Biton at Delphi, or as mirror images, like Dermys and Kittylos from Tanagra in Boeotia (figs. 1.3, 1.4).[6] Even by the fifth century the type had not exhausted itself, although both its style and its functions underwent radical changes. The style became naturalistic, and the uses were expanded to include representations of specific individuals, particularly victorious athletes and military heroes.

Most of the surviving large-scale Archaic kouroi are made of marble, and indeed the kouros type was first developed in stone, for which it is well suited. Stone is a heavy medium, one that can break under its own weight if pose and gesture are not supported. Each marble is carved individually by a subtractive process, which cannot be corrected if too much is removed unless the carver adds marble patches, which can be difficult to conceal. Textures, like light and shadow, are created by carving and by polishing the surface of the stone. The colossal Sounion Kouros comes early in the tradition of stone kouroi, between 600 and 590 B.C., and stands more than three meters in height (fig. 1.5). The statue has elaborate curls carved in high relief, volute-like ears, and huge bulging eyes marked by linear lids. The spine, the shoulder blades, veins, wrists, and ankles are carved as delicate surface decoration.

The marble statues identified as the brothers Kleobis and Biton, which were dedicated in the sanctuary at Delphi at the beginning of the sixth century B.C., are in fact simply kouroi, and they appear to be nearly identical. Indeed, the brothers were known to all, not for their appearances but for their good deed and its reward. Lacking the oxen needed to pull their mother's wagon to the Temple of Hera in Argos, the boys hitched themselves to the wagon and thereby brought their mother to the temple in time for the festivities, for which they

[6] There is also repetition, if not exactly duplication, among korai; see, e.g., the Geneleos dedication from Samos (fig. 5.3).

1.3. Marble statues of Kleobis and Biton, early sixth century B.C. H ca. 2.35 m. with bases. Delphi Museum inv. 467, 1524. Courtesy of Ecole Française d'Archéologie, Athens.

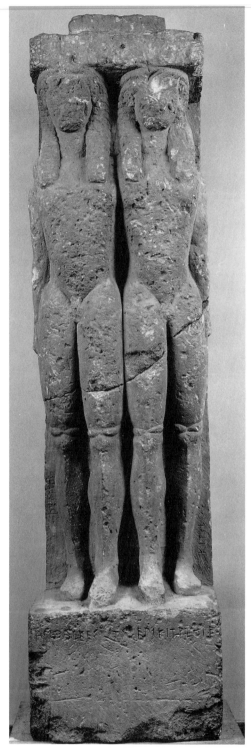

1.4. Limestone grave relief of Dermys and Kittylos, ca. 580 B.C., from Tanagra in 1887. H 2.00 m. H of youths 1.47 m. Athens, National Archaeological Museum no. 56. Courtesy of Ministry of Culture, Archaeological Receipts Fund, Athens.

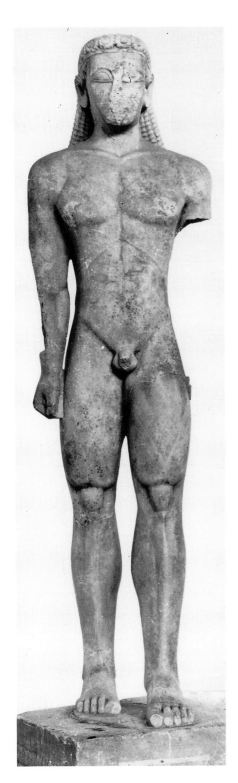

1.5. Marble kouros from Sounion, found in 1906. H 3.05 m. Athens, National Archaeological Museum no. 2720. Courtesy of National Archaeological Museum.

were immediately honored. That night, in response to their mother's prayer to Hera that they might be given the greatest reward, the goddess struck them dead, and so they could never fall from grace.[7] Repetition in stone can also be found, with variations, in the Archaic row of lions from the Lion Terrace on Delos; and two Archaic marble lions from one grave at Olbia seem to be almost identical.[8]

Kouroi were made in media other than stone, but the difference in material has virtually no effect on their appearance. The stylistic format for the kouros, like its function, was fixed, and deviations from that norm were minimal. In other words, if an artist was commissioned to make a kouros, then the kouros had to look the part. A kouros always stood in a frontal position, arms either extended slightly or not. A kouros did not look like a real youth. A small bronze from Olympia illustrates the irrelevance of the medium. This kouros was made in the first half of the sixth century B.C., and it once stood about half a meter in height (fig. 1.6). Now, however, it is in fragments, consisting of two bare legs, the left one advanced, and a clenched right hand that fits against the upper right thigh.[9] The thick hollow figure was made by the lost-wax process; before casting, two curving lines were scored in each wax knee to define the kneecaps. We might wonder why the properties peculiar to the medium of bronze were not exploited, and why the artist simply made a blocklike, self-contained kouros. But the Greeks had only recently learned from the Egyptians about the use of bronze. At the same time they had developed their own types of large-scale statues, which were essentially limited to simple standing, striding, and sitting figures. When the Olympia bronze kouros was made, then, bronze was still a new medium for sculpture, and there was no concept of linking a style to the peculiar properties of the metal. Perhaps this commission was intended as a display of wealth, a bronze statue to rival the large numbers of decorated-bronze tripod cauldrons and armor that were also dedicated at Olympia. At half a meter in height, this bronze kouros would have been noticeably larger than many of the other votive statuettes standing in the sanctuary during the first half of the sixth century.

Unlike the larger statues, the statuettes represent a wide range of figure types, and these are seemingly designed to exploit bronze, a relatively lightweight and flexible medium. It is possible to create a bronze figure with virtually any imaginable gesture or pose, and then make changes as often as necessary while work is still in progress. This flexibility is one of the great advantages of working in bronze, which is an additive process. Surface details and textures are also created while the work is in progress; that is, they are cut into the soft material of the working model. Finally, bronze casting involves the reproduction of a model, and, when the medium is fully exploited, the sculptor and founder can return to that model if a casting fails or if more than one copy of a statue is needed.

The Greeks saw large-scale bronzes in Egypt, and they learned how to cast statues like

[7] Herodotos 1.31.

[8] Volker Michael Strocka, "Variante, Wiederholung und Serie in der griechischen Bildhauerei," *JdI* 94 (1979): 169–70.

[9] See Mattusch, *GBS*, pp. 53–54.

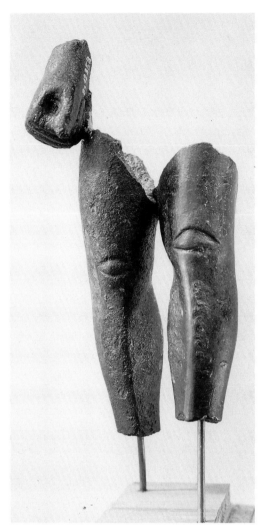

1.6. Legs and hand of a bronze kouros. Max. pres. H 0.155 m. Olympia B 1661, Br. 2702 and Br. 12358. Courtesy of Deutsches Archäologisches Institut, Athens, neg. nos. 72/3546, 72/3547.

them by means of the lost-wax process, the same method they used to produce small-scale bronzes. The first large-scale Greek bronzes were kouroi, so far as we know, and they were stylistically very similar to Egyptian statues. Technically, however, there were probably a good many variations in the details of casting. Figurines were cast solid, but it was more practical, and less expensive, to cast the larger statuettes hollow. The principal technological features follow a certain pattern, and they can be briefly summarized.[10]

[10] For detailed descriptions of the process, with bibliography and with references to the development of modern scholarship on this subject, see Denys Haynes, *The Technique of Greek Bronze Statuary* (Mainz, 1992), and Mattusch, *GBS*, pp. 10–30. For the connections between ancient and modern practice, see P. Cavanagh, "Practical Considerations and Problems of Bronze Casting," in *Small Bronze Sculpture*, pp. 145–60. For a

Lost-wax casting began with the construction of a full-size original, which we might best call the "artist's model." This original model was no doubt normally made of clay. Clay master molds were taken from the original model in separate, joining sections. After these molds had dried, they were reassembled in groups of manageable sizes. Each of the master-mold assemblages was lined with a layer of beeswax, which could be poured in, brushed on, or applied in slabs. Then the master molds were removed, and the beeswax sections of the statue were reassembled into a working model, which could be detailed and reworked. This last step could be a quick finishing process, or it could be extensive, involving adjustment and readjustment of the limbs. Wax might be added for such features as locks of hair and beard, and for the tooling and cutting of fine surface details. The kneecaps on the kouros from Olympia were also cut into the wax, but they appear crudely carved in contrast to the exquisite workmanship seen in the hair and beard of the larger-than-lifesize bronze god from the sea at Artemision (fig. 1.7). Here, the individual strands of hair lying close to the head and entwined in the braid were painstakingly incised in wax, and the plastic locks of hair across the brow, like the long locks of the beard, were added in wax and detailed before the investment of the working model and the casting of the bronze.

For Aristotle, the soul was the incorporeal form for which the body was the corporeal matter, just as vision was the form for the solid matter of the eye. In his explanation of this theory, Diogenes Laertius (third century A.D.) draws a rather complicated parallel for soul and body with the wax working model for a bronze statue of Hermes. In the first stage, the wax has taken the form of the original model. In the second stage, form becomes matter, or actual corporeality is accomplished, just as the bronze statue of Hermes is the corporeal version of the transitory wax model.[11]

To model and cut the surface details of a bronze in the relatively soft wax working model allowed for ease and fluidity in production, as well as for ease in changing and correcting passages in the wax. At this stage, it was easy to reach places that now seem as if they would have been difficult to work on, like the fur on the far side of a ram being clutched under a man's arm, or the strands of hair on the undersides of curls, because these could be individually made and detailed before being added to the working model (fig. 1.8).

When this part of the skilled artistic work was finished, skilled technical work was called for. It would not be practical to attempt to cast a statue whole. Instead, the completed wax figure was sectioned for casting, perhaps in the same parts that had been molded from the original model to produce the working model. For a nude figure, these parts might include the head, the arms, the torso, and the legs, each section involving no more metal than two men could safely lift and pour.[12] The Riace Bronzes were cast in relatively few pieces, the

thorough discussion of the testimonia, see H. B. Walters, *Catalogue*, pp. xvii–lxx; for a concise account, see Gerhard Zimmer, "Schriftquellen zum antiken Bronzeguss," in *Archäologische Bronzen*, pp. 38–49.

[11] Aristotle, *De anima* 2.1.412–13; Diogenes Laertius 5.33. For an interesting discussion of related issues, see Guy P. R. Métraux, *Sculptors and Physicians in Fifth-Century Greece* (Buffalo, 1995).

[12] The temperature of molten bronze is about 1,000°C, but varies according to the proportions of the various metals in the alloy.

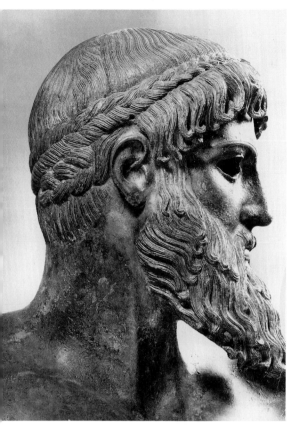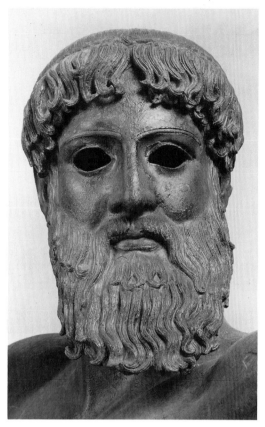

1.7. Head of a bronze god, ca. 460 B.C., found in the sea near Cape Artemision in 1926 and 1928. Total H 2.09 m. Athens, National Archaeological Museum no. 15161. See also fig. 1.17. Courtesy of Deutsches Archäologisches Institut, Athens, neg. nos. Hege 850 and N.M. 4539.

torso and legs of each statue being one large section (see fig. 2.18).[13] And on the seated boxer in the Terme Museum in Rome the genitals were intended to conceal the joins along the creases at the tops of the separately cast legs (fig. 1.9).[14] A draped figure could be cast in many more pieces, because, after casting, the joins were rather easily concealed beneath folds. Thus, in Izmir, a larger-than-lifesize goddess or lady with a windswept veil consists of ten separately cast pieces (fig. 1.10). The veiled head was actually cast in four pieces: a domed skull and two windswept flaps of veil on either side of a face mask. A bronze ring joins the head to the top of another casting comprising the neck, the chest, and the front of

[13] For drawings of the piecing, see Edilberto Formigli, "La tecnica di costruzione delle statue di Riace," in *Due bronzi da Riace. BdA* spec. ser. 3 (Rome, 1984), 1:122, fig. 18 (bodies), 1:131, figs. 28–29 (heads), and 1:132, fig. 30 (lips).

[14] See Nikolaus Himmelmann, *Herrscher und Athlet: Die Bronzen vom Quirinal* (Milan, 1989), no. 1, pp. 201–5 and fig. 1*d*, and *Rotunda Diocletiani: Sculture decorative delle terme nel Museo Nazionale Romano*, ed. Maria Rita di Mino (Rome, 1991), pp. 62–64, pls. 5–8. For the alloy of this bronze, see chap. 4, n. 50, below.

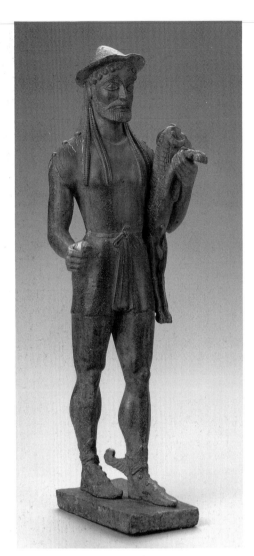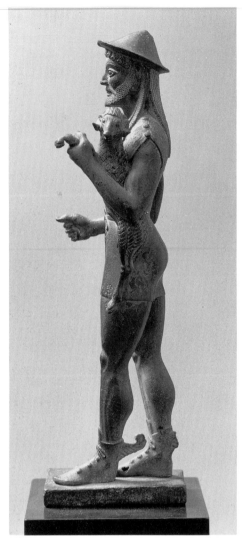

1.8. Bronze statuette of Hermes Kriophoros, sixth century B.C., said to be from Sparta. H 0.264 m. Boston, Museum of Fine Arts 99.489. H. L. Pierce Fund. Courtesy of Museum of Fine Arts, Boston.

the torso. Without four more pieces, however, the draped torso would be incomplete: attached to the front of the torso are the crinkly neckline of a chiton, a triangular fold of the peplos just below that, and the upper two of the three folds of the mantle that run diagonally across the torso.[15]

Each separate section of the working model was cored and covered individually with clay investment—first a fine sliplike layer, then coarser layers containing temper to prevent

[15] Brunilde S. Ridgway suggested a slightly different sectioning of the statue in "The Lady from the Sea: A Greek Bronze in Turkey," *AJA* 71 (1967): 329–34. See also *Art Treasures of Turkey*, ed. T. C. Witherspoon, Smithsonian Institution (Washington, D.C., 1966), p. 91, no. 130.

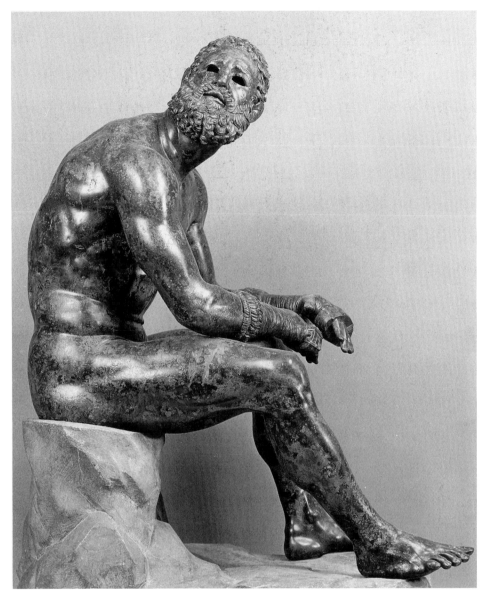

1.9. Seated bronze boxer, found in the substructure of a Roman building on the Quirinal (Via Quattro Novembre) in 1885. H 1.28 m. Rome, Museo Nazionale Romano inv. 1055. See also pl. 3. Courtesy of Archäologisches Institut und Akademisches Kunstmuseum der Universität Bonn. Photo by Wolfgang Klein.

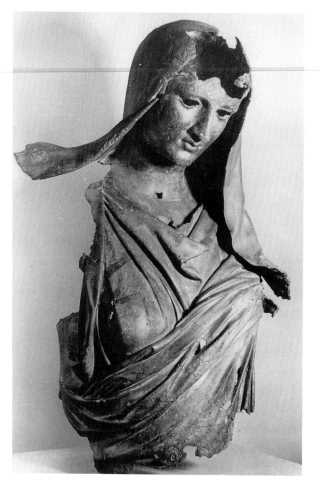

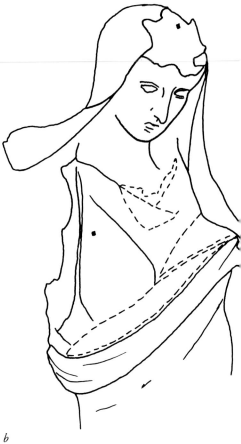

a

b

1.10. Veiled bronze lady, found in the sea near Arap
Adasi (Turkey) in 1953. H 0.81 m. Izmir, Museum of
Archaeology no. 3544. (*a*) Courtesy of Bryn Mawr
College. Photo by Mustafa Kaplin, neg. no. A-1107.
(*b*) Drawing by C. C. Mattusch.

shrinkage.[16] This was the final mold, which was simply broken away and discarded after
casting. Coldworking included joining the separately cast parts of the statue and touching
up the details that had been cut in the wax working model; also involved were the addition
of separately cast curls, the insertion of inlays, and the attachment of attributes.

Irregularities in the thickness of the walls of a bronze indicate where wax was applied
unevenly within the master molds or where additions were made to the wax model. The
inner surface of a finished bronze may be smooth, like the wax it replaces; if there are drips,

[16] For investment molds, see C. C. Mattusch, "Bronze- and Ironworking in the Area of the Athenian Agora,"
Hesperia 46 (1977): 340–79.

1.11. Inner surfaces of two fragments of large-scale bronzes, showing brushmarks, splatters, and a drip from the application of wax to master molds. Max. pres. dim. 0.065 m. and 0.086 m. Corinth Museum MF 7935a (wavy hair) and MF 7935d (fur). Courtesy of American School of Classical Studies at Athens: Corinth Excavations.

brushmarks, or seams, these occurred in the wax when it was being applied to the insides of the master molds (fig. 1.11).

After the wax working model was completed, a liquid clay core was poured inside each hollow section; iron rods, known as the "armature," might be inserted to stabilize and strengthen the core. In addition, metal pins (rectangular in section and usually made of iron), known today as "chaplets," were stuck through the wax model into the core at several points. The heads of the chaplets were left exposed. These would hold the core in position within the mold after the wax was melted out. Attached to the model was a wax gate system, which was melted out along with the wax working model, leaving behind a funnel for receiving the molten bronze, channels for directing the bronze into place, and small vents to let the gases escape.

But first, before the melt, each section of the wax working model, with its gate system, was covered with a clay outer mold, the "investment." This was applied in two or more layers, the innermost layer being the finest, to ensure that the working model was completely coated. The outer layers of the investment were composed of coarser clay with organic and sandy inclusions: these both prevented the clay from cracking and reduced shrinkage during drying and baking. The ends of the chaplets were covered and fixed in place by this mold. Only the top of the wax funnel and the ends of the vents were left exposed.

Next, the mold was placed on a base inside a hole, or "casting pit." Within the pit, at the base of the mold, a fire was built to burn out the wax and any moisture left in the clay. When the wax had burned out, what remained of the gate system was a framework of hollow channels to receive the molten metal and to vent gases, as well as a cavity for the bronze where the working model had been. After the molds cooled, they were packed firmly in sand within the casting pit, and bronze was heated in a crucible in an adjacent furnace. The molten bronze was then poured from the crucible into the funnels of the

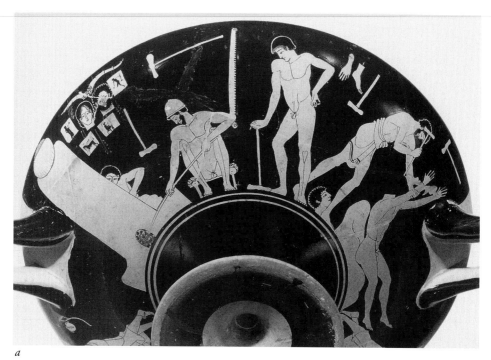

a

1.12. Berlin Foundry Cup, early fifth century B.C., from an Etruscan tomb at Vulci. Berlin, Antiken-sammlung F 2294. See also figs. 2.12 and 2.17. Courtesy of Antikensammlung, Staatliche Museen zu Berlin, Preussischer Kulturbesitz. (*a*) Photo by Ingrid Geske.

packed molds. After cooling, the sand packing in the pit was removed, and the investments were broken away from the bronze castings and discarded. Normally, much of the clay core could be removed from the cast sections of the statue, but some of it could remain inside, most likely because it was too difficult to extract.

After casting, the parts of a statue were fitted together, and also soldered, for a metallurgi-cal join ensured a much firmer fit than a mechanical one. Joins and imperfections were patched and smoothed, and the rectangular holes left behind by iron chaplets were filled with small patches. The surface of the statue was cleaned to reveal its natural gleam. The color of the bronze itself was often further enhanced by the addition of colorful inlays, such as copper nipples, eyebrows, and eyelashes, stone or silver eyes (pl. 1), and silver teeth and fingernails. A wreath might have both copper and silver inlays. Tin might be used as an alternative for silver inlays,[17] and color might be applied to the bronze itself.

Two bronze statues are illustrated on an early fifth-century Athenian kylix, known as the

[17] Today some of the best-preserved examples of inlays are found in furniture decorations. For references, see C. C. Mattusch, "Corinthian Metalworking: An Inlaid Fulcrum Panel," *Hesperia* 60 (1991): 525–28. For inlays and applied color, see n. 25 below.

b

Berlin Foundry Cup; both are in these final stages of production (fig. 1.12).[18] On one side of the cup (fig. 1.12 *a*), a workman with a hammer is joining one hand to a lifesize statue of an athlete that lies before him on a heap of earth, fitting neatly beneath one handle of the kylix. Between the workman's feet lies the head of the youth, open-mouthed, the final piece to be joined. Behind, two workmen are heating the bronze to make that join: a mature man stokes the furnace, a boy works the bellows. A second boy rests on his hammer, watching. The statue on the other side of the cup (fig. 1.12 *b*), that of a colossal striding warrior, is closer to completion, having already been erected and equipped with shield, spear, and helmet. Two workmen, who are only about half the size of the statue, are scraping its thighs with curved blades, cleaning the surface of the bronze. Like the men working on them, both statues have black hair, and their flesh color is not distinguished from that of the humans, so we can assume that this is conventional, rather than an attempt to show polychromy on the statues. The painter has made a point of representing two different styles of sculpture that were being produced in his day. The colossal statue has a stiff pose, an unnatural juxtaposition of a frontal torso with a profile head, arms, and legs, and he has long wavy hair and a single lock falling forward over the shoulder in the Archaic style. The

[18] For discussion and references, see C. C. Mattusch, "The Berlin Foundry Cup," *AJA* 84 (1980): 435–44; G. Zimmer, *Antike Werkstattbilder* (Berlin, 1982), pp. 8, 15–16, figs. 2, 9, pls. 1–5; and, more recently, *Die Etrusker und Europa* (Paris, 1992), p. 135, no. 141, and pp. 40–41 (fig.).

athlete, on the other hand, has a three-dimensional, natural pose as well as the short curls associated with the greater freedom of early Classical athletic statues. On both statues, the whites of the eyes are distinguished from the pupils; either they are meant to have been inset already or, more likely, the artist is not paying much attention to the details of production.

We might wish that the Berlin Foundry Cup could tell us more about the specific roles of artists and founders. Of the workmen who are represented on the kylix, those playing critical roles are mature, bearded individuals. Two of them—the fire stoker and one of the polishers—wear skullcaps. Two others—the joiner and the other polisher—wear mantles hitched up around their waists. The youths engaged in this workshop play menial roles: one is hard at work on the bellows, and it is tempting to think that the other is resting from the same exertion. We shall return to the two well-dressed onlookers in chapter 2, but there is no evidence permitting us to identify them as the artist and the founder. Indeed, the production of bronzes could be a collaborative process between sculptor and founder, or the roles of the two could be distinct. Here, the deciding factor might be the extent to which the wax working model was altered from the original. Both the precise production process used and the nature of a particular commission could affect the deviation of model from original.

One of the great advantages of using the process of lost-wax casting is that it minimizes the risk of failure and the possible loss of original work, because it allows for replication of the original model. Once master molds have been made, the artist's original model is set aside, and from that point onward, only the working model—the wax copy that was made in the master molds—is used. The working model is finished, touched up, perhaps also embellished; then it is used for the actual casting. When a casting fails, it is the wax working model that is lost, and a new one can be made, either from the master molds or, if these no longer exist, from a new set taken from the original model. The work to be redone is exclusively on the wax working model. Similarly, from a single original model, more than one bronze can be cast. In fact, utilitarian objects, such as handles, protomes, lamps, and all sorts of decorative elements were routinely produced in this way, by what we can call "serial production."

An early example of Greek serial production is provided by two solid-cast charioteers (eighth century B.C.) from the sanctuary of Zeus at Olympia, still standing in stiff frontal poses in their chariot boxes (fig. 1.13).[19] Both charioteers have the same broad flat feet, parted legs with massive calves, narrow waists, triangular torsos, broad shoulders, thick necks, bearded oval faces, thin lips, protruding ears, and tall-crested helmets. Their arms,

[19] I am grateful to Susan C. Jones for bringing these two statuettes to my attention. For a general discussion of serial production by the lost-wax process, see C. C. Mattusch, "The Production of Bronze Statuary in the Greek World," in *Das Wrack*, 2:789–800.

 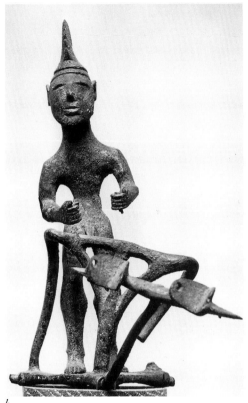

a b

1.13. Two Geometric bronze statuettes of charioteers, eighth century B.C., from Olympia. Max. pres. H. (*a*) 0.135 m., (*b*) 0.134 m. Olympia Museum B 1670 (*a*); Athens, National Archaeological Museum no. 6190 (*b*). Courtesy of Deutsches Archäologisches Institut, Athens, neg. nos. OL 2069, 71/5.

which once clutched the reins, are at waist level before them. These close similarities make it easy to see how the statuettes could have been produced from a simple two-piece master mold, with the arms down at the sides. The wax arms could easily have been bent into position. The chariot boxes were apparently made individually, but as a group, from rolled strips of wax of equal length, then stuck together to make however many chariots were part of the series. The men were placed in their chariots, invested, and cast. Even now, although the bronzes have different degrees of corrosion and of damage, the similarity between them is striking. Their similarity, then, is not because both represent a single regional style,[20] but because they were produced in the same series.

During the Orientalizing period, tripod cauldrons were decorated with groups of match-

[20] See, e.g., Wolf-Dieter Heilmeyer, *Frühgriechische Kunst* (Berlin, 1982), p. 47.

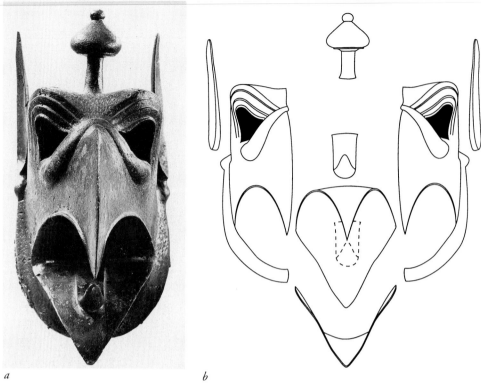

a b

1.14. Colossal cast-bronze griffin, one of a series once attached to a cauldron by long curving necks of hammered bronze, from Olympia. (*a*) Max. pres. H 0.278 m. Olympia Museum B 145 and B 4315. Courtesy of Deutsches Archäologisches Institut, Athens, neg. no. OL 4963. (*b*) Computer-generated drawing from digitized photograph by Avrim Katzman.

ing protomes—of sirens, griffins, lions, and the like. These were a popular dedication in sanctuaries, and the hollow-cast groups of about six or eight protomes were naturally made in series. Especially large cauldrons may have had more and larger protomes. Herodotos describes some of them. In the seventh century B.C., King Gyges of Lydia sent six gold cauldrons to Delphi, each one weighing five talents, or about three hundred pounds. In the sixth century B.C., King Kroisos of Lydia sent two huge cauldrons to Delphi: a gold one, which weighed about five hundred pounds, and a silver one, made by Theodoros of Samos, which held about fifty-four hundred gallons. Kroisos, moreover, was given a bronze cauldron by the Lakedaimonians that held about twenty-seven hundred gallons. Ariantes of Scythia had a bronze cauldron made that was six fingers thick and held fifty-four hundred gallons.[21] The Serpent Column from Delphi, of which 5.35 meters survive, nearly its full height, once supported a gilded cauldron that was surely also very impressive. The only

[21] Herodotos 1.14 (Gyges), 1.51 (Kroisos), 1.70 (the Lakedaimonians for Kroisos), 4.81 (Ariantes). The famous bronze Vix Krater weighs ca. 450 pounds, and holds ca. 250 gallons.

major variable would have been in the technical approaches to making different series of protomes. Thus, the heads alone of three large griffins from Olympia are more than 0.27 meter in height; with their hammered sheet-bronze necks, they would have been between 0.65 and 0.80 meter (fig. 1.14). These three heads were formed from nearly identical groups of waxes. Features were added separately to each one, the same tools were used to punch the scales on all three heads, and originally all were pinned to the necks in the same way. The height of the entire tripod cauldron that they adorned was between 4.60 and 5.60 meters, or about the same as another bronze cauldron described by Herodotos. That one too had griffin protomes, and it was supported by three kneeling bronze figures, which Herodotos says were seven cubits high, or about 3.25 meters.[22]

The two small bronze charioteers are an indication of the demand for a particular type of votive offering at Olympia during the eighth century B.C. We should expect that various ways would be found to produce quickly, again and again, those figurines which were the most popular types of votive offerings. Indeed, there is abundant evidence that serial production was an established practice well before the sixth century B.C. The bronzes that were cast from one original model could look very much alike, or, if alterations were made to the wax working models, they could be quite different. Two riders and two kouroi from Samos are excellent examples of two popular types of bronzes, each pair forming part of a series, if not a complete series, that was cast from a single original model, with some alterations made in the wax working model before casting. The horsemen's legs, perhaps also their arms, seem to have been modeled somewhat differently (fig. 1.15). The kouroi, however, show another big difference: in one case, an inscription was cut into the working model, a dedication by Smikros to Hera (fig. 1.16).[23] In this example, then, the wish of the purchaser was taken into account during production of the statuette.

It may seem curious that, during the Archaic period, the makers of large bronzes, unlike the makers of many statuettes, made no attempt to exploit their medium for its inherent flexibility. No changes were made to the stylistic canons or formulas they had developed for large-scale sculpture, even though the physical characteristics of the new medium might seem to us to encourage change. Rather, they were guided by the limited types that were current for statuary.

The general type of the kouros persisted into the Classical period, but the style gradually changed. Indeed, by the fifth century B.C., the stylized frontal kouros is no longer even recognizable in the statues of athletic victors and military heroes, with their natural stances and their arms outstretched in a variety of gestures. There was also a growing demand for athletic statues that depicted actual sportsmen: jumpers, runners, boxers, diskos throwers,

[22] Herodotos 4.152. For a more thorough treatment of Orientalizing cauldrons and their protomes, with references, see C. C. Mattusch, "A Trio of Griffins from Olympia," *Hesperia* 59 (1990): 549–60.

[23] For a preliminary discussion of these four bronzes, see Helmut Kyrieleis, "Samos and Some Aspects of Archaic Greek Bronze Casting," in *Small Bronze Sculpture*, pp. 15–30. The inscription on the kouros in fig. 1.16b is cut in the outside of the left leg.

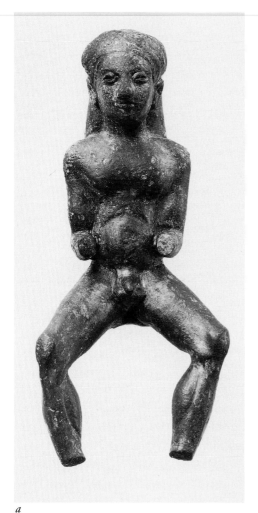 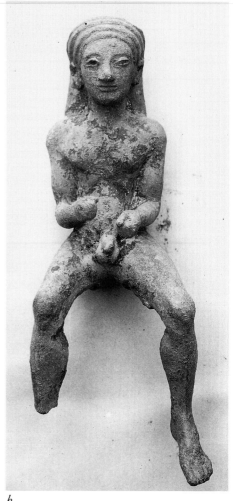

a *b*

1.15. Bronze statuettes of riders, sixth century B.C., from Samos. Samos, Archaeological Museum B 97 and B 2608. Courtesy of Deutsches Archäologisches Institut, Athens, neg. nos. (*a*) 84/364, photo G. Hellner, (*b*) Samos 527.

and the like. Clearly, the athletic statue that is being pieced together on the Berlin Foundry Cup represents such a statue, probably that of a runner. These are not portraits; rather, they are generic versions of young or mature men, at the peak of their physical ability. The physical type is the same as for statues of gods and heroes, but athletes engaged in sport broadened the range of figures that fit the type. It must have been the chance to exploit the versatility of bronze that gave this medium ascendancy over stone. In the fifth century B.C., bronze became the most popular medium for freestanding sculpture, a status it retained into the Roman period.

Bronze has an innate affinity to the human figure, both in color and in flexibility. The

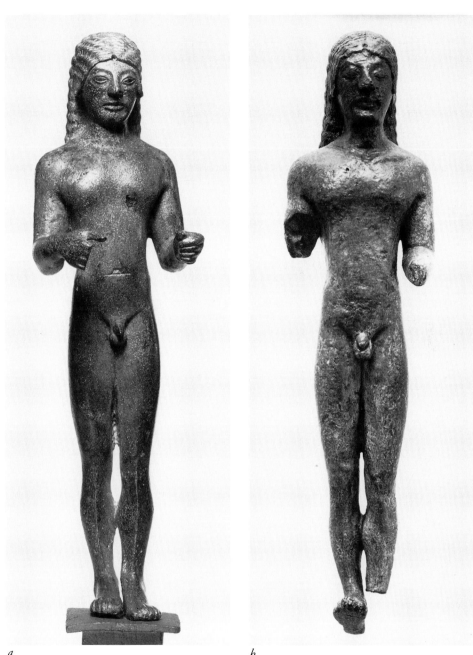

a *b*

1.16. Bronze statuettes of kouroi, sixth century B.C., from Samos. (*a*) Berlin, Antikensammlung no. 31098; (*b*) Samos, Archaeological Museum B 2605. (*a*) Courtesy of Antikensammlung, Staatliche Museen zu Berlin. Photo Ute Jung. (*b*) Courtesy of Deutsches Archäologisches Institut, Athens, neg. no. 85/781. Photo E. F. Gehnen.

larger-than-lifesize bronze god from Artemision illustrates clearly the effectiveness of the medium for representing the human form (fig. 1.17). Arms and legs are easily spread, and the figure appears to have a kind of buoyancy or spring in his stride. The composition is a two-dimensional one, depending on a system of triangles, which are seen to best advantage in silhouette. The smooth rippling muscles contrast with highly textured hair and beard, and the inlaid eyes would have added to the majestic impression created by the image as a whole. The freedom of movement, and the reference to nature in the color of this bronze would have made for a kind of exaggerated naturalism, no doubt intended to create an overwhelming impression on the viewer. Indeed, certain alloys of bronze were reputed to have been developed for their particular color.

Bronze was certainly the most appropriate medium for statues of nude gods and athletes. On a vase fragment from the first quarter of the fourth century B.C., Apollo and Artemis sit before a Doric temple with partly open doors: inside stands a statue of Apollo, left foot forward, holding bow and phiale (pl. 2). The seated gods are rendered as if they were living figures. Apollo, who holds a lyre, has black hair and golden berries painted on his wreath. Artemis, with a staff or a spear, wears gold-painted bracelets and a baldric ornamented with golden buttons. In contrast, the "statue" of Apollo has golden flesh and hair, a white bow and phiale, and details sketched in brown. Otherwise, this "statue" of Apollo has approximately the same long curly hair and physical features as the "living" Apollo.[24] It is interesting in this connection that Dio Chrysostom (ca. A.D. 40–120) remarks that a particularly handsome boxer, Iatrokles, looked like a carefully made statue, and that his skin color was the same as that of a well-mixed bronze.[25] In other words, the human athlete or victor could be understood in terms of the familiar images of gods and heroes.

The eyes of bronze statues were often inlaid, inserted from the outside. The whites were of bone or ivory, the pupils of stone, and a rim of bronze might separate whites and pupils; the whole was encased in sheet bronze, the edges of which were cut to resemble lashes.[26]

[24] See A. D. Trendall, *Red Figure Vases of South Italy and Sicily* (London, 1989), p. 28, fig. 52; idem, *Early South Italian Vase-Painting* (Mainz, 1974), pp. 21, 53, pl. 32. See also Patrik Reuterswärd, *Studien zur Polychromie der Plastik. Griechenland und Rom* (Stockholm, 1960), pp. 125–26.

[25] Dio Chrysostom, *Orationes* 28.3. Reuterswärd observes that by the time of Dio, fifth- and fourth-century bronzes would have looked sun-browned unless they had been cleaned (*Studien zur Polychromie*, p. 115). Several studies of inlays, gilding, and black patination of ancient bronzes have been published in *Das Wrack*, a recent catalog of the finds from the Mahdia shipwreck. General summary: Wolf-Dieter Heilmeyer, "Zur Oberfläche antiker Grossbronzen," 2:801–7. Overview of metal inlays: Barbara Cüppers, "Metalleinlagen als farbige Ziertechnik," 2:1013–16. Two sets of inlaid eyes from the shipwreck: Christiane Brunnengräber, "Zur Herstellungstechnik der Ruderkastenbeschläge," 2:1007–8. Evidence for black patina from copper sulfide on some, but not all, of the bronzes from the wreck: Frank Willer, "Fragen zur intentionellen Schwarzpatina an den Mahdiabronzen," 2:1023–31, and Gerhard Eggert, "Schwarzfärburg oder Korrosion? Das Rätsel der schwarzen Bronzen aus chemischer Sicht," 2:1033–39.

[26] For very striking inlaid eyes on a bronze portrait of Augustus, who valued the strength of his own gaze, see British Museum GR 1911.9–1.1 (from Meroë in the Sudan, H 0.445 m.); for parallels, see Götz Lahusen and Edilberto Formigli, "Der Augustus von Meroë und die Augen der römischen Bronzebildnisse," *AA* (1993): 655–74, esp. fig. 19 for inserted eyes seen from inside the head. For metal additions to Greek marble sculptures, see B. S. Ridgway, "Metal Attachments in Greek Marble Sculpture," *Marble: Art Historical and Scientific Perspectives on Ancient Sculptures* (Malibu, Calif., 1990), pp. 185–206.

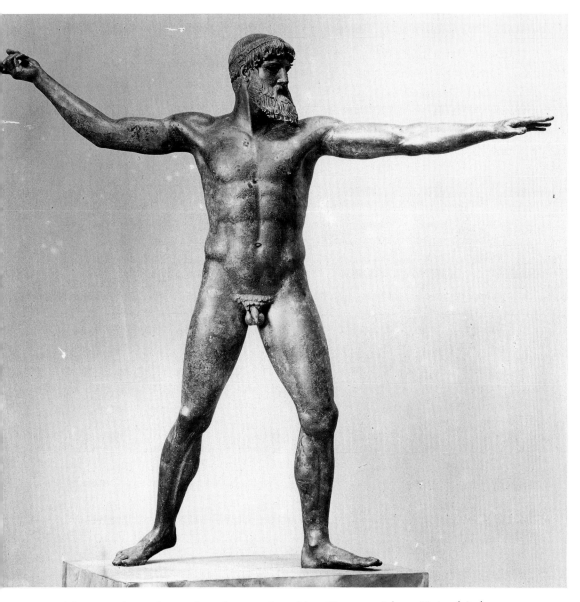

1.17. A bronze god, ca. 460 B.C., from the sea at Artemision. H 2.09 m. Athens, National Archaeological Museum no. 15161. See also fig. 1.7. Courtesy of Deutsches Archäologisches Institut, Athens, neg. no. N.M. 4533.

Eyebrows, lips, and nipples were often inlaid in copper, its reddish color contrasting with the yellower bronze. Teeth might be of silver, as is true in the case of the Riace Bronzes, the Delphi Charioteer, and also the head of the Libyan in the British Museum.[27] Silver

[27] See C. Houser, "Silver Teeth: Documentation and Significance," in *Abstracts*, 88th General Meeting, Archaeological Institute of America, vol. 11 (1986), p. 29. For the Libyan, see chap. 3 below.

fingernails were sometimes attached; apparently, though, they were not common, at least not in the time of Pausanias. He mentions a statue on the Akropolis especially for its silver nails, remarking on the skill or *technē* of the artist, an individual named Kleoitos.[28] His interest does not extend so far as to notice whom the helmeted statue represents. There is now in Princeton, in fact, a bronze finger, with its silver nail *in situ*, evidently from the Athenian Akropolis (fig. 1.18).[29] Bronze hands with silver nails were also used as decorative attachments, as, for example, on the handles of a large food warmer from Pompeii.[30] And the seated boxer in the Terme Museum has inlaid-copper blood dripping from the cuts he has suffered in competition (pl. 3).[31] The wounds were planned before casting: channels for the copper gashes and the dripping blood were cut into the wax working model.

Relatively little is known about the patination of ancient bronzes. The ancient literary testimonia are occasionally directed toward the question of intentionally colored bronzes, but the expertise of writers referring to this subject can easily be questioned. Pliny makes a few general references to various alloys of bronze having different colors. For example, he gives a recipe for statuary bronze, as well as for bronze tablets, that consists of melting (copper?) ore, then adding a one-third portion of scrap metal, which, being reused, he says, imparts to the metal a peculiar brilliance. Finally, twelve and a half pounds of silver–lead for every hundred pounds of melted metal, or 20 percent of the total volume, are added. Pliny adds that when lead is mixed with Cypriot copper, the bronze has the purple color that one sees in robes with purple borders (*praetextis*) on statues.[32] Pliny also thinks that the whitish Corinthian bronze had silver in it, whereas the yellower blend had gold in it. He says that another mixture, which was preferred for portrait statues, looked like liver and was called by the Greek name of *hepatizon*,[33] which must have meant "brown in color." In fact, traces of gold and silver have been found in bronze, although in such small quantities that their addition is not likely to have been deliberate.[34] Lead and tin can produce the results described by Pliny: bronzes with a fairly high percentage of lead or of tin in the alloy are paler and yellower than the more reddish bronzes, which have close to 90 percent copper.

Pliny goes on to mention two statues—one of Aeginetan bronze, the other of Delian bronze—implying that the viewer can see the differences between the two alloys.[35] He also describes some special effects produced in the coloring of bronze statues, but these are

[28] Pausanias 1.24.3.

[29] Pausanias 1.23.3.

[30] Pompeii inv. no. 6798. H 0.96 m. Published in *Riscoprire Pompei* (Rome, 1993), pp. 208–11.

[31] See n. 14 above. For a thorough discussion of this athlete, see Wilfred Geominy and Stefan Lehmann, "Zum Bronzebild des sitzenden Faustkämpfers im Museo Nazionale Romano," *Stadion* 15 (1989): 139–65.

[32] *NH* 34.98.

[33] *NH* 34.8.

[34] For the largest accumulation of data on Greek, Etruscan, and Roman alloys, see Paul T. Craddock, "The Composition of the Copper Alloys Used by the Greek, Etruscan and Roman Civilizations: 1. The Greeks before the Archaic Period; 2. The Archaic, Classical and Hellenistic Greeks; 3. The Origins and Early Use of Brass," *JAS* 3 (1976): 93–113; 4 (1977): 103–24; and 5 (1978): 1–16.

[35] *NH* 34.10.

1.18. Lifesize bronze finger with silver nail, said to be from the Athenian Akropolis and thought to be Roman. L 0.064 m. Princeton, The Art Museum no. y1940–169. Courtesy of The Art Museum, Princeton University. Gift of A. Hyatt Mayor.

somewhat less convincing than his comments about the alloys. He mentions a statue on Rhodes that represented Athamas after he had thrown his son Learchos off a rock. Aristonidas, the artist, made the statue look reddened with shame by mixing iron with copper and allowing the rust to show through the gleam of the bronze.[36] Plutarch also mentions a statue with a face of a different color from that of the body. A statue of Jocasta, mother of Oedipus, reputedly had silver mixed with the metal alloy on the face; this combination, says Plutarch, gave the bronze the appearance of a person about to die.[37] It is more likely that a different patina was used on the statue's face.

Interest in the coloring of ancient statuary has increased in recent years, for the introduction of new mechanical methods of cleaning ancient metals has reduced the damage to the surface previously done by invasive cleansing.[38] Recent studies have shown that the skin of the Riace Bronzes was once black, and that some of the bronzes from the Mahdia shipwreck were intentionally given a black patina by the application of sulfur to their surfaces.[39] Unfortunately, the electrochemical cleaning of bronzes, common until quite recently, resulted in the loss of not only corrosion products but of the actual surface of the bronzes

[36] *NH* 34.140.

[37] Plutarch, *Quaestiones conviviales* 5.1.2.

[38] For an early discussion of patinas, see Henri Lechat, "Aphrodite: Statuette en bronze de la collection de M. Constantin Carapanos," *BCH* 15 (1891): 473–81. The most thorough coverage of the subject is Reuterswärd, *Studien zur Polychromie*. For more recent studies, however, see esp. Hermann Born, "Polychromie auf prähistorischen und antiken Kleinbronzen," in *Archäologische Bronzen*, pp. 71–84; idem, "Zum derzeitigen Stand der Restaurierung antiker Bronzen und zur Frage nach zeitgenössischen polychromen Oberflächen," in *Griechische und römische Statuetten und Grossbronzen*, Akten der 9. Tagung über antike Bronzen in Wien, April 21–25, 1986, ed. K. Gschwantler and A. Bernhard-Walcher (Vienna, 1988), pp. 175–80; idem, "Patinated and Painted Bronzes: Exotic Technique or Ancient Tradition?" in *Small Bronze Sculpture*, pp. 179–96.

[39] See Edilberto Formigli, "Die Restaurierung einer griechischen Grossbronze aus dem Meer von Riace/ Italien," in *Archäologische Bronzen*, pp. 168–74, with bibliography.

and, consequently, of any patina there might have been on that surface.[40] Occasionally, patination is revealed by chance, as was the case with an Archaic statuette of a ram bearer that was put on exhibition beneath a strong raking light. An applied pattern of rays became clearly visible to me, radiating from the peak of the figure's hat.[41]

As a rule, bronze statues seem not to have been gilded very often before the Roman imperial period, but enough of them were around during the first century B.C. for Catullus to have taken notice and to refer to a person, somewhat scornfully, as being "paler than a gilded statue" (*inaurata pallidior statua*).[42] Moreover, not all gilded statues represented gods, as we might have thought. There are late references to three gilded bronzes, said to have been owned as early as the sixth century B.C. by King Kroisos of Lydia, and to one dedicated at Delphi by the long-lived Gorgias of Leontini (483–376 B.C.).[43] Also at Delphi, Pausanias mentions seeing a gilded statue of Phryne made by her lover Praxiteles and dedicated by Phryne herself.[44] Gold-and-ivory (chryselephantine) statues did not have bronze cores, and the golden cult statue of Apollo on Delos was evidently made of wood with gold plates attached to it.[45]

Two examples of gilded statues survive from early contexts; both are of gilded bronze, and both come from the Athenian Agora. These statues, a bronze female head and the leg of a male rider, come from destruction contexts of around 200 B.C. or shortly before. Both statues were once covered with gold foil attached in deep channels that were scored into the wax working model before casting (figs. 1.19, 4.9, and 4.11). Nearly all the gold is now gone (a few traces remain in the channels), and it is clear that the bronzes were not meant to be seen without the gold foil in place. Pausanias saw gilded Nikai, presumably bronze beneath the gold, standing at each end of the roof of the Temple of Zeus at Olympia, but he gives no clue as to the date of these akroteria.[46]

Pliny mentions a bronze by Lysippos that was gilded long after its production. It was a statue of the young Alexander, and Nero was so taken by it that he had it gilded. Although the gold increased its monetary value, the artistic merit was so reduced that the gold was removed, and in this condition the statue was thought to be even more valuable, despite the scars from the work done on it and the cuts from the attachment of the gold.[47] Gold leaf could easily have been applied to this statue, but evidently this method was not yet known. Thus, the thicker gold foil was used, and channels had to be cut into the base metal to hold the edges of the foil.

[40] For a summary of the history of conservation practices and of the effects on patination, see Born, "Patinated and Painted Bronzes."

[41] Ram bearer: Boston, Museum of Fine Arts, H. L. Pierce Fund no. 04.6. H 0.171 m. See *The Gods Delight*, ed. A. P. Kozloff and D. G. Mitten (Cleveland, 1988), pp. 77–81, esp. the figure on p. 80.

[42] Catullus 80.1.

[43] Moses of Chorene 2.11.103 = Overbeck 326; Pausanias 10.18.7. See Mattusch, *GBS*, pp. 175–76.

[44] Pausanias 10.15.1.

[45] See R. Pfeiffer, "The Image of the Delian Apollo and Apolline Ethics," *JWarb* 15 (1952): 27.

[46] Pausanias 5.10.4.

[47] *NH* 34.63.

Later, Roman bronzes were leaf-gilded; that is to say, thin gold leaf was applied with an adhesive to the metal. The alternative is called hot cladding, whereby gold leaf is burnished onto the hot metal, but the alloy could not be a tin bronze, for this would make the gold brittle.[48] Gold is resistant to corrosion, and gilded bronzes, though far more expensive than bronze, would not have required any surface treatment to preserve them from the effects of weather. Bronzes, however, when exposed to the elements, do not fare so well, and they require periodic attention.

To retain their natural gleam, bronzes had to be cleaned. In some cases, instructions are given for particular statues. A third-century B.C. inscription prescribes that a statue of a tyrant slayer be kept free of corrosion and bright (*lampros*), and that it be crowned on certain occasions. Another inscription rules that some votive bronzes must be kept clean (*katharos*).[49] As to the care of bronzes, Pliny observes that objects made of bronze become covered with rust more quickly when they are polished than when they are neglected, and he understands that the best way to preserve bronzes is to coat them with olive oil. Pliny says also that the use of bronze was established long ago in the interest of the long-term survival of monuments, and he notes similarly that official regulations are inscribed on bronze tablets.[50] Cato believes that the lees of olive oil will prevent rust.[51] And Pausanias remarks that the bronze shields taken from the Spartans who were imprisoned on the island of Sphakteria (425 B.C.) were covered with pitch against the effects of time and rust.[52]

In *De Pythiae oraculis*, Plutarch's characters discuss the unusual deep-blue color of the bronze dedications at Delphi. They dismiss the idea that this was an alloy used by early artists, and then discuss whether the color could be the result of the air in Delphi or of oiling the bronzes. In the end, they decide that the bronzes have simply acquired their blue color over time.[53]

That conclusion was correct. Bronze statues that stand in the open air oxidize, which turns them reddish in color. Then the carbon dioxide in the air imparts to the metal a green layer of copper carbonate. Pollution in the air can create a layer of black copper sulfide or

[48] For an explanation of techniques of gilding, including fire gilding/mercury gilding, which was not used widely until the second or third century A.D., see W. A. Oddy, "Vergoldungen auf prähistorischen und klassischen Bronzen," in *Archäologische Bronzen*, pp. 64–70; W. A. Oddy et al., "The Gilding of Bronze Sculpture in the Classical World," in *Small Bronze Sculpture*, pp. 103–24; W. A. Oddy, "Gilding: An Outline of the Technological History of the Plating of Gold on to Silver or Copper in the Old World," *Endeavour*, n.s. 15.1 (1991): 29–33, with bibliography.

[49] Vienna, Kunsthistorisches Museum inv. III 784 (L), of uncertain origin; *IG* 4.840, from the island of Kalauria (now Poros). I have not seen either of these inscriptions. For discussion and references, see Zimmer, *Bronzegusswerkstätten*, p. 153.

[50] *NH* 34.99.

[51] Cato, *De agri cultura* 98.2. For a brief discussion of the sources, see R. Shaw-Smith, "Metal Polish," *Classical Quarterly* 31 (1981): 469.

[52] Pausanias 1.15.4.

[53] Plutarch, *De Pyth. orac.* 395.2–4: see Lechat, "Aphrodite"; J. Jouanna, "Plutarque et la patine des statues à Delphes," *Revue de Philologie* 49 (1975): 67–71; and Stephan Schröder, *Plutarchs Schrift De Pythiae oraculis* (Stuttgart, 1990), pp. 81–84, 114–30.

blue copper sulfate. What Plutarch's characters saw, however, were not bronzes that had been exposed to air pollution, but simply bronzes that showed the effects of the dry climate at Delphi: copper carbonate with less water and more carbon dioxide is blue.[54]

Ancient bronzes that have survived to the present day have been affected severely by the passage of time: often we have to reconstruct the statue that went with a surviving head, or imagine the intended finished color of a bronze. Conservation practices have also changed. For example, most of the large-scale bronzes found in the Villa dei Papiri at Herculaneum during the middle of the eighteenth century have a dark polished surface of greenish black, and all of them seem complete, with the exception of a few missing eyes. In fact, they were reconstructed from a combination of old and new parts that were welded together. Restoration was completed by repatination with a color described as "Herculaneum" in the catalogs that advertize reproductions of these and of other Classical, Renaissance, and even later familiar statues.[55]

Until rather recently, it was usual to clean bronzes electrochemically. A description of cleaning a bronze by this method, written in 1932, both explains the reasons for using this process and alludes to its invasive nature. For this reason, many conservators have now abandoned the method described here and have adopted a far more conservative approach to cleaning bronzes:

> Although it was at once obvious that a beautiful and important work had been secured its quality could not be evaluated from the deformed mass of metal at hand. As the first step in the cleaning process the head was allowed to soak in distilled water, whence it was taken only for occasional brushings. After five weeks of this treatment much superficial accretion had been removed, but some hard corrosion still remained which did not yield to the soluble action of the water. The head was, therefore, wrapped in zinc plate and placed in a dilute solution (about 2%) of sodium hydroxide. It was left in this bath, which was frequently renewed, for nearly two months, when the corrosion had been entirely removed and the original bronze surface was revealed.[56]

A photograph taken of the bronze before cleaning makes it clear that a large amount of external accretion had to be removed just to make the piece recognizable (fig. 1.19 a). Cleaning revealed the base metal, from which all corrosion products had been removed (fig. 1.19 b). This reductive kind of cleaning, however, is destructive of the object itself, for

[54] For a simple description of copper corrosion products, see F. H. Goodyear, *Archaeological Site Science* (London, 1971), pp. 129–30. Both lead and tin have white or gray corrosion products. For descriptions and illustrations of the colors of various kinds of corrosion products, see H. Born, *Restaurierung antiker Bronzewaffen*, Sammlung Axel Guttmann 2 (Mainz, 1993), pp. 19–38: "Korrosionsprodukte."

[55] See chap. 4 below and Luisa A. Scatozza Höricht, "Restauri alle collezioni del Museo Ercolanense di Portici alla luce di documenti inediti," *Atti dell'Accademia Pontaniana*, n.s., vol. 31 (Naples, 1982), pp. 495–540.

[56] T. Leslie Shear, "The American Excavations in the Athenian Agora, Second Report: The Sculpture," *Hesperia* 2 (1933): 519–20, figs. 5–6. For a description of the history of the electrochemical cleaning of bronzes, see Born, *Restaurierung antiker Bronzewaffen*, pp. 65–66, figs. 28–30.

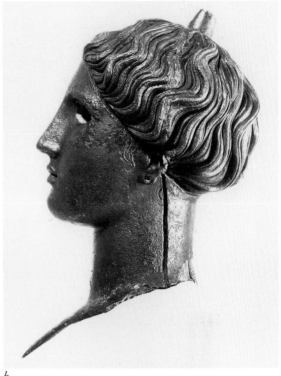

a *b*

1.19. Bronze female head from 1932 excavations in the Athenian Agora, before (*a*) and after (*b*) cleaning. H 0.2 m. Athenian Agora B 30. See also fig. 4.9. Courtesy of American School of Classical Studies at Athens: Agora Excavations.

the corrosion is a product of the metal. Thus, removing the corroded metal leaves a damaged and pitted surface, like removing the scab from a cut. In the catalog of sculpture in the National Archaeological Museum of Athens, reference is made to a bronze that had had "serious decay on its surface" having been "conserved by electrolysis." There is good reason to question whether this now deeply scarred bronze statuette of a flute player is in better condition now than it was at the time of its discovery in 1925 at the Heraion on Samos (fig. 1.20).[57]

Today, many conservators are reluctant to work on bronze in this reductive way, preferring instead to clean the metal mechanically. By using only precision hand tools, one can control what one is doing and remove the surface dirt and accretion—and nothing more. Many bronzes are now cleaned mechanically, thus preserving much more of the original surface of the metal and revealing fine surface details that would be destroyed otherwise.[58]

[57] S. Karouzou, *National Archaeological Museum: Collection of Sculpture. A Catalogue* (Athens, 1968; rpt. 1974), p. 5.

[58] See Hermann Born, "Korrosionsbilder auf ausgegrabenen Bronzen—Informationen für den Museumsbesucher," in *Archäologische Bronzen*, pp. 86–96 and color plates.

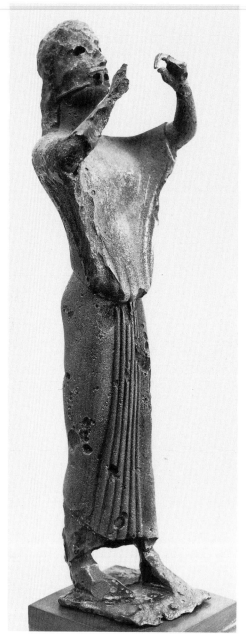

1.20. Solid-cast bronze statuette of a flute player, sixth century B.C., found at the Heraion on Samos in 1925. H 0.42 m. Athens, National Archaeological Museum Br. 16513. Courtesy of National Archaeological Museum.

Time and corrosion, of course, will take their toll. A base metal with a high percentage of copper is reddish in color, whereas the presence of a significant amount of lead or tin in the alloy makes the metal a pale yellow. As it corrodes, a bronze can develop red cupritic oxide close to the base metal, then green malachitic oxide on the surface. An iron chaplet that remains in place turns brown and expands as it corrodes, staining and eventually cracking

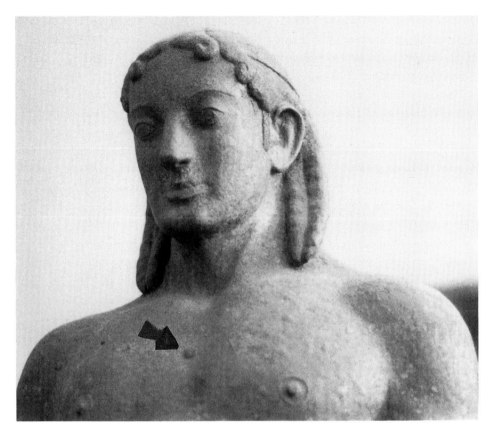

1.21. Head and chest of the Piraeus Apollo, with corroded iron chaplet (*arrow*) in center of chest, from a warehouse destroyed in the first century B.C. Found in 1959 by workmen digging a sewer line beneath Odos Philonos in Piraeus. H 1.91 m. Piraeus Museum. See also fig. 4.12. Photo by C. C. Mattusch.

the bronze (fig. 1.21). Lead and tin corrosion products first turn gray and then white. The hard solder used to join separately cast sections of a statue may have more lead or tin than the base-metal alloy. If so, the characteristic "puddling" of fusion welding can become visible on a bronze when the pale corrosion products of the higher-lead alloy of the weld begin to appear.

Given the few ancient bronzes surviving today, it is difficult for us to comprehend the notion that many "old" statues were visible in public places during Pliny's lifetime, a good number of which were still available for comment during Pausanias's trip through Greece in the later second century A.D. Pliny gives a sense of the immense field when he writes:

> Bronze statuary has flourished infinitely, and would fill a work of many volumes if one wanted to pursue much of it; as for all of it, who could do it? When Marcus Scaurus was magistrate (*aedile*), there were 3,000 statues on the stage of a temporary theater. After

defeating Achaia, Mummius filled the city [of Rome] with statues, but he did not leave enough for his daughter's dowry. And why not pose this question along with the excuse? The Luculli also imported many statues [74–73 B.C.]. And it is said by Mucianus, who was the consul three times [in A.D. 52, 70, and 75], that there are still 3,000 statues on Rhodes, and no fewer are believed to exist at Athens, Olympia, and Delphi. What human being could name them all, and what value can be gleaned from knowing this?[59]

Pliny says that he will mention the most important statues, and name the famous artists, but not try to count them all. Livy implies that there were a great many statues in Rome by the second century B.C., for he reports that in 179 B.C. numerous statues on columns around the Temple of Jupiter on the Capitoline Hill were taken down because they obstructed the view of the temple.[60]

Our own understanding of the large-scale Classical bronzes that have survived has always been influenced by the fact that there are so few of them. And yet, the uniqueness that these works have for us is in no way reflective of the context within which they existed during their own time. We are mistaken if we focus on these bronzes as unique creations, prizing them for their rarity, rather than considering them in the context of that major industry to which Pliny alludes. Once we go beyond the initial aesthetic response to Classical bronzes, and try to understand them in light of their former existence, we shall see not only that such works were produced in large numbers, but that they conformed to a few fixed types (for many were variations on a theme). Furthermore, we shall see that technical considerations were as influential as style on the fundamental character of Classical bronze statuary.

[59] *NH* 34.36–37.
[60] Livy 40.51.3.

REPEATED IMAGES

T he design and execution of a group of figures presents a series of problems for which the Greeks developed solutions during the Geometric period, solutions they continued to use throughout the Classical period. Both in two-dimensional and in three-dimensional formats, a solution was frequently achieved by way of repetition. In Geometric and Orientalizing vase painting, we see similar figures drawn over and over again—first animals, then humans and mythical creatures—as if they were just as simple to render as other decorative elements. The same kind of repetition could be applied to entire compositions. Two mid-fifth-century Attic red-figure pelikai, noticed at random and surely not unusual, provide an interesting illustration of this practice (figs. 2.1, 2.2).[1]

The vases are approximately the same size, and their subjects are also the same: on side A, Poseidon pursues Amymone, Danaus's daughter, whom he has just saved from a satyr; on side B, Zeus pursues an unidentified woman. A careful look at both sides of the first vase (fig. 2.1) reveals that although the subjects are different, the compositions, the outlines of the figures, and their gestures are essentially the same—which is all the more surprising since the two compositions are complex five-figure groups. On side A, Amymone runs along with her hydria dangling empty (she had been searching Argos for water); her head is turned back toward a wreathed Poseidon with long sidelocks, a frontal hairy chest, and an impressive, long-handled trident. To their left stands Aphrodite; to the right, Amymone's companion runs off, hands raised in fright, and a bearded cloaked man with a staff watches the scene, one hand raised in surprise. The composition on side B is nearly identical, except

[1] *CVA* Italy 64, Villa Giulia, vol. 4, by Gabrielle Barbieri (Rome, 1991), pp. 32–36, pls. 29–32. Inv. 20846 (fig. 2.1): H 0.450 m., diam. 0.321 m., diam. mouth 0.196 m., diam. foot 0.220 m. Inv. 20847 (fig. 2.2): H 0.454 m., diam. 0.340 m., diam. mouth 0.199 m., diam. foot 0.214 m. Both vases were reconstructed from fragments with additions, which may have altered slightly their original measurements. Both are from Cerveteri, Banditaccia nekropolis, zone A "del Recinto," Tomb of the Attic Vases, dated to the fifth century B.C.

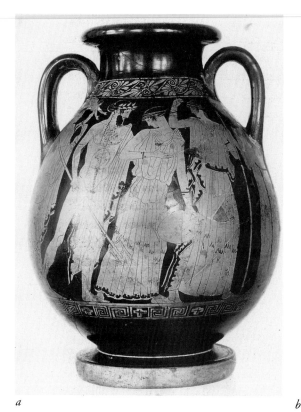

a b

2.1. Attic red-figure pelike showing two rape scenes, fifth century B.C., from a tomb at Cerveteri. (a) Poseidon pursues Amymone; (b) Zeus pursues an unidentified woman. Rome, Villa Giulia no. 20846. Courtesy of Soprintendenza Archeologica per l'Etruria Meridionale.

that Zeus is in profile and his staff is short, instead of Aphrodite a girl stands at the left, and the girl running to the right has her hands down instead of up.

In general, the second vase (fig. 2.2) is the twin of the first. Size, subjects, composition, figure outlines, and gestures are practically identical. The differences are in the surface details: drapery decorations and wreaths are not identical; the spacing of the figures is a little different; one leg is outlined beneath drapery, while another is not. A slightly more significant difference is that the Aphrodite standing behind Poseidon on the first vase has a small Eros flying above her, whereas there is only a girl standing behind Poseidon on the second vase, not Aphrodite, and she is not in the company of an Eros.

Neither vase is a copy of the other; the two vases are simply reiterations of the same themes, rendered in the same terms. Clearly, the painter had worked out a useful formula for representing the complicated five-figure group and then repeated it. On these vases we have four examples of his renderings of the same composition. Furthermore, the repeated composition was not simply a workshop exercise, but was marketed successfully. This is evident from the fact that both pelikai were owned by one family: the matching pair of

2.2. Attic red-figure pelike showing the same rape scenes as in fig. 2.1, also fifth century B.C. and from the same tomb at Cerveteri. Rome, Villa Giulia no. 20847. Courtesy of Soprintendenza Archeologica per l'Etruria Meridionale.

vases came from the same fifth-century Etruscan tomb in the Banditaccia nekropolis at Cerveteri.[2] Whether the two vases were ever displayed as a pair in the household we do not know.

In clay and in bronze, reiteration was somewhat different from the case just described, where the artist repeated his figure group freehand. Freestanding images that were modeled or carved individually could, of course, be repeated if their maker followed a single formula or used a template that established size, relative proportions, and general configuration. Lost-wax casting is by its very nature a reproducible process, in which master molds taken from one original model make it easy to produce a group of like statues in bronze. Variations within a group of several bronze figures could easily be introduced by making a second original model, perhaps a mirror image of the first.

[2] For a study of the intent behind representing a single subject twice on one vase—perhaps to convey a message more fully or more directly—see Ann Steiner, "The Meaning of Repetition: Visual Redundancy on Archaic Athenian Vases," *JdI* 108 (1993): 197–219. For the apparent Etruscan interest in collecting pairs of vases, see Richard D. De Puma, *Etruscan Tomb-Groups* (Mainz, 1986), pp. 60–62, 68, 70–71, 89, who kindly brought my attention to his discussion of this subject.

Today when we think of Greek and Roman sculptural groups, we tend to think of two or three engaged figures, such as a Geometric pair consisting of a man and a centaur holding each other at arm's length, or Hermes holding the baby Dionysos, or the oft-repeated baby grabbing a goose by the neck, or Aphrodite about to smack Pan with her sandal.[3] The Delphi Charioteer is now without his chariot, his horses, and his groom; often they are not recalled in descriptions of the intense young driver, even though a good deal of him would have been hidden by the framework of the chariot in which he stood.[4] We may forget altogether those less interesting groups of statues that stand in a row on a base, interacting little if at all, for we have almost no examples of such groups, despite firm references to them in the literary testimonia as well as the remains of their inscribed bases. These simple rows of figures, the normal way of commemorating a group of individuals, were a familiar sight in the public squares and sanctuaries of the Classical world. Two figurines of athletes standing side by side on a single base, arms outstretched, are one such group, though a small and lively one (fig. 2.3). The Riace Bronzes surely come from another, much grander group of heroic figures, once installed on a single base, no doubt side by side and, if there were more of them, all in a row. These few remaining figures, however, introduce us to the many statue groups that were conceived not like the above-mentioned interacting figures, which normally tell some story, but that were intended instead as rather straightforward political or military monuments: some of them commemorative, others more documentary in nature. Such monuments, more common and thus less frequently considered, will be the subject of this chapter.

The Eponymous Heroes of Athens, in Sculpture

Bronze statues of the Athenian Eponymous Heroes (Eponymoi) stood for some seven hundred years in the Athenian Agora. These were the mythical kings and heroes whose names were assigned to the ten Athenian tribes. Pausanias mentions the statues of these tribal heroes after noting some silver statues, not very large, that he observes near the Tholos. No more said of them, Pausanias goes on to speak of the statues of the tribal heroes which, he says, are "farther up" (*anotero*) from the Tholos.[5] Today nothing is left of the heroes but part of the long base on which they stood. There are, however, a great many references to this monument in the literary sources. The statues of the Eponymous Heroes served as enduring visual representatives of the Athenian tribes that bore their names. The presence of the heroes was a public reference to the function of the Athenian tribal system

[3] Geometric bronze man and centaur: New York, Metropolitan Museum of Art no. 17.190.2072. H 0.111 m. Marble Hermes with infant Dionysos: Olympia Museum. H 2.15 m. Marble baby with goose, from second-century A.D. villa on the Via Appia outside Rome: Munich, Glyptothek no. 268. H 0.84 m. Discussed in chap. 5 below. Marble Aphrodite and Pan from Delos: Athens, National Archaeological Museum no. 3335. H 1.29 m.

[4] Delphi Museum nos. 3484, 3540. H 1.8 m. See Mattusch, *GBS*, pp. 127–35, and chap. 7 below, with fig. 7.7. Also Claude Rolley, *La Sculpture Grecque*, 1: *Des origines au milieu du V* siècle (Paris, 1994), p. 346.

[5] Pausanias 1.5.1.

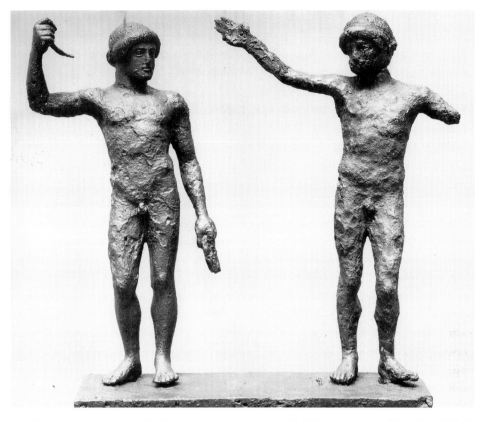

2.3. Two bronze statuettes of athletes on a single base, mid fifth century B.C. H 0.16 m. Delphi Museum no. 7722. Courtesy of Ecole Française d'Archéologie, Athens.

of government. Standing in the center of Athens, near the administrative buildings of the city, the monument was close to the Bouleuterion, where the five hundred members of the Boulē, or Athenian Council, met. (The Boulē was composed of fifty members from each tribe.) The nearby Tholos was a dining hall and headquarters for the fifty members from whichever tribe was providing the current committee (*prytaneis*) in charge of daily operations. As for the statues, if we can find out something of their original appearance, we shall begin to understand the nature of public monuments in the Classical world and the reason for the relative anonymity of so many of them.

The Athenian Eponymous Heroes were also honored in the sanctuary at Delphi. To understand their importance to the Athenians, and their symbolic functions, it is useful to review Athenian foreign affairs and domestic policies during the late sixth and fifth centuries. Of equal interest are the better-known public monuments that were erected by Kimon and by Perikles during their time in power. A good number of these monuments were created by Phidias, who worked for both men.

Just two years after the expulsion of the Peisistratids in 510 B.C., Kleisthenes rose to

power. He abolished the four Ionian tribes and instituted ten new ones,[6] each composed of equal proportions of people from the city, the countryside, and the coast. The new tribes were named after ten heroes, whose names had been freely chosen by the Pythian priestess at Delphi from a list of one hundred names submitted to her.[7] At the same time, Antenor made bronze statues commemorating two different men, Harmodios and Aristogeiton, who were being heroized for their assassination of Hipparchos, the son and successor of the late tyrant Peisistratos. These Tyrannicides, although they had evidently been motivated by a personal grudge, and had killed the less powerful of two brothers, were nonetheless honored for their role in bringing an end to tyranny. Theirs were the first honorary statues to be erected at public expense in the Athenian Agora.[8]

Kimon was born at about this time, probably in 508/507 B.C. His father, Miltiades, was one of the victorious Athenian generals at Marathon in 490 B.C.[9] The 192 Athenians who died there were buried on the battlefield: stelai were erected on their common burial mound, the *Soros*, listing their names by tribe, and each year thereafter a ceremony was held at the site.[10] Pausanias mentions also the marble trophy and a monument to Miltiades set up at Marathon.[11] The very next year, however, after he had made an unsuccessful expedition to the island of Paros, Miltiades was fined fifty talents for having deceived the people; he later died in ignominy, of a wound received on Paros. Kimon, who was about eighteen years old at the time, paid his father's fine, no doubt with some bitterness, since his father had so recently played a decisive role in the Athenian victory at Marathon.[12] In 480 B.C. the Persians sacked Athens, before being decisively defeated by the Greek forces at Salamis and at Plataia.

From 479 to 461 B.C., Kimon was the most powerful military and political leader in Athens. He campaigned unrelentingly against the Persians, and with great success. The Delian League was established in 479/478, and the walls of Athens were rebuilt. In 477, Kritios and Nesiotes were commissioned to make a second group of bronze statues of the Tyrannicides to replace Antenor's pair, which had been carried off by the Persians in 480.

In 476/475 B.C. Kimon defeated the Persians at Eion near the mouth of the River Strymon in Thrace; three herms were dedicated in the Agora to celebrate the victory.[13] At about this time, Kimon brought back from the Aegean island of Skyros the bones of

[6] Herodotos 5.66 and 5.69.

[7] Aristotle, *Athenaiōn politeia*, chap. 21.

[8] *NH* 34.17. See Michael W. Taylor, *The Tyrant Slayers: The Heroic Image in Fifth Century B.C. Athenian Art and Politics*, 2d ed. (Salem, N.H., 1991).

[9] For discussion of the chronology of Miltiades, see H . T. Wade-Gery, "Miltiades," *JHS* 71 (1951): 212–21.

[10] Herodotos 6.117; Pausanias 1.32.3. See F. Jacoby, "Some Athenian Epigrams from the Persian Wars," *Hesperia* 14 (1945): 177.

[11] Pausanias 1.32.4, 5. See also Eugene Vanderpool, "A Monument to the Battle of Marathon," *Hesperia* 35 (1966): 93–106.

[12] For a summary of the events and an analysis of the literary sources, see N. G. L. Hammond, "The Campaign and the Battle of Marathon," *JHS* 88 (1968): 13–57.

[13] Plutarch, *Kimon* 7.

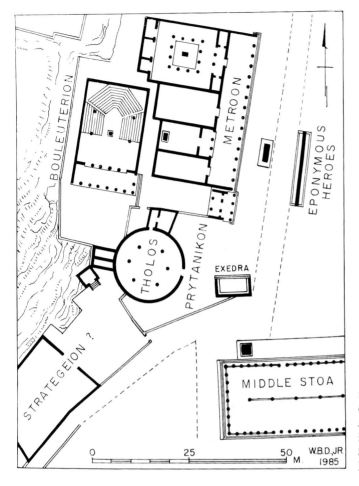

2.4. Plan of the southwest corner of the Athenian Agora. Courtesy of American School of Classical Studies at Athens: Agora Excavations.

Theseus, legendary first king of Athens, and a shrine for these honored relics was founded to the east of the Agora. The Tholos, which was built in Athens at around this time, was to serve as a focal point of Athenian government via its tribal organization (figs. 2.4, 2.5). Here the *prytaneis*, the fifty tribal representatives who oversaw the routine administrative, political, and religious activities of Athens, met daily. Whether or not Kimon was directly responsible for the construction of the Tholos, we know that some of his most successful initiatives were in the financing of extensive public works intended to enhance the city. Plutarch tells us that

> . . . being himself already wealthy, [Kimon] took the money from his campaigns, which he was thought to have won honorably from the enemy, and used it even more honorably for the benefit of his fellow citizens. . . . He was the first to beautify the city with those . . . open and elegant public places of amusement, which a little while later became so extremely popular. He beautified the city by planting the Agora with plane trees, and by

2.5. Aerial view of the southwest corner of the Athenian Agora. Courtesy of American School of Classical Studies at Athens: Agora Excavations.

converting the Academy from a dry and dusty place to a well-watered grove, and also provided it with clear running tracks and shaded walks.[14]

After another victory over the Persians in 470/469 B.C., on the Eurymedon River in Cilicia (southern Turkey), Kimon fortified the south wall of the Akropolis and, according to Plutarch, started construction of the Long Walls from Athens to its port city, Piraeus.[15] In 465 B.C. the Painted (*Poikile*) Stoa was begun (fig. 2.6). Inside, Mikon, an Athenian,

[14] Ibid. 10, 13.
[15] Ibid. 13.

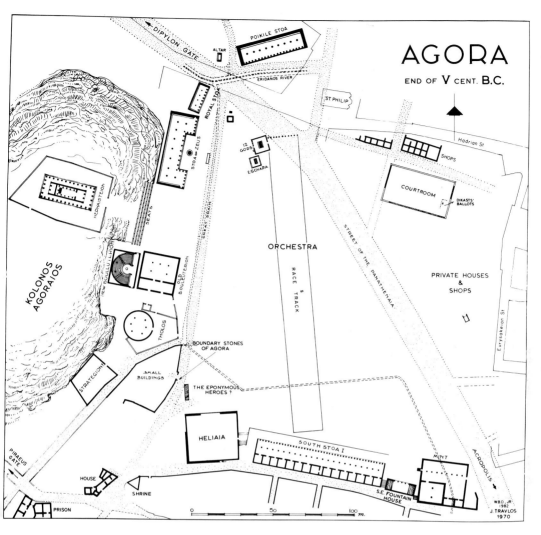

2.6. General plan of the Athenian Agora at end of fifth century B.C. Courtesy of American School of Classical Studies at Athens: Agora Excavations.

painted scenes from the battle of Marathon, including a representation of Miltiades.[16] It was evidently at about the same time, during the 460s, that the statues of the Eponymous Heroes were set up at Delphi. With them stood several other statues, including those of Miltiades and Theseus, both of whom were important to Kimon.[17]

In 461 B.C. Kimon was ostracized, and although he was recalled to Athens a few years

[16] Pausanias 1.15.1, 3; Aelian, *De natura animalium* 7.38; Aeschines 3.186; Plutarch, *Kimon* 4; Scholiast on Aristeides 46.174. Pausanias also refers to statues of Miltiades and of Themistokles at the Prytaneion (1.18.3). For the Painted Stoa, see Camp, *Agora*, pp. 66–72.

[17] See Pausanias 10.10.1.

later, we know little more of him than that he made one last expedition against the Persians, this time to Cyprus, where he died in 449 at about age fifty-nine. Final agreement with the Persians was reached that same year, with the Peace of Kallias.[18]

Perikles was born around 490 B.C., some twenty years later than Kimon. In fact, he belonged to the next generation, one whose chief external concerns were now with Sparta, not Persia. In 461, at about age twenty-nine, Perikles used his rhetorical skills to effect the ostracism of Kimon, even though Kimon "was second to none in Athens in lineage or in wealth, . . . had won the most fabulous victories over the barbarians, and . . . had filled the city with a great deal of money and with the spoils of war. . . . This was the strength of Perikles's hold over the people."[19] Perikles was not concerned with continuing the fight against the barbarians, nor with memorializing Greek victories over Persia: he cared more about glorifying the city of Athens.

Perikles directed his energy, his charisma, and his persuasive rhetoric toward the embellishment of Athens. Around 449 B.C. the Assembly rescinded the Plataian oath not to rebuild those buildings which had been destroyed by the Persians. The Greek cities had deposited a pool of money on the island of Delos to use in case of further attacks by Persia. The money from the Delian treasury had been moved to Athens, and Perikles was able to argue successfully that it should be used to construct new Athenian temples and public buildings.[20]

Before his death in 429 B.C., Perikles could claim responsibility for construction of both the third defensive Long Wall between Athens and Piraeus and the great temple of Demeter at Eleusis, called the Telesterion. In Athens, Perikles had overseen the construction of the Odeon, or music hall, on the south slope of the Akropolis, and, far more important, he had initiated the entire Akropolis building program, including the Parthenon and its chryselephantine cult statue.

Phidias was probably born within ten years of Perikles, in 500 or 490 B.C. Phidias's early commissions came during the 460s, when he would have been in his twenties or thirties, while Kimon was still in power. At the beginning of this decade, having defeated the Persians at the Eurymedon River, the Athenians commissioned several Marathon monuments.[21] It was on these public monuments that Phidias seems to have built his reputation. Already between 470 and 465, he made the colossal akrolithic Athena Areia that was erected at Plataia.[22]

It was surely during the 460s B.C., under Kimon, that Phidias made his statues of the

[18] For the suggestion that Kimon died in 456 B.C. and that the Peace of Kallias was concluded in 456/455, shortly before the transfer of the treasury of the Delian League to Athens in 454, see Antony E. Raubitschek, "The Peace Policy of Pericles," *AJA* 70 (1966): 37–41. For a recent discussion of the Peace of Kallias, see Ernst Badian, *From Plataea to Potidaea* (Baltimore, 1993), pp. 1–72.

[19] Plutarch, *Perikles* 9.

[20] Ibid. 12–14.

[21] Pierre Amandry dates all of the important Marathon monuments to the time of Kimon: "Sur les Epigrammes de Marathon," in *Théoria, Festschrift für W.-H. Schuchhardt* (Baden-Baden, 1960), pp. 1–8.

[22] Pausanias 9.4.1.

Athenian tribal heroes for the sanctuary of Apollo at Delphi, financed by spoils taken from the Persians at the battle of Marathon.[23] These heroes stood near three other monuments commemorating victory in the Persian wars: the Athenian Treasury, the Athenian Stoa, and the Serpent Column.[24] Pausanias reports that on the base below the bronze statue of the Wooden Horse is an inscription to the effect that the heroic statues were dedicated from a tithe of the spoils taken at Marathon. He goes on to name the statues. First are Athena, Apollo, and Miltiades, then seven of the Athenian tribal heroes in this order—Erechtheus, Kekrops, Pandion, Leos, Antiochos, Aigeus, and Akamas—followed by Kodros, Theseus, and Neleus/Philaios/Phileus. Pausanias adds that they were joined later by statues of Antigonos, Demetrios, and Ptolemy. He does not mention Hippothoon, Ajax, and Oineus.[25] Nor does he comment on the specific appearance of any of the statues. We can well imagine Pausanias walking around the dedication and noting the names as he read them beneath the statues.

Some of the blocks from the base of this Marathon monument have been recovered, and they bear the names of the same heroes that Pausanias mentions, as well as references to Phidias, Marathon, and the Athenian dedicators. One reconstruction places the thirteen statues back to back on a wide base—the most important personages first, the others visible between them along the back of the base. Beside the roadway, Pausanias would have seen first Athena, Apollo, and Miltiades, followed by Kekrops and Pandion. Then he would have turned, passed Leos at the end, and turned again to see the heroes at the back of the base: Antiochos, Aigeus, Akamas, Kodros, Theseus, and Philaios.[26] Antigonos, Demetrios, and Ptolemy might have been at the end.

Some evidence points to an even earlier monument to the Athenian heroes at Delphi. It would have been erected at the same time as the Athenian Treasury, probably between 490 and 480, and stood just to the south of it. These bronze statues, representing the same ten heroes as those commemorated on the later monument, were cast by Theopropos of Aegina,[27] according to Claude Vatin's provocative theory about the two groups of statues.

[23] For this widely accepted view, see Jean-François Bommelaer, *Guide de Delphes. Le site* (Paris, 1991), pp. 110–11, no. 110. E. Kluwe argues that this was a private dedication by Kimon: "Das perikleische Kongressdekret, das Todesjahr des Kimon und seine Bedeutung für die Einordnung der Miltiadesgruppe in Delphi," in *Festschrift Gottfried von Lücken* (Rostock, 1968), pp. 677–83. Claude Vatin dates this monument in Delphi to the 450s B.C.: *Monuments votifs de Delphes*, Archaeologia Perusina 10 (Rome, 1991), pp. 229–30.

[24] Werner Gauer has suggested an earlier date (494 B.C.) for the Athenian Treasury, after the fall of Miletos and before Marathon: "Das Athenerschatz und die marathonischen Akrothinia in Delphi," in *Forschungen und Funde: Festschrift Bernhard Neutsch* (Innsbruck, 1980), pp. 127–36.

[25] Pausanias 10.9.1–2. Antony E. Raubitschek suggests that the monument Pausanias saw had been moved downhill when it was expanded in Hellenistic times, and that it had first stood by the Athenian Treasury: "Zu den zwei attischen Marathondenkmälern in Delphi," in *Mélanges helléniques offerts à Georges Daux* (Paris, 1974), pp. 315–16.

[26] See Vatin, *Monuments votifs*, pp. 165–234. If, as Vatin argues, the name of Philaios appears legibly in the inscription, then the problem of the variant texts of Pausanias is solved. I have not studied the blocks myself.

[27] Theopropos also cast a bronze bull for the people of Corfu, the Corcyraeans. This statue stood just inside the sanctuary at Delphi, close by the Athenian heroes of Phidias: Pausanias 10.9.3. The Corcyraeans erected a second bronze bull at Olympia, but no artist's name is assigned to this one: Pausanias 5.27.9. The usual date given to the erection of the Athenian Treasury has been challenged by John Boardman, who has suggested that the

Kodros, Theseus, and Philaios may have been members of the canonical hero list of 490 B.C. (the list made at the time of the Kleisthenic reforms). Later, argues Vatin, Phidias used that same list of heroes for his monument, because it was intended to recall the victory at Marathon, even though by his day the canonical list included Oineus, Hippothoon, and Ajax instead of Kodros, Theseus, and Philaios. Thus Pausanias would not have seen the newer names on the monument by Phidias, for they were not tribal heroes at the time of the battle of Marathon. Inscriptions bearing the names of the new heroes may be associated with the renovation of the area beside the Athenian Treasury during the middle of the fifth century B.C. And, if Pausanias did not mention this earlier monument with statues of the Athenian heroes by Theopropos, which he would have passed shortly after seeing the first one, it may no longer have existed in his day, or he may simply have wished to avoid repeating himself.[28] Jean-François Bommelaer, however, believes that an earlier monument to the Eponymous Heroes never existed.[29]

The statue group at Delphi that served as a memorial to the victory at Marathon was certainly also a reminder of the 192 Athenians who had died there. Were the names of the dead listed there, too, as at Marathon? If so, they would have been listed by their tribes, as at Marathon.[30] By this time, Miltiades's reputation had been rehabilitated, which must have happened during the 460s, while his son was in power. The inclusion of that single historical figure—Miltiades—is surely a reflection of Kimon's success in recalling to all his father's leadership and heroism at Marathon.[31] The statue of Miltiades would have been heroized: he would have been represented as a nude warrior, mature, bearded, helmeted, and armed, rather like the well-known Riace bronzes.[32] The statue of Theseus was surely a reminder that Kimon had brought back that legendary hero's bones to his own city of Athens. Did the statue of Theseus show a youthful hero, as he is usually represented in connection with his labors?[33]

building is earlier, commemorating the Ionian revolt of 499 B.C.: "Herakles, Theseus, and Amazons," in *The Eye of Greece: Studies in the Art of Athens. Essays Dedicated to Martin Robertson*, ed. Donna Kurtz and Brian Sparkes (Cambridge, 1982), pp. 1–28. I thank Olga Palagia for alerting me to this argument.

[28] Vatin, *Monuments votifs*, pp. 229–30. For the idea about why both groups would have consisted of the same heroes (in particular, heroes who were not part of the standard list), Vatin credits Alan Griffiths.

[29] Bommelaer, *Guide de Delphes*, pp. 110–11.

[30] For explanations of why Pausanias does not list Hippothoon, Ajax, and Oeneus at Delphi, of whether Kodros, Theseus, and Neleus/Philaios/Phileus actually replaced them, and, if so, why, see J. G. Frazer, *Pausanias' Description of Greece* (New York, 1965), 5:265–67; Bommelaer, *Guide de Delphes*, pp. 110–11; Pierre Vidal-Naquet, *The Black Hunter*, trans. A. Szegedy-Maszak (Baltimore, 1986), pp. 302–24; and E. Kearns, *The Heroes of Attica*, University of London, Institute of Classical Studies *Bulletin*, suppl. 57 (1989), p. 81 with n. 8. See also Gauer, "Das Athenerschatz," and Uta Kron, *Die zehn attischen Phylenheroen* (Berlin, 1976), pp. 217–19.

[31] K. Stähler believes this statue represented not the Miltiades who was victorious at Marathon but, rather, that man's uncle, who ruled the Athenian colony in the Thracian Chersonesos: "Zum sog. Marathon-Anathem in Delphi," *AM* 106 (1991): 191–99.

[32] Werner Fuchs has suggested that the Riace hero A is one of the statues from the group of the Eponymous Heroes from Delphi: *Zu Neufunden klassisch-griechischer Skulptur* (lecture, Düsseldorf, 1986; publ. Opladen, 1987), pp. 5–31.

[33] Ernst Berger identifies a young helmeted warrior from Tivoli as Theseus, and suggests that the image is based on the one in the Delphi group: "Das Urbild des Kriegers aus der Villa Hadriana und die Marathonische

It is entirely possible that the statue of Athena on the Delphi monument resembled one of the other two Athena statues that Phidias made in Athens during the 460s. One of these was a Marathon monument, the colossal Bronze Athena for the Akropolis, which was begun around 465 B.C. and was finished nine years later, at about the time when Phidias is likely to have been at work on the Delphi monument. The goddess was fully armed, wore a shield on one arm, and was so tall that her spear could be seen from Cape Sounion. The other one was a bronze Athena Lemnia, dedicated about 450 B.C. on the Akropolis, a statue whose great beauty was still being admired in the second century A.D.[34]

By the 450s, Kimon was out and Perikles was in power. Phidias, however, did not suffer. His reputation was such that he could work for both men, and for other clients as well: he completed a major commission at Olympia, the colossal chryselephantine statue of Zeus, after the death of Perikles. The works of Phidias had widespread popularity, and his statues and his war memorials appealed to all Athenians, not just to one party or one generation. Phidias knew how to use his sculpture to make highly visible public statements with wide appeal. Late in the first century B.C., Dionysios of Halikarnassos stressed the majesty, sublimity, and dignity of Phidias's work.[35] Obviously, Perikles made the right choice in hiring Phidias to oversee the rebuilding of the Akropolis.

When the construction of the Parthenon began, Phidias was in his early forties or fifties. Ten years later, the frieze and the cult statue, which was at least his fifth statue of Athena, were in place. When the Peloponnesian War began in 431 B.C., Phidias and Perikles may both have been about fifty-nine years old, or Phidias may have been ten years older than his friend and patron. Two years later, when Perikles died, Phidias must have left Athens for Olympia—unless, as has been well argued, he had already left in the 430s. In Olympia, he made the statue of Zeus that was to become one of the seven wonders of the world.[36]

Although Phidias was a great friend of Perikles, and was probably closer in age to him than to Kimon, his commissions spanned the regimes of both men. Some of Phidias's major early works, started under Kimon, were victory monuments, including the Athena Areia, the Bronze Athena for Athens, and the Eponymous Heroes for Delphi. Later, when

Gruppe des Phidias in Delphi," *RM* 65 (1958): 6–32. Werner Fuchs argues that the Riace bronzes must come from Delphi, and he wonders whether they might actually be the statues of Miltiades and Theseus from the Delphi monument: "Zu den Grossbronzen von Riace," in *Festschrift für Ulrich Hausmann* (Tübingen, 1982), pp. 34–40.

[34] Pausanias 1.28.2. For the evidence for the Bronze Athena, see Overbeck 118–19, nos. 637–44; Mattusch, *GBS*, pp. 168–72; and Zimmer, *Bronzegusswerkstätten*, pp. 62–71. For the Athena Lemnia, see Overbeck 137–38, nos. 758–64; Richter, *SSG*, pp. 173–74. For the theory that the Athena Lemnia was used in the Delphi monument, see Kron, *Die Zehn attischen Phylenheroen*, p. 220n1065.

[35] Dionysios of Halikarnassos, *De Isocrate* 3.

[36] Pliny actually dates Phidias to the eighty-third Olympiad, 448–444 B.C.: *NH* 34.49. For a recent discussion of Phidias's departure for Olympia, see Olga Palagia, *The Pediments of the Parthenon* (Leiden, 1993), p. 14n8. It may be useful to bear in mind, however, that it now seems unlikely that the so-called Workshop of Phidias in Olympia was used to produce the famous chryselephantine statue of Zeus: see Wolfgang Schiering, *Die Werkstatt des Pheidias in Olympia*, pt. 2: *Werkstattfunde*, OF 18 (Berlin, 1991); reviewed by C. C. Mattusch, *JHS* 114 (1994): 226–27.

Phidias was working for Perikles, the tone shifted: instead of glorifying Athenian victories, he began glorifying the city of Athens itself. The Bronze Athena bridged the gap between the careers and concerns of the two political leaders, and it embodied the interests of each, for it was both a victory monument and an ornament for the city.

In planning the sculpture for the Parthenon, Phidias had to reach not just one generation of viewers, but the entire population of Athens, regardless of age. The people needed to recognize the sculpted figures—not necessarily every one of them, but certainly some individuals and some of the major groups of figures. Therefore, the figure types had to be familiar. Individuals might stand out because of their age, their garb, and their attributes, whereas groups might be recognizable because of the repetition of a certain type of figure, and by the actions, the placement, and the relative sizes of those figures.

No one has ever had difficulty distinguishing the group of seated figures on the east frieze of the Parthenon as the gods: they are centrally placed; they are colossal; they are the only seated figures; and in their conversations with one another they all share a godlike detachment from the standing figures shown around them. These gods can be interpreted as an updated version of the seated gods on the Siphnian Treasury at Delphi, which Phidias could have seen a short way up the hill from his Marathon monument.

There is today some argument over the standing men on either side of the gods of the Parthenon frieze [figures 18–23, 43–46] (see fig. 2.7). Are they meant to be invisible to the procession beside them?[37] Are they and the gods unaware of each other? Some of the men have beards and some do not, but all are youthful and idealized. They all wear sandals and cloaks, they are relaxed, evidently chatting among themselves, and they are carrying or leaning on staffs. These individuals have no other attributes. Their role is tied to their being understood as a group: they are deliberately generic. We are clearly intended to read them as such, and not to try identifying them as individuals. Whom would the Athenians have been most likely to recognize in them—nine archons and their secretary, judges, Athenian citizens, spectators, or the Eponymous Heroes?[38] Most scholars believe that they represent the Eponymous Heroes, and their very anonymity fits well with that identification, for their significance to viewers would have rested in their being read as all ten of the Athenian tribes, all being of equal standing.[39]

[37] Frank Brommer, *The Sculptures of the Parthenon* (London, 1979), p. 44.

[38] Archons: Margaret C. Root, "The Parthenon Frieze and the Apadana Reliefs at Persepolis: Reassessing a Programmatic Relationship," *AJA* 89 (1985): 105–6; Ian D. Jenkins, "The Composition of the So-Called Eponymous Heroes on the East Frieze of the Parthenon," *AJA* 89 (1985): 125–27. Judges: Blaise Nagy, "Athenian Officials on the Parthenon Frieze," *AJA* 96 (1992): 62–69. Athenian citizens: Brunilde S. Ridgway, *Fifth Century Styles in Greek Sculpture* (Princeton, 1981), pp. 78–79. Spectators: Keith DeVries, "The 'Eponymous Heroes' on the Parthenon Frieze," *AJA* 96 (1992): 336.

[39] Eponymous Heroes: Robertson, *HGA*, 1:308; John Boardman, *Greek Sculpture: The Classical Period* (London, 1985), p. 108; Brommer, *The Sculptures of the Parthenon*, p. 44; R. E. Wycherley, *The Stones of Athens* (Princeton, 1978), p. 119; Elizabeth G. Pemberton, "The Gods of the East Frieze of the Parthenon," *AJA* 80 (1976): 114; and Martin Robertson, *The Parthenon Frieze* (New York, 1975), pl. 4 (east). Tonio Hölscher summarizes many of the earlier proposed identifications and concludes that ten figures which are so much alike, and which obviously belong together, are most likely to be the tribal heroes: "Ein attischer Heros," *AA* 84 (1969): 416n22. Uta Kron also summarizes the earlier publications: *Die Zehn attischen Phylenheroen*, pp. 202–14. Evelyn

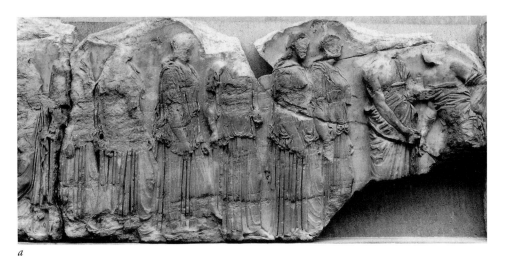

a

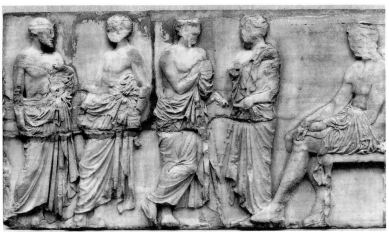

b

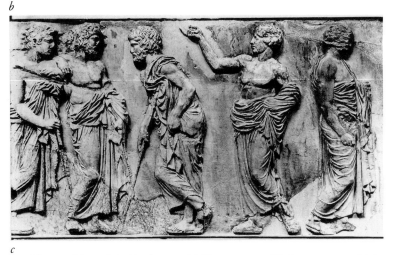

c

2.7. The east frieze of the Parthenon. (*a*) Figures 11–19; (*b*) figures 20–24; (*c*) figures 43–47. London, British Museum. Copyright British Museum.

The figures on the frieze adorning the front of the Parthenon were not the only representations in Athens of this important group of individuals: there were bronze statues of the tribal heroes just below the Akropolis, in the city center. In the Athenian Agora, a mid-fourth-century B.C. statue base in front of the Temple of the Mother of the Gods (the Metroon) is all that remains of the monument to the Eponymous Heroes (fig. 2.8). The high base is more than sixteen meters in length, and it held a row of ten standing statues, with a tripod at either end of the group. Around the base was a fence made of stone posts and wooden railings. Statues of two Macedonian kings, Antigonos and Demetrios, were added to the group in the late fourth century B.C. when two new tribes were created in their names, but they were removed a hundred years later, after Philip V's vicious attack on the city. By that time, Ptolemy III of Egypt had been added to the group; shortly thereafter, Attalos I of Pergamon had a tribe named after him. In the second century A.D., the Roman emperor Hadrian was the last eponymous hero to join the group. It was always customary for public notices to be posted on wooden tablets in front of the Eponymoi. Here citizens could read about their tribes' proposed laws, corrected laws, and lawsuits, and find lists of ephebes, lists for military service, and announcements of honors.[40]

The first reference to the monument of the Eponymous Heroes was made by Aristophanes in 424 B.C., seventy-five years before the statue base was built in front of the Metroon. Aristophanes simply mentioned the place where lawsuits were displayed.[41] The Athenian audience would have known where that was. As a major bulletin board for tribal information, the monument to the Eponymous Heroes would have been well known and frequently visited.

There is an earlier foundation about fifty meters south of the fourth-century statue base, beneath the later south aisle of the Middle Stoa. This foundation, measuring 9.70 meters in length, has tentatively been identified as a base for an earlier monument to the Eponymous Heroes, and could be what Aristophanes saw. The pottery excavated there dates between about 430–425 and 350 B.C., which is when the later monument of the Eponymoi was built.[42] Still, there is virtually no evidence for what this earlier foundation supported, and we might wonder whether a base that was only 9.70 meters long could have provided sufficient space for all ten heroes, let alone ten heroes and two tripods, like the later base.

We cannot really be certain, then, where or when the first monument to the Eponymous

B. Harrison describes the subject matter of the entire frieze as an allegory about the evolution of Athenian government and the foundations of the Athenian social order: "The Web of History: A Conservative Reading of the Parthenon frieze" (paper delivered at "Parthenon and Panathenaia" symposium, Princeton University, September 18, 1993).

[40] See Wycherley, Agora 3, pp. 85–90, nos. 229–40. The major publication of the monument is by T. Leslie Shear Jr.: "The Monument of the Eponymous Heroes in the Athenian Agora," *Hesperia* 39 (1970): 145–222. Shear proposes (p. 169) that the notices were posted inside the fence during the fourth century B.C. They would have been easier to post and easier to read, however, if they were hung on the fence itself, which would explain the need for a fence.

[41] Aristophanes, *Knights*, lines 977–980.

[42] Shear, "The Monument," pp. 205–22.

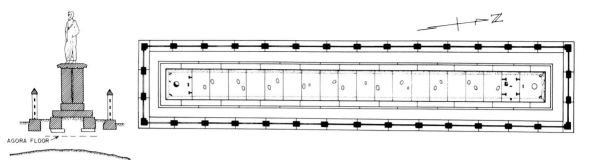

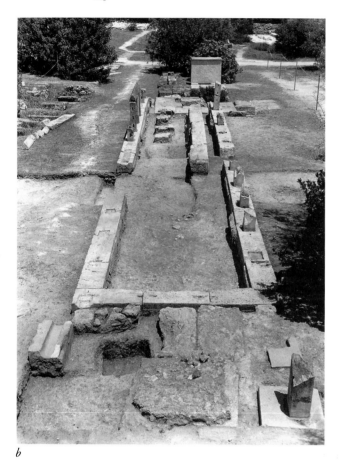

b

2.8. The Athenian Agora. (*a*) Restoration plan and elevation; (*b*) view of the fenced base for the statues of the Eponymous Heroes. Courtesy of American School of Classical Studies at Athens: Agora Excavations.

Heroes was erected, only that there was one. We have references to its necessary function as a notice board for tribal information, but no descriptions of it. We do know, however, that this monument and the statues of the Tyrannicides were the earliest commemorative monuments to be erected within the limits of the Agora proper. Like the Tyrannicides, the monument to the Eponymoi should have existed from near the time of the Kleisthenic reforms, when the ten tribes were instituted. After all, the public notices posted there provided military and legal information for each of the ten tribes. Certainly a monument would have

been set up when the rebuilding of the Agora began in the fifth century B.C., perhaps about the same time as the installation of the second group of the Tyrannicides, during the 470s. There was a great deal of building activity in the Agora during the second quarter of the fifth century, under Kimon, when the plane trees, the Painted Stoa, the herms, and the Tholos were added, and when work was probably also being done on the Royal Stoa and the Old Bouleuterion.[43] A suitable place could have been selected for the Eponymous Heroes during the same period, and it would have been appropriate to line them up near the Old Bouleuterion and the Tholos, in the same area where we later hear of them. In the 420s, Aristophanes took it for granted that everyone knew where lawsuits were displayed. In the fourth century, Aristotle specifically identified the Eponymoi as being in front of the Bouleuterion;[44] much later, in the second century A.D., Pausanias put them "farther up" (*anotero*) from the Tholos.[45]

The long monument base in front of the Bouleuterion is dated by the excavated pottery to the mid–fourth century B.C. There is no evidence for any earlier structure on this spot. Wherever the Eponymoi stood before, we have no reference to the earlier group being moved or to new statues being made. Perhaps the statues from the earlier group were reused on the fourth-century base.

When Pausanias mentions the monument to the Eponymous Heroes, he names all ten of the original Athenian heroes (Hippothoon, Antiochos, Ajax, Leos, Erechtheus, Aigeus, Oineus, Akamas, Kekrops, and Pandion), adding that there is another statue of Pandion on the Akropolis, one that is well worth seeing. He goes on to say that the statues of Attalos, Ptolemy, and Hadrian were added later.[46] Because Pausanias does not describe any of the individual statues of the Eponymoi in the Agora, we must assume that there was nothing noteworthy about any of them. In fact, no one ever describes them. This must be because everyone knew what the Eponymous Heroes looked like, and nothing special stood out about any of them. They simply stood in a row and represented the tribes. They were always defined as a group.[47] They were not individualized but were distinguished from one another only by their names, which Pausanias would most likely have noted when he read them as headings on the notice boards posted in front of the statues.

Although this group of statues retained its function in the Agora for hundreds of years, the statues are never mentioned for their great antiquity or for their old-fashioned appearance. They must have conformed to some standard which endured over the centuries. Where did the inspiration for the Eponymous Heroes come from? Were they perhaps the

[43] Uta Kron suggests that public notices were first posted near the herms: *Die Zehn attischen Phylenheroen*, pp. 234–36.

[44] Aristotle, *Ath. pol.* 53.4.

[45] Pausanias 1.5.5. Whatever Pausanias meant by *anotero*, we know where the monument was located in the second century A.D. See Shear, "The Monument," pp. 181–86.

[46] Pausanias 1.5.1–5.

[47] For a discussion of various fifth-century B.C. groups of statues, including groups by one artist and groups by two or more artists (to which each artist either contributed a different type of figure or for which each artist made part of a series of similar figures), see Mattusch, *GBS*, pp. 119–43.

same familiar cloaked man that had become popular in both vase painting and sculpture during the late sixth and early fifth centuries? This type of figure, normally bearded, most often appears at the edges of scenes, apparently as an anonymous bystander, not as an active participant.

The Eponymous Heroes of Athens, in Painting

Three red-figure Athenian vases made in the early fifth century B.C. shed light on this question. A ram's head rhyton by the Triptolemos Painter, decorated with a scene of five reclining symposiasts, clearly names Kekrops and Theseus, and preserves the ——ON of a third name, probably Pandion (fig. 2.9).[48] Theseus and one other figure are beardless, but the other three are bearded, including Kekrops, and the one who may be Pandion has white hair and beard.[49] Apart from the beards and the white hair, all of the figures could be about the same age. On a kylix by Douris (fig. 2.10), the names of two out of three bearded and cloaked onlookers with staffs are inscribed: they are Pandion and Kekrops, standing to either side of the action and watching Eos, the Dawn, grab Kephalos (fig. 2.10a). On the other side of the cup, two unlabeled bearded men frame and observe Zeus grabbing Ganymede, whose friend escapes with their toy, a hoop (fig. 2.10b).[50] Hippothoon is named on a dinos attributed to the Syleus Painter (fig. 2.11). Mature and bearded, Hippothoon wears a chiton and cloak, and leans on a staff; he is watching an apparent ceremony involving Demeter and Persephone.[51]

Figures like these appear on many vases of the early fifth century B.C., but they are usually not identified and they function simply as observers. The two bearded and cloaked men on the Berlin Foundry Cup seem not to be participants in the activities, yet they are important enough to be as large as the statue of the warrior shown, filling the entire height of the panel (fig. 2.12). Generalized figures like these also appeared in statuary, and they were probably of the same type on which the statues of the Eponymoi were based. We might ask whether these bearded and cloaked individuals are not more than observers. This generic type of figure, so often represented at the edges of events, might have been a normal way of making a general tribal reference, a familiar reminder of a flourishing and smoothly functioning Athenian society.[52]

When mythic, the Eponymoi are quite different: they are individualized and are given specific attributes. For instance, when Pausanias describes the vast paintings of the Trojan

[48] See Robert Guy, "A Ram's Head Rhyton Signed by Charinos," *Arts in Virginia* 21 (1981): 2–15, for an interpretation of the figures on the vase as Attic kings, with reference to the Persian Wars.

[49] Perhaps the white hair and beard allude to his being the father of Kekrops. See Pausanias 9.33.1.

[50] See *J. Paul Getty Museum Journal* 13 (1985): 169, no. 23.

[51] I am grateful to Kevin Clinton for bringing this vase to my attention. See his "The Eleusinian Mysteries and Panhellenism in Democratic Athens," in Palagia and Coulson, ed., *The Archaeology of Athens and Attica*, pp. 161–72.

[52] For other possible identifications of the two standing figures on either side of the scene on side B of the Berlin Foundry Cup, see C. C. Mattusch, "The Berlin Foundry Cup," *AJA* 84 (1980): 440–41.

2.9. Neck of a red-figure Attic rhyton, first quarter of fifth century B.C., showing symposium with Kekrops, Theseus, and [Pandi]on(?). Virginia Museum of Fine Arts 79.100. Courtesy of Virginia Museum of Fine Arts, Richmond, Va. The Adolph D. and Wilkins C. Williams Fund.

War in the Lesche at Delphi, he mentions Akamas, the son of Theseus, and describes him as wearing a crested helmet.[53] Evidently, the statue of Akamas in the Marathon dedication at Delphi was not wearing a helmet or anything else that might have distinguished him from the other statues on the base.

In the literary tradition, the ten heroes are in no sense equally important. Kekrops, Erechtheus, Pandion, and Aegeus were the first, third, fourth, and fifth kings of Athens. Oineus, the bastard son of Pandion, was the king of Kalydon. Ajax and Akamas both fought in the Trojan War, but Ajax was a far more popular figure, even though Akamas was a son of Theseus. Aegeus and Ajax both committed suicide. Hippothoon, Antiochos, and Leos were shadowy individuals at best.

During the last third of the fifth century B.C., the Eponymous Heroes come to be treated as individuals. Sometimes they are involved in narrative events on Athenian vases, where they can be identified by their names inscribed beside them. Akamas is a bearded king or an elder; Kekrops is a king with coils; Pandion, Oineus, and Hippothoon are young warriors or travelers who arrive, depart, or inhabit a kind of Attic paradise; and in one case, a young Pandion sits with a bird on his wrist (fig. 2.13).[54] Beazley once observed that "there is a

 [53] Pausanias 10.26.2.

 [54] For a complete listing, see Kron, *Die Zehn attischen Phylenheroen.* Akamas as a mature individual or king: Bell krater by the Dinos Painter, Syracuse 30747 (*ARV²* 1153.17; J. D. Beazley, "Some Inscriptions on Vases: III," *AJA* 39 [1935]: 486–88). Kekrops as a king with coils: Lekythos by the Selinus Painter, Hamburg, Schauenburg (*ARV²* 1201.4; W. Hornbostel et al., *Kunst der Antike: Schätze aus norddeutschem Privatbesitz* [Mainz, 1977], p. 329, no. 281). Calyx krater by the Kekrops Painter, Adolphseck, Landgraf Philipp of Hesse 77 (*ARV²* 1346.1; *CVA* Germany 11, Schloss Fasanerie, vol. 1, pl. 20; *EAA,* s.v. "Cecrope"). Pandion and Oineus as youths: Bell krater by the Dinos Painter, Syracuse 30747 (*ARV²* 1153.17; Beazley, "Some Inscriptions on Vases: III," pp. 487–88). Pandion as youth: "Oinochoe by the Eretria Painter, Palermo 12480 (*ARV²* 1249.21; E. Brabici, "Vasi greci inediti dei musei di Palermo e Agrigento," *AttiPal* 15 [1929]: 16–19, pl. 2; Beazley, "Some Inscriptions on Vases:

a

b

2.10. Red-figure Attic kylix by Douris, first quarter of fifth century B.C., showing two scenes with tribal heroes as onlookers. (*a*) Eos and Kephalos with Pandion and Kekrops; (*b*) Zeus and Ganymede with two unnamed onlookers. Collection of the J. Paul Getty Museum 84.AE.569, Malibu, Calif.

2.II. Hippothoon at Eleusis, shown on a red-figure Attic dinos attributed to the Syleus Painter, first quarter of the fifth century B.C. Collection of the J. Paul Getty Museum 89.AE.73, Malibu, Calif.

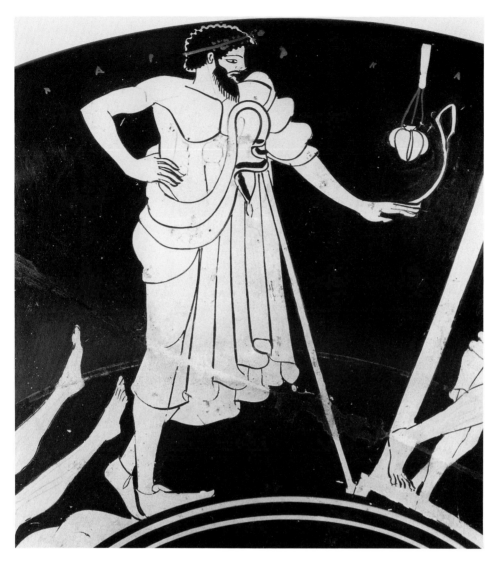

2.12. Cloaked onlooker with staff, shown on the Berlin Foundry Cup, early fifth century B.C. Berlin, Antikensammlung F 2294. See also figs. 1.12 and 2.17. Courtesy of Antikensammlung, Staatliche Museen zu Berlin, Preussischer Kulturbesitz. Photo Ingrid Geske-Heiden.

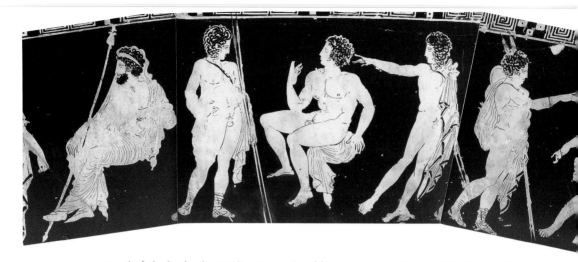

2.13. Detail of a hydria by the Meidias Painter, late fifth century B.C., showing Athenian tribal heroes as individuals, including (*left to right*) Akamas, Hippothoon, Antiochos, (Klymenos), and Oineus. London, British Museum E 224. Hamilton Collection. Copyright British Museum.

tendency to youthen everyone [on vases] in the late fifth century and the fourth . . . and many rather colourless Attic heroes find their way into art at this period."[55] Indeed, it is not easy to keep track of the various guises of these heroes, some of whom are little known to us from myth.

The Tyrant Slayers

From the beginning, Greek freestanding sculptures adhered to certain fixed types, and sculptures of heroes were no exception. Statues of Harmodios and Aristogeiton, the lovers who were famed as tyrant slayers, are a good example of a familiar Archaic genre: the striding, attacking god or hero (fig. 2.14). The Tyrannicides fit easily into this class, although their ages are differentiated. Actually, they embody two forms of the attacking hero: both are shown at the peak of their physical ability, but one is youthful, the other mature. The type survives further into the Classical period, but becomes more naturalistic with, for example, the bronze god from Artemision (see figs. 1.7, 1.17).

The Tyrannicides also appear in vase painting. On a stamnos in Würzburg, the Tyrannicides wear cloaks, and there is a certain naturalism to their anatomy (fig. 2.15). They are

III," p. 487). Young Pandion, bird on wrist, and young Antiochos: Lekanis by the Meidias Painter, Naples Santangelo 311 (*ARV²* 1314.17; Lucilla Burn, *The Meidias Painter* [Oxford, 1987]). Mature Akamas, youthful Hippothoon, Antiochos, and Oineus: Hydria by the Meidias Painter, London, British Museum E 224 (*ARV²* 1313.5; P. E. Arias and M. Hirmer, *A History of 1000 Years of Greek Vase Painting* [New York, n.d.], pp. 375–77, pls. 214–15; Burn, *The Meidias Painter*, pp. 16–19).

⁵⁵ J. D. Beazley, "Some Inscriptions on Vases: V," *AJA* 54 (1950): 321.

2.14. Roman marble reproduction of the Tyrannicides. H 1.95 m. Naples, Museo Nazionale inv. 6009, 6010. Farnese Collection. Courtesy of Soprintendenza Archeologica delle Province di Napoli e Caserta.

2.15. The Tyrannicides on a red-figure Athenian stamnos, first quarter of the fifth century B.C. Würzburg, Martin von Wagner Museum L 515. Courtesy of Martin von Wagner Museum, Universität Würzburg. Photo by K. Oehrlein.

indeed represented as real people. But all the standard heroic features are also present: one is bearded and one is not; both are barefoot, right arms striking, left arms down.[56] Except for the daggers, attributes are not necessary, since their actions identify them.

Sometimes the two heroes are represented in vase painting as if they are the famous statue group. In this category, an oinochoe in the Boston Museum of Fine Arts is of particular interest (fig. 2.16), because this vase and four other oinochoai probably came from the same Athenian tomb, that of the young cavalry officer Dexileos, who was killed in combat in 394 B.C. All five vases are related in style, and their subject matter forms a singularly unified theme if we think in terms of the death of a young hero and horseman.

[56] *ARV*[2] 256.5. See also Mattusch, *GBS*, p. 126.

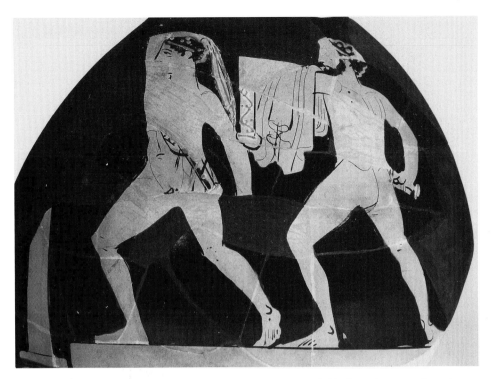

2.16. The Tyrannicides on a red-figure oinochoe, ca. 394 B.C., probably from the grave of Dexileos in Athens. L 0.16 m. Boston, Museum of Fine Arts 98.936. H. L. Pierce Fund. Courtesy of Museum of Fine Arts, Boston.

The one vase shows the greatest Athenian heroes, the Tyrannicides. The scenes on the other vases all evidently relate to the great spring festival of Dionysos, the *Anthesteria*. The subjects are a victorious racing chariot, dancing youths and maidens, a gay festal parade on horseback, and a scene of revelry with Dionysos, a maenad, and a satyr.[57]

We know that when the Persians sacked Athens, they carried off the statues of the Tyrannicides. And so a second group was made, about thirty years later than the first. By the time Pausanias visited Athens, the first pair had been returned there, either by Alexander the Great or by one of his successors. Antenor made the older statues and Kritios made the second group, writes Pausanias, but he mentions no stylistic differences between them, even though the two groups were then standing side by side in the Agora, giving ample opportunity for comparison.[58] In fact, not one ancient author describes the two groups.

[57] Boston Museum of Fine Arts nos. 98.936, 98.935, 01.8254, 01.8255, and 98.934. See Emily Vermeule, "Five Vases from the Grave Precinct of Dexileos," *JdI* 85 (1970): 94–111, who details what is known of these five fragmentary and squat oinochoai, describes each one thoroughly, and considers how important they all are "in spite of their unprepossessing appearance as a chronologically-fixed group and as a suggestion of the kind of funeral imagery a family wanted for a dead youth" (p. 94). For other examples, see Mattusch, *GBS*, pp. 122–25.

[58] Pausanias 1.8.5.

Scholars have wondered which of the two groups was the model for several Roman reproductions (see fig. 2.14). Here, the two figures are heroized, with formulaic striding poses, one arm raised, the other down. The only distinguishing feature is the beard on one, helping us to identify him as Aristogeiton, who was older than Harmodios. Perhaps we cannot decide whether these are copies of the first or of the second group, precisely because there was so little difference between the two statue groups.[59] Did Kritios and Nesiotes simply repeat Antenor's famous statues, following the accepted type for an attacking figure? We need hardly wonder which group is reflected in Athenian vase paintings of around 400 B.C.: it was the second group, the one then standing in Athens. And yet it is a generic group, the heroes being recognizable only by their gestures and by the difference between them in age. If we look for stylistic differences between two public statue groups that were made thirty years apart, we do not take into account the force of tradition, the familiarity that the Athenians had established with the statues of their two greatest heroes. It was important to recognize them at a glance, to feel comforted by the knowledge that such a short time after the Persians had sacked and burned Athens, images of these two favorite heroes had already been replaced in their accustomed spot in the center of the city. Surely there would have been no notable difference between the new statues and the stolen ones. The more alike the two groups were, the more rapidly the message would be transmitted: equilibrium had returned to Athens, and the city was again under the protection of the Tyrant Slayers.

Heroes

Different types of statues could call for different styles of representation. And so it is that on the Berlin Foundry Cup we see the simultaneous production of two statues which, stylistically, might today be assigned different dates but which have different styles only because they have different functions. One is an "Archaic" striding warrior, the other a far more naturalistic "early Classical" athlete (fig. 2.17).[60] The two onlookers are of yet another type, the generic hero: as such, they are large figures with a strong but anonymous presence. They stand at either side of the scene in which the colossal statue of the warrior is being finished (fig. 1.12 *b*). Maybe they stand there as reminders of Attica itself, of its prosperity and well-being.

Like the Tyrannicides, the Eponymoi were conceived of as a group, but they were certainly not represented in the Agora as mythic figures taking part in a narrative. Instead, they would have been standardized to fit their generic role as representatives of the tribes. Such a generic figure served as the model for each of the ten standing cloaked figures on the east frieze of the Parthenon, where they are differentiated only by age. Probably they all

[59] For discussion of this question, see S. Brunnsaker, *The Tyrant-Slayers of Kritios and Nesiotes* (Stockholm, 1971), pp. 45–83, with bibliography.
[60] See chap. 6 below and Mattusch, "The Berlin Foundry Cup," pp. 442–44.

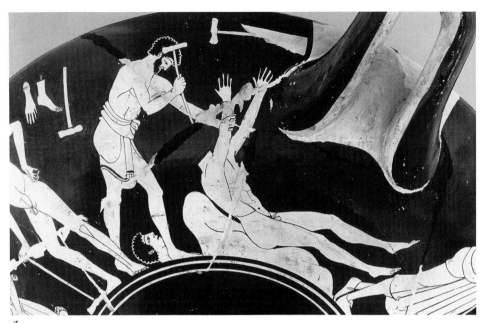

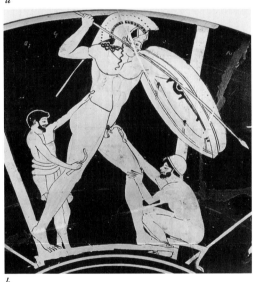

a

b

2.17. Details of the statues shown on the Berlin Foundry Cup, early fifth century B.C. Berlin, Antikensammlung F 2294. See also figs. 1.12, 2.12. Courtesy of Antikensammlung, Staatliche Museen zu Berlin, Preussischer Kulturbesitz. (*a*) Photo Jutta Tietz-Glagow. (*b*) Photo Ingrid Geske-Heiden.

wore the same mantle and sandals, and they may have carried staffs.[61] They were as familiar as the generic type in vase painting: it would have been inappropriate to distinguish members of the group by assigning them additional attributes. The names of the tribes

[61] A base found in Rome, with the Greek inscription of Pandion, has one bare foot on it, but it is impossible to tell whether the statue was of Pandion in his mythic or his heroic role. See Uta Kron, "Eine Pandion-Statue in Rom," *JdI* 92 (1977): 139–68; also Hölscher, "Ein attischer Heros," pp. 410–27, and figs. 1–6, who identifies marble bearded heads in Naples and in Millesgarden as Roman copies of tribal heroes, probably owned by admirers of Attic culture.

would have been sufficient and appropriate identification.[62] If the original statues adhered to this approved format, there would have been no need to make new ones on the occasion of moving the monument in the fourth century B.C. They would simply be moved, unremarked, from one place to another.

As for how the group was made, we need only consider the two Riace Bronzes, which were based on a single model, even though they turned out quite differently (fig. 2.18).[63] The heads and musculature of the two statues look very different, but their general outlines are almost exactly the same. Both stand firmly on the right foot, with the left foot forward, knee relaxed, the right hip thrust out and the right hand lowered, the left forearm raised to hold a shield, and the head turned to the right. Statue B's body is leaner and flatter than statue A's, and the right hip is thrust more firmly outward, while the feet of statue A are set slightly farther apart. Statue A has a broad, youthful face, framed by long loose curls and by a cascading layered beard, whereas statue B has a longer, narrower face and short hair and beard.

Both statues, as noted above, were based on the same original model. For each statue, a set of master molds, probably made of clay, was taken from that model. The master molds could easily have been packed up and taken to whomever had been contracted to make the waxes from them for casting. Perhaps this meant that the master molds were taken to another workshop or even to another city. There, one or more artists, working at the same time or at different times, might line sets of master molds with wax, then remove the master molds and finish the wax working models. It was while each working model was being detailed, before casting, that the two figures acquired their markedly different appearances, while retaining virtually identical measurements and outlines. Use of the same original model, though not providing the final details, served to standardize the height, proportions, and configuration of the two statues. Thus they could easily satisfy one commission and stand on the same base.[64]

Because the Riace Bronzes have lost their inscriptions, they are, for us, simply generic heroes, and we have no idea whether they once represented legendary or historical figures. In antiquity, the inscribed name might be the only means of giving a statue some identity. A particular type of statue would have been suited to any number of individuals. In fact, Pausanias provides proof of this when he notes that statues of Miltiades and Themistokles near the Prytaneion (town hall) in the Athenian Agora were at some point renamed after a Roman and a Thracian.[65]

[62] Evelyn B. Harrison prefers to describe the group of the Eponymoi as "a balanced mixture of soldiers and civilians." See her essay "The Iconography of the Eponymous Heroes on the Parthenon and in the Agora," in *Greek Numismatics and Archaeology: Essays in Honor of Margaret Thompson* (Wetteren, 1979), p. 83.

[63] See Mattusch, "The Casting of Greek Bronzes: Variation and Repetition," in *Small Bronze Sculpture*, pp. 135–38. For a differing opinion, see Claude Rolley, *La Sculpture Grecque*, 347–50.

[64] For the technique of the Riace Bronzes, see Edilberto Formigli, "La tecnica di costruzione delle statue di Riace," in *Due bronzi da Riace: Rinvenimento, restauro, analisi et ipotesi di interpretazione. BdA* spec. ser. 3, vol. 1 (Rome, 1985), pp. 107–42. For the full measurements of the statues, see Claudio Sabbione, "Tavole delle misure," in *Due bronzi*, pp. 221–25, app. 2.

[65] Pausanias 1.18.3.

The Eponymous Heroes were a generic group of ten, identifiable only by their inscribed names. Unlike the Riace Bronzes, whose helmets, shields (only the straps of which survive), and nudity strongly suggest they were warriors, all of the Eponymous Heroes would have been draped, some bearded and some not, and perhaps would have carried staffs, as do the figures on the Parthenon frieze. Two models for the statues would have ensured plenty of variety in their poses, offering the possibility of alternating weight-bearing leg and free leg. But the point of such statues was not individuality: on the contrary, it was their close resemblance to one another. When Phidias made the Eponymous Heroes for Delphi, the type was already well established, as was that for Kimon's warrior father, who would simply have been armed. When the Parthenon frieze was carved, anyone would have recognized instantly, as a group, the standing men on the east frieze. The formula for them had been used repeatedly in painting and sculpture for nearly forty years, and the Athenians knew it by heart (see fig. 2.7).

The literary testimonia make it clear that seeing and understanding the general import of a large group of freestanding figures was a skill in which Classical audiences must have been well versed. Indeed, the inscriptions that Pausanias consulted, sometimes to the exclusion of the work itself, and that today provide us with significant clues to lost statuary, were beyond the comprehension of a large portion of the general public. They had to depend on the actual images, their groupings, and their attributes. If we bypass Pausanias's historical narratives, his cultural remarks, and his mythological commentaries and, uninformed, simply read the list of what he saw in a city or sanctuary, we begin to understand the experience of walking through Delphi or Olympia, of passing by some of the large statue groups. We can see how the statues alone would quickly have informed the public of their identity and their value, if not their particular significance. In Athens, the group of tribal heroes numbered thirteen when Pausanias saw them in the second century A.D. At Olympia, the groups of bronze statues he saw included a row of praying boys (5.25.6), five pairs of Trojan heroes (5.22.2), and thirty-five chorus boys (5.25.2–4). At Delphi, right inside the gate to the sanctuary, and across the road from the Athenian monument with its sixteen statues, were bronze statues of the thirty Spartans who, under Lysander, defeated the Athenian fleet at Aigospotamoi in 405 B.C. (10.9.6–10). Those statues would have been of the standard heroic genre that had come to full fruition in the fifth century and that is so well illustrated by the pair of Riace Bronzes.

A new, more representational phase began in the fourth century B.C. After Alexander's victory over the Persians at the Granikos River in 334 B.C., Lysippos made a huge statue group of the twenty-five fallen heroes, erected at Dion in Macedonia. These statues were innovative, Pliny says, because they were actually portraits, and they were all striking likenesses.[66]

[66] *NH* 34.64; and Arrian, Anabasis 1.16.7. Concerning the Granikos monument, see chap. 3 below. For discussion of statue bases for some large groups, see Dorothea Arnold, *Die Polykletnachfolge: Untersuchungen zur Kunst von Argos und Sikyon zwischen Polyklet und Lysipp. JdI* suppl. 25 (Berlin, 1969), and Felix Eckstein, *Anathemata: Studien zu den Weihgeschenken strengen Stils im Heiligtum von Olympia* (Berlin, 1969).

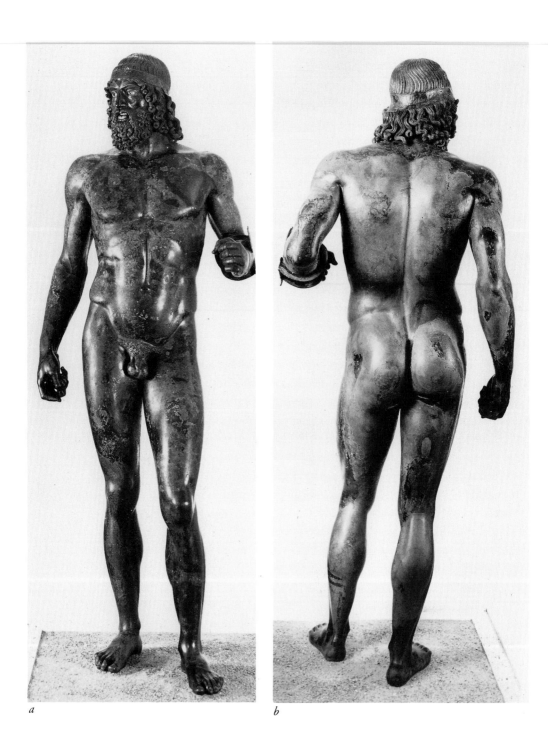

2.18. The Riace Bronzes, probably fifth century B.C., found in the sea at Riace Marina in 1972. H of statue (*a, b*) 1.98 m., statue B (*c, d*) 1.97 m. Courtesy Soprintendenza Archeologica della Calabria.

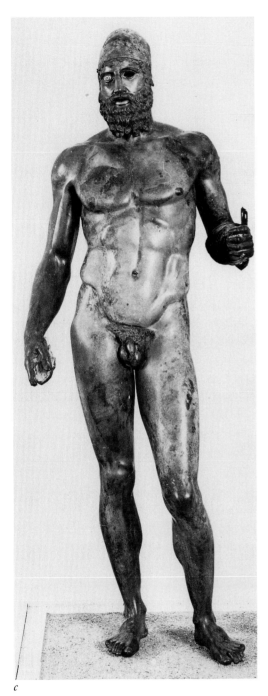

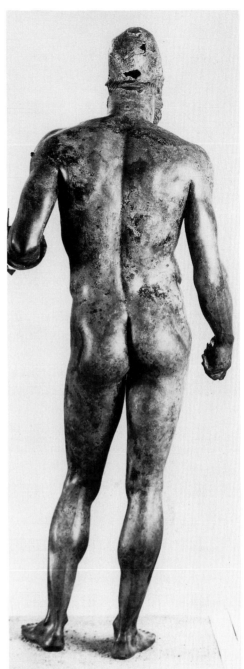

c

d

CHAPTER THREE

PORTRAITS

Pliny discusses bronzes with characteristic breadth: he tells stories about statues and their owners, he gives biographical information about bronze artists, and he comments on statues that are unusual or noteworthy in some way. He is very interested in numbers, and remarks that there are probably still three thousand statues in Rhodes, Athens, Delphi, and Olympia (see chapter 1). This point has often been used as an indicator of the importance of bronze statuary and the extent of the large-scale casting industry during the Classical period. Pliny cites one prolific sculptor, the famous artist Lysippos, and comments that Lysippos is reputed to have put away a gold coin for every statue he made. Further: "Lysippos is said to have produced 1,500 works, all of them so skillful that even a single one of them could have made him famous."[1]

Pliny's list of some of the more famous bronze statues made by Lysippos has received much attention, and the list has, of course, been important in establishing Lysippos's oeuvre. Included are the Apoxyomenos, a drunken girl playing a flute, a couple of hunting groups, a chariot carrying Helios, various chariot groups, portraits of Alexander and of his friends, and a satyr. The Roman copies in marble of the Apoxyomenos and of the Alexander portraits are frequently discussed.

There is no disagreement on when Lysippos of Sikyon worked. Pliny places him in the 113th Olympiad (328–325 B.C.), probably near the apex of his career. By that time, Lysippos had been associated for some years with the Macedonian royal family. We know from various sources that he worked for Alexander (356–323 B.C.), making his first portrait of him when Alexander was a boy.[2] Lysippos also made twenty-five bronze portraits to honor the companions of Alexander who died during the battle at the Granikos River in 334 B.C.; this vast statue group was erected in Dion, but it was later moved to Rome by Metellus,

[1] *NH* 34.37.
[2] *NH* 34.63; for other sources, see Overbeck 273–88, nos. 1443–1512.

after the conquest of Macedonia in 148 B.C.[3] Scholars agree that Lysippos had a long career, and that he was active from the 360s B.C. to nearly the end of the fourth century.[4] We cannot be sure about the exact length of Lysippos's active life, but there is no doubt that he was a well-known and unusually productive artist. If we believe Pliny's account, Lysippos could charge enough for his statues to be able to put away a gold coin for every commission. If the account itself is apocryphal, it can still serve as a reference to the wealth accumulated by this well-known and sought-after sculptor.

Let us return to Pliny's account, and look carefully at the description, albeit secondhand, of Lysippos's background and of his approach to sculpture:

> Lysippos of Sikyon is said by Douris not to have been the pupil of anyone, but originally to have been a bronzeworker, and to have first considered becoming a sculptor after listening to a response given by the painter Eupompos. When asked which of his predecessors he followed, he [Eupompos] said, pointing to a crowd of people, that it was nature herself, and not an artist, whom one ought to imitate. Lysippos, as we have said, was a most prolific artist and made more statues than everyone else.[5]

Douris, a Peripatetic philosopher from Samos (ca. 340–260 B.C.), was a contemporary of Lysippos.[6] A pupil of Theophrastos, he included among his writings the lives of painters and sculptors. He seems to have been particularly interested in recording anecdotes about the rise of artists from obscurity and poverty to fame and wealth. His story about Lysippos is one of those anecdotal accounts, and it seems perfectly reasonable. It can certainly serve as a guidepost to the nature of this sculptor's work. Unlike most artists, Lysippos did not begin his career as a pupil of another artist: he was a bronzeworker. As we learn from another passage, his brother Lysistratos was also a founder.[7] Besides the two brothers, three sons of Lysippos are said to have studied with their father, later becoming artists in their own right.[8] In other words, the family of Lysippos included bronze sculptors as well as bronze casters, and they evidently worked together.

Eupompos of Sikyon was an extremely influential painter, the founder of the Sikyonian school of painting in the fourth century B.C. In fact, one of his students, Pamphilos, taught the great painter Apelles. At least one of the paintings by Eupompos was of a victorious

[3] Overbeck 282–83, nos. 1485–89. See Giuliana Calcani, *Cavalieri di bronzo: La Torma di Alessandro, opera di Lisippo* (Rome, 1989), and eadem, "L'immagine di Alessandro Magno nel gruppo equestre del Granico," in *Alexander the Great: Reality and Myth*, ed. Jesper Carlsen et al. (Rome, 1993), pp. 29–39.

[4] See, e.g., Richter, *SSG*, p. 225. For a recent summary of the evidence and bibliography, see Stewart, *Greek Sculpture*, pp. 289–94.

[5] *NH* 34.61.

[6] For the testimonia, see Felix Jacoby, *Die Fragmente der griechischen Historiker* (Leiden, 1961), pt. 2A, no. 76, pp. 136–58. For a discussion of the work and influence of Douris, see K. Jex-Blake and E. Sellers, *The Elder Pliny's Chapters on the History of Art*, rev. rpt. (Chicago, 1977), pp. xlvi–lxvii.

[7] *NH* 35.153.

[8] *NH* 34.66.

gymnast holding a palm.[9] If Lysippos was present, as Douris says he was, when Eupompos made the remarks attributed to him, it is surely not farfetched to imagine a conversation between the painter and the bronze founder on the subject of nature in art. At any rate, when Lysippos became a sculptor, we have convincing evidence that he, too, adhered more closely to nature than to the ideal in representing athletes and other persons.

It is tempting to think that Lysippos's background in the family foundry and his familiarity with the technology gave him the means to experiment with the medium. As a result, he might have played down his role as artist, having developed a way to substitute for the artist's original model one that could be taken directly from an individual's face. By molding from nature, he would have seen the pathway to achieving realistic portraiture more directly, without having to depend on his own artistic imagination. With this more mechanical approach, the artist's direct responsibility for projects would have been lessened, and the workshop's productivity could have been increased. The sources suggest that this is exactly what Lysippos did: he was innovative in the field of portraiture, and he was prolific.

Lysippos made numerous portraits of Alexander, which were said to bring forth Alexander's true character in the bronze and to constitute the best renderings of Alexander's physical characteristics.[10] Lysippos also cast a bronze portrait of Sokrates, and the circumstances of the commission suggest that the philosopher's features would have been easily recognizable. Diogenes Laertius reports that right after the philosopher's execution in 399 B.C., the Athenians changed their minds about what they had done, and closed the palaestras and the gymnasia. They banished all the accusers except Meletos, whom they executed. Finally, they honored Sokrates with the bronze statue by Lysippos, which was placed between the Dipylon Gate and the Sacred Gate of Athens, in a building called the Pompeion where processions were prepared.[11] Lysippos was certainly chosen for his impressive credentials, and this suggests that the statue was produced sometime during the second half of the fourth century B.C. We cannot be sure that Lysippos followed the advice of Sokrates, who is reported by Xenophon to have recommended that an artist should imitate not only the living man's body and pose, but also his ethos and the feelings that affect his body and the activities of his soul.[12] If Lysippos did so, he must have been much more than a technician, and Plutarch's praises for the quality of his portraits suggest he was.

[9] "This painter's influence was so great that he created a new division in the art of painting. Before his time, there had been two schools, called the Hellenic and the Asiatic, but on account of Eupompos, who was a Sikyonian, the Helladic school was subdivided into three parts, the Ionic, the Sikyonian, and the Attic" (*NH* 35.75–77).

[10] Plutarch, *De Alexandri fortitudine seu virtute* 2.2; also Plutarch, *Alexander* 4.1 (Overbeck 281, nos. 1479, 1480). For portraits of Alexander, see R. R. R. Smith, *Hellenistic Royal Portraits* (Oxford, 1988), esp. pp. 57–69; Paolo Moreno, "L'immagine di Alessandro Magno nell'opera di Lisippo e di altri artisti contemporanei," in Carlsen et al., ed., *Alexander the Great*, pp. 101–36; Andrew Stewart, *Faces of Power: Alexander's Image and Hellenistic Politics* (Berkeley, 1993); and Paolo Moreno, *Scultura ellenistica* (Rome, 1994).

[11] Diogenes Laertius 2.43.

[12] *Mem.* 3.10.1–5.

Portraits of individuals who lived during the fourth century B.C. were definitely chang-ing: they seem not to have been so excessively idealized as they were during the fifth century. Instead, we begin to see recognizable individuals. In other types of sculpture, too, we see physical features that are not necessarily flattering, such as advancing age. All of these physical likenesses could be corrected or improved on in the wax working model, or they could be left just as they had been molded from the face or body of the sitter. In this respect, the sculptor would have had a far easier job of producing a portrait than the painter, for the sculptor could, to some degree or in some cases, substitute technical skills for the painter's basic need of artistic skill in representing the human form. In fact, Lysippos had been trained in those technical skills, and it was here that at least one other member of his family excelled.

It is interesting and probably not coincidental that Pliny, in a passage about Lysistratos, suggests that Lysippos's brother, too, used nature as his model, molding directly from the human form:

Hominis autem imaginem gypso e facie ipsa[13] primus omnium expressit ceraque in eam formam gypsi infusa emendare instituit Lysistratus Sicyonius, frater Lysippi, de quo diximus. hic et similitudines reddere instituit; ante eum quam pulcherrimas facere stude-bant. idem et de signis effigies exprimere invenit, crevitque res in tantum, ut nulla signa statuaeve sine argilla fierent.

The first person who formed a likeness in plaster from the face [figure?] itself and who established a method of pouring wax into this plaster mold and then making corrections in the wax was Lysistratos of Sikyon, the brother of Lysippos. . . . And he established a method of reproducing likenesses, for before this they had tried to make them [portraits] as beautiful as possible. The same person invented a method of molding copies from statues [i.e., taking casts from them], and the method became known to such a degree that no figures or statues were made without clay.[14]

This passage falls within Pliny's discussion of the modeling of clay. As it stands, the passage may be out of place, part of it belonging elsewhere. But this much of it, either by itself or integrated with Pliny's discussion of modeling, makes good sense. Pliny is proceed-ing chronologically. He has just spoken of innovators in clay modeling—first Boutades, then Rhoikos and Theodoros—with a reference to the potters who introduced modeling to Italy. Then he has shifted back to Boutades, before proceeding to Lysistratos and various

[13] Pollitt observes that *e facie ipsa* can refer to the whole body as well as to the face: *Greece*, p. 104n53.

[14] *NH* 35.153. There is one more sentence—"quo apparet antiquiorem hanc fuisse scientiam quam fundendi aeris" (Hence it appears that this skill [of forming clay] is older than that of casting bronze)—which may belong instead to 35.152, as L. Urlichs proposed: *Chrestomathia Pliniana* (Berlin, 1857), p. 375. For previous discussion and bibliography, see G. M. A. Richter, *Ancient Italy* (Ann Arbor, 1955), p. 113.

later artists. Pliny speaks of a change in the production of bronze statues, and he attributes that change to Lysistratos, who we know lived during the fourth century B.C. Evidently, the innovation was the use of a pure form of indirect lost-wax casting. In other words, Lysistratos began either to use actual human beings as his original models or to make original models that were finished and complete. When he took master molds from these models, and lined them with wax, the resulting wax working models needed no real improvement and no additional work.[15]

The above passage meshes neatly with what is said about Lysippos working directly from nature. The waxes were nearly finished as they came out of the master molds. After no more than a bit of touching up, they could be invested and cast. Thus an artist did not need to be present to finish the modeling or to add details to the wax working models. Once the artist had finished making the original model, the purely technical responsibilities of taking master molds, making waxes, coring, investing, and casting could be completed by technicians. Indeed, this may well account for the fact that Lysippos is credited with having produced an unusually large number of bronzes during his lifetime. Either he took a mold from a living form and touched it up, or he created an original model; then he was finished. He was free to move on to the next project, leaving all the technical procedures to be completed by foundry technicians. In the above passage, Pliny ascribes the founder's role to Lysippos's brother Lysistratos, who would have supervised the employees in the family workshop.

The founders would have used the indirect lost-wax process alone, rather than combining it with the direct process, and would thus have saved time, effort, and money. The thin layer of wax that was spread in the master molds would not become thick and irregular by further modeling: so less bronze was used in the pour. Furthermore, the chances of a successful casting were increased. Finally, in the event of failure, it would not be necessary to call the artist back to work: the molding and casting could be repeated by the technicians.

One consequence of this development—use of the indirect process alone—was, at least in later times, the proliferation of exact copies: that is, reproductions of certain well-known and popular sculptures. When Lucian noted that the Hermes in the Athenian Agora was "covered over with pitch because of being molded every day by the sculptors,"[16] he was observing this very process, which, by the second century A.D., had been in use for more than five hundred years. It may well be that Lysippos introduced this process for use in the rapidly expanding field of portrait sculpture, so that it could be faster, safer, and perhaps cheaper. If so, the "portraitist" could be replaced in large part by highly skilled technicians.

Scholars have usually linked the fourth-century B.C. Daochos monument, a statue group at Delphi, with Lysippos. The monument, which stood above and to the northeast of the

[15] Rhys Carpenter used this passage to argue that a plastic, or modeled, approach to sculpture supplanted a glyptic, or carved, approach at the beginning of the Hellenistic period: "Observations on Familiar Statuary in Rome," *Memoirs of the American Academy in Rome* 18 (1941): 74–81. To accept Carpenter's argument, however, we must first accept all the dates that *he* assigned to works on the basis of whether he thought they looked plastic or carved.

[16] Lucian, *Zeus tragoidos* 33.

Temple of Apollo, was dedicated to Apollo and consisted of nine marble statues, representing eight men from six generations of one family (and probably also Apollo). The statues stood in a row, in the traditional manner for commemorative groups. Daochos, a tetrarch at Pharsalos in Thessaly, was a member of the powerful Council of the Amphiktyonic League, which administered the Temple of Apollo at Delphi (and its property) and conducted the Pythian Games. Daochos dedicated the marble statues of his family members in 338–336 B.C.

Parts of all eight portrait statues survive, together with inscriptions identifying the eight men represented on the long base (fig. 3.1). The statues fall into the tradition of the generalized portraits of the Classical period, in that all are endowed with youthful vigor, although some are draped and some are nude, depending on the roles for which they were remembered. For example, the dedicator, Daochos II of Thessaly, is draped, as is appropriate for a man who served as a tetrarch. His great-grandfather Agias, however, is portrayed as a well-muscled nude youth, in deference to Agias's numerous athletic victories during the second decade of the fifth century B.C. Sisyphos II leans on a herm.

A near double for the inscription identifying Agias on the Daochos monument was found at Pharsalos in Thessaly during the late nineteenth century. At Pharsalos, however, the statue had been of bronze, and its sculptor was named—it was Lysippos. The Pharsalos inscription is evidently now lost, so the restorations to the text cannot be checked. But as a result of this inscription's discovery the marble Agias at Delphi has often been identified as a contemporary marble copy of the bronze Agias at Pharsalos. Many related questions have been raised. Was the marble Agias carved by Lysippos or by his workshop, which included three of his sons?[17] Given that the monument as a whole was dedicated by Daochos, who made the other statues in the group? How many artists were involved? In general, all the statues are accepted as being stylistically compatible with one another.[18]

No doubt a marble copy of a bronze could have been made in the fourth century B.C., but Lysippos is not named as the artist of the Delphi Agias, nor did he customarily work in marble, nor is there any reason to doubt that there might have been two statues of an athlete as famous as Agias. Not only did Agias's numerous victories merit a statue in his hometown of Pharsalos, but a commission for the statue went to Lysippos in the fourth century. Indeed, the Lysippos commission could well have replaced an earlier statue of Agias, which would have been erected soon after his victories, certainly during his lifetime.

Besides winning five times at Nemea and five times at Isthmia, Agias had won twice at

[17] On the sons and their work, see *NH* 34.66.

[18] For the inscriptions, see Franklin P. Johnson, *Lysippos* [1927] (New York, rpt. 1968), pp. 117–24; for the one in Pharsalos, see Jean Marcadé, *Recueil des signatures des sculpteurs grecs* (Paris, 1953), 1:67–68. For a summary of the questions about the monument and bibliography, see Tobias Dohrn, "Die Marmor-Standbilder des Daochos-Weihgeschenks in Delphi," *Antike Plastik* 8 (1968): 33–52; Holly Lee Schanz, *Greek Sculptural Groups: Archaic and Classical* (New York, 1980), pp. 21–34; Blanche R. Brown, *Anticlassicism in Greek Sculpture of the Fourth Century B.C.* (New York, 1973), pp. 36–37, 76–77n100; Ridgway, *HS* I, pp. 46–50. For the Agias as Lysippan art, see Paolo Moreno, *Vita e arte di Lisippo* (Milan, 1987), pp. 34–43, and idem, ed., *Lisippo. L'arte e la fortuna* (Rome, 1995), pp. 81–90. Among those who doubt that the Delphi Agias is a work by Lysippos or a copy of the bronze statue in Thessaly are Pollitt, *Hellenistic Age*, p. 306n4, and Smith, *HS*, p. 52.

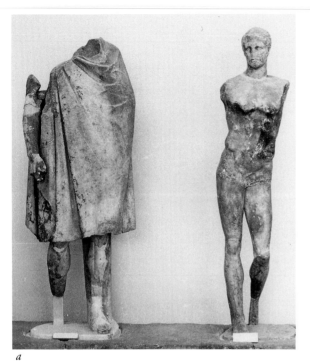

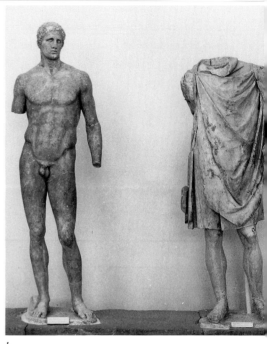

a

b

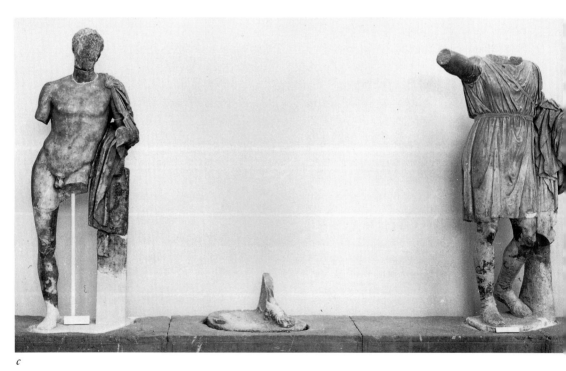

c

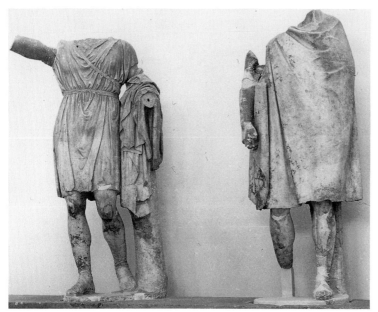

d

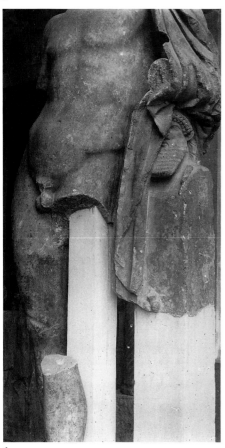

e

3.1. Lifesize marble statues from the Daochos dedication at Delphi, 338–336 B.C. (*a*) Daochos I, Agelaos; (*b*) Agias, Aknonios; (*c*) Sisyphos II, foot of Daochos II; (*d*) Sisyphos I, Daochos I; (*e*) Detail of left side of Sisyphos II, with herm as support. Delphi Museum. Courtesy of (*a–d*) Ecole Française d'Archéologie, Athens, and (*e*) Deutsches Archäologisches Institut, Rome, Inst. Neg. 56.1627.

Delphi, and so when his great-grandson dedicated statues there of nine illustrious family members, it was only natural that he would have included one of Agias. It is certainly important that the date of the Daochos dedication at Delphi is fixed in the third quarter of the fourth century, but this should not suggest to us that even one part of that monument, whose inscription names not a single artist, was the work of such a famous sculptor as Lysippos.

During antiquity, Lysippos was perhaps most widely known for his portraits of Alexander. No originals survive, but certain heroic types of bronze statuettes may be reminiscent of his famous Alexander with a lance. Lysippos is said to have emphasized the turn of Alexander's head, his gaze, and the sense of power.[19] Indeed, the standing male, youthful or mature, was a traditional type for heroic and commemorative statues, one that began in the fifth century B.C. The type is well illustrated by the Riace Bronzes. Initially, the stance may have been based on that of the Doryphoros by Polykleitos; certainly nudity was standard for all figures known for their physical prowess, as it had been during the Archaic period for statues of kouroi.

Pliny tells us that Lysippos made figures with smaller heads, more detailed hair, and more slender proportions than had been customary previously.[20] Lysippos also adapted the traditional nude to his image of Alexander with the lance, and this new variant on the type, often emulated, was itself eventually altered in dress, pose, and attributes as needed to fit images of particular gods and mortals.[21] Imitators of this Alexandrian image replaced Alexander's physical appearance with their own, as in the case of the larger-than-lifesize bronze ruler in the Terme Museum, in Rome (fig. 3.2).[22] Although this figure is nude, others may not be, and may instead be dressed and armed as warriors: sometimes they are human leaders, sometimes they are the god Ares/Mars himself (fig. 3.3).[23]

Extant Bronze Portraits

The literary sources attest not only to some of the sculptures made by Lysippos, to his style, and to his workshop, but also to the technical innovations made by this artist and by other members of his bronzeworking family. Is it possible that the developments we know from the literary testimonia are reflected in surviving bronzes?

The heads of bronze statues were normally cast separately from the bodies, and more

[19] Plutarch, *Alexander* 4.1; idem, *De Alexandri Magni fortuna aut virtute* 2.2.

[20] *NH* 34.65.

[21] For the type of Alexander with the lance, see Louvre BR 370 (H 0.165 m.), well illustrated in A. Pasquier, *The Louvre: Greek, Etruscan and Roman Antiquities*, trans. K. Painter (London, 1991), p. 45; also M. Bieber, *Alexander the Great in Greek and Roman Art* (Chicago, rpt. 1964).

[22] See Nikolaus Himmelmann, *Herrscher und Athlet: Die Bronzen vom Quirinal* (Milan, 1989), pp. 126–49, with bibliography; Robertson, *HGA*, pp. 477, 520–21, 554, 716n39; P. Moreno, *Scultura ellenistica*, 414–21. For the alloy of this statue, see chap. 4, n. 50, below.

[23] See C. C. Mattusch, "A Bronze Warrior from Corinth," *Hesperia* 61 (1992): 79–94, with bibliography.

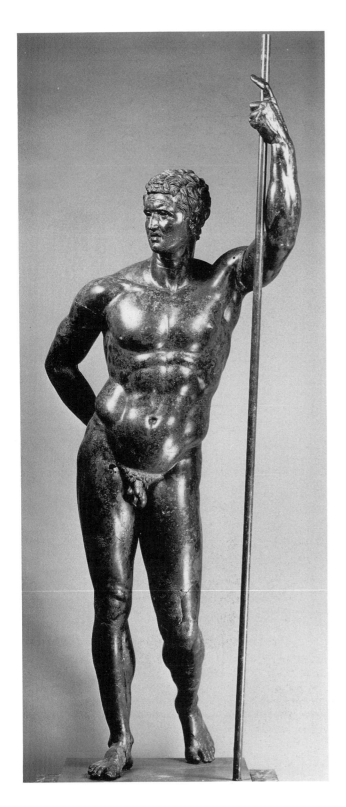

3.2. Bronze statue of a ruler, found in Rome (Via Quattro Novembre) in 1885. H to top of head 2.44 m. Rome, Museo Nazionale Romano inv. 1049. Courtesy of Archäologisches Institut und Akademisches Kunstmuseum der Universität Bonn.

a *b*

3.3. Bronze statuettes of political or military leaders. (*a*) H 0.235 m. Corinth MF 4016, stolen in April 1990 and not yet recovered. Courtesy of American School of Classical Studies at Athens: Corinth Excavations. (*b*) H 0.169 m. From Athens, E. P. Warren Collection. Boston, Museum of Fine Arts 01.7507, purchased by contribution. Courtesy of Museum of Fine Arts, Boston. (*c*) H ca. 0.150 m. Sparta Museum. Courtesy of Deutsches Archäologisches Institut, Athens, neg. no. Sparta 289. (*d*) H 0.185 m. From Dodona. Athens National Archaeological Museum no. 16727. Courtesy of Deutsches Archäologisches Institut, Athens, neg. no. N.M. 6303.

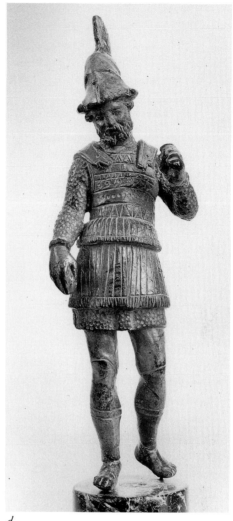

c d

attention was often given to finishing the details of the head than was necessary for the rest of the statue. Bronze heads that most accept as from the fifth century B.C. (e.g., those of the Riace Bronzes and of the Artemision god) are thick and irregular castings, proving that the wax working models were significantly worked over before being invested and cast. Sometime after the fifth century, it seems, thin-walled bronzes made an appearance, and by the Hellenistic period the practice of working over the wax model extensively was being replaced in many parts of the Classical world by a newer, more streamlined approach to casting.

Many post-fifth-century bronze heads are thin, even castings—so much so that they seem almost masklike in appearance. Such heads, of course, contain far less metal than the thick castings and may weigh no more than a few pounds. Naturally, the bronze cost less.

In addition, these heads were faster to produce, for thin-walled bronzes were easier to pour successfully, and they would need fewer repairs generally. Such thin-walled bronzes may well exemplify the innovations that have been attributed to Lysippos and his workshop.

As we have seen, a single original model could be used to produce a series of nearly identical bronze statues whenever it might be necessary or desirable to do so—as, for example, with statue groups, whether they were to be images of legendary heroes or portraits of public figures. Indeed, because somewhat standardized types were used for freestanding sculpture, only the head might be reworked in wax by the artist, as may well have been the case with the Riace Bronzes, with their entirely different heads and faces (fig. 2.18 a–d).

Relatively few post-fifth-century bronzes survive that are universally accepted as portraits, and most of those that we have identified are now reduced to heads alone. Most of these bronzes have been published extensively. The four heads we shall consider in the following pages are especially well known, and two or three of them appear in nearly every textbook on Greek art. All four are far more realistic than those vigorous and enthusiastic helmeted youths and men which belong to the tradition arising from the Alexander portraits. Although there is general agreement on the identities of two of them—a boxer and a philosopher—the only consensus that has been reached on the other two is that they are probably portraits. The real debate about these heads, it should be said, focuses on chronology, and it is rare when two scholars cite the same date for any one head. Perhaps if we look briefly at the chronological dispute in each case, we shall see that this kind of discussion may never lead anywhere.

What a relief it would be if, by looking at the technical features of the heads, we could fix more precise dates for these portraits. Unfortunately, we shall find that we cannot establish such a chronology. We shall, however, see a connection between these bronze portrait heads and the reported developments of the Lysippos workshop or, more broadly, a connection with the technical changes introduced during the fourth century B.C. Those changes were not universal: some artisans preferred to continue using the traditional method, for the greater freedom it afforded them; others embraced the new practice, perhaps for its cost-effectiveness. Finally, we shall see that the evidence for the original context in which a bronze existed, or for the context in which it was destroyed, can provide us with a date far more useful than those various stylistic dates which we can never fix with any assurance.

The Head from Cyrene

A lifesize bronze head of a man, found in Cyrene in 1861, has usually been accepted as a portrait of a local North African (fig. 3.4).[24] It represents a still-young man, with a smooth

[24] I am grateful to D. E. L. Haynes for allowing me to study this head. See Robertson, *HGA*, p. 517, pl. 159a; Rolley, *BG*, p. 227, no. 209. For early references, see Laurenzi 98, no. 29.

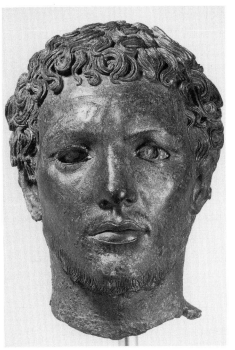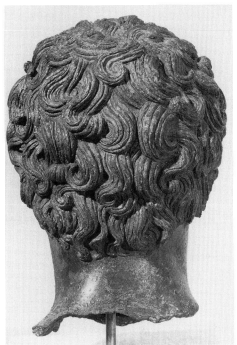

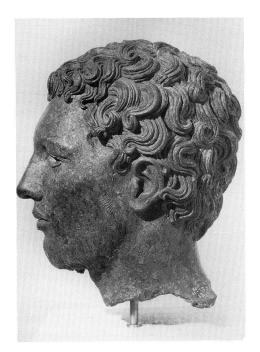

3.4. Lifesize bronze head of a young North African, from Cyrene, in 1861. H ca. 0.305 m. London, British Museum Br. no. 268. Copyright British Museum.

face; a fleshy brow projects above the long, straight nose. The gaze is commanding, but the jaw seems almost slack, and small pouches below the eyes reveal approaching middle age. Silver teeth would have glinted between the slightly parted reddish copper lips. The fine, hatched eyebrows and the sparse, wiry mustache and beard, characteristic of North Africa, were delicately cut directly into the surface of the wax head. Locks of short, tightly curled hair here and there spring away from the head entirely, making a fine display of the sculptor's virtuosity in modeling the wax.

There have been a few attempts at more specific identification of this bronze, such as that he might have been a noble Berber who had adopted a Greek life-style, or a king of Numidia or Mauretania.[25] Comments regarding attribution center on whether it is a pre-Lysippan work from the Peloponnesos or whether it might be a work by Lysistratos.[26] Most scholars date the head to the fourth century B.C. Reinhard Lullies and Max Hirmer give a date of 360 B.C.[27] François Chamoux, Luciano Laurenzi, and Brian Cook prefer the middle of the century.[28] The second half of the century is the choice of H. B. Walters, Elisabeth Rosenbaum, Martin Robertson, and Lucilla Burn.[29] Gisela Richter, however, prefers to place the head between 300 and 280 B.C.[30]

The stylistic and chronological concerns seems to have little to do with the context of the head's discovery in North Africa. The ancient city of Cyrene, now called Shahat, lies several kilometers inland from the Libyan coast. After the Battiad kings were overthrown in 440 B.C., Cyrene enjoyed a democratic government for more than a hundred years. Then Ptolemy I, who visited Cyrene in 322 B.C., annexed all of Cyrenaica. It was during one or the other of these periods—the democratic or the Ptolemaic—that most scholars believe the bronze head was cast.

The head was not, however, discovered in its original context. It was found beneath a late mosaic floor on the site of the Temple of Apollo, in a valley to the northwest of Cyrene's agora. The only possible clue to the identity of the man represented is that the head was found with some fragments of a bronze horse (or horses?), and so we might be tempted to identify him as an equestrian. Unfortunately, the number and nature of the fragments are not now readily discovered, and so it is also possible that this could have been the head of a

[25] Berber: François Chamoux, *Cyrène sous la monarchie des Battiades* (Paris, 1953), p. 48. Libyan: Rolley, *BG*, p. 227. Numidian or Mauretanian king: Walters, *Select Bronzes*, text to pl. 15; R. M. Smith and E. A. Porcher, *History of the Recent Discoveries at Cyrene* (London, 1864), p. 94 and pl. 66.

[26] Pre-Lysippan, Peloponnesian school: Laurenzi 98, no. 29. By Lysistratos: Walters, *Select Bronzes*, text to pl. 15; idem, *Catalogue*, pp. 34–35, no. 268. School of portraiture that originated with Lysippos: Smith and Porcher, *Cyrene*, p. 94.

[27] Lullies/Hirmer 90, no. 210.

[28] Chamoux, *Cyrène*, p. 48; Laurenzi 98, no. 29; B. F. Cook, *Greek and Roman Art in the British Museum* (London, 1976), pp. 130 and 133, fig. 105.

[29] Walters, *Select Bronzes*, text to pl. 15; Elisabeth Rosenbaum, *A Catalogue of Cyrenaican Portrait Sculpture* (London, 1960), p. 35; Robertson, *HGA*, p. 517; Lucilla Burn, *The British Museum Book of Greek and Roman Art* (London, 1991), pp. 132 and 134, fig. 115.

[30] Richter, *Portraits*, p. 51 (although a fourth-century date is given on p. 50, in the caption for the illustration of the head).

charioteer, for there was a hippodrome at Cyrene.[31] If indeed this is a charioteer, then the possibility that the head is a portrait seems unlikely. But the head is a unique production, which suggests that it does represent a particular person. The amount of effort that was put into modeling the wax working model suggests that this is the portrait of an aristocrat; if so, he was surely a rider, not a charioteer.

As it is now, the bronze head is an almost complete casting. A bronze ledge of hard solder around the inside of the neck proves that the finished edge was just below the break. The metal is a tin bronze, but the mouth, which was made separately and inserted, is almost pure copper.[32] The teeth are silver, held in place inside by a bronze plate. The eyes retain their white-paste inlays, within bronze capsules which are fringed along the edges for the lashes. Only four small repairs were needed during the coldworking of the head, all on the neck, and they were all neatly done with rectangular bronze patches.

Inside the top of the head, there is an odd feature, which may represent a practice peculiar to this particular founder or workshop. A squarish bronze projection measuring about 0.038 by 0.040 meter apparently served to secure the core within the mold during casting. Normally, we should expect to see small iron pins, or chaplets, used to pin the core to the mold.[33] In that case, the outside of the bronze would be patched to cover the location of the pins. On the outside of this head, however, there was no need for a patch. Instead, the bronze support fused with the bronze of the head during casting. It was the only support used.

As a whole, this is a relatively thick casting, the bronze of the neck being between 0.005 and 0.006 meter thick. The interior surface is very uneven, and the contours are only roughly similar to the exterior shape. As we might expect, the curls that burst free of the head are solid bronze: there is no sign of them on the interior; they were individually modeled in the wax. Also, the interior shows only slight depressions for the ears and the nose, for they too are nearly solid bronze. Like the curls, they were modeled freehand in the wax. All of this means that the artist worked the wax himself, in order to get as accurate a rendering as possible of an individual's features. This head, then, was cast directly from the wax in which the artist worked the final details of the likeness. We might conclude that the portrait was made by an artist who had not yet learned the lessons of the Lysippan workshop regarding how to speed up the production of portraits. The high quality of this casting, though, suggests that speed of execution and repetition were not as important to this sculptor as his painstaking creation of a single sensitive likeness. If this was the case, we still have no clue as to the date of the bronze beyond the evidence for the history of the site of Cyrene.

[31] Walters, *Catalogue*, pp. 34–35; Rosenbaum, *Catalogue*, p. 35. If the pieces of horse(s) can be located, they may help us determine whether one or more animals were represented, what its/their position was, and thus whether the head is that of a rider or of a charioteer.

[32] Paul T. Craddock, "The Composition of the Copper Alloys Used by the Greek, Etruscan and Roman Civilisations: 2. The Archaic, Classical and Hellenistic Greeks," *JAS* 4 (1977): 113–14: head = 91% Cu, 7.9% Sn; lips = 99.5% Cu.

[33] See Mattusch, *GBS*, pp. 17, 225, with references.

The Olympia Head

One bronze usually dated to the fourth century B.C. is the lifesize wreathed head of a victorious boxer, discovered in the Sanctuary of Zeus at Olympia in 1880, north of the Prytaneion (fig. 3.5).[34] There are many minor differences of opinion about its date. Although a few have placed it in the third century B.C., the head is usually dated to the fourth century B.C. or, more specifically, to the middle or the second half of the fourth century.[35] Because the style of the head is of high quality, scholars have attempted to ascribe it to a particular artist, usually to the Athenian sculptor Silanion, whose portrait of the boxer Satyros of Elis was seen by Pausanias at Olympia.[36]

The Olympia Boxer may be victorious, but, like the seated boxer in the Terme Museum (see fig. 1.9 and pl. 3), he is clearly aging: he has sagging, leathery cheeks and a squint. The narrow eyes are puffy and heavily hooded by a fleshy brow, knitted and bulging. The lower lid of the right eye appears to be swollen. The nose is long and flattened, the tip lost through removal of the corrosion products. Both ears are swollen, the left one largely concealed by the hair. The right ear, where it appears below the hair, is noticeably puffy. There are two rings marked on the boxer's spare neck.

There is no evidence regarding the appearance of the Olympia Boxer's body, and it is difficult to imagine a body to match the face. Would this have been a standing nude in the tradition of fifth-century statues of athletes, or would he have been noticeably aging?

[34] Adolf Furtwängler reports that the Olympia Boxer came from well below the level of the Roman period, and he thinks that this bronze may be one mentioned by Pausanias when he visited the area: Furtwängler, *Bronzen*, pp. 10–11, no. 2. Peter-Cornelis Bol reexcavated the site in 1972 and concluded that the head had been found *just* below the level of the Roman period, but that it might have been intentionally saved: Bol, *Grossplastik*, pp. 114–15, with a quote from the daybook of Georg Treu, the original excavator of the area. I am grateful to Rosa Proskinitopoulou for permission to study this bronze. Unfortunately, because of the excessive weight of the head, neither the wooden plates screwed just inside the opening of the neck nor the attached metal stand could be removed. As we shall see, the thickness of the hair and beard is the primary reason for the weight.

[35] Fourth to third century: H. Schroder, "Über den Marmorkopf eines Negers in den Königlichen Museen," *60. Programm zum Winckelmannsfeste* (Berlin, 1900), p. 18. Early third century: A. W. Lawrence, *Later Greek Sculpture* (London, 1927), p. 16. Third century: C. Friedrichs and P. Wolters, *Die Gipsabgüsse antiker Bildwerke* (Berlin, 1885), p. 145, no. 323; W. W. Hyde, *Olympic Victor Monuments and Greek Athletic Art* (Washington, D.C., 1921), p. 255. Fourth century: Furtwängler, *Bronzen*, p. 11, no. 2; Richter, *Portraits*, p. 47. Mid–fourth century: Bol, *Grossplastik*, p. 42. 350–340 B.C.: Laurenzi 101, no. 34. 335–330 B.C.: Boardman/Dörig/Fuchs 444. 335 B.C.: E. Schmidt, "Silanion der Meister des Platonbildes," *JdI* 49 (1934): 193; J. Charbonneaux, R. Martin, F. Villard, *Hellenistic Art* (New York, 1973), p. 212. 330 B.C.: G. Rodenwaldt and W. Hege, *Olympia* (Berlin, 1937), p. 53; Hans-Volkmar Herrmann, *Olympia: Heiligtum und Wettkampfstätte* (Munich, 1977), p. 172; Stewart, *Greek Sculpture*, p. 180. Second half of fourth century: Finn/Houser, pp. 7, 37. Late fourth century: Lullies/Hirmer 97; Robertson, *HGA*, text to pl. 160a.

[36] Pausanias 6.4.5. Besides two victories at Olympia, Satyros won five times at Nemea and twice at Delphi. Silanion is also noted for his portrait of Apollodoros as well as for his statues of Achilles and of a trainer exercising athletes (*NH* 34.81–82), of Plato (Diogenes Laertius 3.25), of Jokasta (Plutarch, *De recta ratione audiendi* 3.30 [*Moralia* 674a] and *Quaestionum convivialium libri* 6.5.1.2 [*Moralia* 674a]), of Sappho (Cicero, *In Verrem* 2.4.57.125–26), of Theseus, and of two boy boxers, Telestas and Demaretas from Messenia (Pausanias 6.14.4, 11). For thorough bibliography, see Stewart, *Greek Sculpture*, pp. 288–89. Some attributions to Silanion: Schmidt, "Silanion," p. 193; Rodenwaldt and Hege, *Olympia*, p. 53; Boardman/Dörig/Fuchs 444; Charbonneaux, *Hellenistic*, pp. 212, 215; Herrmann, *Olympia*, p. 172; Finn/Houser, p. 37.

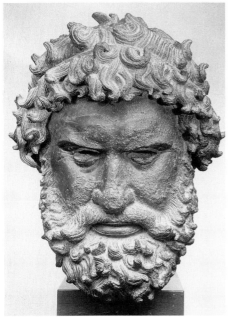

a

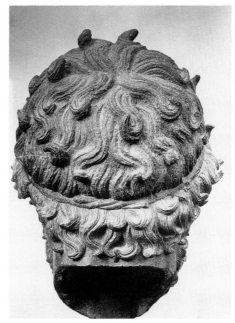

b

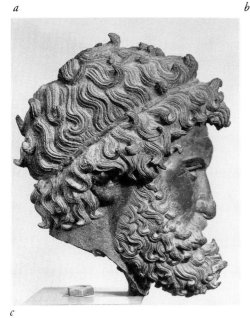

c

3.5. Lifesize bronze head of a boxer, from Olympia in 1880. H 0.28 m. Athens, National Archaeological Museum no. 6439. Courtesy of Deutsches Archäologisches Institut, Athens, neg. nos. 72/333, 72/336, 72/334.

Perhaps this boxer's body was simply a well-muscled and mature standing figure. From the appearance of his neck we should certainly envision a far less complex pose than that of the seated Terme Boxer.[37] Indeed, although the Olympia Boxer bears the unmistakable scars of his sport, they are not exaggerated, and he seems to bear himself with a victor's composure and self-satisfaction, whereas the unwreathed Terme Boxer is seated informally. He turns abruptly sideways, wearing a pained, almost beseeching expression, his swollen bronze features ravaged by open cuts, from which drips copper "blood."

The Olympia Boxer's eyes were once inlaid on ledges more than 0.02 meter wide, with sharp rims at the outside. A fine blade was used to mark a delicate herringbone pattern in the wax for the eyebrows, closely following above and below the sharp angle of the brow. The mouth is slightly open, as if for better breathing. The sharply delineated lips are inlaid, although they seem to be made of the same metal as the head itself; no teeth are visible inside.[38] Most of the surface of the mustache is lost, but the upper beard, like the crown of the head, was engraved with a broader blade than that used for the twisting ends of the curls.

The disordered tufts of the Olympia Boxer's heavy hair radiate from a central point below the top of the back of the head. They are rendered as if damp with sweat, as they would be on an athlete who has just finished his competition. The hair, in fact, imparts much individualism to the head: it is intricately detailed, with elaborately projecting and undercut curls, particularly thick over the forehead and ears. An olive wreath encircles the head snugly, indenting the hair. The wreath actually resembles a branch: it is an irregular half-round, twisted together at the back, its ends cut at an angle. Two small leaves are still attached on the right side; small gouges on the branch at regular intervals, about 0.02 meter apart, mark the locations of others.

Inside the head, Furtwängler noted a seam along the line of the olive wreath.[39] In fact, a careful look reveals that the wreath marks the division between two separate castings: the crown and the lower part of the head. The curls above and below the wreath do not line up with one another, because the strands were cut separately and with different tools. The curls on the crown of the head are larger than those below the wreath, and consist of broader, coarser strands of hair. The curls above the wreath were cut into the wax with a burin whose blade was about 0.004 or 0.005 meter wide; a much finer blade was used below the wreath, the blade being no more than 0.002 meter wide.

The hair of the battered and seated boxer in the Terme Museum in Rome is not encircled with a victor's wreath, but the casting of the head was still divided in two. Here too the curls

[37] See Robertson, *HGA*, pp. 520 and 716n40; Pollitt, *Hellenistic Age*, p. 146; Stewart, *Greek Sculpture*, p. 225. For other standing and seated boxers, see Himmelmann, *Herrscher und Athlet*, pp. 150–80 and 165–72 (plates); and Paolo Moreno, *Scultura ellenistica*, 60–67.

[38] The maximum opening of the mouth is 0.001 m.; the maximum width of the upper lip 0.003 m., of the lower lip 0.006 m. For cast lips that were to be inlaid in statues, see Bol, *Bronzetechnik*, p. 149 with figs. 104–5.

[39] Furtwängler, *Bronzen*, p. 10. Bol also observed that there was a join in the region of the olive wreath: *Grossplastik*, p. 114.

radiate from a central point, and the first two to three roughly marked rings of curls are a separately cast small cap, irregular but more or less oval in shape. The roughly worked curls of this cap do not in any way line up with the rows of more carefully marked curls on the lower part of the head. It seems likely that the heads of statues were divided in this way in order to facilitate the removal of the clay core material after casting. This would make it easier for eyes, encapsulated in their copper lash plates, as well as a set of copper lips to be set in place from the outside.

Although much of the original surface of the Olympia Boxer is damaged, it is evident that there are no patches; nor, apparently, are there any minor casting flaws. And the exterior of the head bears no signs of chaplets. The neck is unusually thick, ranging from 0.006 to 0.011 meter, and the inner surface appears to be rather smooth, following, at least in general, the external contours of the head. Inside the back, just visible beyond the modern wooden plate, a slight depression marks the projecting mass of the hair. In front, where the neck curves into the beard, a bronze drip follows the line of the curve. This means that a model preceded the head, which had master molds taken from it. The drip would have occurred when the wax was being sloshed around inside the rejoined master molds, in order to coat the surface fully.

Even if the wax model for the face was in a relatively finished state, the rest of the wax head that came out of the master molds was far from complete, and much wax would have been added to complete the details. The straggling curls, so extensively undercut, could not have been reproduced from a model, even with the use of multiple master molds. Nor is there any evidence that these curls were cast separately and soldered to the head. Instead, the tufts of hair were formed and incised directly into the wax before casting. As a result, the curls are cast solid, the artist having added them to the wax. The Olympia head is unusually heavy, because so much wax was added to prepare the working model for casting. This working model served as the artist's model, for it was here that the artist created many of the final details. The Olympia head is thus, like the head from Cyrene, a unique work of sculpture. The unflawed casting is proof of the consummate skill of the founder to whom the artist's own working model was entrusted. Clearly there was little risk in this foundry of losing the only original to some mistake in casting or to some accident in the workshop.

Antikythera

In 1900, sponge fishermen discovered an ancient shipwreck off the island of Antikythera, between Kythera and Crete. Finds from the ship—Hellenistic and early Roman pottery, amphoras, glass, and an astrolabe—have fixed a date for the wreck between 80 and 50 B.C.[40]

[40] For the date, see G. D. Weinberg et al., *The Antikythera Shipwreck Reconsidered*, Transactions of the American Philosophical Society, n.s. 55.3 (Philadelphia, 1965). All of the material is in the National Archaeological Museum in Athens. For a summary of the evidence, see Bol, *Antikythera*, pp. 108–20. Bol dates most of the statues to the first half of the second century B.C. (p. 108). Friedrich Gelsdorf summarizes the evidence for

The ship's cargo also contained large and small bronzes, bronze furniture attachments, and marble sculpture. These seem to have been of various dates, ranging from perhaps as early as the fourth century B.C. to as late as approximately 100 B.C.

A portrait bust decorating a fulcrum has been identified as Arsinoe III and has been dated to her lifetime, just before 200 B.C.[41] There is no firm consensus, though, regarding the identification of portraits as Arsinoe III, and this small bust, which once decorated the arm of a couch, may be more appropriately seen as a goddess, perhaps Artemis.

Among some forty marble statues from the shipwreck are two Aphrodites; there are also oft-repeated types, including a Herakles of the Farnese type, a couple of statues of Hermes, and an Apollo. And there are more classicizing works—of, for instance, Herakles and Apollo. We also have marble torsos, seated figures, a half-kneeling boy, a pair of dancers, two statues of Odysseus and one of Achilles, several fragmentary horses, as well as some less easily identifiable works and many small pieces from sculptures.[42] Most of the marbles have been severely damaged and eaten away by the salt water and by marine organisms. Their styles differ, so the group as a whole cannot be dated by style, and it is not possible to do more than speculate about whether the sculptures are the products of one or more workshops, or whether they were all made at about the same time or in entirely different periods.

The most complete large bronze from the Antikythera shipwreck is a statue of a youthful athlete, usually dated to the fourth century B.C. on the basis of its style (fig. 3.6). The statue has been restored twice from many fragments, and the original surface is lost, as are portions of the statue, including the base of the neck, a large area above the hips, and part of the left thigh. The bronze youth was cast in pieces; divisions are reported at the level of the nipples, on the upper arms, above the buttocks, and across the middle of the thighs. The head, the mouth, and the front of the left foot were also separately cast. Eyes, teeth, and nipples were inset.[43]

As restored, the bronze youth is solid and well muscled, with slightly rounded shoulders and a thick neck. He bears his weight on the left foot; the right foot trails behind. The left arm hangs by his side, and the right arm is raised in what might best be described as a majestic gesture. His head is turned to the right, lips slightly parted, and his gaze is directed toward his raised right hand, which once grasped an object, sometimes conjectured to have been a ball. The vacant expression is enlivened by a frame of thick, tousled curls. The

ancient sea routes and art transport in *Das Wrack*: "Antike Schiffahrtsrouten im Mittelmeer" (2:751–58) and "Antike Wrackfunde mit Kunsttransporten im Mittelmeer" (2:759–66).

[41] Athens, National Archaeological Museum no. 15099: Beryl Barr-Sharrar, "The Anticythera Fulcrum Bust: A Portrait of Arsinoë III," *AJA* 89 (1985): 689–92; eadem, *The Hellenistic and Early Imperial Decorative Bust* (Mainz, 1987), pp. 67–68, C138.

[42] See Bol, *Antikythera*, pp. 43–107 and pls. 23–56.

[43] For the most recent restoration, see Christos Karousos, "To chronikon tis anasystaseos tou chalkinou neou ton Antiktheiron," *ArchEph* (1969): 59–79. The findings are summarized by Bol, *Antikythera*, pp. 18–24. I have not looked at this statue closely. Similar sectioning for casting has been observed in the fragmentary statues from the Porticello shipwreck, which is dated to ca. 400 B.C.: see Brunilde S. Ridgway, "The Sculpture," in Cynthia J. Eiseman and B. S. Ridgway, *The Porticello Shipwreck* (College Station, Tex., 1987), pp. 63–106.

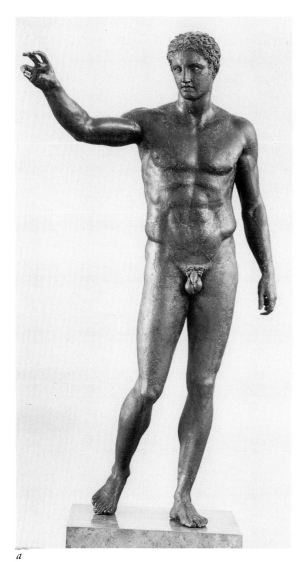

a

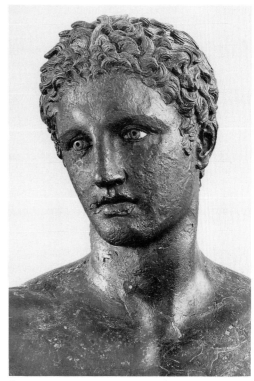

b

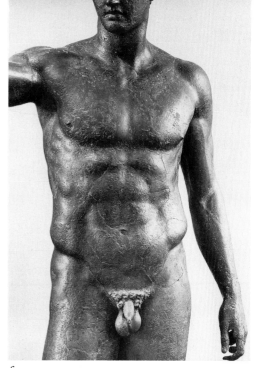

3.6. Youthful bronze athlete, recovered from the Antiky-
thera shipwreck (ca. 80–50 B.C.) in 1900. H 1.96 m. Athens,
National Archaeological Museum no. 13396. Courtesy of
Deutsches Archäologisches Institut, Athens, neg. nos. N.M.
5357a, 5360, 5358.

c

statue, usually placed within the Polykleitan tradition, is most often dated to the third quarter of the fourth century B.C.[44] It is, however, difficult to be certain about the original appearance of this statue, because it has been so heavily restored on two occasions.[45]

The fragmentary bronzes from the Antikythera shipwreck are a diverse group, and it seems that the statues had been installed before they became part of this first-century B.C. shipment, for the feet are filled with massive lead dowels. Besides the head of an elderly man,[46] the left arm of a boxer,[47] two swords,[48] a lyre,[49] two right arms with hands and a right hand,[50] two left hands and a left arm,[51] and four fragments of drapery,[52] there are eight feet, all with massive lead dowels for attachment to bases.[53] Six of the feet are shod, and we might hope that the sandals could provide a clue to dates, but they do not; for these sandals, all of a type known as *trochades*, were worn from the fifth century B.C. until Roman times.[54]

The two swords from the shipwreck can be matched somewhat more successfully. They are closely paralleled by a sword, from a destruction context in the Athenian Agora of about 200 B.C., that was evidently worn by a statue of a rider.[55] Two similar but more ornate sword hilts from Dodona can be closely dated: the inscribed bases for the statues to which they belonged identify the "owners" as strategoi who were honored between 230 and

[44] See Rhys Carpenter, *Greek Sculpture* (Chicago, 1960), pp. 44, 161–63, 170–73; Lullies/Hirmer 92–93; Robertson, *HGA*, pp. 409, 470, 485. If he is not called an athlete, the statue has been identified as Paris or Perseus; for references to the earlier scholarship, see Olga Palagia, *Euphranor* (Leiden, 1980), p. 34, no. 5.

[45] For the original restoration of the statue, see J. N. Svoronos, *Das Athener Nationalmuseum* (Athens, 1908), 1:18, fig. 2, and pls. 1, 2. For description of the two restorations and for additional references, see Houser, 1987, pp. 179–96.

[46] Athens, National Archaeological Museum no. 13400. H 0.35 m.

[47] Athens, National Archaeological Museum no. 15111. L 0.765 m.

[48] Athens, National Archaeological Museum no. 15102, L 0.42 m.; no. 15103, L 0.83 m.

[49] Athens, National Archaeological Museum no. 15104. L 0.28 m.

[50] Athens, National Archaeological Museum no. 15112, L 0.760 m.; no. 15105, L 0.830 m.; no. 15107, L 0.305 m. An iron chaplet, square in section, is visible on the outside of the upper arm of no. 15105.

[51] Athens, National Archaeological Museum no. 15095, L 0.30 m.; no. 15108, L 0.11 m.; no. 15106, L 0.57 m.

[52] Athens, National Archaeological Museum no. 15088.

[53] Unshod left feet: Athens, National Archaeological Museum no. 15093, L 0.275 m.; no. 15094, L 0.230 m. Shod left feet: no. 15110, L 0.320 m.; no. 15114, L 0.320 m. Shod right feet: no. 15091, L 0.320 m.; no. 15092, L 0.315 m.; no. 15115, L 0.314 m.; no. 15119, L 0.34 m. It seems likely that of two of these feet (nos. 15091 and 15110) belong with the right arm (no. 15105) and with the head (no. 13400): see Bol, *Antikythera*, pp. 24–32 and pls. 6–19.

[54] See Morrow, *Footwear*, p. 115. Even if we could prove without a doubt that the statue of the elderly man once wore two of these sandals, we could not accept Morrow's suggestion of a fourth-century date for that statue, because the sandals themselves need not date to the fourth century. See also Ridgway, *HS* I, p. 57, for a date of 340–330 B.C. For further information on *trochades* worn by later statues, see M. Pfrommer, "The Emperor's Shoes: Hellenistic Footwear in Roman Times," *Bulletin of the Cleveland Museum of Art* 74 (1987): 124–29.

[55] Athenian Agora B 1382. For the argument that the rider represents Demetrios Poliorketes, and for a fourth-century B.C. date for both rider and sword, see Caroline Houser, "The Appearance of a Hellenistic Type of Sword: Art Compared with Artifact," in *Abstracts*, 94th Annual Meeting, Archaeological Institute of America, vol. 16 (1992), p. 24; and Camp, *Agora*, pp. 164–65. For the rider's leg, see also chap. 1, p. 28 above; chap. 4, pp. 125–29, below; and fig. 4.11.

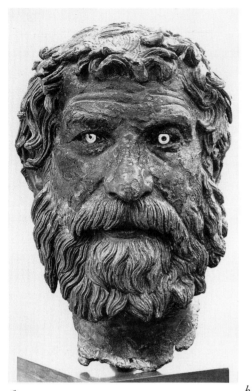

a

b

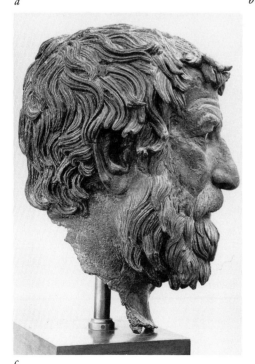

c

3.7. Lifesize bronze head of an older man, re-
covered from the Antikythera shipwreck (ca. 80–
50 B.C.) in 1900. H 0.29 m. Athens, National
Archaeological Museum no. 13.400. Courtesy of
Deutsches Archäologisches Institut, Athens, neg.
nos. N.M. 6065, 6069, 6067.

219 B.C.[56] Unfortunately, this information brings us no closer to dating any of the rest of the material from the shipwreck.

One of the most interesting bronzes from the Antikythera shipwreck is a lifesize bearded head of an elderly man (fig. 3.7). The head has been published frequently, and scholars usually agree that it represents a philosopher.[57] He is identified on the museum label as a "Cynic" and dated there to the second half of the third century B.C. In the absence of any other information or ideas concerning whom the head might represent, arguments have centered on where to date it on the basis of its style. Suggestions range over a period of nearly two hundred and fifty years, from the second half of the fourth century to 100 B.C.[58] It is unlikely that a consensus will ever be reached; consideration of style has always fueled the study of ancient sculpture, and this most popular and highly subjective approach to the field shows no signs of abating.

Where the head has been rubbed free of corrosion, the metal is reddish, suggesting that the alloy contains a significant amount of copper, but it has evidently not been analyzed.[59] Because the head was cleaned extensively, the dark-gray surface is pitted where it was once corroded. The most damaged areas are on the top of the head, the face, the left side of the beard and neck, and the hair above the forehead, giving the man a rather misleadingly disheveled appearance. The ends of a few curls around the right ear are lost, but on the left side much more hair is missing, leaving the entire ear exposed; the ear is rather large and, although it was carefully modeled, the original intention surely was not to expose it. Before the tips of the curls were lost, the hair probably did not look as matted as it does now.

Some restorations were made on the neck in plaster and wax. Much of the interior of the head is not now visible. A modern wooden plate, just below the mouth and just above the nape of the neck, supports the head; marine encrustation covers much of the inside. It is impossible to tell, therefore, how regular the entire interior surface might have been.

So far as can be seen, the interior surface follows the contours of the locks of hair, but not

[56] I am grateful to Olga Palagia for bringing these swords to my attention. See Ioulia P. Vokotopoulou, *Odigos Mouseiou Ioanninon* (Athens, 1973), pp. 70–71, pls. 27, 28; Sotirios Dakaris, *Dodoni* (Athens, 1993), pp. 21–22.

[57] P. Moreno actually identifies the philosopher as Bion of Olbia, on the Black Sea: *Scultura ellenistica*, 271–74, figs. 336–37. P. Kabbadias likened this head to that of the Olympia Boxer: "The Recent Finds Off Cythera," *JHS* 21 (1901): 207, and "Statues rendues par la mer," *Revue des Etudes Grecques* 14 (1901): 124.

[58] Some samples of dates assigned to this head follow. Perhaps 340–330 B.C.: Morrow, *Footwear*, p. 115; Ridgway, *HS* I, p. 57. Early Hellenistic: Klaus Fittschen, "Griechische Porträts," in *Griechische Porträts*, ed. K. Fittschen (Darmstadt, 1988), p. 19. 240 B.C.: Semni Karousou, "Der Bronzekopf aus Antikythera—ein Kynischer Philosoph," in *Pro Arte Antiqua: Festschrift für H. Kenner* (Vienna, 1985), 2:207. Second half of third century: Lullies/Hirmer 100; Bol, *Antikythera*, p. 26. Third quarter of third century: Boardman/Dörig/Fuchs 507. 240–220 B.C.: Charbonneaux, *Hellenistic*, p. 395. Last quarter of third century B.C.: Ernst Buschor, *Das Hellenistische Bildnis* (Munich, 1949), p. 23. Second century: Bieber, *Hellenistic*, p. 164. 180–170 B.C.: Laurenzi 124, no. 82. 220–100 B.C: G. M. A. Richter, *Portraits of the Greeks*, vol. I, 1st ed. (London, 1965), p. 38; but also see Richter, *Portraits* (rev. ed.), p. 52, for a date in the third or second century B.C.

[59] In 1909, an alloy derived from qualitative analysis was reported for one of the Antikythera bronzes, probably the youth: Cu 84.74%, Sn 14.29%. No other components were given: cited by Earle R. Caley, "Chemical Composition of Greek and Roman Statuary Bronzes," in *Art and Technology*, ed. S. Doeringer et al. (Cambridge, 1970), pp. 38–40.

where the hair and beard are deeply incised, for the wax had to be thick enough to accommodate this work. Where tufts of hair and beard have broken off, they are solid bronze. Although the hair on top of the head appears to have been only roughly marked, this is largely owing to the condition of the bronze. In fact, the thick wax that was to represent the hair was carefully incised with a burin whose blade was about 0.003 meter across; a smaller burin was used for the finer and more varied work on the beard. Some hairs were also lightly marked on the neck, below the beard.

The broad, fleshy forehead, much more exaggerated than that of the Olympia Boxer, has two deep and curving horizontal brow lines, giving the man a distinct frown. The projecting eyebrows, although they are in bad condition, are clearly made up of the long straggling hairs characteristic of an aging man; they were deeply cut into the wax with a tool of the same size as that used for the beard. Deep wrinkles at the outer corners of the eyes are almost entirely lost. The eyelashes are broken off, but the capsules have dark-brown corrosion products and are obviously made of a different metal from that used for the head, probably pure copper. White fill forms the pupils, and a dark metal ring once encircled inset irises.[60] The nostrils are about 0.01 meter deep, but they do not cut through the metal. The mouth was apparently cast with the head. It is closed, with a rather flat lower lip, and the upper lip is hidden by the mustache.

The neck no longer has the original finished edge, but it is evident that the edge was in the immediate area of the break, because some of the hard solder is still visible.[61] Molten bronze was used to solder the head to a body: the head was held upside down while the solder was poured into the front of the neck; it ran down inside the partially hollow beard. A rough, bubbly-looking interior is the result of this operation.

After casting, the head was repaired with small rectangular patches. The positions of three of these patches are still visible on the neck and in the hair.[62] There are also a few small holes that were apparently never repaired: one in the right side of the neck next to the beard;[63] three smaller ones in the beard; a larger one just below the beard on the front of the neck; and a few more small holes in the face and on the back of the head.[64] Wherever these holes occur, the walls of the bronze are no more than about 0.001 meter in thickness. Toward the back of the head, where the locks of hair spiral outward, there is an irregular patch or plug, roughly five- to six-sided, which seems to have been forced into a hole it did not fit.[65] The patch itself is pierced by two small holes.[66]

[60] Depth of metal ring ca. 0.020–0.025 m.; diam. ca. 0.011 m.

[61] Along the present edge, the neck ranges from 0.003 to 0.005 m. in thickness.

[62] A patch on the left side of the neck measures ca. 0.010 × 0.004 m., about the same as one in the hair; one on the right side of the neck is 0.005 m. across.

[63] Max. dim. 0.01 m.

[64] They measure ca. 0.001 m. in diameter. It is possible that these holes appeared as a result of early reductive cleaning (as chap. 1, fig. 1.20).

[65] The hole measures ca. 0.03 × 0.03 m. I do not know whether this repair is ancient or modern.

[66] One hole measures ca. 0.005 × 0.006 m.; the other is irregular, with a max. dim. of 0.005 m.

The head probably belonged to a standing draped figure; indeed, it is hard to imagine that it could have been otherwise. The restoration by J. N. Svoronos, using feet, arms, and drapery from the shipwreck, may not be far from the truth. Certainly this head is in the tradition of portraits of Greek philosophers, and it bears a distinct resemblance to the marble portrait of the Copenhagen Demosthenes, who wears the himation and sandals (*trochades*) resembling those on the pair of detached feet from the Antikythera shipwreck.[67] The frown on the Antikythera face expresses an intensity that does not appear in the faces of the Riace Bronzes, giving this older man a more distinct character, even though the two Riace heads were more painstakingly individualized. The artist who made the Antikythera head was able to spend far less time on the task, for this is a relatively thin casting, with only just enough extra wax added to the working model to mark the final details. Although our only evidence for the date of this statue is that of the shipwreck itself, we might suspect that the more rapid method of production was chosen by a workshop that catered to the increasing demand for sculpture by the Hellenistic market.

The Delos Head

In 1912, on Delos, Charles Avezou and Charles Picard excavated a lifesize bronze head of a man (fig. 3.8).[68] The head, owing to its extraordinary naturalism and vivid expression, has been widely recognized as a magnificent example of ancient portraiture. The technique used to make the Delos head, however, has received little attention, even though technique may be the key to understanding the innovations of Lysippos and Lysistratos in the field of portraiture. For this head is strikingly different from the head from Cyrene and the Olympia Boxer. The Delos head is a uniformly thin-walled, lightweight casting. Furthermore, the surface of the head is not complicated by projections, with the exception of the nose. This is a bronze that could have been produced quite rapidly: essentially no additions were made by the sculptor after he made the original model. In the foundry, a simple two-piece master mold could have been used to copy the original model, and a minimum amount of bronze was needed for the casting.

By the early seventh century B.C., Delos was the site of an important sanctuary dedicated to Apollo. Peisistratos of Athens had the sanctuary purified in the sixth century B.C. by having all the tombs removed from the area. In 478 B.C., after the defeat of the Persians,

[67] Reconstructed drawing of philosopher: Svoronos, *Das Athener Nationalmuseum*, 1:30, fig. 22. Demosthenes: Copenhagen, Ny Carlsberg Glyptothek, I.N. 2782. For illustrations, see Richter, *Portraits* (rev. ed.), pp. 112–13 and fig. 74. For these sandals being Hellenistic, see Bol, *Antikythera*, p. 32. Morrow (*Footwear*, p. 85) places them at least as early as the fourth century B.C.

[68] I am grateful to Olga Tsachou-Alexandri and to Rosa Proskinitopoulou for allowing me to examine this head. Height of head 0.270 m.; H of entire piece 0.325 m. Width of face above ears 0.220 m. Depth of cranium, front to back, 0.220 m. Breadth between temples 0.170 m. The measurements are from Charles Picard, "Portrait d'homme inconnu: Tête de bronze trouvée par Charles Avezou dans la 'Vieille Palestre' de Délos," *MonPiot* 24 (1920): 86. For more extensive measurements, see P. de la Coste-Messelière, "Un exemplaire périnthien d'un bronze d'Herculaneum," *BCH* 48 (1924): 280n1.

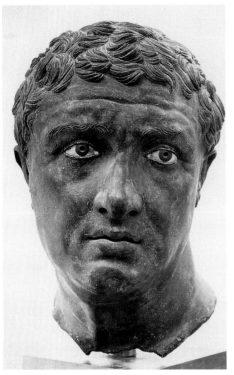 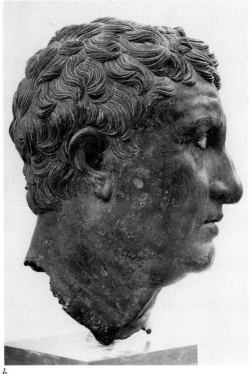

a b

3.8. Lifesize bronze head of a mature man, from Delos in 1912. H 0.325 m. Athens, National Archaeological Museum no. 14.612. Courtesy of Deutsches Archäologisches Institut, Athens, neg. nos. N.M. 6045, 6047.

Delos became the seat of the league of Greek cities and the location of their common treasury. The league, however, was under the leadership of the Athenians, as was the treasury, and they removed it to Athens. In 426 B.C. the Athenians decreed a second purification of the island. Delos became independent in 314 B.C. and remained so until 166 B.C., when the Romans made Delos an Athenian possession under the administration of an Athenian magistrate (*epimeleiteis*). At the same time, the island became a free port: as a rich commercial center, it was thronged with Greeks, Romans, and Easterners and was visited by many foreign traders. Here the Greek and Roman worlds were inextricably linked.

Besides the flourishing slave trade of this later period, a major local export was surely the Delian alloy of bronze, which long held first place in sales, Pliny says, over the other two major alloys—Corinthian and Aeginetan—although in Pliny's day Corinthian bronze was the most highly valued.[69] Perhaps it was Polykleitos who established the reputation of Delian bronze, since he was reputed to have preferred it to the Aeginetan bronze used by his

[69] *NH* 34.1, 6–8, 48.

rival Myron.[70] Also, Pliny tells us, "Delian bronze was the first to become famous, the whole world filling the market in Delos, and for that reason attention was paid to the workshops. It was there that bronze was first used for the feet and fulcra of couches, and afterward it came to be used for images of gods and for statues of men and of other living creatures."[71]

During the first century B.C., Delos was dealt two crippling blows: in 88, by the troops of Mithridates Eupator of Pontos, and in 69 by pirates. Meanwhile, their markets were being lost to Rome. The island never recovered, but Delian bronzes continued to be prized elsewhere. Cicero makes no mention of statues, but he reports that the house of Chryso-gonus on the Palatine in Rome was crammed with Delian and Corinthian vessels (*Pro Roscio Amerino* 133) and that Sthenius had collected fine Delian and Corinthian bronzes (*In Verrem* 2.176). He also accuses Verres of appropriating Delian-bronze vessels in Sicily and exporting them (*In Verrem* 4.1, 2.176).

The lifesize bronze head was excavated in the region of the Sacred Lake, north of the Sanctuary of Apollo, and came from the Granite Palaestra, which was built during the mid–second century B.C. In 69 B.C. this building was included in the Wall of Triarius, constructed for protection against the pirates of Athenodoros. The bronze head actually comes from a room that seems to have been in use later than the palaestra as a whole. The head did not belong where it was found, which was in fill about 0.50 meter above the doorsill of one of the southwestern rooms of the building.[72] We cannot tell when the Delos head was detached from its body, but we may assume that it was produced after 166 B.C., during the prosperous years under Athenian domination, and surely before the crippling attack by Mithridates in 88 B.C.

Because of the relatively abundant historical and contextual evidence, then, we are able to narrow down the dating of this head somewhat, but there is still a great deal of discussion about whether it is from the second or late second century B.C., or the late Hellenistic period, or 100 B.C., or the beginning of the first century B.C.[73] The man depicted was once

[70] *NH* 34.10.

[71] *NH* 34.9. Charles Picard mentions that bits of metal and a hearth were found in 1910 at the site of the Sacred Lake, and he refers to previous finds of the same sort from near the Agora of the Italians: "Portrait d'homme inconnu," p. 86.

[72] See Picard, "Portrait d'homme inconnu," p. 84; Casimir Michalowski, *Les portraits hellénistiques et romains. Exploration archéologique de Délos* (Paris, 1932), vol. 13, chap. 1, with pls. 1–6, figs. 1–2; and P. Bruneau and J. Ducat, *Guide de Délos*, 3d ed. (Paris, 1983), pp. 78, 193–94, fig. 61. Picard (p. 84) suggests that the head was thrown there after the period of Triarius.

[73] Second century B.C.: Richter, *Portraits* (rev. ed.), p. 52; Charles Picard, *La sculpture antique de Phidias à l'ère byzantine* (Paris, 1926), p. 213. Mid–second century B.C.: Laurenzi 128, no. 92. Late second century B.C.: Christine Havelock, *Hellenistic Art*, rev. ed. (New York, 1981), p. 37, no. 20. Late Hellenistic period: L. Alscher, *Griechische Plastik, IV: Hellenismus* (Berlin, 1957), p. 155; S. Papaspiridi, *Guide du Musée National: Marbres, bronzes, et vases* (Athens, n.d.), p. 222. Mid–second century to first half of second century B.C.: Michalowski, *Les portraits*, 13:3. 100 B.C.: Pollitt, *Hellenistic Age*, p. 71; Bieber, *Hellenistic*, p. 163; F. Poulsen, *Probleme der römischen Ikonographie* (Copenhagen, 1937), p. 15. End of second century B.C.: B. Schweitzer, *Die Bildniskunst der römischen Republik* (Weimar, 1948), p. 63. Beginning of first century B.C.: G. Hafner, *Späthellenistische Bildnisplastik* (Berlin, 1954), p. 31; Lullies/Hirmer 106.

likened to the Antikythera Philosopher, and both bronzes were identified as Rhodian works of the third century B.C.[74] A production date of around 100 B.C., however, accords well with the political and economic situation of Delos at the time.

The bronze represents a beardless middle-aged man with short curly hair and a fleshy face, which might best be described as having a mobile expression. Nowhere is the surface of the bronze flat. The cleft double chin, the fleshy mouth, the strong, uneven nose, the slightly hollow cheeks, puffy beneath the eyes, the knitted brow—all these express the distinct character of an individual. The parted lips look almost as if the man has opened them to draw a breath. The head is turned to the left, and the eyes gaze upward. They are accentuated by a heavy vertical fold over the nose and by a horizontal fold following the line of each brow. There are two more deep curving wrinkles in the forehead, the upper one disappearing into the hair. Diagonal veins on each temple seem to pulsate. The liveliness of the sparse hairs of the eyebrows and the thick short hair add further to the sense of movement and life.

If he was in keeping with tradition, this man was probably standing, clothed in a chiton or in a chiton and mantle, like so many of the marble portrait statues of the period from Delos. The distinctive features and the masterfully rendered expression signify that this is a portrait. There is some disagreement, though, about who might be portrayed. He has been identified as "a man famous in his time," as a Greek or an Italian, as "surely either a Greek or at least a non-Roman," or as possibly a Syrian.[75] Maybe he is simply a member of one of the well-to-do guilds on Delos; or, given the later Athenian domination of the island, he may be an Athenian magistrate, an *epimeleiteis*.

When scholars consider who might have created the Delos portrait, they normally assume that the sculptor was a Greek,[76] even though there may well have been some ethnic diversity among the artists working on Delos, depending upon the cultural backgrounds of their patrons. Sometimes the Delos head is described in terms of Lysippan art.[77] We may not all agree with this artistic link, but if we take into account the literary testimonia, we may recognize in the head certain of the developments ascribed to Lysippan technology or, more broadly, to the fourth century B.C.

[74] Karousou, "Der Bronzekopf aus Antikythera," p. 210.

[75] A famous man: S. Meletzis and H. Papadakis, *National Archaeological Museum of Athens*, trans. W. Hall and T. Papadakis, 17th ed. (Athens, 1991), p. 130, no. 152. A Greek: Havelock, *Hellenistic Art*, p. 37, no. 20. A Greek or Italian businessman or magistrate: Pollitt, *Hellenistic Age*, p. 71. An Italian: Lawrence, *Later Greek Sculpture*, p. 34. Charles Avezou believed the head to be that of a Roman who was about forty years old: noted by M. Homolle, "Séance du 11 octobre," *CRAI* (1912): 510. A non-Roman: R. R. R. Smith, "Roman Republican Portraits," *JRS* 71 (1981): 33n87. A Syrian?: Picard, "Portrait d'homme inconnu," p. 99; Boardman/Dörig/Fuchs 521.

[76] The head from Delos has been compared with the Borghese Warrior (Paris, Louvre, Borghese Collection MA 527), and Agasios is sometimes mentioned as a possible sculptor. See Poulsen, *Ikonographie*, p. 15; Boardman/Dörig/Fuchs 521; and Bieber, *Hellenistic*, pp. 163–64.

[77] Picard, "Portrait d'homme inconnu," p. 97; Michalowski, *Les portraits*, Delos 13: 3; Georg Lippold, review of Michalowski in *Gnomon* 12 (1936): 584; Bieber, *Hellenistic*, p. 164.

The initial cleaning of the head from Delos, soon after its discovery in 1912, does not seem to have damaged the clarity of the original surface detail. The exterior surface of the bronze remains in excellent condition. Where the original metal is visible, it is quite yellow, with two layers of corrosion products above it: the inner one reddish (cupritic oxide), the outer one green (malachitic oxide). Wooden plates fixed inside the head, securing it to the modern metal stand, obscure much of the interior, but it is possible to see inside the neck and to look through the open mouth and through a hole in the left nostril.

The head is a complete casting with a finished edge at the base of the neck, which would have fitted neatly into the neckline of a chiton. Most of the original edge is preserved, but there is one irregular break in the front and a second break on the right side of the neck. Inside the neck, the bronze retains marks from the application of the wax to the master mold. The wax was poured and spread as thinly and evenly as possible. Here and there are a few bronze drips and seams, and an area on the left side of the neck was scraped with a spatulate tool about 0.004 meter wide. A little folding and thickening of the edge of the casting may also have been done with this tool.

The casting is thin, with a smooth, regular interior surface that closely follows the external contours. The thickness ranges from approximately 0.004 to 0.007 meter, and the bronze is thicker only where the engraving of details in the locks of hair required a slightly thicker layer of wax. The casting is nearly flawless, and there are no patches. A few tiny holes can be seen where the molten bronze perhaps did not quite fill the thin space allotted to it. These include five irregular holes in the hair, all less than 0.007 meter across: one on top of the head; two in back; one above the left ear, where the metal broke through either because it was too thin or after cleaning; and one just behind the right ear. A sixth, slightly larger flaw exists on the left back of the neck. Again, there are no bronze patches whatsoever; perhaps these small holes were filled with a perishable material, such as wax that was tinted the same color as the metal.

The locks of hair are marked with deep, wide incisions, cut with a sure hand into the wax. Burins of various sizes were used for this task, and the blades of these tools were triangular in section. In front of each ear is a small curl or sideburn, the one on the right side curling forward, the one on the left curling back toward the ear. These curls were cut more shallowly in the wax than the rest of the hair, and the engraving was done with a finer tool. This tool might best be described as needlelike, and it was not triangular in section.

The curly hairs of the expressive eyebrows were also engraved in the wax with a fine-pointed tool, and a few lines are delicately engraved along the lids. The eyelash capsules are evidently made of copper, for they are of much redder metal than the head itself.[78] They seem to have been folded over and slit at each angle of the eye, so that they could be expanded to fit perfectly, and they rest on a shallow ledge, an extension of the lower eyelid. Only stumps of the lashes survive, and these remains curve downward over the eye before fanning out, thereby securing the whites in place.

[78] The lash plates are approximately 0.001 m. thick.

The eyes were set in position from outside, with oval bone or ivory whites forming a base for the whole. Lachrymal caruncles were added to the inner corners of the eyes, in a paste (whiter than the whites themselves) that may have helped to glue the whites firmly in place. Each of the dark-gray inset irises has a round opening in the center for the pupil, narrowing inward to a conical shape.[79] The whites show through the holes for the pupils.[80]

The oval nostrils are indented to a depth of about 0.007 meter, and the left one breaks through the thin bronze, revealing that the entire nose is hollow, even the tip. The ears are likely to be hollow as well. The lips curve inward to an opening of between two and three millimeters. Like the openings for the eyes, the open mouth could have served to extrude the clay core used during casting. Without such holes, chaplets would have been inserted through the wax into the core before investment, in order to hold the core in place within the mold during casting. Later, during coldworking, the holes left by the chaplets would have been patched.

Except for the nose, there are no projections on this head, no complicated undercuttings. There is no beard, and the hair is short. The tight, flat curls and clean-shaven face, besides being fashionable, had technical advantages. For one thing, master molds consisting of only two sections could have been taken from the original model to produce the wax working model. Moreover, the fine inner layers of the clay investment could be rapidly applied to a wax with an uncomplicated surface. Dipping the wax in fine liquid clay, or slip, would have been the first step, and would have ensured that core and mold were joined through the openings at the eyes and mouth. After casting, the investment mold could have been thoroughly and quickly broken away from the bronze head, there being no deep crevices or undercuts. Then the cleaning of the relatively smooth surface could have proceeded with speed.

We do not know whether the model for this bronze head was a man's actual face or a sculptor's creation.[81] We do know, however, that this kind of casting—thin and even, with little additional work done on the wax—is characteristic of bronzes that are produced in editions (i.e., in series). The only reworking of the wax seems to have been the engraving of the hair and of the eyebrows, although even these details may have been reproduced by means of the mold taken from the original model, and just touched up in the wax.[82]

[79] Diam. of each iris 0.014 m.; diam. of hole for pupil 0.005 m.; depth ca. 0.004 m.

[80] For similar eyes, see Bol, *Bronzetechnik*, p. 150 and figs. 106–8; also Mary C. Sturgeon, *Sculpture I: 1952–1967*, Isthmia 4 (Princeton, 1987), p. 157, no. 141, pl. 79 *f* and *g*.

[81] Picard originally suggested that the artist modeled in clay, after nature. As did Michalowski, Picard argued that the bronze is a sand casting. Like Avezou, Picard claimed to have seen core material and a wooden armature inside; that material (which Picard said was the same as that used in the Delphi Charioteer) is described as plaster mixed with red clay. See Picard, "Portrait d'homme inconnu," pp. 86–90; Michalowski, *Les portraits*, 13:1; and Homolle, "Séance," p. 510.

[82] Rhys Carpenter believed that the Delos head was modeled and built up in wax, tools having been used only to retouch details, and that the hair and eyebrows were engraved in the metal after casting: *Greek Sculpture*, pp. 241–42. The thin-walled casting, however, shows little evidence that the head was built up in the wax. Furthermore, the curving lines of hair and brows would have been far more difficult to engrave in metal than in wax, and would have produced rough edges, or burrs, of which there are no traces on this head.

The Delos head, then, could have been cast as one of a series of bronzes. Whether only one was made, or more than one, we do not know. In any case, the head conveys the spirit and the appearance of a distinct individual. That it was produced by a technique that makes it easy to copy the original model does not demean this portrait or make it any less striking a document of character.

The advantages of this form of production were felt by both the artist and the foundry. Production was quick when the model was simply reproduced in wax and then cast, and a failed casting could easily be redone. Whether the client was, say, a private individual who wanted only one portrait, or perhaps a public figure who wanted more than one likeness, the process of reproduction was reliable and rapid. If not inexpensive, bronzes nonetheless became far more accessible to a larger public than had been the case during the fifth century B.C. The Delos head, a thin-walled and even casting, is no doubt characteristic of many bronzes produced from the fourth century B.C. onward for the larger and richer audiences of the Hellenistic period.

BRONZES OF UNCERTAIN DATE

A stele from Athens preserves an inventory made by the treasurers of Athena in approximately 330 B.C. This inventory records about seventeen stelai, some of which lie on the ground, and lists some twenty-five bronze statues of several different kinds, all of which must have been standing on the Akropolis during the fourth century B.C. Although the list is very fragmentary and its purpose is no longer evident, it provides fascinating information about the appearance and condition of the statues; it even gives the names of a few of the people who dedicated them.[1]

The stelai are listed first, followed by the more numerous statues, in no apparent order: five children, six nudes, four males, four beardless males, three bearded males, a perirrhanterion, and three palladia. In the surviving lines of the inscription, there are specific references to attributes and to the damages the statues had sustained. Fifteen of the statues mentioned were holding something, and among their attributes were shields, a hare, a leather cap, a helmet, a dagger, a rooster and, perhaps, another bird, an oinochoe, and handles. Twice, a statue[?] base (*bathron*) is mentioned. There are also references to particular parts of bodies, including feet, a leg, a thigh, fingers, a head and, most often, hands and eyes. Where these are still directly linked to descriptions of the damages, the eyes have fallen out, the hands, fingers, or toes are lost, and the attributes are missing. Here and there, we read that the rest of a statue is in good condition (*hygieis*).

Why might an inventory have been made of these private dedications on the Akropolis? It has been suggested that this was an inventory of works destined to be melted down for reuse,[2] or, in modern terminology, "deaccessioned." But why would so much attention have been paid to describing the condition of statues that were destined simply for destruc-

[1] *IG* 2².1498–1501A. See Diane Harris, "Bronze Statues on the Athenian Acropolis: The Evidence of a Lycurgan Inventory," *AJA* 96 (1992): 637–52.

[2] Harris, "Bronze Statues," pp. 638–39.

tion? Why did it matter that parts of the statues were all right? And if destruction was the reason for the inventory, why were pedestals mentioned? Surely, statues being readied for the furnace would have been removed from their bases. Was not this list more likely to have been an inventory of which statues and stelai existed in the Sanctuary of Athena at a given time, with reference to the condition of each?

What might have been the usual lifetime of a statue? We might wonder whether bronze statues that were left to acquire a patina by exposure to the elements were also allowed to deteriorate, losing first patches and colored inlays, then fingers and toes. Did statues taken to Rome arrive in disrepair? Were they then repaired? Indeed, as we shall see, the bronzes discovered at Herculaneum in the eighteenth century are described and illustrated in the early catalogs as if they were intact, with no reference to their condition or to the measures undertaken to effect their restoration. Today, as a result, little is known about what is original and what has been restored on these bronzes.

Naples Head, Athens Head

In his book about Greek sculpture, Rhys Carpenter mentions on a single page two bronze female heads, which he groups with several other portraits, all of which exemplify for him "the third-century manner of tempered formalism." He dates the entire group of heads to "the central decades of the third century."[3] Carpenter makes no further connection between the two bronzes, although these are the only two works that he illustrates in the course of his argument (figs. 4.1, 4.2). At a glance it is clear that the two bronzes closely resemble each other. A more careful inspection, in fact, reveals that they are almost exactly alike—except that one is attached to a bust and has one blank eye and one eye filled with painted plaster, whereas the other is broken at the neck and has cast eyes. The former is in Naples, and it was found in 1756 in the Villa dei Papiri; the latter bronze, now in Athens, was a gift to the National Archaeological Museum in 1931. A survey of the histories of these two heads is an important preliminary to a careful technical examination of each.

The modern history of the sculptures from Herculaneum is rather well known, because the discovery and excavation of the ancient towns destroyed in A.D. 79 by the eruption of Mount Vesuvius immediately attracted a great deal of attention. In 1755, the year before the head now in Naples was excavated in Herculaneum, Ottavio Antonio Bayardi published the first volume of his *Catalogo degli antichi monumenti di Ercolano*. The book contains what might best be described as a checklist of hundreds of the objects discovered, including paintings, bronzes, marbles, and all sorts of decorative and utilitarian objects. The sizes of the objects are given, but a "statua" may be large or small, and bronzes and marbles of all types—deities, portraits, and genre figures—are listed together, with no indication of where they came from or when. Paintings are occasionally cited as being fragmentary, but other-

[3] Rhys Carpenter, *Greek Sculpture* (Chicago, 1960), p. 187, pls. 35, 43.

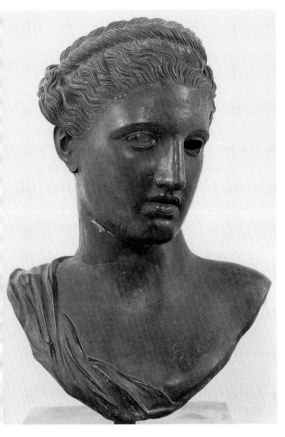

4.1. Lifesize bronze head of a woman, found in 1756 in the Villa dei Papiri at Herculaneum (destroyed A.D. 79). H as restored 0.50 m. Naples, Museo Nazionale inv. 5592. See also fig. 4.3. Courtesy of Soprintendenza Archeologica della Province di Napoli e Caserta.

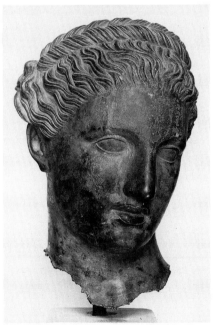

4.2. Lifesize bronze head of a woman, usually cited as being from Perinthos but actually a modern bronze from Izmir. H 0.355 m. Athens, National Archaeological Museum no. 15187. See also fig. 4.4. Courtesy of National Archaeological Museum, Athens.

wise there is no reference to the condition of the objects. Indeed, the newly discovered works were never illustrated before restoration, nor does there seem to be anything more than general reference to the nature of the restorations carried out. What was incomplete was simply made whole, because that was the way in which people were accustomed to see antiquities.

There was a well-established tradition of fully restoring fragmentary antique sculptures, whether they were bronze or marble. This practice did not necessarily involve keeping track of what was being repaired or what had to be added in order to complete the statues. The final public appearance of a restored antique statue depended more on what suited the contemporary ethos than on any interest in re-creating the original appearance of the statue. This practice had been flourishing since the sixteenth century. A good example of the extremes to which restoration might be taken is provided by Benvenuto Cellini, who restored an antique marble for Duke Cosimo I between 1548 and 1550. The statue of a standing youth, consisting of the body and legs, was sent to Cosimo from Palestrina. Cellini explains that he is not usually interested in restoration, but that he was so impressed with this statue that he offered to restore it as a Ganymede, adding not just a head, arms, and feet but also an eagle. A block of old Greek marble was ordered and sent from Rome, but Cellini decided not to use it after all, and eventually the finished statue was sent to Cosimo I.[4]

In the town of Portici near Herculaneum, the Palazzo Reale housed the Museo Ercolanese. Camillo Paderni, who became the curator in 1751, was in charge of the restoration of the ancient bronzes that were taken to the Museo Ercolanese. Included were the bronzes from the Villa dei Papiri.

According to records dating between 1750 and 1765, the actual restoration of bronzes was undertaken at the Real Fonderia di Portici, where the chief restorer was Tommaso Valenziani. Statues were pieced together and missing parts were replaced. Paderni's correspondence refers to both old and new metal being used in this process, the alloy for the latter including scrap metal from Naples. Other materials used in restoration included tin, plaster, and marble powder, and a new patina was also applied to the statues. When the repair of a statue was finished, Paderni reports that old and new pieces of metal were indistinguishable, and that only the line of solder that joined them was visible.[5] The early accounts differ over which parts of particular bronzes are restored, and today it is even more difficult to draw conclusions about what is original and what is restored from simply looking at the bronzes.

[4] Benvenuto Cellini, *Autobiography* 2.69–72. Cellini's statue of Ganymede is in the Museo Nazionale, Florence, H 1.05 m. See John Pope-Hennessy, *Cellini* (London, 1985), pp. 227–30, pls. 129, 130.

[5] These documents were published by Lucia A. Scatozza Höricht in "Restauri alle collezioni del Museo Ercolanese di Portici alla luce di documenti inediti," in *Atti dell'Accademia Pontaniana*, n.s., vol. 31 (Naples, 1982), pp. 495–540. For a highly readable account of the "restoration" of the statues from Herculaneum and Pompeii, see Charles Seltman, *Riot in Ephesus: Writings on the Heritage of Greece* (London, 1958), chap. 1: "A Mine of Statues," pp. 13–24.

In early-modern times, lost eyes have been replaced with bronze or filled with plaster colored green; these have usually been left blank, in order to look as though they had been cast solid.[6] Two large bronzes from the Villa dei Papiri whose eyes were restored in this way are the well-known seated Hermes and a bust topped with the archaizing head of Apollo (or a youth) with ringlets across the forehead. But a herm crowned with a beautifully executed head of the Doryphoros and prominently signed by the maker, Apollonios, son of Archios the Athenian, looks as if it retains the original bronze solid-cast eyes.[7] Normally, inset eyes that remain in place on the large bronzes from the Villa dei Papiri seem to have marble whites with iris and pupil of a darker stone.

When Johann Joachim Winckelmann visited Portici in 1762, only a few of the bronzes were on display, and he noted that people had just begun to make plaster casts of the sculptures.[8] In fact, the Real Fonderia made plasters of the statues and of the busts, and sent a shipment of them to Spain as early as 1765, accompanied by Paderni. These plaster casts were made, of course, after the bronzes had been restored. As for the actual restoration, Winckelmann wrote that the bronzes were subjected to fire, which removed the rust; then a new color was applied, which was quite different from the old patina, and, on a few heads, he thought it looked disagreeable.[9] Others have mentioned that the ancient bronzes were being melted down and the metal reused, or that the statues, some with the wrong heads, were being used to decorate houses and public buildings.[10]

In 1778, the antiquities of Herculaneum were transferred to the Palais d'Etudes in Naples, and in 1790 the bronzes were moved to the Real Museo Borbonico, which became a public institution, the Museo Nazionale, in 1860.[11] The finds from Herculaneum and Pompeii captured the public interest immediately, and sculptures and paintings alike made an important impact on the arts of the period.[12]

The bronzes from Pompeii and Herculaneum were copied extensively after 1860. Soon,

[6] For a description of this practice, see Götz Lahusen and Edilberto Formigli, "Der Augustus von Meroë und die Augen der römischen Bronzebildnisse," *AA* (1993): 666.

[7] Hermes: inv. 5625, H 1.15 m. (Wojcik D12, pp. 120–27). Apollo: inv. 5608, H 0.434 m. (Wojcik C1, pp. 87–89). Doryphoros: inv. 4885, H. 0.540 m. (Wojcik G1, pp. 171–73; I have not yet examined closely the eyes of this herm).

[8] Agnes Allroggen-Bedel and Helke Kammerer-Grothaus, "Il Museo Ercolanese di Portici," in *La Villa dei Papiri*, 2d suppl. to *Cronache Ercolanensi* 13 (Naples, 1983), pp. 83–128, with reference to Winckelmann letter no. 94 on p. 97n81.

[9] Letter no. 57, quoted in Otto Benndorf, "Über die Grossbronzen des Museo Nazionale in Neapel," *Jöal* 4 (1901): 171. Winckelmann's description of subjecting bronzes to fire for restoration and repair may refer to the use of flow welding to join the old and new pieces of a statue being repaired.

[10] I. C. McIlwaine, *Herculaneum: A Guide to Printed Sources* (Naples, 1988), 1:89.

[11] For a history of the museums and of the various transfers of antiquities, see Enrica Pozzi, "Il Museo Archeologico di Napoli, storia e problemi di una istituzione culturale," in *Le collezioni del Museo Nazionale di Napoli* (Rome, 1989), vol. 1, pt. 1, pp. 11–25. For the experiences of some of the early travelers, see Chantal Grell, *Herculaneum et Pompéi dans les récits des voyageurs français du xviii^e siècle* (Naples, 1982). For Winckelmann at Herculaneum and Portici, see Wolfgang Leppmann, *Winckelmann* (New York, 1970), pp. 167–85.

[12] For a summary, see Ferdinando Bologna, "The Rediscovery of Herculaneum and Pompeii in the Artistic Culture of Europe in the Eighteenth Century," in *Riscoprire Pompei* (Rome, 1993), pp. 102–15.

reproductions were available of literally all the bronzes, in their restored condition. In 1900, one illustrated catalog offered bronzes, including the head of Berenice, at full scale or in two smaller sizes in either of two patinas: Herculaneum or modern.[13] Some years later, another Neapolitan foundry offered Berenice in a broader range, all at full scale: either in marble or in bronze with one of four patinas. The modern patina was a polished brown; Herculaneum patina was dark green and less polished; Pompeii patina was an unpolished green and blue with copper oxide; and an artistic Corinthian version was also offered, evidently with variable color. Among the other works listed on the same page of the catalog were the Belvedere Apollo and a bust of Dante.[14]

In 1908, Charles Waldstein, who had by now finished excavating in Greece at the Argive Heraion, announced plans to undertake a large-scale excavation of Pompeii, under the oversight of an international committee. His report on how "the most generous subscribers" would be rewarded gives us a sense of just how well known the sculptures from Herculaneum were, of how popular were reproductions of them, and of the large numbers of these modern versions that entered into circulation during the early twentieth century. Waldstein's laudatory account of the condition of the bronzes leaves us wondering whether he had any idea how they had been cleaned and restored, and suggests that his only interest in the now-famous bronzes lay in the fact that copies might be available for him to use for his political endeavors:

> The chemical department has also done very successful work in dealing with bronzes. We are all rejoiced to hear that they can now secure immunity in the ancient bronze-*patina*, so that we need no longer hesitate, after due precautions have been taken, to make moulds from the most delicate bronzes. The exquisite bronze of the Seated Heracles, recently found in the Villa by the men of Section D, which caused such a thrill of excitement throughout the whole works—in fact, all over the world,—is now maintained by the competent authorities to be an early Greek reproduction of the famous Herakles Epitrapezios of Lysippus. We hear that the King of Italy has decided to have a number of facsimile reproductions made of this work, to be mounted on a pedestal bearing an inscription signed by the King, with the name of the person to whom it is to be presented

[13] *Catalogue illustré de Sab. de Angelis & fils* (Naples, 1900), p. 19.

[14] G. Sommer & Figlio, *Catalogue illustré: Bronzes–Marbres* (Naples, 1926), no. 8. I am grateful to Joan R. Mertens for bringing these catalogs to my attention. Chicago's Field Museum has a collection of approximately three hundred bronze reproductions of bronze vessels, furniture, utensils, and other utilitarian objects from Pompeii and Herculaneum, carefully inventoried in F. B. Tarbell, *Catalogue of Bronzes, etc., in Field Museum of Natural History, Reproduced from Originals in the National Museum of Naples*, Field Museum Anthropological Series, vol. 7, no. 3 (Chicago, 1909). These reproductions were made in the foundry of Sabbatino de Angelis (see n. 13 above). Like bronze reproductions of the sculptures, the objects in the Field Museum were restored and patinated. It is of some interest to read in the preface to Tarbell's *Catalogue* that it was "impossible in most cases to make out to what extent the originals have been repaired since their discovery, or to what extent objects have been combined without proof" (p. 93).

inscribed in each case. After consultation, the King has decided to give a certain number of these to each national committee to be presented to their most generous subscribers.[15]

The bronze female head that was excavated in the Villa dei Papiri on April 29, 1756, was identified as Berenice or Artemis (figs. 4.1, 4.3).[16] The woman turns her head to the left, inclining it slightly. Her face is serene, its features smooth and expressionless, the eyes demurely looking downward. She gives no sign as to whether she is a goddess or a mortal. The hair is perhaps the strongest feature. Strands of long straight hair were deeply cut into the wax working model: some strands are combed back from her forehead, others up from the nape of the neck; from the crown of her head, the strands radiate downward. The meeting of these two distinct areas is concealed by a thick braid that begins at the nape of the neck on the right, encircles the head tightly, and then narrows to a point that is tucked in at the right back. Winglike locks above each ear cross over the braid, then fold underneath it.

The head of the Berenice/Artemis was found at the eastern end of the large rectangular peristyle, along with seven more bronzes, five of which were seemingly in a line with this one, although they are of different scales and had no apparent program. In the row were a well-preserved lifesize bust of an archaizing Apollo/kouros, then the Berenice/Artemis, three deer, and a bust that has been identified variously as an athlete, as Ptolemy Philadelphus, or as a Herakles of the Lansdowne type. The other two bronzes found close by were a running pig and the arm of a statue.[17]

There are no illustrations of the Berenice dating from the time of its discovery, but the head was reported by the military engineer/archaeologist Karl Weber and his associate Giuseppe Corcoles, registered by the museum curator/conservator Camillo Paderni, and noted again by Francesco La Vega, also an engineer/archaeologist. All they say of the head's condition is that part of the nose had broken off, that there were various breaks in the neck, and that half of the head was broken.[18] Nothing is said about the fact that at least one of the eyes was missing. Indeed, both of the eyes and the bust were immediately restored.

In 1767, the head was published in the first volume of *De bronzi antichi d'Ercolano,*

[15] Charles Waldstein and Leonard Shoobridge, *Herculaneum: Past, Present, and Future* (London, 1908), p. 165.

[16] *Delle antichità di Ercolano*, vol. 5, *De' bronzi di Ercolano*, pt. 1 (Naples, 1757), pp. 213–14. For particulars about the excavations—procedures and ethics—see Nancy H. Ramage, "Gods, Graves, and Scholars: 18th-Century Archaeologists in Britain and Italy," *AJA* 96 (1992): 653–61. For this head, see Dimitrios Pandermalis, "Sul programma della decorazione scultorea," in *La Villa dei Papiri*, p. 44, no. 23, and Wojcik C2, pp. 89–90.

[17] Archaizing Apollo/kouros: Naples, Museo Nazionale, inv. 5608, H 0.43 m. (Wojcik C1, pp. 87–89). Deer: Naples inv. 4886 and 4888, H 0.98 m. and 0.96 m. (Wojcik D7 and D8, pp. 116–18); third deer not in Museo Nazionale. Male bust: Naples inv. 5594, H 0.48 m. (Wojcik C4, pp. 92–94). Running pig: Naples inv. 4893, H with base 0.40 m. (Wojcik D10, p. 119). Arm of statue: not in Museo Nazionale.

[18] Domenico Comparetti and Giulio de Petra, *La villa ercolanese dei Pisoni, i suoi monumenti e la sua biblioteca* (Turin, 1883), pp. 264–65, no. 24, pl. X.3, and pp. 183, 254.

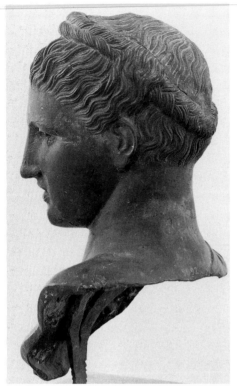

a

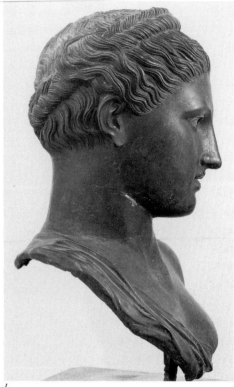

b

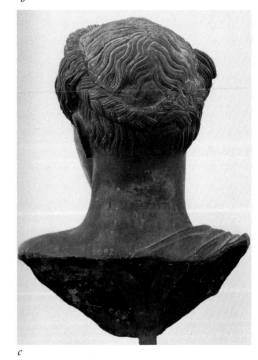

c

4.3. Lifesize bronze head of a woman, found in 1756 in the Villa de Papiri at Herculaneum (destroyed in A.D. 79). H as restored 0.50 m. Naples, Museo Nazionale inv. 5592. See also fig. 4.1. Courtesy of Soprintendenza Archeologica della Province di Napoli e Caserta.

identified as a portrait of Berenice.[19] The illustrations, drawn by G. Casanova and engraved by F. Campana, show the head on a diagonally draped bust, with no sign of any damaged areas nor any indication that anything is restored. The eyes are rendered as if in place, but with no definition of iris and pupil. In fact, all of the bronzes illustrated in this volume are represented as if they are intact. In a French catalog published in 1805, the eyes of the Berenice are again shown to be solid, by a shadow in the corner of one eye.[20] In the 1841 catalog of the Real Museo, the Berenice is illustrated between two male busts identified as Ptolemy Philadelphus (found beside her) and Ptolemy Philometer—she with solid but undetailed eyes, they with irises and pupils marked.[21] In fact, the two Ptolemys were found with their eyes, but only part of Berenice's right eye was salvageable, and that was filled in with plaster and painted dark brownish-green to match the bronze. The same group of busts is illustrated in *Chefs d'œuvre de l'art antique* (1867), but with the addition of tiny shadows to show the outward curve of each of Berenice's otherwise blank eyes.[22]

In the early 1900s, Erich Pernice reported that the bust on the Berenice was a modern addition, as was the portion of the head above the braid; in the original, noted Pernice, these pieces had been separately cast. Pernice argued, less convincingly, that the top of the head must be a modern restoration because it was so roughly marked, in contrast to the finely detailed hair around the face.[23] These points did not attract much attention, however, nor did they change the focus of the scholarship, which has always been on the identity of the head, as it has been with the other bronzes from Pompeii and Herculaneum. The restorations are not discussed. Instead, scholars have wondered whether she might be Berenice, and much consideration is given to the history of the various Ptolemys. She has also sometimes been called Artemis, an Amazon, or Sappho (Artemis because the bust was found beside the bust of an archaizing Apollo/kouros, although the latter is smaller in scale than the former).[24]

[19] *De bronzi antichi d'Ercolano* (Naples, 1767), pls. 63–64. For the notes written at the time of discovery by the engineers Francesco La Vega and Karl Weber, and by the work supervisor Giuseppe Corcoles, see Domenico Comparetti and Giulio de Petra, *La villa ercolanese* (Turin, 1883; rpt. Naples, 1972), pp. 183, 264, no. 24; also Wojcik C2, pp. 89–91. It was Camillo Paderni who wrote, concerning the head's condition, that "è alquanto patita, avendo parte del naso staccato e nel collo diverse rotture, e staccasi il mezzo della testa" (It is somewhat damaged, part of the nose broken, several breaks in the neck, and broken in the middle of the head) (quoted by Wojcik C2, p. 90). Various scholars have noted that the lips must have been plated; this would have been done with copper.

[20] *Antiquités d'Herculanum*, engravings by Th. Pirolli, text by S.-Ph. Chaudé (Paris: F. & P. Piranesi, 1805), vol. 4: *Bronzes*, pl. 37.

[21] *Real Museo di Napoli* (Naples, 1841), pl. 12 (drawn by Raphael Pacileo, engraved by Lasinio Fil).

[22] *Chefs d'œuvre de l'art antique*, 2d ser. (Paris, 1867), vol. 4, pl. 105.

[23] E. Pernice, "Untersuchungen zur antiken Toreutik," *JöaI* 11 (1908): 213 with n. 5. The idea about the top of the head being modern is picked up by P. de la Coste-Messelière, "Un exemplaire périnthien d'un bronze d'Herculanum," *BCH* 48 (1924): 281.

[24] Berenice: *Real Museo Borbonico* (Naples, 1831), 7:1–5, pl. 12. Also Berenice in such works as *Herculaneum et Pompei. Recueil général des peintures bronzes mosaïques* (Paris, 1840), 7:63, pl. 19; A. Ruesch, *Guida del Museo Nazionale di Napoli* (Naples, 1908), pp. 210–11, no. 849; and Bianca Maiuri, *Museo Nazionale di Napoli* (Novara, 1957), p. 68 and (1971 ed.), p. 65. Bernoulli disputed the idea that the head represented Berenice or that it could

The appearance of a second bronze female head very much like the one in Naples forced scholars to address a second question: namely, what it means to have two large bronzes that look alike. Their identity was still debated, but now technical issues had to be considered as well. Before we address them, we shall quickly survey the second head's history, which is of some interest.

The Athens head has usually been called the head from Perinthos, because for a long time it was believed that Anastasi Stamoulis bought the bronze in Perinthos during the early 1900s (figs. 4.2 and 4.4). Perinthos, today called Eregli, was a Greek city on the north shore of the Sea of Marmara, not far from Kalchedon, the home of Boëthos. Anastasi Stamoulis came from the nearby town of Silivri, ancient Selymbria, where he was a prosperous grain dealer. It is now known that the bronze head was purchased in 1922 in Izmir, not in Perinthos. Nine years later, in 1931, the Stamoulis family gave this bronze to the National Archaeological Museum.[25] In 1939, the head was taken to the United States for safekeeping—by whom I have not been able to determine, but Charles Picard reported that the head was still in the United States in 1948.[26] It was evidently returned to Athens sometime during the 1950s. The Athens head was published in 1960 by Rhys Carpenter,[27] in 1966 by Helga von Heintze, and in 1970 by Hans Jucker, who convinced more than one scholar that it was a modern forgery. Thereafter, the head was installed in a hallway flanked by museum offices. In 1987 the Athens head was included in a special exhibition (as "probably Sappho," with Perinthos named as the provenance), after which it was returned to the back hallway.[28]

The description given above of the Naples head also fits the Athens head—except that

be a portrait at all: J. J. Bernoulli, *Römische Ikonographie*, 1: *Die Bildnisse Berühmter Römer* (Stuttgart, 1882), p. 216n1. Rayet subsequently proposed that the Naples head was an Artemis or, less likely, an Amazon, rather than Berenice: Olivier Rayet, *Monuments de l'art antique* (Paris, 1884), 2:1–4 and plate. Also see La Coste-Messelière, "Un exemplaire périnthien," p. 276, and Wojcik, who would like her to have an accompanying Apollo (C1, p. 91). Sappho: Helga von Heintze, *Das Bildnis der Sappho* (Mainz, 1966), esp. pp. 26–27; Renata Cantilena et al. in *Le collezioni del Museo Nazionale di Napoli*, vol. 1, pt. 2, p. 128, no. 161.

[25] Stamoulis had been collecting local antiquities, from the region of Silivri and Eregli, since 1859. In 1912, his collection included Greek, Roman, and Byzantine sculpture, architectural fragments, inscriptions, votive and funerary monuments, and more. See Georges Seure, "Antiquités thraces de la Propontide: Collection Stamoulis," *BCH* 36 (1912): 534–41. In 1924, Stamoulis gave Greek, Roman, and Byzantine coins collected between 1875 and 1922 to the Athens Numismatic Museum. See G. P. Oikonomou and E. Baroucha-Christodoulopoulou, *Nomismatiki Syllogi Anastasiou P. Stamouli* (Athens, 1955), pp. v–vi. That the head was actually purchased in Izmir was reported to the National Archaeological Museum by a member of the Stamoulis family in 1975. I am grateful to Rosa Proskinitopoulou for this information, and to Olga Tsachou-Alexandri for giving me permission in 1993 to study the head. Olga Palagia informs me that more than one copy of a work has been purchased in Izmir as an "original."

[26] Charles Picard, *Manuel d'archéologie grecque: La sculpture*, vol. 3, pt. 2 (Paris, 1948), p. 797n1.

[27] Carpenter had been the director of the American School of Classical Studies at Athens from 1927 to 1932, and he must have known the Perinthos head well, for it came to the National Archaeological Museum during his tenure. See Louis E. Lord, *A History of the American School of Classical Studies at Athens, 1882–1942* (Cambridge, Mass., 1947), p. 358, and Lucy Shoe Merritt, *History of the American School of Classical Studies at Athens, 1939–1980* (Princeton, 1984).

[28] *A Voyage into Time and Legend Aboard the Kyrenia Ship*, ed. Olga Tsachou-Alexandri and Elsy Spathari (Athens, 1987), p. 95, no. 98.

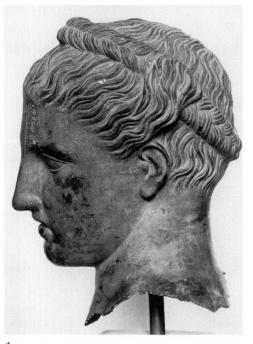

a

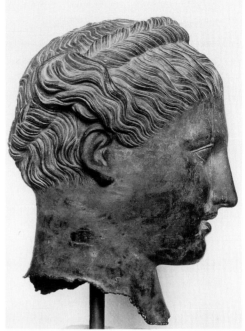

b

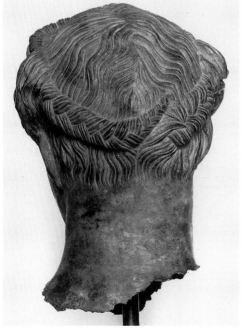

c

4.4. Lifesize modern bronze head of a woman, from Izmir. H 0.355 m. Athens, National Archaeological Museum no. 15187. See also fig. 4.2. Courtesy of National Archaeological Museum, Athens.

the latter had the eyes cast with the head, and there is no bust, only an irregular edge near the base of the neck. The obvious similarities between the two heads have caused some consternation. A brief review of the publications on both heads will give us a sense of how scholars have dealt with this problem. In 1924, Pierre de la Coste-Messelière noted that the profiles and the unusual hairstyle of the two are so similar that they must both be replicas of one original, but that there are enough differences between them that they cannot be two works from the same mold. Both heads, he concluded, were likely to have come from a single workshop, probably in Athens, where famous works were reproduced for export. He suggested that the better-finished Naples head went to Italy, to the connoisseurs' market; whereas the unfinished Athens head could still be sold, but in a less refined locale, Thrace.[29] Like La Coste-Messelière, Charles Picard did not like the earlier idea that these heads were replicas of the Artemis of Versailles, and he would state only that both were post-Hellenistic and certainly authentic.[30]

As we have seen, in 1960 Rhys Carpenter dated both heads to the middle of the third century B.C.[31] Six years later, Helga von Heintze held that the Athens and Naples heads were Roman adaptations of the same fourth-century B.C. original, which she suggested could have been the bronze Artemis from the Piraeus.[32] There are some general similarities, but neither hair nor profile fits with the Artemis.

In 1970, Hans Jucker argued powerfully that the Athens head was a modern copy of the Naples head. He contended that the eyes were cast and should not have been, that the conches of the ears were too shallow, and that flaws on the Naples head had been picked up in the copy. The close similarities between the two, he asserted, must have been the result of the one being mechanically copied from the other.[33] Because Jucker wrote at a time when scholars had not yet fully reevaluated Kurt Kluge's belief that sand casting had been practiced in antiquity, and thus still followed Kluge, I decided to investigate the two heads. I hoped that they might both prove to be Classical after all and, like the two Dionysos herms discussed below in chapter 5, might actually be two works from the same series.[34] After all, we have some examples of early statues with cast eyes—such as an Archaic head in Boston and, I thought, the Piraeus Apollo—as well as molds for another such statue, dating to the middle of the sixth century B.C.[35]

As for the Naples head, the bronze bust is in fact, as Pernice said, a modern restoration. A

[29] La Coste-Messelière, "Un exemplaire périnthien," pp. 276–86. The differences he notes between the two heads are as follows: the Naples head is more angular, and the crown of the head was separately cast; the "Perinthos" head has solid-cast eyes, was cast in one piece, and appeared to him to be an unfinished sand casting.

[30] Charles Picard, *La sculpture antique de Phidias a l'ère byzantine* (Paris, 1926), p. 100n2.

[31] Carpenter, *Greek Sculpture*, p. 187.

[32] Heintze, *Das Bildnis*, pp. 26–27.

[33] Hans Jucker, "Die 'Berenike' aus Perinth," *AA* 85 (1970): 487–92.

[34] For an outline of the development of the scholarship on ancient casting techniques, see Mattusch, *GBS*, pp. 22–30.

[35] See Mattusch, *GBS*, for the Archaic head in Boston (pp. 60–63 with fig. 4.12: Boston, Museum of Fine Arts no. 95.74); for the Peiraeus Apollo (pp. 74–79: Peiraeus Museum); and for the molds for a kouros (pp. 54–60 with figs. 4.4–4.10: Athens, Agora Museum nos. S 741, S 797).

broken portion of the right cheek and large broken areas of the neck were repaired, and the entire bust was added. The restorations were attached by round pins, which were not used during antiquity (see below), and by hard solder. A diagonal border of chiton along the right side of the bust looks suspiciously like the chiton on the right shoulder of the Artemis of Versailles (see fig. 7.6). Moreover, the nose of the Naples head, its profile entirely restored—from the bridge down to the flare of the nostrils—bears a striking resemblance to the nose of the Artemis from Versailles. We might even wonder whether the restorations of the Naples head could have been based on the Artemis of Versailles. Many copies of that well-known statue, as restored, were in existence by the 1750s. The restorations of the Naples head may even have led some scholars to identify it as Artemis and to compare it with the Artemis from Versailles.[36] How easily scholarship can be thrown off course by modern restorations—either by those that are carefully concealed, as they are here, or by those that are not clearly identified—is not hard to see. Taken as a group, the seven large bronzes found with the Naples head in the Villa dei Papiri do not definitively support an identification as Artemis or, for that matter, anyone else in particular. The smaller bust of the archaizing Apollo/kouros was indeed next in line to the female head, but the others in the row were three deer and a bust of a curly-haired youth, perhaps a portrait. The running pig and the arm from another statue are even more enigmatic. It is hard to discern any carefully designed program in this group.[37]

The portion of the Naples head above the braid was separately cast and soldered into place, as was fairly common practice in antiquity. The hair on the crown was less carefully marked, and with a broader blade, than that below the braid. This is not surprising, for I have noticed that the hair on a separately cast crown often did not match the hair on the rest of the head. We need only recall the Olympia Boxer (fig. 3.5), whose victor's wreath marks the two separately cast sections of the head. No attempt was made to match the hair on the crown with that below the wreath. The seated boxer in the Terme Museum was constructed in a similar way (fig. 1.9, plate 3), with a separately cast crown, but this statue wears no victor's wreath to mark and conceal the division of the head, and the crown is a small irregular oval, covered with sloppy curls and in no way integrated with the locks of hair. The reason for casting the crown separately was surely to make it easy to clean the core material out of the head afterward.[38]

[36] Identifications of the Naples head as Artemis: Salomon Reinach, *Recueil de têtes antiques, idéales ou idéalisées* (Paris, 1903), pp. 177–78; Rayet, *Monuments de l'art antique*, vol. 2, pl. 8.

[37] Nonetheless, the possibility of there having been an overall sculptural program in the Villa dei Papiri has been extensively discussed, particularly with respect to whether the nature of such a program might have been public or private, didactic or aesthetic. See Dimitrios Pandermalis, "Zum Programm der Statuenausstattung in der Villa dei Papiri," *AM* 86 (1971): 173–209; idem, "Sul Programma della decorazione scultorea," pp. 19–50; Richard Neudecker, *Die Skulpturen-Ausstattung römischer Villen in Italien* (Mainz, 1988), pp. 105–14; and P. Gregory Warden and David Gilman Romano, "The Course of Glory: Greek Art in a Roman Context at the Villa of the Papyri at Herculaneum," *Art History* 17 (1994): 228–54.

[38] It has been suggested more than once that the crown was cast separately so as to allow for the insertion of eyes from within. The eyes, however, were inserted from outside, encased in the angle of the copper lash plates. The edges of the lash plate were then turned up to secure the eye, their curled and clipped edges serving as eyelashes.

During restoration, the crown of the Naples head was carelessly reattached, no attempt being made to conceal the large dollops of hard solder along the upper side of the braid. The hairdo is mystifying, for its closest parallels occur on two bronze statues that would seem to be totally unrelated, either to each other or to the Artemis. The long-haired, larger-than-lifesize Artemision god, although he has a thick double row of bangs curling loosely down onto his forehead, has the rest of his hair pulled up from the nape of his neck, combed straight down from the crown of his head, and encircled tightly by a long braid (fig. 1.7). This statue is usually dated to approximately 460 B.C. The same sort of long braid circles the head on a lifesize statue of a boy in the Walters Art Gallery, but the hair above the forehead is parted in the middle and makes flat waves around the face, somewhat like a modified melon hairdo (fig. 4.5).[39] Neither of these latter two bronzes has additional wings of hair above the ears and overlapping the braid. Why are there no other parallels? Was this simply someone's creative idea of how to design a demure Classical hairdo?

Scholars have been concerned not only about the identity of the Naples head but about the date of the "original" from which it was copied. In general, the range of opinions is not so great as it is with the sleeping Eros or the running Hypnos discussed in chapter 5. The various dates for the Naples head cluster within a period from the later fourth century to the middle of the third century, and some scholars do not clarify whether they think it is *this* head which was made at the preferred date or the original of which this head is a copy.[40] But can we be sure that there *was* an "original"? The biggest problem here has always been that there are two heads, not one, and that they look too much alike. This confusing factor has led to some particularly complicated interpretations, such as that one head might be an ancient copy of an ancient original, the other an ancient copy of *that* copy.[41]

The Athens head, it turns out, is indeed modern, just as Hans Jucker thought, and there is no question that this is the case. My path to that conclusion, however, was significantly different from the one traveled by Jucker, and it revealed additional conclusive points about both heads. Most important, my direct examination of both of the heads has revealed what is actually ancient and what is restored on the Naples head; and, as we shall see, it has also clarified what was invented to make the Athens head *look* ancient.

The Athens head was cast in one piece, and it is a thin and even casting, ranging between 0.002 and 0.003 meter in thickness. Both of these features are perfectly normal for Classical bronzes: the latter feature shows only that a bronze is a close reproduction of the original

[39] See Dorothy Kent Hill, *Catalogue of Classical Bronze Sculpture in the Walters Art Gallery* (Baltimore, 1949), p. 3, no. 1, pl. 1. The Esquiline charioteer is one of a few parallels in marble, again without the wings above the ears. See Eugenio La Rocca, *L'Auriga dell'Esquilino* (Rome, 1987), with a few other examples in marble and terra-cotta.

[40] Thus Lippold dates the Berenice to the last third of the fourth century B.C., along with the Artemis of Versailles and various other works. The page on which he does so has the heading "Frauen–Tiere" (Women–Animals), and the "Berenice" comes last among the former, directly before lions. See Georg Lippold, *Die Griechisches Plastik. Handbuch der Archäologie*, vol. 5, pt. 1 (Munich, 1950), p. 291 with n. 10.

[41] Vassileos Kallipolitis called the Athens head an ancient copy of the Naples head: "Chronikon: Ethnikon Archaiologikon Mouseion," *Deltion* 25 (1970): 5.

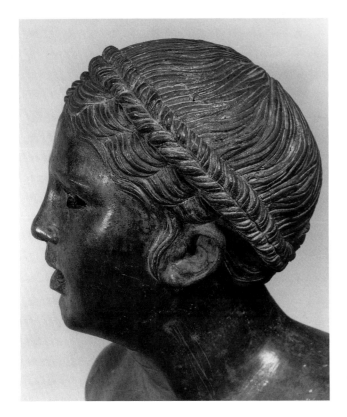

4.5. Detail of head of a life-size bronze child, missing arms and left foot and said to be from southern Italy. Max. pres. H of statue 1.14 m. Baltimore, Walters Art Gallery inv. 23.71. Courtesy of The Walters Art Gallery, Baltimore.

model. The Athens head, however, has several unusual physical features. Where I compared the measurements of the two heads, those of the Athens head are invariably about one millimeter smaller than those of the Naples head. This is to be expected when one bronze has been cast after another, and it is a sure sign that the Athens head was made from molds taken off the Naples head. Furthermore, the lower lip has a line marked around it, as if it is inset. But it is not: the metal of the lip is the same as that of the face. The inlay for the upper lip, though, appears to have been lost, for this lip is depressed. These facts suggest that when molds were taken to make the Athens head, the Naples head had lost its inset upper lip, but the lower one was still in place.[42] Also, what looks like an irregular vertical flaw or seam running down the right side of the Athens nose is a reproduction of the line where the modern nose was attached to the Naples head.

The Naples head has an open mouth; the Athens head has a small hole inside the left side of the mouth, clearly unintentional, where the casting has broken through. The ears on both heads are flat and shallow, with thick rims, which are barely undercut on the Naples head and not at all undercut on the Athens head.[43] The strands of hair on the Athens head

[42] The Naples head has now lost both of its inset lips; only the raised edge remains, as an outline around the lips.

[43] Hans Jucker noted this feature in "Die 'Berenike' aus Perinth," p. 491.

were cleanly marked with a burin; but, like the ears, the eyelids are shallow and not precisely marked. The one-piece casting in Athens had a neat incised line drawn around the braid in the wax working model: this line removed the evidence of the modern solder that was used to reattach the crown of the Naples head in the eighteenth century.

Some of the corrosion on the Athens head is brown and some is green, those colors alternating with no changes in depth, no apparent reason for the variation. Sometimes the green is on top of the brown, sometimes vice versa. There is no flaking, not even on the face, where the surface is much rougher than elsewhere on the head and the hair. Instead, all of the "corrosion" is firmly attached. In places, the green overlaps a "broken" edge: so the corrosion was painted on. Is this the "imitation Pompeii" patina?[44] Inside, there is absolutely no accretion. Rather, there are shiny metal projections inside each cheek. In fact, uncorroded bronze is very close to the "corroded" surface, and the shiny metal shows through in numerous places.

Under a magnifying glass, what looks like a broken edge around the neck of the Athens head is easily recognizable as a smooth cast edge, but made along an uneven line that looks broken. This line is an invention: it does not correspond to any of the breaks on the head in Naples. So far as I know, all of the other reproductions of the Pompeii and Herculaneum bronzes, like those of the Belvedere Apollo (see chapter 5), were made after the sculptures had been restored. Foundries, moreover, normally identify their workmanship: the Chiurazzi foundry in Naples affixes its own mark to each wax working model before casting. It thus becomes clear that the founder of the Athens head intended to deceive the buyer.

In 1994, moreover, the alloy of the Athens head was tested. The results show without a doubt that the bronze is modern, for the alloy contains significant quantities of zinc, a metal that was not used in large amounts in Classical antiquity.[45]

The Fonderia Chiurazzi in Naples has been in existence since 1860, the year in which the Real Museo Borbonico became a public institution.[46] It was at this time that the market for copies of bronzes from Pompeii and Herculaneum opened up and that ancient bronzes could be copied extensively. The Fonderia Chiurazzi was one of the places to which a collector could go to purchase these copies. In the 1920s, this foundry was evidently joined by the Sabbatino de Angelis foundry, which had also specialized in casting reproductions of

[44] In 1994, an American chain of stores called the Pottery Barn had patina kits for sale. The illustration on the box showed the marble Nike from Samothrace (Paris, Louvre MA 2369) with a metallic green patina.

[45] Atomic absorption analysis revealed that the primary components of the alloy are 60% copper, 35.10% zinc, 2.04% lead, and 1.04% antimony. There are only traces of tin, iron, nickel, silver, arsenic, and bismuth. I am very grateful to George Varoufakis for agreeing to do this analysis and for sharing the results with me, as well as to Olga Tsachou-Alexandri, director of the National Archaeological Museum in Athens, for permission to sample the head, and to Eleni Mangou, chemist in the National Archaeological Museum, who worked with Varoufakis on the analysis.

[46] I am grateful to John Herrmann for telling me about the Chiurazzi foundry. My heartfelt thanks also go to E. Chiurazzi and his staff for showing the foundry to the participants in the 1994 NEH Summer Seminar, in which I was fortunate to take part, and for answering many questions about production methods. I thank in particular John Moore, who generously posed many questions in my behalf.

the bronzes from Pompeii and Herculaneum. According to the proprietor, Mr. E. Chiurazzi, the most recent Chiurazzi catalog was published in 1929. Before World War II, the Fonderia Chiurazzi had a staff of six hundred, and the workshop produced bronzes, marbles, and ceramics. During the 1970s, the foundry cast reproductions of the bronzes from the Villa dei Papiri for the courtyards of a modern version of that villa: the J. Paul Getty Museum in Malibu, California. Such commissions are, however, infrequent, and by 1994 the staff of the Fonderia Chiurazzi had shrunk to ten (most of whom, if not all, were family members) and only bronzes were being produced.

The materials and processes used in the Chiurazzi foundry seem not to have changed much over the past hundred and thirty years. One room contains shelves filled with plaster master molds, most of which had been taken from ancient statues. Now, however, the foundry is no longer allowed to cast copies of the ancient bronzes in the Archaeological Museum of Naples, and many of these molds can no longer be used. Shelved and standing throughout the foundry are plaster casts of ancient statues, full size or reduced. Among the unfinished bronzes are full-size heads of the two dark-gray marble centaurs from Hadrian's villa at Tivoli, one bearded and the other beardless, as well as the head of the bronze youth or kouros from the Via dell'Abbondanza in Pompeii.[47] There are also plaster casts of ancient and modern portrait heads, as well as other works (some of them unfamiliar), a colossal relief plaque ordered for a bank but never claimed, and a couple of lifesize honorary statues.

In the summer of 1994, a red-wax working model was being made from a full-size plaster cast of the Venus de Milo, and a larger-than-lifesize dancing satyr with cymbals, already cast, had been pieced together across the upper thighs and was in the process of being hard-soldered. The latter was a full-size reproduction of a well-known antique marble statue in Rome, the Borghese Satyr, incorporating the extensive early-nineteenth-century restorations by the Danish sculptor Bertel Thorvaldsen.[48] In addition, two small-scale bronzes were being finished: a reclining Cleopatra/Ariadne (fig. 4.6) and a disrobing Aphrodite.[49] The dark-gray matte casting skins of these two small pieces had been partially removed, revealing in places the bright ruddy color of the base metal. The metal gates had been cut off, but raised irregular seams, where the bronze had entered cracks in the plaster investment molds, had yet to be removed. Small round holes through the bronze, no more than

[47] For the centaurs, which are now in the Capitoline Museum in Rome, see Haskell/Penny 178, no. 20 (the Furietti Centaurs), where the color of the stone is identified as "bigio morato."

[48] Rome, Villa Borghese, inv. 802. H 2.06 m. Nineteenth-century repairs: arms, hands, and evidently a good portion of the legs. It is generally agreed that the satyr originally held flutes, not cymbals. I am grateful to Nancy Ramage for discussing with me the restorations on this statue. See Wolfgang Helbig, *Führer durch die öffentlichen Sammlungen klassischer Altertümer in Rom* (Tübingen, 1966), 2:744–45, no. 1995; Bieber, *Hellenistic*, p. 39; Robertson, *HGA*, pp. 478, 705n81, and fig. 149c.

[49] For the Cleopatra/Ariadne (Vatican, Galleria delle Statue), see Haskell/Penny 184–87, no. 24. Another small-scale bronze version of this statue is on the hearth in the front hall of Thomas Jefferson's house, Monticello, in Virginia.

4.6. Small-scale modern bronze Ariadne/Cleopatra. L ca. 0.6 m. Naples, Fonderia Chiurazzi. Photo by C. C. Mattusch.

two millimeters in diameter, had been left by the chaplets. Such holes and other small cracks and imperfections in the bronze were being repaired as follows: each hole was drilled out with a threaded bit; a section of one of the metal gates was cut with a matching screw thread; then the resulting screwlike plug was turned neatly into the hole. The protruding portion of the plug was cut off, and the surface was cleaned and polished to conceal any sign of repair. Larger flaws, requiring additional metal, are repaired by flow welding onto the damaged area. The patina is applied last, concealing all traces of either the casting or the subsequent repairs that have not been eliminated by the coldwork. Different parts of a single bronze may be given different patinas.

Small round repairs like these were not made during antiquity: chaplets were square in section and, so far as I know, ancient patches were rectangular or, occasionally, polygonal. Furthermore, the piecing of statues today is more arbitrary than was the case in antiquity.

In the Chiurazzi foundry, the dancing satyr was divided across both legs at mid-thigh, whereas an ancient bronze would either have had torso and legs cast in one piece, like the Riace Bronzes, or it would have been divided at points that were easy to conceal. For example, the standing ruler and the seated boxer in the Terme Museum both have the left leg separately cast; on both statues, the leg joins the body along the top of the leg and between the buttocks (figs. 1.9, 3.2).[50] As for the alloy, according to a Chiurazzi employee, the foundry purchases ingots of copper–tin bronze, then adds scrap metal during the melt.[51]

The Chiurazzi ovens for baking the plaster molds and melting the wax gate systems and working models are constructed of cement blocks, but these are not bonded together. One has the impression that the ovens could be dismantled and rebuilt in different configurations, although this has obviously not been done for some time. A permanently installed track-and-pulley system is used to lift molds from the baking oven into the area of the sand pit, where they are lowered and packed for the pour. After casting, the molds are left to cool for approximately twenty-four hours before being disinterred and broken away to reveal the bronze beneath, ready for coldwork to begin with the cutting off of the bronze gate system.

A lifesize casting of the marble Laokoon group has just been completed in the Fonderia Chiurazzi, having been in progress for seven or eight years, though not continuously (fig. 4.7). The project is one that the staff undertook for themselves; it was not a commission. Their Laokoon group is the full size of the marble group in the Vatican before the outstretched right arm was replaced with the bent (ancient) arm. Thus the bronze is approximately 2.4 meters in height; it weighs fourteen hundred kilograms. The figure of Laokoon was cast in two pieces, divided through the chest; the son to his left was cast separately, and presumably the one to his right was also cast separately. The master molds used for this cast were relatively old ones, for they reproduce the right arm of the Laokoon extended, as it had been restored until the bent arm was found in 1906.[52]

When asked about the dark-brown patina of the Laokoon group, Mr. Chiurazzi replied that since the original was marble, he could make the bronze whatever color he wished. The patina was, in fact, a matter of great pride, for a patina like this one is thought of as a special family recipe. In contrast, the full-size black-bronze replica of the Borghese Satyr, as completed by Thorvaldsen, was described by one of the employees as having simply a "Herculaneum patina," a standard color.

The Laokoon group is the foundry's showpiece, and it bears the name of Chiurazzi prominently written on the left corner of the top step of the altar supporting Laokoon,

[50] See Maria Rita Sanzi di Mino and Anna Maria Carruba, "Nachträge zu Thermen-Herrscher und Faust-kämpfer," in N. Himmelmann, *Herrscher und Athlet: Die Bronzen vom Quirinal* (Milan, 1989), pp. 176–77 (boxer: Cu 80%, Sn 10%, Pb 10%) and 182–83 (ruler: Cu 89%, Sn 8%, Pb 3%).

[51] This is not so different from the recipe described by Pliny: *NH* 34.98.

[52] See Haskell/Penny 243–47 and fig. 125.

4.7. Lifesize modern bronze Laokoon. H ca. 1.84 m. Naples, Fonderia Chiurazzi. See also fig. 4.8. Photo by C. C. Mattusch.

4.8. Detail of the Chiurazzi signature on the modern bronze Laokoon (see fig. 4.7). Photo by C. C. Mattusch.

where it was cut with a broad-bladed tool in the wax working model (fig. 4.8). In fact, all bronzes produced by the Chiurazzi foundry are clearly identified, but this is usually done by a less easily noticeable procedure. Each wax working model is marked with the foundry's circular stamp: the reason for doing this, I was told, is to show that the bronze is a Chiurazzi casting. Every bronze that reproduces an antiquity is cast from the work as it was restored, with no indication of breaks, nor of the repairs that are visible on the "originals." And, unlike the "Perinthos" head in Athens, none of these works is cast with "broken" edges.

A Female Head and a Male Leg from the Athenian Agora

Pliny reports that in the past, people coated bronze statues with bitumen. In view of this, he finds it surprising that later on it was fashionable to plate statues with gold, a practice that he surmises might have been invented in Rome.[53]

A gilded bronze head of a female figure was discovered in 1932, during the first season of excavations in the Athenian Agora (figs. 1.19, 4.9).[54] The head had belonged to a figure of no more than half lifesize, and its style was generally agreed to be that of the last quarter of the fifth century B.C. The woman seems to have worn a topknot, or a *lampadion*, and she was restored thus in a watercolor by Piet de Jong.[55] There are many parallels for this hairstyle: we find it on the women represented by the Meidias Painter in the last quarter of the fifth century as well as on countless women and Erotes of later South Italian painters, particularly those of Paestum and Campania, who worked during the latter half of the fourth century B.C. (fig. 4.10).[56] The same topknot continued to be fashionable in Athens; thus, such a hairstyle is worn by one of the Seasons (*Horai*) on a relief carved for the Theater of Dionysos in the first century B.C.

The bronze head from the Agora was once covered with gold foil, and it has almost always been identified as that of one of the golden Nikai of Athens that are known from the literary testimonia.[57] Dorothy Thompson, however, has argued convincingly that the statue would have been too small to hold the two talents of gold (part of the Athenian gold reserve) assigned to each Nike, particularly when one considers that the head was covered only with thin gold foil.[58] Indeed, the inscriptions that inventory these statues of Nikai

[53] *NH* 34.15.

[54] See T. Leslie Shear, "The Campaign of 1932," *Hesperia* 2 (1933): 519–27. Shear reports that the head was "wrapped in zinc plate and placed in a dilute solution (about 2%) of sodium hydroxide. It was left in this bath, which was frequently renewed, for nearly two months, when the corrosion had been entirely removed and the original bronze surface was revealed" (p. 520). This treatment accounts for the pocked surface of the bronze. For description, technical remarks, and bibliography, see Mattusch, *GBS*, pp. 172–74.

[55] Shear, "The Campaign," p. 524, fig. 9.

[56] See, for instance, vases by the Danaid Painter, as illustrated by A. D. Trendall, *Red Figure Vases of South Italy and Sicily* (London, 1989), pp. 166–67, fig. 309.

[57] See Arthur M. Woodward, "The Golden Nikai of Athena," *ArchEph* (1937): 159–70.

[58] Dorothy Burr Thompson, "The Golden Nikai Reconsidered," *Hesperia* 13 (1944): 178–81. She estimates that a Nike like this one could have held no more than one-hundredth of that amount. Even Homer A. Thompson admitted that "our statue seems small in comparison with the Nikai which are known from the marble inscriptions containing the treasure records of Athena, yet its history runs strikingly parallel" ("A Golden Victory," in *A Portfolio Honoring Harold Hugo* [Meriden, Conn., 1978], n.p.).

4.9. Half-lifesize bronze female head from the Athenian Agora, excavated in 1932. H 0.20 m. Athenian Agora B 30. See also fig. 1.19. Courtesy of American School of Classical Studies at Athens: Agora Excavations.

refer to them always as *chrysios, chryse,* or *chryson,* all of which mean "golden," as distinct from *katachrysos* or *epichrysos,* which mean "gilded." [59]

Quite a few gilded statues survive from the Roman imperial period, but even then they were a mark of special distinction. We must assume that the Agora head belonged to a

[59] For the golden Nikai and literary evidence for the dates when they were melted in order to mint coins, see William S. Ferguson, *Treasures of Athena* (Cambridge, Mass., 1932).

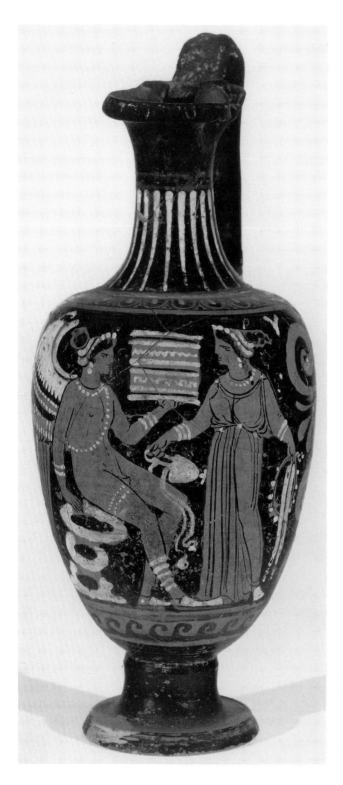

4.10. Apulian red-figure oinochoe, last third of the fourth century B.C., showing a woman and Eros with top-knots. Toronto, Royal Ontario Museum 923.13.53. Photo courtesy of the Royal Ontario Museum, Toronto, Canada.

statue of some importance. That significance becomes even more apparent when we consider that to gild a statue with gold foil, as in this case, required much more gold, not to mention effort, than the gold leaf that was usually applied to statues during the Roman period.

Nearly complete, the Agora head is a relatively thin and regular indirect casting; the neck would have been slotted into the triangular neckline of a chiton. The alloy is a tin bronze, containing 91 percent copper, 8.4 percent tin, and only traces of other metals.[60] The letter Ξ, incised on the left rear of the neck in the wax working model, was probably a reference point used during production.[61]

The Agora head is today disfigured by the deep grooves within which gold wires once served to lock the sheets of gold foil in place. These grooves were cut around the hairline and up either side of the neck, and it is here that traces of gold (and silver) can be found. The detailing of the strands of hair is much coarser and more cursory than one would expect for a bronze, where fine tools are often used. Here, however, only a thick blade was used to mark the hair, no doubt because that would make it easier to fit the gold foil into the creases. Both the hair and the grooves were cut this way, rather clumsily, into the wax working model, because the intention was to conceal everything beneath gold foil. To the viewer, the rich gleam of the gold would have been the point of this small statue, and that is why less attention than usual was given to the underlying bronze.[62]

Gilding with gold foil, the earliest method of gilding, was replaced by gilding with gold leaf, which is much thinner and which is attached with an adhesive or by burnishing onto a hot metal surface. Then, in the third century A.D., fire gilding was introduced, with mercury being used as the adhesive, and this required a base metal that was very low in tin.[63] Foil gilding, it seems, was used on few occasions. Lysippos once made a bronze of Alexander as a boy, and Nero was so charmed (*delectatus*) by this statue that he had it gilded. Pliny reports that this so diminished its beauty that Nero had the gold removed, and after that the statue was thought to be even more valuable, even with the grooves that had been gouged in it to receive the gold.[64] The gilding of the Agora head, however, was intended from the first, and thus the bronze without gold looks unfinished and somewhat

[60] Sampled by George Varoufakis; tested in 1977 by Paul T. Craddock at the British Museum, using atomic absorption spectrometry. I am grateful to Jan Jordan for sending me this information. See also W. A. Oddy, L. B. Vlad, and N. D. Meeks, "The Gilding of Bronze Statues in the Greek and Roman World," in *The Horses of San Marco* (London, 1979), pp. 182–87. The thickness of the head and neck ranges from ca. 0.001 to 0.004 m.

[61] It was surely not the initial of the artist, as Shear suggested: "The Campaign," p. 526.

[62] Evelyn B. Harrison has suggested that the Agora head, although cast in the fifth century B.C., was not gilded until around 310 B.C. She agrees with Homer Thompson that the head was probably stripped by Lachares at the beginning of the third century B.C., regilded later that century, and stripped again for good at the end of the century: Harrison, "Alkamenes' Sculptures for the Hephaisteion: Part III, Iconography and Style," *AJA* 81 (1977): 424. Olga Palagia kindly referred me to this argument.

[63] For the various forms of gilding, and for references, see W. A. Oddy, "Gilding: An Outline of the Technological History of the Plating of Gold on to Silver or Copper in the Old World," *Endeavour*, n.s. 15.1 (1991): 29–33.

[64] *NH* 34.63.

rough. Her generalized appearance could also mean that she was not intended to be seen up close, and Brunilde Ridgway's suspicion that she might have been an akroterion is a good one; high overhead, detailing would have been immaterial.[65]

The Agora head could have been made in the latter part of the fifth century B.C., or it could have been made much later than that, to judge from the long life of the hairstyle and from the generalized rendering of the features, which might best be called *retardataire*. We cannot be sure what happened to the body, but the head was stripped of its gold foil and thrown into a well to the west of the Royal Stoa in about 200 B.C., perhaps slightly earlier. All of the material in the well was evidently dumped there at the same time.[66] This was a period of upheaval, with Athens allied with Pergamon, Rhodes, and Rome against Philip V of Macedon, who was intent on seizing Athens.

Only one other surviving gilded bronze can be dated with confidence to the Greek period, and it is gilded in the same way as the Agora head, with foil that was fixed in grooves by gold wire. The second gilded bronze also comes from the Athenian Agora. It is part of a lifesize rider, who is represented primarily by the left leg with its tunic, but also by a sword (fig. 4.11).[67]

The bronze leg appears to be a complete casting, and one of high quality, for there are no visible patches.[68] Grooves for the attachment of gold foil were cut into the wax model around the sole, across the instep, around the ankle, and up the shin and the calf. The leg drops loosely, as is to be expected of an equestrian sitting without stirrups on a standing or walking horse. We can imagine the horse with one forefoot enthusiastically raised, one ear pricked forward, the other backward, in the manner of many Classical bronze horses that have survived. The rider is shod with a *krepis*, laced to just above the ankle.[69] The gilded sword is enigmatic, for it is of a type that was common from the fifth century B.C. onward.[70]

[65] Brunilde S. Ridgway, *Fifth Century Styles in Greek Sculpture* (Princeton, 1981), p. 124.

[66] Agora Deposit H6:4. I am grateful to Susan Rotroff for sending me her thoughts on the date.

[67] From Agora Deposit J5:1. See T. Leslie Shear Jr., "The Athenian Agora: Excavations of 1971," *Hesperia* 42 (1973): 165–68. Sword: B 1382. Drapery fragments: B 1383 and B 1385. I am grateful to John Camp for permission to examine the leg, and to Caroline Houser for discussing the leg with me. Houser is preparing a full publication of the statue to which the leg, the sword, and a few other fragments belonged.

[68] Its alloy contains 61–71.5% copper, 23.5–35% lead, only 3.1–3.8% tin, and traces of silver, iron, antimony, nickel, cobalt, arsenic, and bismuth. George Varoufakis took four samples; these were analyzed by Paul Craddock at the British Museum, using atomic absorption spectrometry. I am grateful to Jan Jordan for sending me the data. The weight of the leg is 16.5 kg., and for that information I am grateful to Caroline Houser.

[69] Kathleen D. Morrow cites other examples of this type of shoe which are dated throughout the third century B.C.: *Footwear*, pp. 95–108. For this and other riders' shoes, see Giuliana Calcani, *Cavalieri di bronzo: La Torma di Alessandro, opera di Lisippo* (Rome, 1989), pp. 82–84, figs. 43, 45. See also chap. 3, n. 54, above.

[70] For the sword, see Houser, 1987, pp. 259–61, and Houser, "The Appearance of a Hellenistic Type of Sword," in *Abstracts*, 94th Annual Meeting, Archaeological Institute of America, vol. 16 (1992), p. 24. For parallels in tomb painting around 200 B.C., with references, see Stella G. Miller, *The Tomb of Lyson and Kallikles: A Painted Macedonian Tomb* (Mainz, 1993), pp. 54–55, pl. 3. Olga Palagia pointed out to me that two similar bronze swords were worn by statues of Aitolians at Dodona, and that these are securely dated by the inscriptions to the third century B.C. See Ioulias P. Vokotopoulou, *Odigos Mouseiou Ioanninon* (Athens, 1973), pp. 70–71, pls. 27 and 28; Sotirios Dakaris, *Dodoni* (Athens, 1993), pp. 21–22.

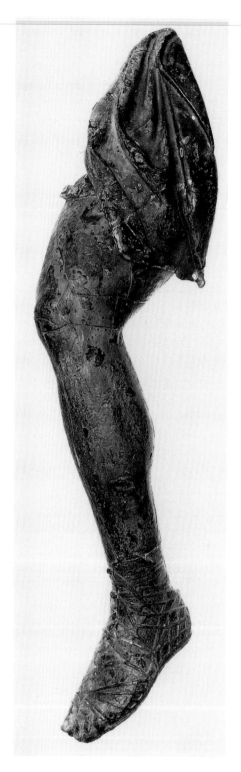

4.11. Lifesize bronze leg of a rider from the Athenian Agora, excavated in 1971. L 0.87 m., th ca. 0.003–0.009 m. Athenian Agora B 1384. Courtesy of American School of Classical Studies at Athens: Agora Excavations.

From inscriptions, we know about three bronze equestrian statues that stood in the area of the Agora: one of the Macedonian Asandros, dated to 314/313 B.C.; another of Audoleon, king of the Paionians, dated to 285/284 B.C.; and one of Demetrios Poliorketes of Macedon (336–283 B.C.).[71] It has been suggested that there might have been another statue of Demetrios Poliorketes as a rider, on top of a gateway that was built to honor an Athenian cavalry victory, but Pausanias mentions only that the gate carried a *tropaion* (trophy). That gate, however, was near the statue of Hermes Agoraios and the Painted Stoa, in the same area where the leg was dropped down the well in about 200 B.C.

There was at least one other statue of Demetrios Poliorketes in the Agora. He and his father, Antigonos, were given great honors for freeing the Athenians in 307/306 B.C. from the rule of Demetrios of Phaleron, of whom Pliny says there had been in Athens some three hundred sixty bronze statues, which the Athenians smashed and melted down. Diogenes Laertius repeats this information, adding that most of the statues were of Demetrios riding a horse or driving a chariot, and that they were all made within the space of three hundred days![72] Diodorus Siculus reports that the Athenian tribute to Demetrios and Antigonos for ridding them of the tyrant was substantial:

> The Athenians, with Stratokles writing the decree, voted to erect golden (*chrysas*) statues of Antigonos and Demetrios in a chariot near the statues of Harmodios and Aristogeiton; to give them both crowns costing two hundred talents; to establish an altar to them called the Altar of the Saviors; to put forward two new tribes in addition to the ten, named Demetrias and Antigonis; each year to have games, a procession, and a sacrifice in their honor; and to weave their likenesses into the peplos of Athena.[73]

The golden chariot group was given an extraordinary place of honor. The Tyrannicides had, after all, been the first individuals ever to be honored with commemorative statues set up at public expense. We can only wonder whether the chariot of Demetrios and Antigonos was accompanied by a gilded Nike wearing the *lampadion* hairstyle. As for the once-gilded Agora leg, perhaps it did belong to a statue of Demetrios Poliorketes; but it certainly did not come from a chariot group, for it is the leg of a rider. We might even be tempted to wonder whether the leg is from one of the three hundred sixty statues of Demetrios of Phaleron, many of which showed him as a horseman. Did this one leg, tucked away in some dark corner, survive the Athenians' wrath for a hundred years, before being dropped into a well? Unfortunately, we do not know whether there was a gilded equestrian statue of either Demetrios in the center of Athens.

[71] Wycherley, Agora 3, pp. 97, 208, 210, nos. 278, 692, 696. For the full text of the third inscription, see Nikolaos Kyparissis and Werner Peek, "Attische Urkunden," *AM* 66 (1941): 221–27: no mention of gold is made, nor is the date of the monument clear.

[72] *NH* 34.27; Diogenes Laertius, *Lives* 5.75, 77.

[73] Diodorus Siculus 20.46.2.

Both of the gilded bronzes from the Agora were dismembered and thrown away sometime around 200 B.C. Like the bronze head, the leg was found in a public well, and one that was located in the same general region: in the northwest corner of the Agora, in front of the Royal Stoa. The leg was thrown into the well on top of material that can be dated between 240 and 215 B.C.; debris from the second century B.C. collected on top of the leg.[74]

Any connection with Macedon during the last years of the third century was fatal. The Athenians retaliated fiercely in reaction to Philip V's ravaging Attica in 200 B.C. So the golden chariot group of Antigonos and Demetrios would have been destroyed, not to mention the statues of Antigonos and Demetrios in the guise of Eponymoi, if such statues actually had been added to the monument of the tribal heroes. Livy's description is a vivid one:

> The Athenians immediately proposed and adopted a decree requiring that all statues and other representations of Philip, and the related inscriptions, as well as images of his ancestors, both male and femle, should be taken down and destroyed . . . and that the places in which any honorary inscription had been set up to him were detestable. . . . And it was also decreed that if anyone ever did anything thereafter that pertained to bringing disgrace on Philip, the Athenian people would support it.[75]

And so, pieces of two gilded bronzes from the Athenian Agora, a goddess (or perhaps a woman) and a male rider, met their end at approximately the same date. Pieces of dismantled statues were usually melted down, but not these. Instead, they were thrown into two wells, both in the northwest section of the Agora. We do not know whether the statues once stood in this part of the Agora, nor can we be certain when they were cast. The leg is that of a man. The woman's head almost certainly belonged to a goddess, for we know of no golden mortal women before the Roman period, unless the golden statue of Phryne at Delphi was, as Athenaios alleges, made by her lover, Praxiteles.[76]

That both the head and the leg from the Agora were foil-gilded, and that they are the only surviving examples of this technique, may seem unusual to us. We cannot tell whether they represent the practice of a single workshop or artist, or whether this is simply how the Athenians or, for that matter, all Greeks gilded statues before leaf gilding was introduced. Indeed, the two Agora bronzes are gilded somewhat differently: there are far fewer grooves on the head than on the leg, and more care was given to their location. The alloys of the two bronzes are also different: the head is a tin bronze, the leg is a leaded bronze. We might

[74] Well J5:1. I am grateful to Susan Rotroff for sharing information about the date of the well. The preliminary excavation report on the statue was published by T. Leslie Shear Jr.: "Excavations of 1971," pp. 121–79.

[75] Livy 31.44.4–8. For summaries of the archaeological evidence and of the literary testimonia, see Camp, *Agora*, pp. 163–68. Camp proposes that the bronzes were simply thrown down the well, and he suggests that the reason they were not melted down for reuse was that people were particularly angry at that moment (p. 168).

[76] Athenaios 13.591B. Because Athenaios lived in the second century A.D., it can easily be argued that he may not be a reliable source on this point.

hope this could tell us something about their dates, but until the alloys of many more bronzes from Greece are known, we cannot draw any conclusions from this information.

The Piraeus Bronzes

In 1959, four bronze statues were discovered by workmen digging a sewer line beneath a street in the Piraeus, the port city of Athens. Excavations were immediately undertaken by Ioannis Papadimitriou, director of the Greek Archaeological Service, and by Euthymios Mastrokostas, the Epimelete of Attica. Besides the four bronze statues, they found a bronze tragic mask, two bronze shields, two marble herms, and one small marble sculpture of Artemis Kindyas, the local goddess of the city of Kindye in Caria. She is veiled, and her arms and hands are tightly wrapped in her garment.[77] The bronzes are now on display in the Piraeus Museum. The Piraeus bronzes and marbles have not yet been published as a group, beyond the accounts written at the time of discovery. When the Piraeus bronzes have been published, they have usually been treated individually, with most attention being given to dates and attributions.

According to Eugene Vanderpool's account of the discovery in the Piraeus, the statues were found in an ancient warehouse, lying neatly together in two groups beneath the charred remains of the roof. In one group were a colossal bronze kouros or Apollo lying on his back, with a marble herm on top of him; next to him was a colossal bronze Artemis, facing in the opposite direction. These artifacts lay beside a second group, consisting of a colossal bronze Athena, a small bronze Artemis, a herm, and a bronze mask. Vanderpool dated the fire that destroyed the building to the first century B.C.[78] The fire is widely accepted as having been associated with Sulla's sack of Athens in 86 B.C.

Although all these bronzes were found together, their different styles have suggested to scholars that they were made at different dates. Because of these differences, they have usually been published separately.

The Apollo is 1.91 meters in height and, at first glance, the statue may look like a canonical kouros, except for the inclined head (figs. 4.12, 1.21). Several other features are highly uncommon for a kouros. This figure has unusually smooth and undetailed hair, with fat pasty-looking curls on the forehead and a thick but smooth cap of hair on the crown of the head. He wears a plain fillet and, since the hair is also so simple, we might wonder whether it was once concealed by a wreath, such as those represented on a few Archaic bronze statuettes from Olympia and Sparta.[79] Below the fillet of the Piraeus

[77] See Robert Fleischer, s.v., "Artemis Kindyas," in *LIMC* 2.1:764, no. 4, and *LIMC* 2.2:573 (illus.). Fleischer dates this statue to the late Hellenistic period.

[78] Eugene Vanderpool, "News Letter from Greece," *AJA* 64 (1960): 265–267. See also Miltis Paraskevaidis, "Ein wiederentdeckter Kunstraub der Antike?" *Lebendiges Altertum* 17 (1966); Hansgerd Hellenkemper, "Der Weg in die Katastrophe: Mutmassungen über die letzte Fahrt des Mahdia-Schiffes," in *Das Wrack*, 1:154–56, with references.

[79] For other examples, see Mattusch, *GBS*, pp. 60–63, with references.

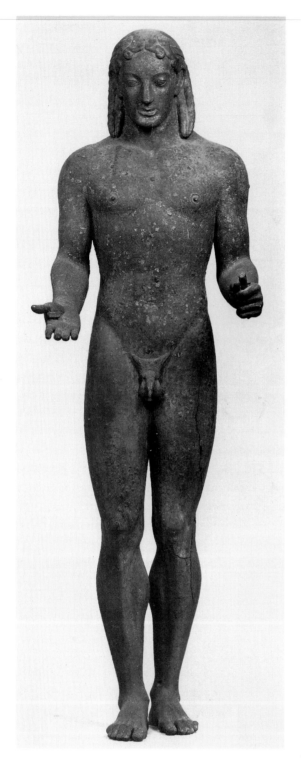

4.12. Bronze statue of Apollo, from a
warehouse destroyed in the first cen-
tury B.C. Discovered in Piraeus in 1959.
H 1.91 m. Piraeus Museum. See also fig.
1.21. Courtesy of Ministry of Culture,
Archaeological Receipts Fund, Athens.

Apollo, heavy beaded locks fall behind the ears to the shoulders, ending in points. The right foot is advanced, a reversal of the normal stance for kouroi, but one that evidently appears first in figures that are transitional between the Archaic period and the early fifth century B.C. (e.g., the Kritios Boy).[80] On a more normal note, the arms are free of the body from just below the armpits, and both arms are flexed and extending forward from the elbows. The flattened right palm probably once held a phiale, of which a piece remains; the left hand clasped a bow.

The bronze Athena, at 2.35 meters in height, is nearly half a meter taller than the kouros (fig. 4.13). She wears a peplos, as well as an aegis decorated with a Gorgoneion and with serpents. The head lies a bit to the right and is inclined slightly forward, giving the goddess a benevolent air. The crested Corinthian helmet is ornamented with griffins and owls in relief. Athena's right hand, outstretched, once had something attached to it, perhaps a phiale. She may have held a spear upright in her left hand, which rested on a shield; both spear and shield would have been secured by the mass of lead that is still there.[81] This statue was cast in several pieces, the joins being easily concealed beneath the drapery. The stone whites and irises of the eyes are still in place, as are the teeth (apparently of ivory).[82]

There are two statues of Artemis, and they are of different sizes. The larger one is 1.94 meters in height, slightly more than lifesize (fig. 4.14). This goddess wears a peplos and has a quiver strapped to her right shoulder. Her head is cocked to her left, and her left arm is at her side, where she probably grasped a bow between the thumb and forefinger of that hand, where one can still see some of the lead that was used for attachment. Her outstretched right hand seems to have held a phiale. Eyes, lips, and teeth were inset.[83] Her weight is borne on the right foot, and the left foot trails. Although the smaller Artemis (H 1.55 m.) is badly corroded, it is clearly similar to the larger one, but with the position of the feet reversed (fig. 4.15). The turn of the head is slightly more acute than that of the larger Artemis, the extension of the arms more pronounced. Like the larger Artemis, this statue also wears the peplos, but with a short cloak added. The quiver strap across the right shoulder is inlaid with a silver meander, and the eyes are inset.[84] The left foot bears the weight, and the right one trails.

The body and legs of the bronze Apollo were cast in one large piece, with only the arms, head, and genitals separately cast, as is characteristic of sixth- and fifth-century B.C. bronzes whose technique has been examined. But it would not be surprising to learn that this kind of sectioning was merely efficacious for a nude male statue, and that it might be used for

[80] Kritios Boy: Athens, Akropolis Museum no. 698; see G. M. A. Richter, *Kouroi*, 3d ed. (New York, 1970), p. 149, no. 190, figs. 564–69 and, more recently, Jeffrey M. Hurwit, "The Kritios Boy: Discovery, Reconstruction, and Date," *AJA* 93 (1989): 41–80. For other examples of this stance, see Mattusch, *GBS*, p. 77n75.

[81] Vanderpool suggested that the decorated shield (with a chariot race in repoussé relief) could have belonged to this statue: "News Letter," p. 266. See also Houser, 1987, pp. 212–13, fig. 13.7.

[82] Houser, 1987, pp. 215–16.

[83] Ibid., pp. 197–211, for full description and bibliography.

[84] Ibid., pp. 244–54.

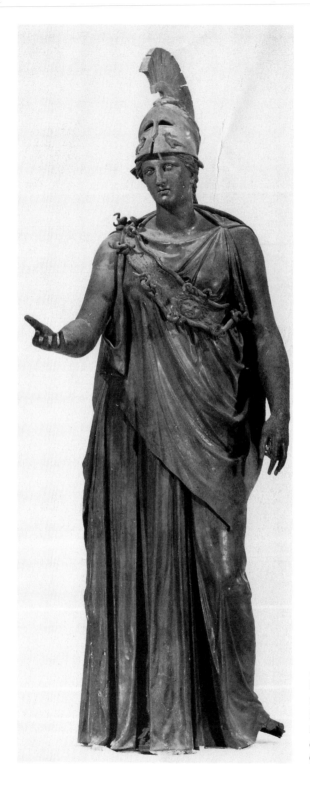

4.13. Bronze statue of Athena, from a warehouse destroyed in the first century B.C. Discovered in Piraeus in 1959. H 2.35 m. Piraeus Museum. Courtesy of Second Ephoreia of Prehistoric and Classical Antiquities, Athens.

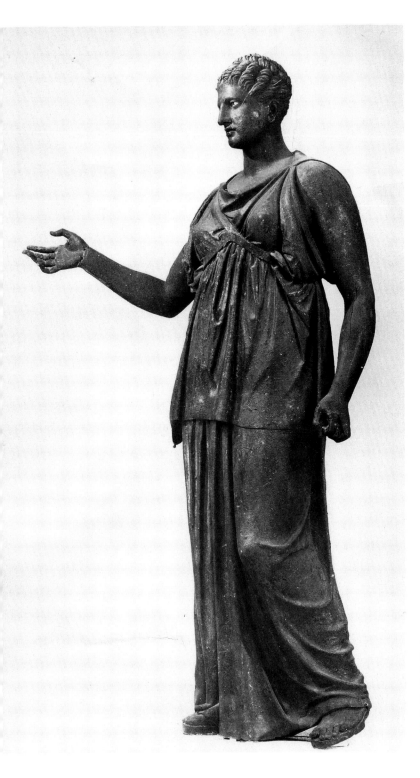

4.14. Larger bronze statue of Artemis, from a warehouse destroyed in the first century B.C. Discovered in Piraeus in 1959. H 1.94 m. Piraeus Museum. Courtesy of Second Ephoreia of Prehistoric and Classical Antiquities, Athens.

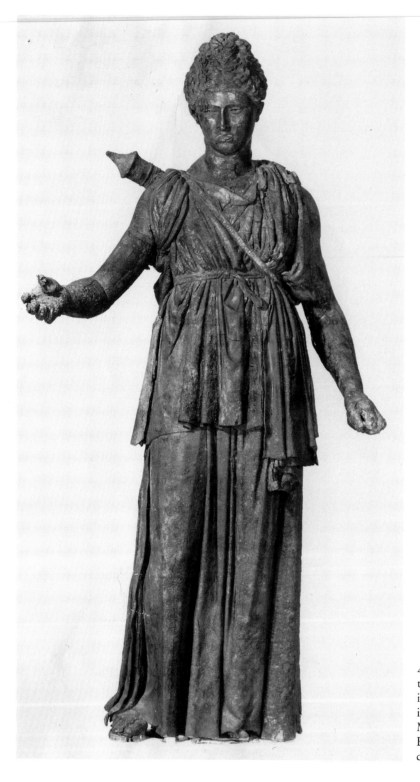

4.15. Smaller bronze statue of Artemis, from a warehouse destroyed in the first century B.C. Discovered in Piraeus in 1959. H 1.55 m. Piraeus Museum. Courtesy of Second Ephoreia of Prehistoric and Classical Antiquities, Athens.

such a bronze regardless of date. The same might be true of the simple iron armature found inside the Apollo. This statue is relatively thick-walled, and the eyes were not inset but were cast with the head in a manner that has been found on a few other Archaic bronzes, as well as on bronzes from the Roman imperial period.[85]

Arthur Steinberg is the only person to date who has written about the casting of the female statues from the Piraeus. He observed that on both the Athena and the large Artemis, long vertical sections of the skirts were modeled, molded, and cast separately. There are also large horizontal sections, joined at the waist on the Athena and concealed by the overfold of the peplos; the aegis was probably also a separate piece. On the larger Artemis, the belt hides a join. Both statues are also joined at the necks, the neckline hiding the joins. The feet were separately cast; and the arms of both statues of Artemis are joined at the biceps, whereas those of the Athena are joined beneath the drapery on the shoulders. Hard solder was used to strengthen the mechanical joins.[86]

On technical and stylistic grounds, the Piraeus Apollo has been dated from as early as 530–520 B.C. to as late as 450 B.C.[87] There has not, however, been much controversy. Stylistically, the bronze Athena has attracted the most attention among the four statues. The closest parallels for the bronze Athena are found among sculptures that are assigned to the fourth century B.C. Since both Euphranor and Kephisodotos are reputed to have worked in Athens during that century, comparisons have been made between the Piraeus Athena and the marble Apollo Patroos from the Athenian Agora, a work attributed to Euphranor, and between the bronze Athena and the marble copies of the group of Eirene and Ploutos by Kephisodotos.[88] Indeed, the Piraeus Athena has actually been identified as Kephisodotos's Athena Soteira, which was erected early in the fourth century B.C. and lasted until Sulla's destruction of the Piraeus in 86 B.C.; the one mentioned by Pliny and seen in the Piraeus by Pausanias was a bronze replacement for that original. Geoffrey Waywell suggests that the measurements of the statues are so close that the Mattei Athena might have been copied from this statue and sent to Italy before 86 B.C.[89] The marble Mattei Athena in the Louvre has been called a copy of the Piraeus Athena.[90] Ridgway believes, however, that the Mattei Athena is Antonine in date and thus cannot have been

[85] For technique, see Mattusch, *GBS*, pp. 74–79.

[86] Arthur Steinberg, "Joining Methods on Large Bronze Statues: Some Experiments in Ancient Technology," in *Application of Science in Examination of Works of Art*, ed. Wm. J. Young (Boston, 1973), pp. 103–38. Steinberg noted flow-welded joins of various kinds, and these are illustrated.

[87] For style and date in the 470s, see George Dontas, "Ho Chalkinos Apollon tou Peiraia," in *Archaische und Klassische Griechische Kunst* (Mainz, 1986), pp. 181–92; for a late-sixth-century date, see Houser, 1987, pp. 26–54. Claude Rolley has proposed an even later date—in the second quarter of the fifth century B.C. See Rolley, *La sculpture grecque*, 1: *Des origines au milieu du V^e siècle* (Paris, 1994), pp. 398–99.

[88] For Euphranor, see Olga Palagia, *Euphranor* (Leiden, 1980): either an original bronze of 340/330 B.C. or "a good later reproduction of a type created in 350/40 B.C." (p. 23).

[89] Geoffrey B. Waywell, "Athena Mattei," *BSA* 66 (1971): 373–82.

[90] Mattei Athena: Louvre 530. Copy: ibid., pp. 373–74. Also see Palagia, *Euphranor*, p. 22; Houser, 1987, pp. 225–29. It would be useful to have a point-by-point comparison of these two statues, with specific measurements for both of them.

copied from the Piraeus Athena, unless the bronze statue was "originally created with a 'double' which could serve as model for the later copyists."[91]

Because the proportions, the pose, and the drapery of the larger Artemis resemble those of the marble Apollo Patroos, this statue, like the Athena, has been dated to the fourth century B.C. and attributed to Euphranor.[92] Owing to its poor condition, the smaller Artemis has escaped any extensive stylistic assessment. The relief ornament on her sandals has been noted, though, along with the cylinders on the sides of her soles, the latter detail shared with the Athena: that both features may be Hellenistic in inception might be expected to raise serious doubts about the dates of these statues, but such doubts have not been expressed.[93]

Not enough is known about the other finds from the ancient Piraeus warehouse to do any more than mention them here. The bronze tragic mask (H 0.45 m.) has heavy cascading locks of hair, raised bulging brows, and huge round eyes (once inlaid), a wide-open mouth, and a tightly curled beard. It has been dated to the later fourth century B.C. or to the Hellenistic period. The two marble herms represent the bearded Hermes, and are of the Alkamenid type. Stylistically, they could date to the period just before the destruction of the warehouse. Each is 1.43 meters in height. As for the rest of the finds, the information available is this: one bronze shield is reportedly decorated in repoussé with a chariot race; the other is blank; and the marble statue, thought to be late Hellenistic in style, represents Artemis Kindyas.[94]

Although no one seems to disagree with the idea that the Piraeus warehouse in which the bronzes and marbles were found probably burned during Sulla's sack of Athens in 86 B.C., there are many theories about how the bronzes came to be there. Usually, the bronzes are considered to have been in transit. One suggestion is that they came from Delos—loot taken to Athens during the Mithridatic Wars—and were on their way to Rome.[95] Another is that they were a group of sacred statues that had been made in Delos and were then taken to Athens to prevent their destruction by Mithridates during the Sullan Wars of 88–86 B.C.[96] It has also been suggested that the statues were made by Athenian artists working on Delos.[97] Could they have been made in Athens?

As we have seen, the various styles of the Piraeus bronzes have suggested to more than

[91] Ridgway, *RC*, p. 34.

[92] George Dontas, "La grande Artémis du Pirée: Une œuvre d'Euphranor," *Antike Kunst* 25 (1982): 15–34.

[93] Morrow, *Footwear*, pp. 71–73: Morrow does not let the late date that she gives the other examples of these features interfere with her accepting a date of 340–330 B.C. for all three of the shod Piraeus bronzes.

[94] See Paraskevaïdis, "Ein wiederentdeckter Kunstraub der Antike?" For the herms, see also Harrison, Agora 11, pp. 127, 148–49. For Artemis Kindyas, see n. 77 above.

[95] See Harrison, Agora 11, p. 127 with n. 149; together with more recent general publications by others, such as Houser, 1987, pp. 51–52.

[96] Ridgway, *HS* 1, p. 363. Ridgway goes on to say that the sandals of the Athena and of the small Artemis are not earlier than the second half of the second century B.C., so these statues may be copies of earlier works. See also Morrow, *Footwear*, p. 92.

[97] Ridgway, *HS* 1, p. 363.

one scholar that they were produced at different times. The Apollo has a few uncharacteristic features for a kouros, none of them very unusual in themselves. But, taken together—the inclined head, the strangely massive and undetailed hair, the cast eyes, the right foot forward—this is an odd combination of features. Is the statue Archaic, or is it reflective of an Archaic work?

All four of these statues extend the right hand, apparently to hold a phiale. Why? Would this gesture have been usual for images dedicated to the same deity in a particular sanctuary? If so—that is, if we could prove that they come from one sanctuary—we would have a fascinating piece of information. Or might one workshop have produced all of these bronzes, despite their stylistic differences? Did one workshop simply produce statues of deities with phialai in the right hand?

All four of the bronze statues have lead dowels in their feet for installation on bases. Probably, then, they had been erected somewhere else before they were brought to the warehouse in the Piraeus. It seems unlikely that they all belonged to a single group, for the fact that the smaller Artemis is of a different scale than the other statues suggests that this one would not have been erected alongside the others. Still, all of them could have been set up at the same site. Were they all removed, as a group, and shipped to the Piraeus?

If alloy is a reliable indicator, the evidence could be interpreted as suggesting that these statues were made in one workshop, for they have very close copper–tin–lead alloys. The major components in the alloys are as follows: Apollo (Cu 91%, Sn 8%, Pb 1%); Athena (Cu 87%, Sn 11%, Pb 1%); larger Artemis (Cu 86%, Sn 12%, Pb 1%); tragic mask (Cu 85%, Sn 12%, Pb 3%).[98] Could this admixture of lead have been a standard component of statuary bronzes?

Were these statues produced over an extended period of time? Or do the similar alloys, and gestures, and even the sandals suggest that they were all made at about the same time? Or if these statues were produced over an extended period of time, do their similar technical and stylistic features simply represent the established norms for statuary set up in a particular place or fulfilling the same general function? Perhaps ancient viewers recognized such statues as standard dedications of a certain type—one that we may find echoed in the fourth-century B.C. red-figure vase fragment that shows a statue of Apollo inside a temple, phiale in the right hand and bow in the left, while outside the temple sit Apollo and Artemis, portrayed as if they were living figures of colossal proportions (pl. 2). All three figures are of comparable "style." Can we make any stylistic comparisons between the Piraeus Apollo and the three female statues with which he was found? Perhaps we should try. After all, the context in which they were found is the only actual date that we have for the statues. And the Piraeus Apollo is, after all, not a canonical kouros: he may be no more than a late reference to this traditional and familiar type of image. Could the female statues be described in the same way?

[98] Wet chemical analyses done for Bruno Bearzi and reported in Bearzi, "Il bronzo nella antichità," *La Fonderia Italiana* 2 (1966): 65, table 1; also see Steinberg, "Joining Methods," p. 108, table 1.

Maybe these four statues stood near one another in some sanctuary, were uprooted from their bases, and were brought together to the warehouse in the Piraeus. That there are other examples of the imposing helmeted statue of Athena, in marble, suggests that this type of figure had a function which endured over a long period of time, although later that function may have changed to a more decorative role.[99] Until all these images of Athena are closely studied as a group, though, we do not have sufficient evidence to insist that they constitute a single series or edition (i.e., all of the statues having been produced from a single original model). We are likely to find that such Athenas have enough differences to be more aptly described as a theme on which there were variations—in gesture, in volume, in surface details, and in attributes. And such variations can always be made by different artisans, at different dates, perhaps to suit particular clients. At this point, then, we can only categorize these helmeted statues of Athena as a popular and enduring type.

Is it possible that the Piraeus bronzes were all made in one workshop? How important is it to find dates for all of them? The products from any such workshop could have included images in more than one style, some of them serially produced like the two bronze herms, others new creations, some perhaps even reproductions of famous works.

If we consider the possibility that the Piraeus Apollo might be a second-century B.C. interpretation of an Archaic kouros, it may be easier to understand the curious combination of features that seem to defy explanation when they all belong to one Archaic statue. The large size of the statue, the solid-cast eyes with incised iris and pupil, the lack of detail in the massive hair, and the weight equally planted on somewhat naturalistic legs and feet are all features that tend to attract our attention. These characteristics baffle our sense of chronological correctness. Add to that the problem that the right foot, instead of the left one, is forward—very unusual for a kouros. And even worse, the head is inclined, something we are not at all accustomed to see in kouroi.

Could it be that the Piraeus Apollo is simply a *reflection* of the Archaic style? If so, then the stylistic anomalies are easier to understand for anyone looking at the statue without presuppositions. The Piraeus Apollo could be understood as emulating a traditional sculptural theme, which was selected to stir the imagination, not to challenge the critical eye. But when we turn from the vague allusion to the specific details, and look at the statue with academic eyes, we have doubts about our initial grasp of its style and begin to worry about the date to which we would like to fix that style. To make sense of old-fashioned elements that are not necessarily parallel, we must place them in a perspective relevant to the artist's own period. Such an interpretation brings to mind an interesting modern parallel: a nineteenth-century "Etruscan" terra-cotta sarcophagus that was invested with some details

[99] A parallel can be drawn with the massive caryatids that were first made for the Erechtheion in Athens during the last quarter of the fifth century B.C. In the 130s A.D., four full-scale freestanding reproductions of these figures, with supporting bolsters still on their heads, were placed in a row beside the pool called the Canopus at Hadrian's villa in Tivoli.

from the nineteenth century, the period in which the work was made. Once we know that the sarcophagus was made in the nineteenth century, we can easily see it as a work that was intended to appeal to Victorian taste.[100]

Two slightly smaller bronzes provide indisputable examples of the enduring appeal both of the Archaic style and of a particular sculptural type. They look very much alike, and this cannot be coincidental. One is an Apollo from Pompeii, destroyed in A.D. 79; the other is the Piombino Apollo, which is dated, on stylistic and epigraphic grounds, to the first century B.C. (pls. 5, 6). The figures are about the same height; and their proportions, contours, and features are also very close in appearance.[101] Both stand with the feet flat on the ground, the left foot advanced. The arms are positioned identically: bent at the elbow, with the right palm outstretched as if to hold a phiale, the left hand loosely clenched as if to grasp a bow. Their heads are held erect, and the overall form of the complicated and highly unusual hairdo is the same: rows of curls across the forehead; a fillet; and long hair tied into a small, freestanding knot at the level of the shoulders. There are also differences. The Pompeii Apollo has a double row of snailshell curls above a row of spiral curls crossing the forehead, all in high relief; the Piombino Apollo has only a double row of snailshell curls, cursorily marked. The Pompeii Apollo has a rolled and decorated diadem instead of the Piombino's plain fillet, which is visible only in back. In addition, the Pompeii Apollo retains its inlaid eyes, and there are signs of two long locks appearing from behind each ear and hanging down across the chest at neatly spaced diagonals. Essentially, though, these two boy/Apollo statues are the same figure, differing only in the superficial details. They are two examples of one Archaic type, but this is a version that was invented long after the Archaic period. Their hairdo was designed after the Archaic period; the rounded physical forms betray a familiarity with more naturalistic renderings of the human form than those produced during the Archaic period. These figures are no more than an allusion to an Archaic Apollo.

We might say that these two statues are products of a revival of interest in the Archaic Apollo figure. That revival, moreover, if the Piombino Apollo is dated correctly, had begun by the first century B.C. The popularity of this particular figure can likewise be fixed in the last quarter of the first century A.D. There is no question that the makers of these two statues had access to the same original model. The evidence so far suggests that they could

[100] British Museum (BM GR 1873): see *Fake? The Art of Deception*, ed. Mark Jones (London, 1990), pp. 30–31. There is no doubt that the Piraeus Apollo is ancient, but someone in antiquity could have been attempting a forgery. If so, would the buyer have been indiscriminate enough to overlook such an anachronistic characteristic as the lowered position of the head? That would have been easy enough to do.

[101] Pompeii Apollo: H of head 0.18 m. (see *Riscoprire Pompei*, pp. 263–64, no. 193). This statue is noted in Ridgway, *RC*, p. 29n69 (discussion of the Piombino Apollo on pp. 22–23); eadem, "Birds, 'Meniskoi,' and Head Attributes in Archaic Greece," *AJA* 94 (1990): 611; and Mary-Anne Zagdoun, *La sculpture archaïsante dans l'art hellénistique et dans l'art romain du Haut-Empire* (Paris, 1989), p. 214. Piombino Apollo: H of head 0.182 m. (see Brunilde S. Ridgway, "The Bronze Apollo from Piombino in the Louvre," in *Antike Plastik* [Berlin, 1967], 7:43–75).

even have produced their bronzes from the same master molds; but if they did, they finished their working models quite differently.[102]

The right hand of the Piraeus Apollo is extended, palm up, and what looks like a piece from the edge of a phiale is still in place. The left hand held something vertically, evidently a bow. These positions thus parallel those of the two smaller Apollos. Various features on the Piraeus statue are, as we have seen, anomalous. Furthermore, its discovery context is early first century B.C. Still, we cannot be certain that the Piraeus Apollo was made shortly before that time, and that he belongs to the same archaizing genre as the two smaller figures, any more than we can be certain that the Piraeus Apollo is, instead, an Archaic statue. But if we see him as a reflection of the Archaic style, he does not raise the questions that he does if we insist that he must be "an Archaic work," for he does not fit into that category as we have hitherto defined it.

[102] I have not yet looked at either of these two statues carefully, and detailed measurements will be needed to be absolutely certain that a single model was used.

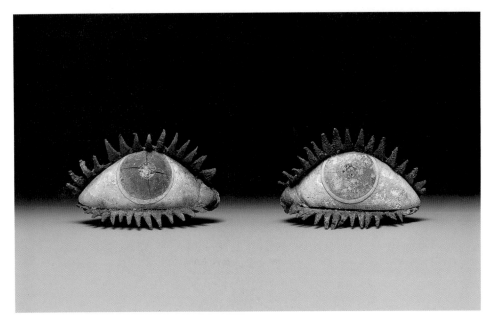

Plate 1. Pair of eyes made of marble, frit, quartz, and obsidian, with bronze lashes. Once inlaid in a statue of about twice lifesize. W of left eye 0.058 m.; W of right eye 0.06 m. The Metropolitan Museum of Art, Purchase, Mr. and Mrs. Lewis B. Cullman Gift and Norbert Schimmel Bequest, 1991 (1991.11.3ab). Copyright © 1991 by The Metropolitan Museum of Art.

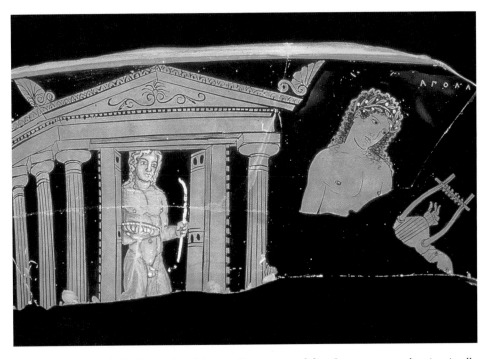

Plate 2. Fragment of calyx krater from Taranto, first quarter of fourth century B.C., showing Apollo and Artemis seated outside a temple and a statue of Apollo inside the temple. Amsterdam, Allard Pierson Museum no. 2579. Courtesy of the Allard Pierson Museum, Amsterdam.

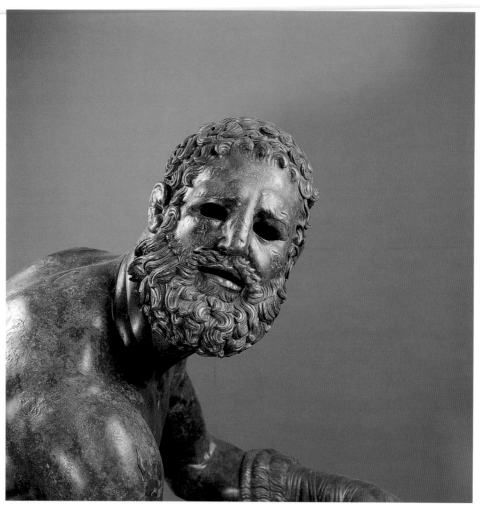

Plate 3. Face and shoulder of seated bronze boxer, with inlaid-copper lips and dripping blood. H
1.28 m. Rome, Museo Nazionale Romano inv. 1055. See also fig. 1.9. Courtesy of the Archäologisches
Institut und Akademisches Kunstmuseum der Universität Bonn. Photo by Wolfgang Klein.

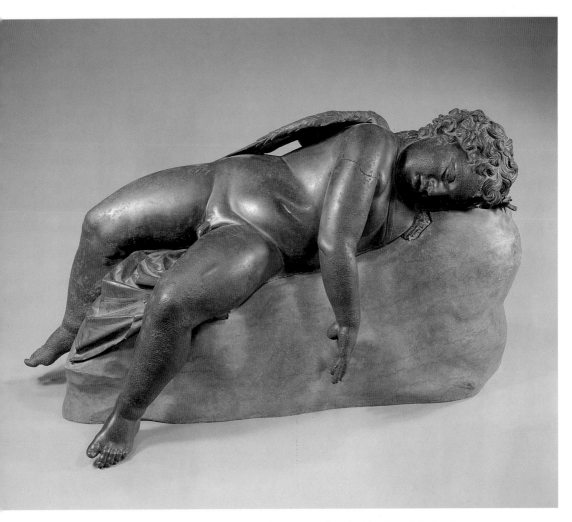

Plate 4. Lifesize bronze sleeping Eros, purchased in 1943 and said to be from Rhodes. L 0.852 m. New York, Metropolitan Museum of Art 43.11.4. Rogers Fund, 1943. See also fig. 5.9. Copyright © 1985 by The Metropolitan Museum of Art.

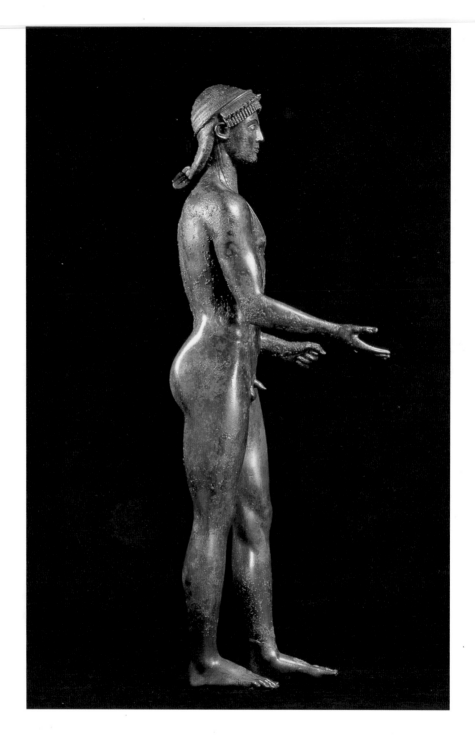

Plate 5. Bronze Apollo from the house of C. Julius Polybius at Pompeii (destroyed A.D. 79 and excavated in 1977). H 1.28 m. Pompeii inv. 22924. Courtesy of "L'Erma" di Bretschneider.

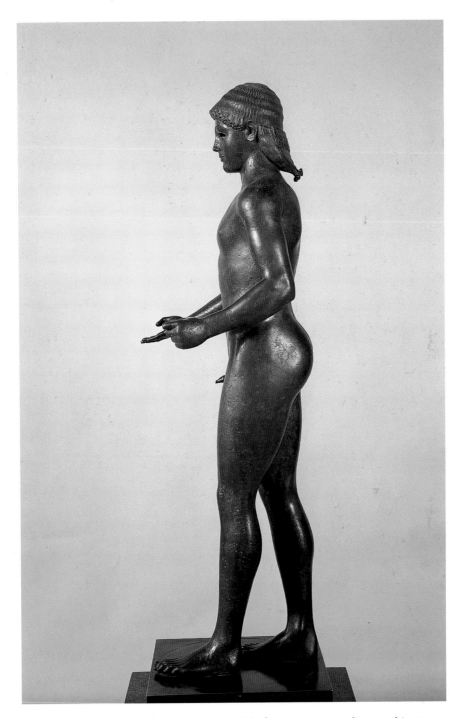

Plate 6. Bronze Apollo from Piombino, probably first century B.C., discovered in 1812 or 1832. H 1.16 m. Paris, Louvre Br. 2. Courtesy of the Louvre, Musées Nationaux, Paris. Photo Réunion des Musées Nationaux.

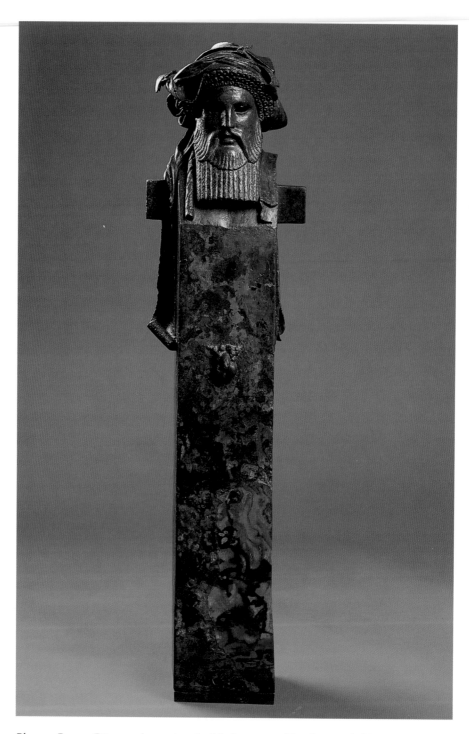

Plate 7. Bronze Dionysos herm signed with the name of Boëthos, probably second century B.C, from the Mahdia ship (wrecked in the 80s or 70s B.C. and discovered in 1907). H 1.03 m. After restoration in 1992/1993. Tunis, Bardo Museum F 107. See also figs. 5.11, 5.13, 7.3. Courtesy of Rheinisches Landesmuseum, Bonn. Photo by H. Lilienthal.

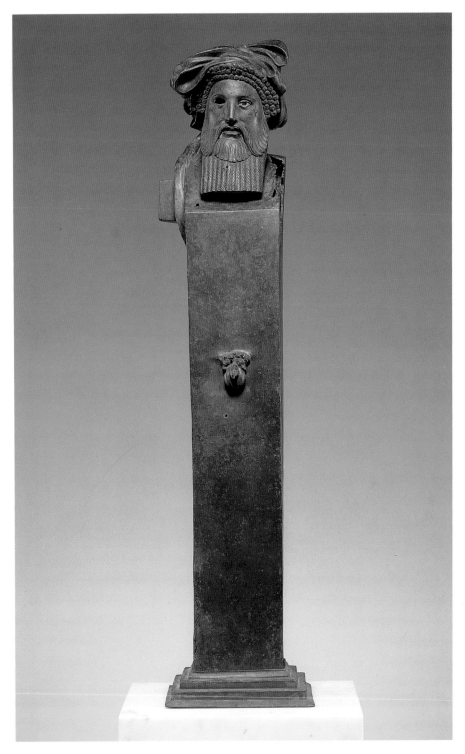

Plate 8. Bronze Dionysos herm, purchased in 1979. H 1.03 m. Collection of the J. Paul Getty Museum no. 79.AB.138, Malibu, Calif. See also figs. 5.23, 7.4.

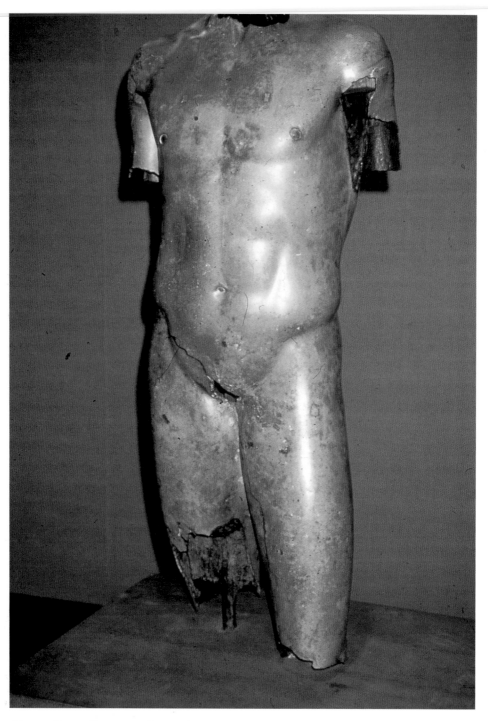

Plate 9. Bronze Vani torso, from a destruction context of the 80s B.C., excavated in 1988 on the central terrace of the ancient site at Vani. Lifesize, max. pres. H ca. 1.01 m. Vani Museum. See also fig. 6.4. Photo by C. C. Mattusch.

CHAPTER FIVE

A GREEK BRONZE ORIGINAL?

One of the four large akroteria adorning the central portion of the façade of the National Archaeological Museum in Athens is a terra-cotta version of the Belvedere Apollo. The other three are reproductions of the Diadoumenos, of Eirene holding the infant Ploutos, and of a woman in chiton and mantle who is more difficult to identify because she is not well known today, although she may have been easily recognizable during the second half of the nineteenth century. This last statue is probably Hera, and she appears to resemble most closely the Barberini Hera and the Hera from Otricoli, both of which are in the Vatican Museums.[1] Unlike the other three akroteria on the façade of the Athens Archaeological Museum, of which there are various ancient examples, the marble Belvedere Apollo in the Vatican is the only one of its type. Nor has that statue any certain connection with Greece.

Indeed, the statue has always been far better known in Italy than in Greece, and it remains a major stopping point for groups touring the Vatican Museums (fig. 5.1). When the Englishwoman Charlotte Eaton visited the Vatican in 1817, her guide saved the Apollo for last, lest she and her group "should look at nothing afterwards." Her lengthy and enthusiastic response to the statue clearly reflects the public sentiment of her day, and it begins: "Never, never was there revealed to the dreams of gifted genius a vision of such celestial, such soul-beaming beauty!"[2]

A restored Belvedere Apollo occupies a niche in the courtyard of the eighteenth-century Palazzo Rondinini in Rome.[3] This well-muscled figure with a wreath of curls around his

[1] See Bieber, *Ancient Copies*, figs. 160–61, 166.

[2] Charlotte A. Eaton, *Rome in the Nineteenth Century*, 5th ed., Bohn's Illustrated Library (London, 1852), 1:104. Her four pages of reactions to the Apollo Belvidere [*sic*] are well worth reading, and contain some remarkable comments. She concludes: "All that we can, or need ever know of this admirable statue, is, that it is supremely beautiful; and if it be a copy, we have scarcely a wish for the original" (p. 107).

[3] The palazzo, on the Via del Corso, now houses the Banca Nazionale dell'Agricoltora. For the Barberini Hera and the Hera from Otricoli, both in the Vatican, see Bieber, *Ancient Copies*, figs. 160 and 166.

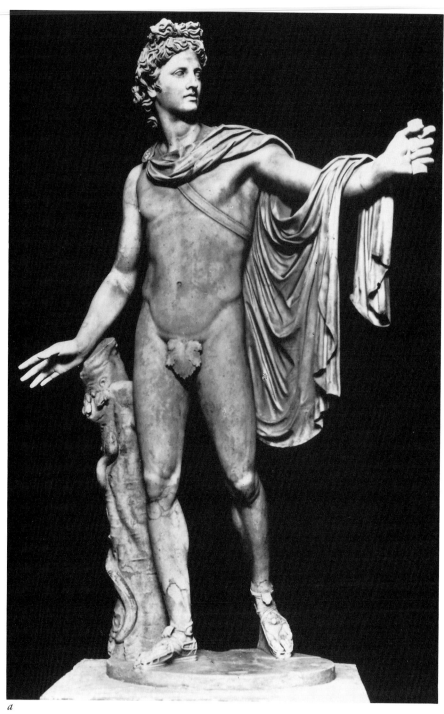

a

5.1. Marble Belvedere Apollo, probably from Rome and known since ca. 1500. H 2.24. m. (*a*) With restorations by G. Montorsoli; (*b*) as at present, restorations removed. Rome, Vatican Museums, Belvedere Courtyard. Courtesy of the Vatican Museums.

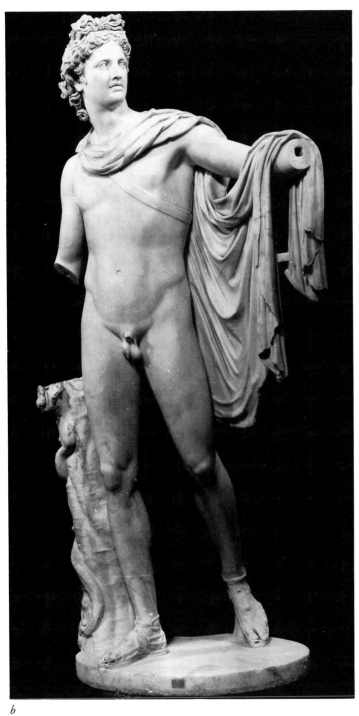

b

face, long spiral locks on both shoulders, wearing a heavy short mantle, extending two bronze arrows in his right hand, and with a serpent in front of him and a lyre behind him, bears only minimal resemblance to the statue from which he is derived. Today in Rome, small porcelain and metal souvenirs of the Apollo and of its head and bust are ubiquitous—not to mention postcards, watercolors, prints, medals, bracelet charms, cartoons, and large-scale sculptural variations.

The Belvedere Apollo became famous early in the sixteenth century. Where the marble statue came from is not definitively known, but it was owned by Cardinal Giuliano della Rovere and was probably found on the grounds of San Pietro in Vincoli on the Esquiline Hill of Rome. After Rovere became Pope Julius II in 1503, the statue was moved to the Belvedere Courtyard of the Vatican, where it was first mentioned in 1509.[4]

The figure of Apollo stands on the right foot; the left foot trails behind. The left arm, extended to the side, is raised nearly to the horizontal, and the head is turned sharply to the left. The right upper arm hangs at the side: the missing right hand once extended slightly forward, and a strut attached the wrist to the thigh; below that, a tree trunk adjoins the right leg to mid-thigh. A short mantle is pinned at the right shoulder, falls down behind, then loops up over the left forearm, forming a series of catenary folds below the arm and to the left of the nude body. A quiver, strapped across the chest, and sandals complete the wardrobe. Early drawings show the figure without its left forearm and the fingers of the right hand. In 1532/1533, Giovanni Angelo Montorsoli removed what was left of the right hand, evened up the breaks in both arms, cut off and smoothed over a strut on the right thigh, and restored both hands, moving the right hand a little farther from the leg. By 1540, the statue was being molded for copies. Three hundred years later, copies of all sizes and in many materials were still being made, some of the whole statue, others of the head alone.

Johann Joachim Winckelmann thought so highly of the Apollo Belvedere that he imagined it to have been stolen from Greece and taken to Italy by Augustus or Nero. In 1764, Winckelmann wrote an appreciation of the statue. An English translation about a hundred years later is an indication of the feelings many viewers had for the statue. Winckelmann considered the Apollo to be

> . . . the highest ideal of art. The artist has constructed this work entirely on the ideal, and has employed in its structure just so much only of the material as was necessary to carry out his design and render it visible. . . . In the presence of this miracle of art I forget all else, and I myself take a lofty position for the purpose of looking upon it in a worthy

[4] For the history of the statue, see Hans Brummer, *The Statue Court in the Vatican Belvedere*, Stockholm Studies in History of Art 20 (Stockholm, 1970), pp. 44–47; Haskell/Penny 148–51 et pass.; Francis Haskell and Nicholas Penny, *The Most Beautiful Statues: The Taste for Antique Sculpture, 1500–1900* (Oxford, 1981), pp. ix, xii, 11–12 (no. 15), 24 (no. 36), 25 (no. 37), and 55 (no. 75); Georg Daltrop, "The Apollo Belvedere," in *The Vatican Collections: The Papacy and Art* (New York, 1982), p. 63, no. 20; and Deborah Brown, "The Apollo Belvedere and the Garden of Giuliano della Rovere at SS. Apostoli," *JWarb* 49 (1986): 235–38.

manner. My breast seems to enlarge and swell with reverence, like the breasts of those who were filled with the spirit of prophecy, and I feel myself transported to Delos and into the Lycaean groves,—places which Apollo honored by his presence,—for my image seems to receive life and motion, like the beautiful creation of Pygmalion. How is it possible to paint and describe it![5]

Winckelmann himself, like many of the other early travelers, never went to Greece, which was under Turkish rule until the second quarter of the nineteenth century. Instead, Italy was the focus of their journeys, thus skewing their view of Classical art toward the architecture, painting, and sculpture that they saw there. By the end of the first quarter of the nineteenth century, however, the pedimental sculptures from Aegina and from the Parthenon were known: they had been removed from Greece and taken to convenient viewing places—London and Munich—and, thereafter, travelers began extending their tours to include Greece. Soon, original Greek sculptures from Aegina and Athens would be as widely known as the ancient sculptures with which people had become familiar while touring Italy in the eighteenth century.

During the hundred years after Winckelmann wrote his tribute to the Apollo Belvedere, there was much disagreement over whether that marble sculpture was actually an original. By the early nineteenth century, this and other ancient marbles were gradually becoming more readily accepted as Roman copies of lost Greek bronzes, a trend that had been initiated by a friend and colleague of Winckelmann, the German painter Anton Raphael Mengs, and that gathered strength as the pedimental sculptures from the Parthenon and from Aegina became familiar monuments. The great English traveler Augustus Hare wrote: "It is now decided that this statue, beautiful as it is, is not the original work of a Greek sculptor, but a copy, probably from the bronze of Calamides." Nonetheless, Hare paid tribute to the reputation of the Apollo, quoting Mrs. Sarah Siddons, *Childe Harold's Pilgrimage*, and Henry Hart Milman.[6] And in Baedeker's 1904 guide to Italy, no comment is made concerning whether the statue is an original or a copy. The Apollo Belvedere, like the Laokoon, simply receives two stars.[7]

Today the Belvedere Apollo is usually considered to a be a Roman copy, for which reason, apparently, Reinhard Lullies and Max Hirmer did not include the Belvedere Apollo in their *Greek Sculpture*, but they did include the Laokoon, while acknowledging that there were differences of opinion as to its authenticity.[8] Even so, the Laokoon is not now generally viewed as a Greek original, but rather as a "replica, adaptation, or new [Roman] creation."[9] There is no such dispute over the Belvedere Apollo. When the Apollo is

[5] J. Winckelmann, *The History of Ancient Art*, trans. G. H. Lodge (Boston, 1880), 2:312–13.
[6] Augustus J. C. Hare, *Walks in Rome*, 14th ed. rev. (London, 1897), 2:226–27.
[7] K. Baedeker, *Italy from the Alps to Naples: Handbook for Travellers* (London, 1904), p. 299.
[8] Lullies/Hirmer 107, nos. 278–79.
[9] Smith, *HS*, p. 109.

included in textbooks, it appears with Greek art, and it is always called a Roman copy. It is to the credit of the Apollo's reputation that it continues to be illustrated in textbooks, even in one still so widely used as H. W. Janson's *History of Art*, where the statue is illustrated in color in its present condition, without Montorsoli's restorations. The caption identifies it somewhat ambiguously as a "Roman marble copy, probably of a Greek original of the late 4th (or 1st) century B.C."[10] Christine Havelock suggested slightly different attributions: she asked whether the lost bronze original should be attributed to the fourth-century B.C. Athenian sculptor Leochares or to an artist of the second century B.C.[11]

Why are we so interested in style, in authorship, and in date? A look at the Belvedere Apollo reveals that there is certainly need of further stylistic evaluation. The drapery, when viewed along the line of the left arm is rather flat and might be criticized for being an overly simplified and lifeless backdrop for the body. Indeed, the body is unexpectedly elongated, with little definition of musculature, in what might best be called a "manneristic" style. As a whole, the Apollo has a striking presence: the face is mature, and the attitude is commanding. Where, then, is the pubic hair? It is jolting to notice that the figure has none, for this is certainly not an image of a little boy.[12]

Like the Belvedere Apollo, the Artemis of Versailles has no provenance, and it too has always been recognized as an important antique marble (fig. 5.2). A diademed Artemis wearing a short chiton, mantle wrapped around her waist, steps energetically forward on her left foot, turning her head sharply toward her raised right hand, with which she is about to pluck an arrow from the quiver on her back. Her left arm extends downward, and there is a stub of a bow in that hand. The hand is positioned between the antlers of a small rearing stag, its hind legs planted behind Artemis and its body joined to a tree trunk supporting her left leg.

The statue was first mentioned in 1586, when it was at Fontainebleau.[13] Restorations were made at least twice, in the early seventeenth and early nineteenth centuries.[14] What these restorations were and how they were decided on were not questions that concerned students of this statue. Indeed, in the seventeenth century, copies were already being made of the restored statue. In 1798, the Artemis was installed in the Louvre.[15] Although she is

[10] H. W. Janson, *History of Art*, 4th ed. (New York, 1991), p. 195, fig. 222.

[11] See Christine Havelock, *Hellenistic Art*, 2d ed. (New York, 1981), p. 124, no. 91. For an analysis of the current scholarship in the field of Classical sculpture, see B. S. Ridgway, "The Study of Classical Sculpture at the End of the 20th Century," *AJA* 98 (1994): 759–72.

[12] I am indebted to Mary Hollinshead, Nancy Ramage, Linda Roccos, and Alice Taylor for the discussions we had of this statue, and for the ideas we shared as we looked at the Belvedere Apollo in 1994. For a recent discussion of the scholarship and aesthetic of Winckelmann, with particular attention to links between the ideal and the erotic in the context of the late eighteenth century, see Alex Potts, *Flesh and the Ideal: Winckelmann and the Origins of Art History* (New Haven, 1994).

[13] Haskell/Penny 196, no. 30.

[14] According to one catalog of the collections at the Louvre, the left arm was incorrectly restored by Barthélemy Prieur and should instead be raised, holding a bow: Mme. Chevallier-Vérel, *Encyclopédie photographique de l'art* [The photographic encyclopedia of art], *The Louvre Museum* (Paris, 1928), 3:198–99.

[15] See Alain Pasquier, *The Louvre: Greek, Etruscan and Roman Antiquities* (London, 1991), pp. 43–44 with fig. on p. 42.

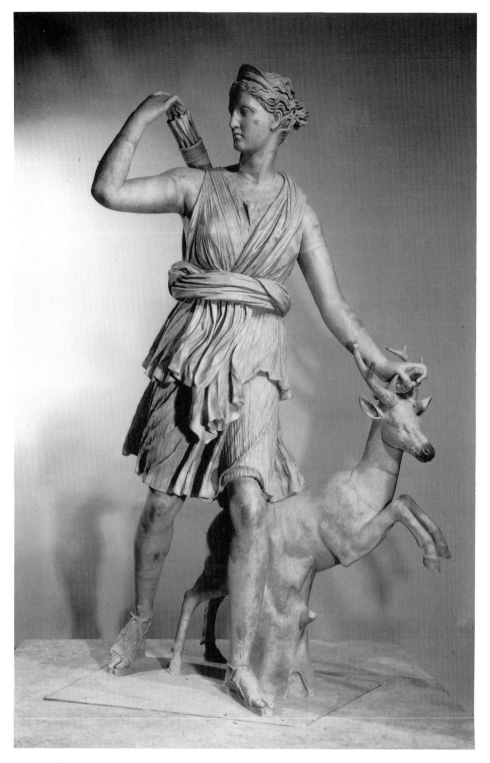

5.2. Marble Artemis of Versailles, known to have been at Fontainebleau in 1586. H 2 m. Paris, Louvre MA 589. See also fig. 7.6. Courtesy of the Louvre, Musées Nationaux, Paris.

not today one of the best-known Classical statues, her image has endured. In a sacrificial scene on the relief decorating Heinrich Schliemann's tomb in Athens, she appears as a statuette on a high base.[16] And "Diana" olive oil from Kalamata bears her image on both the label and the lid, rendered not as if she is a statue, but as a living goddess. In other words, this statue has acquired a post-antique life of its own: like the Belvedere Apollo, the Artemis of Versailles is famous in its own right.

Scholars first approached this statue by way of the literary testimonia. Pausanias describes a statue of Artemis, made by Praxiteles, which had a torch, a quiver, and a dog and which stood in a sanctuary outside the town of Antikyra in Phokis.[17] Coins from Antikyra show a short-skirted striding Artemis holding a torch and with some small animal at her feet, possibly a dog. Because of these two pieces of evidence, scholars have normally referred to the statue as a Roman copy of an important Greek statue. The "original" of this marble statue has been called a work of the fourth century B.C. and has been linked to Praxiteles, primarily because of the passage in Pausanias. But the "original" Artemis has also been associated with the Belvedere Apollo, and both are often ascribed to Leochares. In a recently published catalog of antiquities in the Louvre, the Artemis of Versailles is identified as a Roman copy of a second-century B.C. adaptation of a fourth-century original by Leochares.[18]

The fact is that we do not know where the Artemis came from, or who made it, or when, or whether it "copies" or emulates some other work. Certainly not unique, it was a popular antique genre. Of the fairly numerous sculptural versions of Artemis/Diana as a huntress, some are ascribed to the fourth century B.C., others to the Hellenistic period.[19] There is no reason to believe that a general agreement can ever be reached regarding the appearance of the "original" Artemis, if there was one, or its authorship, or its date. The same issues surround the Belvedere Apollo and many other statues that appear regularly in surveys of Greek art.

In a survey of Greek and Roman sculpture written in 1911, Adolf Furtwängler and Hans Ludwig Urlichs made it clear that they believed the works of marble they were studying in the European collections were imitations of famous bronze originals.[20] At about the same time, however, H. B. Walters qualified his own statement to that effect by pointing out that the works being studied were "mostly sculptures found in Italy, about which we have no direct information."[21] His caution in approaching the subject had little effect on the

[16] Schliemann's tomb, designed by the architect Ernst Ziller, was completed in 1892: see *Neo-Classical Architecture in Greece*, introd. John Travlos (Athens, 1967), figs. 259–62.

[17] Pausanias 10.37.1.

[18] See Pasquier, *The Louvre*, pp. 43–44.

[19] Fourth century B.C.: see Bieber, *Hellenistic*, p. 63, and idem, *Ancient Copies*, pp. 71, 73. Hellenistic: see Richter, *SSG*, p. 203. For a summary of the arguments over the date and for a good bibliography, see Ridgway, *HS* I, pp. 93–94 (with 106n42), 97–98.

[20] Adolf Furtwängler and H. Ludwig Urlichs, *Denkmäler griechischer und römischer Skulptur* (Munich, 1911).

[21] H. B. Walters, *Art of the Greeks* (London, 1906), p. 57.

thinking of other scholars, and the views presented in handbooks tended toward sweeping generalization. In 1920, Ernest Gardner, who firmly believed that the Belvedere Apollo was "a marble copy of a bronze original" of the Hellenistic period, wrote: "Originals may be defined as works which were actually made by the hand or under the immediate direction of the sculptor to whom they are to be assigned. . . . Copies form the great majority of the statues preserved in almost all European museums." He also mentioned that the later the date of the copy, the more mechanical it is.[22]

Fifty years later, it was generally agreed that there was a difference between Greek originals and Roman copies. Gisela Richter entitled chapter ten of her book on Greek sculpture "Greek Sculpture Compared with Roman Copies and Modern Forgeries." She allowed that "some [Roman copies] even approximate the Greek originals so closely that it is difficult to distinguish between them; but mostly they lack the sensitiveness that characterizes Greek work."[23] Margarete Bieber held the same views and, discussing drapery, she wrote that "the Greek statues are without mistakes." She also expressed the widely held view that "the faithful imitation of works of art which the ancients acknowledged as outstanding was not begun until after the first century B.C."[24]

Just a few years later, in the first of a series of lectures on ancient copies, published in 1984, Brunilde Ridgway called into question the meanings that have traditionally been applied to the words "original" and "copy." She wrote: if the word "copy" means "the reproduction of a work to such an extent that its similarity to the prototype is easily recognizable and, at least in the intention of the maker, the two pieces can be considered the same, then the Greeks themselves 'copied' from the very beginnings of stone carving, in the sixth century B.C."[25] Her examples of freestanding sculpture are Kleobis and Biton (fig. 1.3) and Dermys and Kittylos (fig. 1.4), although one might also mention a group of repetitive figures like the three korai in the Geneleos dedication from Samos (fig. 5.3).[26]

When we consider bronze instead of stone, we find that copying, or reproduction with molds, is a fundamental characteristic of the medium. In fact, we can trace the practice of copying much further back than the stone sculptures of the sixth century B.C., for it was during the Geometric period, by the ninth century B.C., that the Greeks had begun to cast bronzes by reproducing models in wax. "Copying" was understood, and techniques for

[22] Ernest A. Gardner, *A Handbook of Greek Sculpture*, rev. ed. (London, 1920), pp. 10, 12.

[23] Richter, *SSG*, p. 137.

[24] Bieber, *Ancient Copies*, p. 1. Also see, however, Frank Brommer, "Vorhellenistische Kopien und Wiederholungen von Statuen," *Studies Presented to David Moore Robinson*, ed. George E. Mylonas (St. Louis, 1951), 1:674–82. For the argument that the copying of Classical works began during the first quarter of the second century B.C., in Pergamon, see Jörg-Pieter Niemeier, *Kopien und Nachahmungen im Hellenismus* (Bonn, 1985). Peter-Cornelis Bol warns of the complexities here, observing that a single sculpture from the Antikythera shipwreck may combine actual copying on the front with free interpretation on the back: *Antikythera*, esp. pp. 98–103.

[25] Ridgway, *RC*, p. 6.

[26] For illustrations, see John Boardman, *Greek Sculpture: The Archaic Period* (London, 1978), figs. 66, 69–70, 91–92.

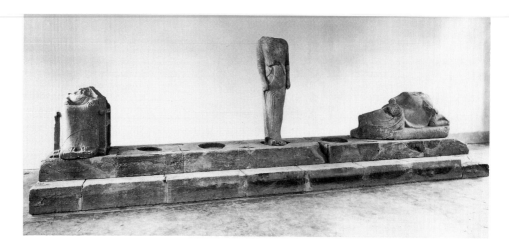

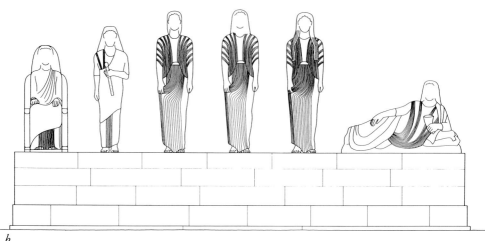

b

5.3. Marble Geneleos dedication, ca. 550 B.C., in Samos. L of base ca. 6 m. (*a*) View. Courtesy of Deutsches Archäologisches Institut Athens, neg. no. Samos 2546. (*b*) Restoration drawing. Courtesy of Hermann J. Kienast.

copying were being exploited. Certain categories of objects, such as votive offerings, had to be mass-produced. Workshops that produced statuettes had the same basic casting techniques at their disposal as those that produced handles or tripod legs or protomes. And the greater the demand for bronze dedications, the more likely a workshop was to develop faster, simpler foundry practices.

Because we have been brought up in a scholarly tradition based upon aesthetics, we are inclined to think of the two Geometric charioteers from Olympia as masterpieces (fig. 1.13). Maybe they are. Still, we must remember that they are not "originals" but are more like "copies": specifically, two in a series, in which parts of each "copy" were no doubt individually worked.

The strict categorization of the "Greek original" and the "Roman copy" is essentially a construct of the modern world. That construct is both artificial and oversimplified and, therefore, has imposed unnecessary limitations on our understanding of ancient sculpture. There are indeed examples of famous Greek statues that were reproduced by the Romans, such as the statues of the Tyrant Slayers and the Hermes of the Agora, both in Athens (see chapter 6). But we have been so dominated by this single distinction between "original" and "copy," particularly with regard to freestanding sculpture, that when we consider a series of works, or even a genre, we may imagine that they all hark back to one "original." When we perceive that the "original" no longer exists, we proceed to identify it through its "copies," and there comes a time when someone considers the copies in place of the original. Georg Lippold, in his *Kopien und Umbildungen griechischer Statuen* (Munich, 1923), distinguishes originals from masterpieces (originals that are copied) and from proto-types, and he uses as many as ten terms to describe various kinds of "copies." In German, this is a complicated construct. In translation, the distinctions become blurred, even between "original" and "copy." When we remember to explain that a work is a "copy" rather than an "original," we tend to take it for granted that the latter has something to do with "Greek" sculpture. To make matters worse, the work under consideration may have been heavily restored during the Renaissance or later, most likely to conform to the taste of the period.

We are here considering bronze statues as a separate category from marble, particularly for the opportunities for individuality offered by the additive process, but also for the simple mode of molding for reproduction. If we now look at some well-known Classical sculptures in this light, we shall be able to bring a new perspective to our understanding of those works.

The Running Hypnos

Representations of Hypnos/Somnus, the Classical god of sleep, exist in all media and in many guises: sleeping; running; young or old; as a participant in various mythological scenes. One particularly popular type shows Hypnos as a running figure with wings on his head and carrying attributes in both hands. This running image of Sleep was widely popular in the ancient world: at Classical sites in France, Spain, and Italy, large and small versions have been found, in marble and in bronze, some freestanding and some in relief.

The freestanding figures of Hypnos/Somnus are all very much alike, and the publica-tions about them provide a good illustration of where the efforts of scholars have tradi-tionally been directed with respect to what seems to be a single visual idea. Only one of these images can be dated by the context in which it was found, which was a first-century A.D. villa in Spain. Because the study of Classical sculpture has focused primarily on style, it should not surprise us that great importance has been attached to attributing the "original" statue of the running Hypnos to one of various artists whose names are known from the

literary testimonia. Indeed, most scholars agree that there was a single famous original of the Hypnos. Usually, rather than trying to make distinctions among the many surviving figures of the running Hypnos, scholars simply note the attributes and their possible iconographic significance, then proceed to generalize about the "original" Hypnos, calling it a work of the fourth century B.C. or, more often, a well-known statue, perhaps even a cult statue. Artists to whom the "original" has been assigned include Skopas, or his school, Leochares, and Praxiteles.[27] One lifesize bronze head of Hypnos, most recently identified as a Roman copy of a fourth-century Greek original, was once boldly called a Greek work, and A. W. Lawrence even suggested that this head was made by "an associate" of Praxiteles (fig. 5.4).[28] Since several statuettes of Hypnos come from sites in Roman Gaul, it has also been suggested that models went there directly from Greece, rather than being routed to their destinations through Italy.[29] Recently, the tendency has been to date the "original" running Hypnos later: for example, in the second half of the second century B.C.[30]

Surviving today are twenty or more freestanding images of Hypnos, some small, some large.[31] It has always seemed somewhat puzzling that Sleep should be running, but this is as he is often described in the literary testimonia, and every one of these figures is hurrying along, bringing sleeping potions and poppies along with him. There seem to be no substantial variations on the pose (fig. 5.5). Hypnos steps forward onto the left foot, and the

[27] Copy of a famous statue: H. Brunn, *Griechische Götterideale in ihren Formen erläutert* (Munich, 1893), pp. 26–36. Copy of a cult statue: Maxime Collignon, *Les statues funéraires dans l'art grec* (Paris, 1911), p. 341. Fourth century B.C.: A. Danicourt, "Hypnos," *RA* 43 (1882): 8. Skopas: Adolf Furtwängler, *Meisterwerke der griechischen Kunst* (Leipzig, 1893), pp. 648–49; Stephanie Boucher, *Bronzes romains figurés du Musée des Beaux-Arts de Lyon* (Lyons, 1973), p. 107; eadem, *Recherches sur les bronzes figurés de Gaule pré-romaine et romaine* (Rome, 1976), pp. 154–55; Catherine Lochin, s.v. "Hypnos/Somnus," in *LIMC* 5:607. School of Skopas: Robert Ricard, *Marbres antiques du Musée du Prado à Madrid* (Paris, 1923), pp. 40–41. Skopas or Praxiteles: L. Lerat, "Trois petits bronzes gallo-romains du Musée de Besançon," *Gallia* 8 (1950): 102. Praxiteles: A. S. Murray, *A History of Greek Sculpture*, rev. ed. (London, 1890), 2:34; idem, *Greek Bronzes* (London, 1898), p. 71; A. Blanco, *Museo del Prado: Catálogo de la escultura* (Madrid, 1957), pp. 68–69. Leochares: Hans Schrader, "Hypnos," in *85. Winckelmanns-programm* (Berlin, 1926), pp. 1–26.

[28] I am grateful to Brian F. Cook for allowing me to study this head. Fourth-century B.C. Greek original: Eduard F. von Sacken, *Die antiken Bronzen des k.k. Münz- und Antiken-Cabinetes in Wien* (Vienna, 1871), 1:79. Roman copy: Brian F. Cook, *Greek and Roman Art in the British Museum* (London, 1976), p. 179. Greek: Walters, *Catalogue*, p. 34. Associate of Praxiteles: A. W. Lawrence, *Classical Sculpture* (London, 1929), p. 253. Close to the Apollo Sauroktonos by Praxiteles: Hippolyte Bazin, "Hypnos, dieu de sommeil, ses représentations dans les musées et collections du sud-est," *Gazette Archéologique* 13 (1888): 27.

[29] Boucher, *Bronzes romains*, p. 107; eadem, *Recherches*, p. 155.

[30] See Paul Zanker, *Klassizistische Statuen* (Mainz, 1974), p. 116. Second century(?): Kurt Gschwantler, *Guss und Form* (Vienna, 1986), p. 113, no. 157.

[31] For examples in all media, see Lochin, s.v. "Hypnos/Somnus," in *LIMC* 5:591–609, esp. 597–98, nos. 40–57. For an early but thorough discussion of the type, including also reliefs, gems, and mosaics, see Wilhelm Klein, *Praxiteles* (Leipzig, 1898), pp. 136–37. An update and further discussion of the scholarship: Annalis Leibundgut, *Die römischen Bronzen der Schweiz*, 3: *Westschweiz Bern und Wallis* (Mainz, 1980), pp. 33–34, no. 26, pl. 32. Also see *LIMC* 5:597, nos. 40–57. Two more large bronzes can now be added to the list. One of these, from a New York private collection, is described in *Glories of the Past: Ancient Art from the Shelby White and Leon Levy Collection*, ed. Dietrich von Bothmer (New York, 1990), p. 242, no. 175. On the other, from a Roman villa near Córdoba, see Desiderio Vaquerizo Gil, "El Ruedo: Una villa excepcional en Córdoba," *Revista de Arqueología* 11, no. 107 (1990): 36–48, with illustrations.

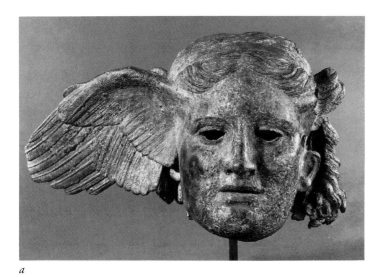

a

b

c

5.4. Lifesize bronze head of Hypnos, said
to have been found at Civitella d'Arno
(near Perugia) in 1855. H 0.21 m. London,
British Museum Br. 267. Copyright British
Museum.

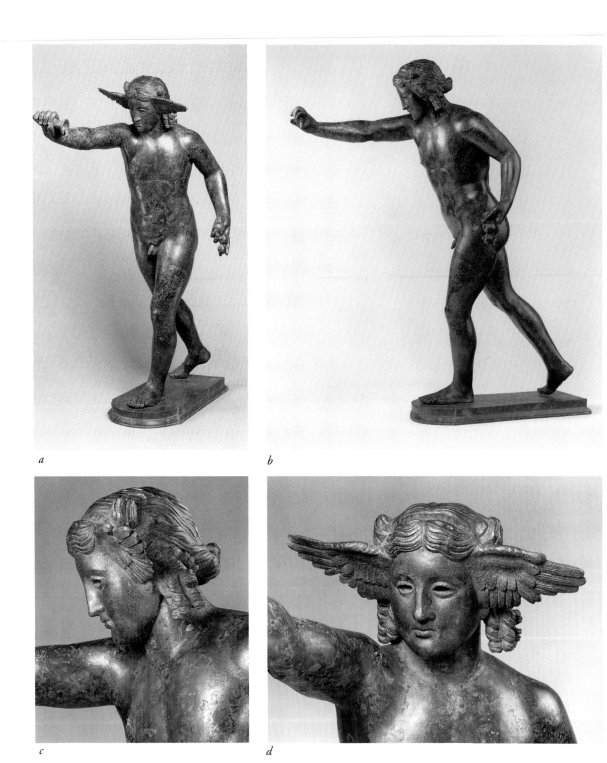

a
b
c
d

5.5. Bronze statue of Hypnos. H 0.619 m. The Shelby White and Leon Levy Collection. Courtesy of Shelby White and Leon Levy. (*a*) Photo by Sheldan Collins. (*b–d*) Photos by Bruce White (SL 1990.1.175).

right foot is placed well back and raised onto the ball as if to propel the body forward. He extends the right arm nearly straight out in front of him, and he appears to hold in his hand a rhyton or a drinking horn of some kind, tipped sideways and spilling a liquid, probably meant to be a sleeping draught. His left arm swings freely back, the torso turning slightly toward that side, and he carries poppy seeds in the left hand. Hypnos's youth is established by the fact that he has no pubic hair. The head is bent forward so that the eyes look downward. The small wings extending horizontally from Hypnos's temples are reminiscent of a hovering bird. Long hair is rolled into a bun on the nape of the neck and, above each wing, into a knot, while a few short curls hang down behind each wing. A fillet encircles the head above the wings.

Three lifesize heads of Hypnos, two in bronze and one in marble, appear to be almost exactly alike. One of the bronzes has been in the British Museum for many years (fig. 5.4).[32] The mouth is slightly open; the eyes were inset, and the wings were separately cast, slotted in, and soldered in place. The other bronze was found, together with its upper body, outside Córdoba, Spain, in 1989. It came from a Roman villa that was inhabited from the first to the fourth century A.D.; the statue, though, belonged within the first period of habitation, roughly during the reigns of Claudius and Nero. With the bronze were wall paintings, mosaics, and marbles, including two herms, an Attis, and a group of Perseus and Andromeda.[33] Apparently, these works formed a collection of decorative sculptures that ornamented the villa's central courtyard. The casting appears to be of the highest quality, and the fillet is inlaid with silver leaves; the torso is that of an adolescent.

The white-marble head belongs to a statue, complete except for its arms and wings, in the Museo del Prado in Madrid (fig. 5.6).[34] The statue is universally referred to as a copy of a Greek bronze original. Again, the body is that of an adolescent who is losing his childhood fleshiness but who has not yet acquired muscle tone.

The head, the wings, and the attributes of Hypnos have always seemed to attract most of the scholarly attention. As a result, the oddest thing about the Hypnos figures has been overlooked: he is not always an adolescent; sometimes he is a younger boy, still quite chubby, perhaps six or eight years old. One example of the younger Hypnos is in Berlin (fig. 5.7). The head and arms are missing, but the body is that of a little boy, noticeably plump, particularly in the stomach and the thighs.[35] Another particularly young Hypnos is

[32] The metal has been tested from the left ear, the right wing, the right curl, the left curl, and the head itself; the primary constituents of the alloy are 86–86.5% copper, 1.6–2.2% lead, 10.8–11.4% tin. From Paul T. Craddock, "The Composition of the Copper Alloys used by the Greek, Etruscan and Roman Civilisations: 2. The Archaic, Classical and Hellenistic Greeks," *JAS* 4 (1977): 103–23.

[33] See Vaquerizo Gil, "El Ruedo."

[34] Reported to have been acquired from the Duque de Frías for the Casa Real. See Blanco, *Museo del Prado*, pp. 68–69.

[35] For an illustration in color, see *Staatliche Museen zu Berlin: Die Antikensammlung im Pergamonmuseum und in Charlottenburg* (Mainz, 1992), p. 240, no. 124. I am grateful to Gerhard Zimmer for allowing me to study this statue, and to Uwe Rundstock for discussing the bronze with me and showing me various technical features. What is preserved of the statue was evidently cast in one piece, except for the front of the right foot. Still surviving on the neck is the original ledge for the join, which followed the crease under the chin up to a point

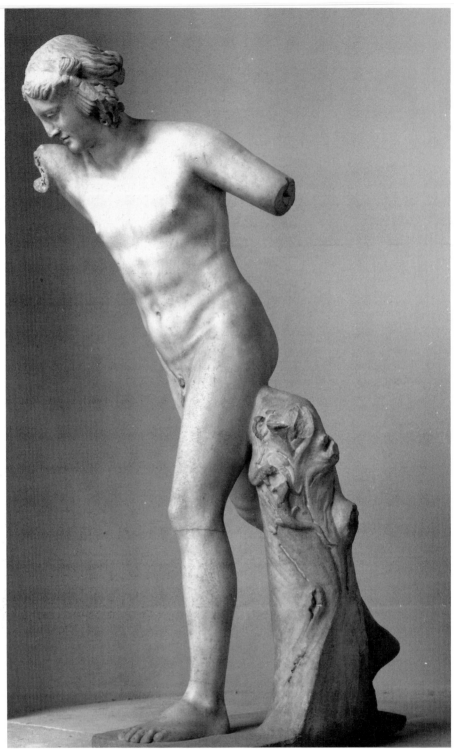

a

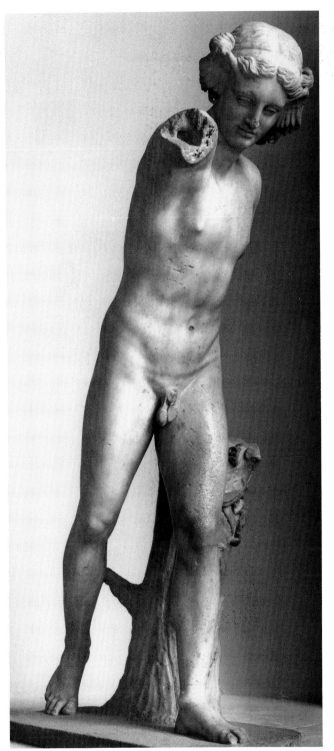

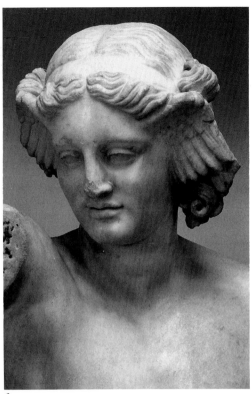

c

5.6. White-marble statue of Hypnos. H 1.5 m. Madrid, Museo del Prado no. 89. Courtesy of Museo del Prado.

b

in a private collection in New York and is one of the best-preserved examples (fig. 5.5). The thick, short legs and chunky torso make this Hypnos look far younger than does the head which, in profile, could almost pass for the head in the British Museum. From the front, however, this face is broader and coarser. Nonetheless, it is still that of a youth who could be some years older than his body would suggest. In his left hand, as we have seen, he holds some poppies, gone to seed; in his right, a tipped horn pours out bronze "liquid."[36]

The literary testimonia are rich concerning the subject of Hypnos. Hesiod introduces us to Sleep: although Sleep and Death are the terrible sons of Night, and live with her in Tartaros, where the Sun never goes, Hypnos is kind to men.[37] Homer likens him to a mountain bird with a clear call; he says that the gods call this bird Chalkis, but men call him Kumindis.[38] The need for Sleep and the power of the god are frequently mentioned in literary testimonia ranging in date from the first century B.C. to the second century A.D. Ovid's Sleep lies dozing in a cave with poppies and innumerable other sleep-inducing herbs growing around its mouth; when he wakes, Sleep is still heavy-lidded, yet his power over Iris, the messenger goddess, is such that she hurries from the cave.[39] For Virgil, Sleep flies down from heaven to put someone to sleep; and deep sleep is a heavy weight, resembling the peace of death.[40] Statius, late in the first century A.D., writes of Sleep as a young and gentle god, wearing a cloak and carrying a horn. At night, when he flies lightly over an individual, his wings induce sleep. By daybreak, Sleep has an empty horn, and he drops it while he too sleeps in a deep and quiet cave.[41]

Pausanias, traveling in Greece during the later second century A.D., saw two statues of Sleep in a sanctuary of Asklepios at Sikyon, one just inside the enclosure wall (*peribolos*), the other in the stoa. Although Pausanias writes that only the head is left of the first statue, lying on the ground, he must recognize it as Hypnos from the wings on its temples. The second statue, called Hypnos Epidoteis (the Bountiful), is lulling a lion to sleep.[42] Pausanias names no artists, so these were probably not famous statues: we can only imagine that he recognized the statues by their attributes and activities. The way in which he describes the ruined statue, first saying that it is lying on the ground, then adding that except for the head nothing is left of it, leads us to think that the statue was originally intended to be lying down. The statue of Hypnos lulling a lion to sleep was evidently

below the ears, then made an angle and curved along the nape of the neck. The break in the left arm, just below the shoulder, is close to the original join, as is the break around the left instep (the complete right foot has a similar join on the instep). The penis is inset, as are the copper nipples; patches of various sizes and shapes are *in situ*; and the color of the metal, where exposed, is a deep golden yellow.

[36] The base, rounded in front, is apparently ancient. See Bothmer, ed., *Glories of the Past*, p. 242, no. 175.

[37] Hesiod, *Theogony*, lines 755–63.

[38] Homer, *Iliad* 14.289–91.

[39] Ovid, *Metamorphoses* 11.592–632.

[40] Virgil, *Aeneid* 5.838–61, 6.520–22.

[41] Statius, *Silvae* 5.4 and *Thebaid* 2.144–45, 6.27, 10.88–158.

[42] Pausanias 1.10.2.

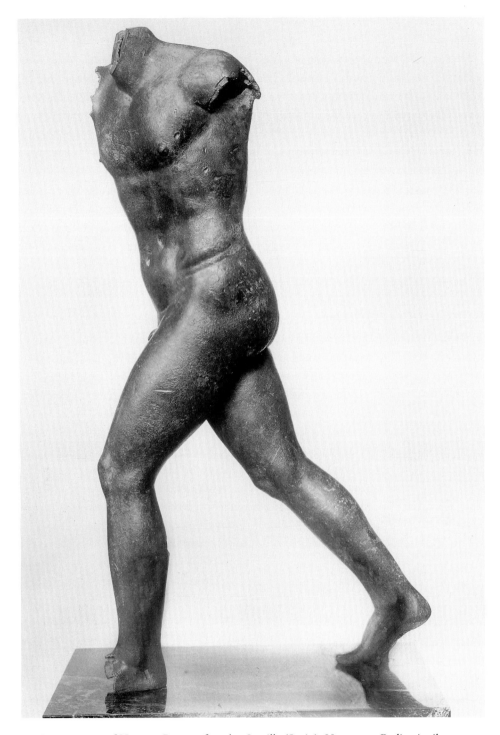

5.7 Bronze statue of Hypnos, Roman, found at Jumilla (Spain). H 0.715 m. Berlin, Antikensammlung Sk 1542. Courtesy of Antikensammlung, Staatliche Museen zu Berlin, Preussische Kulturbesitz.

unusual, nothing like the running figures which were so common. But this is all Pausanias tells us.

So where did the running Hypnos come from? He was certainly a popular concept in sculpture, particularly in the reliefs on Roman sarcophagi, where he is sometimes mature, sometimes young and delicate, sometimes a pudgy baby. We have seen the difficulties that scholars have had in dating the "original" from which the running type came, and we have seen that it can be young or very young. If we think of a single original model for a bronze Hypnos at the head of this tradition, we can imagine its being repeated as often as requested. Either a couple of versions were produced in the first place—one being a child, the other a baby—or tastes changed, and only later did a younger version come into fashion alongside the adolescent Hypnos. Either way, the casting process, and the usual practice of casting head and body separately, allowed for both repetition and change. So long as the idea of the running Hypnos survived, the visual manifestation of the god running along with his potions in hand could have been youthened according to buyers' preferences. If there was one artist who created this type, it was evidently not one of those few famous artists whose names are so conveniently preserved for us in the literary tradition. Knowing the casting process, can we really be sure that there was only one artist, one original?

We know from the Berlin Foundry Cup just how well Classical artists could vary their styles and how fully founders could take advantage of their medium. The feet shown hanging in the background of one scene on that cup are clear testimony to Greek versatility on both the technical and the artistic fronts (figs. 1.12 *a*, 2.17 *a*). It hardly seems appropriate now to assign a single Hypnos to a single artist, or to search for a particular date for such a statue: this genre was too long-lived, this type too popular, for that to be necessary. Nor was the type limited to a particular medium. Surely the buyer of a Hypnos would choose not just that general type of statue, but also the younger or the older version with certain attributes, the size, and the medium. All these features had more to do with the production of an individual work than with the conception of the *type* of the running Hypnos.

Sleeping Eros

Eros was a popular subject in the arts of later Greece and Rome—in poetry, in painting, and in sculpture. When represented as a sleeping child, he was especially enigmatic and thought-provoking. Six epigrams in the Greek Anthology are directed to Eros who, sleeping, is disarmed.[43] Once, he is described as sleeping in a wood among rose blossoms; elsewhere he lies beside a well. From one epigram we learn that the power of Eros is so great—even thus, on his back—that the author fears his only escape can be in death, if then. The child god's weapons are, of course, his bow and arrows, as well as a torch.

[43] Greek Anthology 9.826–27 and Planudean Appendix, nos. 210–13. For a brief discussion and additional references, see Barbara Hughes Fowler, *The Hellenistic Aesthetic* (Madison, 1989), pp. 148–50.

Sculptures of Eros disarmed and asleep, in marble and bronze, come from Greece, Italy, Cyprus, Turkey, North Africa, Spain, and France, and from throughout northern Europe (fig. 5.8). Sometimes, he is difficult to distinguish from Hypnos shown asleep,[44] but the popularity of this version of Eros is clearly attested by many examples about which we have no doubt. In Corinth, for instance, pieces from two marble statues of sleeping Erotes have been identified.[45] Eros may be sleeping on his back, facing right or left, lying on one side or the other, flat, draped over a rock, or propped up. His usual attributes include a quiver, bow and arrows, and the drapery beneath him. A torch, a lizard, and poppies are sometimes added. He can also become the infant Herakles, with a lionskin and a club. He may be connected with a fountain, or he may have a funerary connotation.[46] This is a popular genre, with infinite variations.

No one has ever doubted that the lifesize sleeping Eros in the New York Metropolitan Museum is a bronze of the highest quality, or that it is the best (or one of the best) examples of the genre (fig. 5.9 and pl. 4).[47] The statue is preserved almost in full, lacking only the left arm of Eros and the base on which he once lay. It is said to have come from Rhodes. The pudgy child lies on his left side, legs slightly spread, wings loosely folded along his back, and his right arm flopped in front of him. His head droops, his curly hair is tousled, and the flesh of his face hangs loosely, the mouth open. The drapery on which Eros lies is visible at his back and between his legs, a quiver strap crosses his chest, and the tips of a couple of arrows can be seen beside his hair. The left arm probably curled around his head, like the arms of so many sleeping Erotes.[48]

The question of the date of the Metropolitan Eros has attracted a great deal of attention. The assignments, all based on style, have an extraordinarily wide range, and shades of difference in opinion seem to be preferred to agreement. Gisela Richter's own indecision

[44] For the overlapping types of Eros and Hypnos asleep, see Lochin, s.v. "Hypnos/Somnus," in *LIMC* 5:594–96, nos. 11–34. For a brief but thorough summary of the activities and weapons of Eros awake, with references to the literary testimonia, see Anne Carson, *Eros the Bittersweet* (Princeton, 1986), p. 148. I thank Richard Mason for showing me this book.

[45] I am grateful to Charles Edwards and Nancy Bookidis for this information.

[46] See especially Magdalene Söldner, *Untersuchungen zu liegenden Eroten in der hellenistischen und römischen Kunst* (Frankfurt, 1986). Fountain from Nea Paphos, Cyprus: Porphyrios Dikaios, *A Guide to the Cyprus Museum*, 3d ed. (Nicosia, 1961), p. 104; Georgios Bakalakis, "Satyros an einer Quelle gelagert," *Antike Kunst* 9 (1966): 21n3; Cornelius Vermeule, *Greek and Roman Cyprus* (Boston, 1976), p. 51. Funerary: Otto Benndorf and Richard Schöne, *Die antiken Bildwerke des lateranischen Museums* (Leipzig, 1867), nos. 176, 370. For illustrations of sleeping Erotes, see Salomon Reinach, *Répertoire de la statuaire grecque*, 2d ed. (Paris, 1908), 2:490–93 and (Paris, 1913), 4:299–301; Königliche Museen zu Berlin, *Beschreibung der antiken Skulpturen* (Berlin, 1891), pp. 64–66, nos. 143–49; and Guido A. Mansuelli, *Galleria degli Uffizi. Le sculture* (Rome, 1958), vol. 1, pt. 1, nos. 106–9, figs. 107–10. Of particular interest as a parallel in bronze is a lifesize head of a sleeping Eros in Morocco, Rabat inv. V.172: Christiane Boube-Piccot, *Les bronzes antiques du Maroc* (Rabat, 1969), 1:160–63, no. 174, pls. 90–92. The heads, however, do not resemble each other except that both were attached to their bodies in the same way, at a join curving around under the chin, then angling backward to follow the hairline along the nape of the neck.

[47] See Joan R. Mertens, *Greek Bronzes in the Metropolitan Museum of Art, BMMA* 43.2 (1985): 52–53.

[48] For what appear to be close parallels, see Rome, Conservatori nos. 903, 1157; Söldner, *Eroten*, 2:609–10, nos. 24–25.

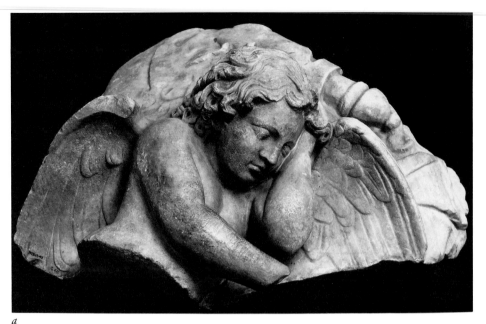

a

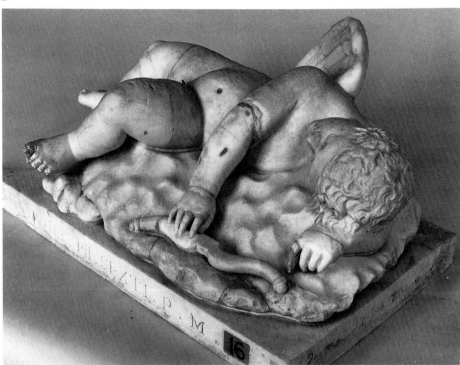

b

5.8. Parts of two lifesize sleeping Erotes, Roman, in marble. (*a*) L as pres. 0.42 m. Toronto, Royal Ontario Museum 925.13.43. Courtesy of the Royal Ontario Museum, Toronto, Canada. (*b*) Lifesize, extensively restored. Rome, Vatican Museums, Chiaramonti Collection. Courtesy of Deutsches Archäologisches Institut, Rome, Inst. Neg.88Vat716.

about the bronze encapsulates the problem: when she first published the Eros in 1943, she called it either the original or very close to it, and dated it between 250 and 150 B.C., an opinion that she still held ten years later and published in the Metropolitan Museum *Handbook*. In the 1969 *Handbook*, she still thought it was probably a Greek original, but dated it to a narrower stretch of time, between 240 and 200 B.C.[49]

No matter how frequently the Metropolitan Eros is published, scholars never agree on a date for it, and there is no sign of any desire for consensus. Consideration of the dates assigned to the statue is indeed a daunting prospect. We can choose from the third century B.C., 270 to 260 B.C., the middle Hellenistic period, the third to the second century B.C., around 200 B.C., perhaps the second century B.C., the second Pergamene school, the mid–second century B.C., circa 150 B.C., the middle or later second century B.C., the second half of the second century B.C., the third quarter of the second century B.C., or the late Hellenistic period.[50] Indeed, the problem of a date for the Eros seems to exist for its own sake, and no other approaches to the bronze are being undertaken.

There is no evidence to suggest that any particular artist was responsible for an "original" sleeping Eros, from which all of the extant versions could have been derived. We have no literary testimonia that refer to a statue of a sleeping Eros. Nonetheless, J. D. Beazley and Bernard Ashmole were not deterred from assigning the "original" sleeping Eros to Polykles of Athens in the mid–second century B.C. Yet Pliny lists Polykles as having made a famous sleeping Hermaphrodite, not a sleeping Eros.[51]

As for the magnificent Metropolitan Eros, scholars have suggested that it is either *the* "original," on which all of the other statues are based, or *an* "original."[52] If we wish to find

[49] G. M. A. Richter, "A Bronze Eros," *AJA* 47 (1943): 365–78; eadem, Metropolitan Museum of Art, *Handbook of the Greek Collection* (New York, 1953), p. 124, and 6th ed. (1969), p. 177. In a more recent catalog, the Eros is "Greek, 3rd to 2nd c. B.C.": *The Metropolitan Museum of Art: Greece and Rome*, introd. Joan R. Mertens (New York, 1987), p. 72.

[50] Third century B.C.: Phyllis Williams Lehmann and Karl Lehmann, *Samothracian Reflections* (Princeton, 1973), p. 189n9. The Lehmanns also asserted that the bronze Eros must have been a fountain statue, citing "traces of exposure to the spray of water [that] are clearly visible on the left foot." No such traces can now be seen. 270–260 B.C.: Söldner, *Eroten*, 2:605. Middle Hellenistic period: Helbig, *Führer*, p. 288. Third to second century B.C.: Mertens, *Greek Bronzes*, p. 52; eadem, *Metropolitan Museum of Art* introd., p. 72. Around 200 B.C.: A. W. Lawrence, *Later Greek Sculpture* (New York, rpt. 1969), p. 23. Perhaps the second century B.C.: Ridgway, *HS* I, p. 328. Second Pergamene school: Richard Brilliant, *Arts of the Ancient Greeks* (New York, 1974), p. 346. Mid–second century B.C.: G. Gualandi, "Sculture di Rodi," *Annuario della Scuola archeologica di Atene e delle Missioni italiane in Oriente* n.s. 38 (1976): 34n1. Ca. 150 B.C.: Werner Fuchs, *Die Skulptur der Griechen*, 4th ed. (Munich, 1993), p. 319. Middle or later second century B.C.: Robertson, *HGA*, p. 553, pls. 175 c, 176 a. Second half of second century B.C.: J. Charbonneaux, R. Martin, and F. Villard, *Hellenistic Art* (New York, 1973), p. 395. Third quarter of second century B.C.: Hans Walter, "Zur späthellenistischen Plastik," *AM* 76 (1961): 150. Late Hellenistic: Christiane Dierks-Kiehl, *Zu späthellenistischen bewegten Figuren der 2. Hälfte des 2. Jahrhunderts* (Cologne, 1973), p. 92.

[51] J. D. Beazley and Bernard Ashmole, *Greek Sculpture and Painting to the End of the Hellenistic Period* (Cambridge, rpt. 1966), p. 84. Pliny: "Polycles Hermaphroditum nobilem fecit" (*NH* 34.80).

[52] Bieber thinks it is the original (*Hellenistic*, p. 327), as does Bernard Andreae ("Schmuck eines Wasserbeckens in Sperlonga," *RM* 83 [1976]: 307). Wolfgang Helbig thinks it might be (*Führer*, 2:288), and B. S.

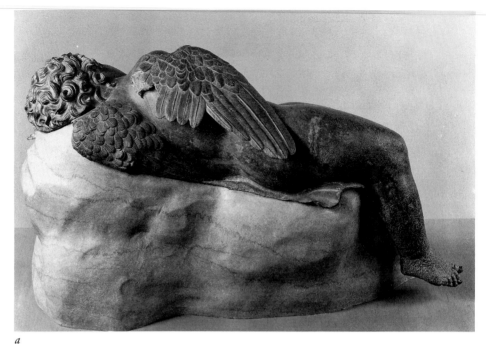

a

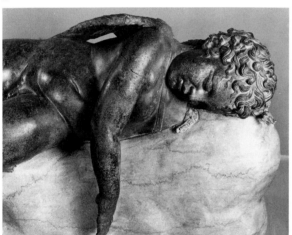

b

c

5.9. Lifesize bronze sleeping Eros, purchased in 1943 and said to be from Rhodes. L 0.852 m. New York, Metropolitan Museum of Art 43.11.4. Rogers Fund, 1943. See also pl. 4. Courtesy of Metropolitan Museum of Art.

something new to say about the Metropolitan Eros, we should look again at the statue itself. It is rich in technical information, and from it we shall be able to learn something about whether to describe the figure as an "original" or as a "copy."[53]

Except for the modern base, the bronze is almost complete. Underneath, it is not a full figure but has a cast edge that fit the original base; the thighs also have no undersides. The bronze was cast in several pieces: the left wing and the body; the right wing; the head; the right arm; the triangular piece of drapery between the legs; and probably the left arm, which is now missing. Throughout, this Eros is a thin-walled and even casting. Thus it has the look of a bronze "copy": that is to say, a bronze that closely follows the original model, very few alterations having been made in the working model, and none that required much additional wax. This bronze could have been one in a series, or it could have been a unique casting, depending then as now on the maker and the market. The more you paid, the better the sculpture you could get. The Metropolitan Eros is undeniably a fine bronze, and it may be that only one was cast from the original model. If there were more, we might think in terms of the numbered and signed limited editions of modern artists.

We know of no other Erotes that are exactly like the Metropolitan bronze, and no two of the many other Erotes have been closely matched, although we should expect that workshops would have produced such figures in quantity, given the great popularity of the genre and the wide range of findspots. All of these Erotes are obviously not based on a single original; nor do they come from a single series, or even from a single workshop. They are too different—in style, in material, in function, and in provenance. For example, Figure 5.10 shows the sleeping Eros in reverse. The Erotes are simply variations on a popular theme, one that was surely current in other contexts besides outdoor sculpture, fountain ornaments, and funerary monuments. The character of the popular genre, not just in sculpture but in painting and literature, will serve to remind us that such an image need not have a famous artist's name attached to it, however much we might wish for the convenience of finding an artist's name inscribed on a statue or on its base or, at the very least, recorded alongside such a work in the literary testimonia.

The problem of a date for the bronze Metropolitan Eros cannot be solved stylistically because no single date is really applicable to such a familiar type. As for the technique, it is highly sophisticated, but still we can only tentatively conclude that the Eros is no earlier in date than the Hellenistic period, and we can make no assumptions about how late it might be. Instead of seeking the date of some "original" on which every other sleeping Eros depended, thus ignoring the inherent diversity of such a series, we might more profitably consider how long this type of figure remained popular, in how many guises, and in how

Ridgway is not sure (*HS* I, p. 327). Söldner calls it *an* original: *Eroten*, 2:605, no. 17. Brilliant thinks it *may be* a Hellenistic original: *Arts of the Ancient Greeks*, p. 346.

[53] I am grateful to Carlos A. Picón for allowing me to study this statue, and to Richard E. Stone for having it removed from exhibition for me to examine.

many contexts. The epigrams tell us much about just how familiar the public was with this young god, and they bring to life the unpredictable nature of Eros as he was known in the popular imagination. That two examples come from Corinth gives us only a clue to the market's demand for such figures.

During the early sixteenth century, Erotes once again seized the popular imagination, no doubt fueled by the discovery of such images from antiquity. We see Erotes represented in both the sculpture and the painting of the Renaissance, and we are treated to endless variations on the theme of sleep. Michelangelo is reported to have made a lifesize-marble sleeping Eros, which was buried and later sold as an antiquity.[54] Eros appears in painting as well. Piero di Cosimo added several Erotes to the background of his *Venus, Mars, and Amor*, all of them playing with the armor of the sleeping Mars, and one Eros in particular lies on top of the cuirass, legs splayed, in a pose that is an unmistakable reference to Classical statues of this genre.[55] A seventeenth-century marble sculpture in Rome consists of three white sleeping Erotes flopped on top of one another against a black background.[56] In the eighteenth century, P. E. Monnot sculpted the *Waking Child*, a languid marble baby lying on his back, one knee up, drapery beneath him and draped over his raised left arm.[57] Many of the nineteenth-century variations continue the heavily sentimental tradition, as is the case with *The Angel's Whisper* by Benjamin Edward Spence.[58]

The type of the sleeping Eros, then, has been of far more enduring interest than was true of the running Hypnos, partly because the sleeping winged baby allows for many more interpretations. Sometimes he even passes as Hypnos. There are, as we have seen, many variations, and the type has been revived repeatedly and for many uses. I do not know of more than one Eros coming from precisely the same series, and, in bronze, only the one large Eros survives. In contrast, there appear to be two distinct versions of the running Hypnos, with relatively little variation: an adolescent group and a more childish group. In one case, a figure has the head from one version and the body from the other. It remains to be seen whether two or more of them are so much alike that they can be assigned to a single series or, we might say, to one "sculptural edition." Given the small numbers of bronzes that have survived, this is unlikely, unless the head from Córdoba is found to match the head in the British Museum. There is, however, at least one extant example of what can

[54] See Giorgio Vasari's life of Michelangelo. For discussion and references, see Howard Hibbard, *Michelangelo* (New York, 1978), p. 22; Phyllis P. Bober and Ruth Rubinstein, *Renaissance Artists and Antique Sculpture* (Oxford, 1986), p. 89, no. 51; and *Michelangelo e l'arte classica*, ed. Giovanni Agosti and Vincenzo Farinella (Florence, 1987), pp. 43–47.

[55] Piero di Cosimo, *Venus, Mars, and Amor* (ca. 1505). Berlin, Staatliche Museen, Gemäldegalerie no. 107.

[56] Rome, Villa Borghese, room 6, no. 184: just under lifesize, labeled as an anonymous work of the seventeenth century.

[57] Stamford, Northamptonshire, Burghley House. Illustrated in Hugh Honour, "English Patrons and Italian Sculptors in the First Half of the Eighteenth Century," *Connoisseur* 141, no. 570 (1958): 221, fig. 3: ca. 1700(?).

[58] Liverpool, Sefton Park Palm House. See Benedict Read, *Victorian Sculpture* (New Haven, 1982), p. 205, fig. 267.

a

b

5.10. Bronze statuette of sleeping Eros, purchased in 1913; from the Ficoroni Collection. L 0.21 m. New York, Metropolitan Museum of Art acc. no. 13.225.2. Courtesy of Metropolitan Museum of Art.

only be called an antique sculptural edition in bronze. It consists of two bronze herms, each of them approximately one meter in height.

Two Herms

Although they may not be as interesting as statues, images in the form of the herm were just as common in the ancient Mediterranean world. Pausanias reports that the Athenians introduced these limbless figures.[59] Archaeological evidence may corroborate his testimony. The earliest Greek herms date to the Archaic period, and they consist of the head of the god Hermes surmounting a tall rectangular shaft with a curve at the top, similar to the curve of the upper chest and shoulders. Short horizontal bosses on either side take the place of arms, and there are male genitals midway up the front of the shaft. At first, all these pillars represented Hermes, who was the protector of travelers, cities, and homes. These stylized representations were therefore placed at street corners and crossroads, at gateways and boundaries, and in doorways. Besides being placed on ground protected by or sacred to Hermes, herms might be found in sanctuaries of various other gods, in the gymnasium, and in the palaestra. There was also a cult of the herms.

Both the ubiquity and the importance of herms in fifth-century Athens are attested by a passage in Thucydides. He describes the citizens' dismay and outrage on discovering that the herms standing in public had been mutilated during the course of one night in 415 B.C.:

> . . . the stone herms in the city of Athens, the rectangular figures, of which, according to local tradition, there are many both in doorways and in temples. In one night, most of the herms had their faces cut off. No one knew who was responsible, but large rewards were offered by the state to discover who had done it, and it was voted that anyone who knew anything, citizen, foreigner, or slave, or who knew of any other such sacrilege, should tell of it without fear. This was all taken very seriously, for it seemed to be an omen regarding the departure of the ships, as well as evidence of a conspiracy to overthrow the government.[60]

The "departure" to which Thucydides refers was the expedition of the Athenian army against Sicily in 415 B.C., and it was indeed a terrible failure. Alkibiades, one of the generals who had been chosen to lead the expedition, was accused before he left of being one of the *Hermokopidai* (those who had vandalized the herms). The charges were temporarily dropped, however, and Alkibiades was able to go to Sicily. When he was recalled to Athens to face a full inquiry concerning the crime, and also to answer the charge that he had been

[59] Pausanias 1.23.3.
[60] Thucydides 6.27.

involved in the blasphemous parody of the Eleusinian Mysteries, he did not comply but instead sought asylum in Sparta.

By the fifth century B.C. some herms erected in Athens had commemorative functions, rather than protective ones. Thus, after Kimon defeated the Persians at Eion on the Strymon River in 476 B.C., he was allowed to dedicate three stone herms in the Agora to celebrate the victory.[61] There was a Stoa of the Herms beside the Panathenaic Way, and a row of herms stood in front of the Royal (*Basileios*) Stoa.[62] Herms could also be installed as private dedications. During the fifth century B.C., at least one herm was placed in the Eleusinion, a sanctuary of Demeter just south of the Athenian Agora, beside the Panathenaic Way as it began its climb to the Akropolis. That herm is said to have been adorned with two crowns or wreaths, a feature for which there also seems to be evidence on an extant bronze herm.[63]

The head on a herm was not necessarily that of Hermes, but could be that of some other god or goddess. Later on, heads representing victorious young athletes were placed on herm shafts. Portrait herms, evidently also a later development, were very common during the Hellenistic and Roman periods. Herm shafts bearing the heads of famous statesmen, philosophers, and poets might be used as garden ornaments, or placed in niches, or even set up in rows along galleries. Some had two heads attached to each other, back to back, representing such combinations as two gods or two famous historical figures. Herms were also used as architectural supports or as the posts in balustrades. Sometimes, too, they served as supports for marble figures, which rested one elbow on the head of the herm, as does the statue of Sisyphos II in the fourth-century B.C. Daochos dedication at Delphi (fig. 3.1*e*). Most herms are best described as being either Classical or archaistic in style. Some have short hair, others have long hair; some represent gods, others represent famous people.[64]

Most of the large-scale Classical herms that survive today are made of stone; a few are of terra-cotta. It is indeed strange that the only two large bronze herms we have should bear such striking similarities to each other. One of these has been known since the beginning of the twentieth century; the earliest mention of the other seems to be 1971, when it was on the market. Naturally, when the second herm appeared, having no provenance, questions were raised about its authenticity: specifically, about whether it was "copied" from the other, "original" herm.

[61] Plutarch, *Kimon* 7.

[62] See H. A. Thompson and R. E. Wycherley, *The Agora of Athens*, The Athenian Agora 14 (Princeton, 1972), pp. 94–96. For the Royal Stoa, see Camp, *Agora*, pp. 53–57.

[63] See Agora inscription I 5484: Wycherley, *Agora* 3, p. 82, no. 226. For discussion, see Harrison, Agora 11, pp. 121–22. For the possible use of a wreath on a bronze herm, see n. 89 below.

[64] For exhaustive treatment of the types, uses, and development of herms, see Henning Wrede, *Die antike Herme*, Trierer Beiträge zur Altertumskunde 1 (Mainz, 1985); Harrison, Agora 11, pp. 108–76; Reinhard Lullies, *Die Typen der griechischen Herme*, Königsberger Kunstgeschichtliche Forschungen 3 (1931); and Olga Palagia and David Lewis, *BSA* 84 (1989): 333–34.

The first of these bronze herms comes from the so-called Mahdia shipwreck (figs. 5.11, 5.13, 7.3, and pl. 7). A ship carrying numerous marbles and bronzes, including sculpture, furniture, decorative items, and architectural elements, sank in the 80s or 70s B.C. Presumably, this was one of the many merchant ships sailing between workshops in Greece and the vast numbers of buyers in Italy during the first century B.C. The ship's contents may actually represent one specific order, perhaps meant to outfit a Roman house or villa.

It has been noted that the four marble figures of nude children or child satyrs from the ship have three exact parallels in pool ornaments from the first-century A.D. Tiberian villa at Sperlonga, on the Tyrrhenian coast north of Naples, which could mean that some marbleworking shop had a profitable life of at least one hundred years' duration.[65] It is also possible, however, that this popular type of fountain figure was produced from models owned by more than one workshop.

In 1907, objects from the wreck were discovered by fishermen off the coast of Tunisia, near the modern town of Mahdia. When archaeologists investigated the site, they recovered vast quantities of material, including a bronze herm of Dionysos, measuring approximately one meter in height. The herm was one of several large-scale bronzes found in the Mahdia shipwreck: among them, the most often published is a statue of a winged boy.[66] Both the boy and the Dionysos herm were in remarkably good condition, and both retained the lead dowels that had been used to attach them to bases. The only major damage to the herm is that a large section is missing from the lower-left front angle of the shaft, and around that area the bronze is bent outward, as if the herm had once been pried off its base.[67]

The head of a turbaned Dionysos crowns the herm, and a dotted inscription on the right arm-boss names Boëthos of Chalkedon, a second-century B.C. artist, as the maker of the herm.[68] The bronze statue represents a boy standing firmly on his left foot, his right foot trailing. Wings grow from his shoulders, and he wears a twisted leafy wreath on his head. The boy's right hand is raised to the wreath, and in his left hand he once held something upright, perhaps a bow. Scholars have traditionally identified the boy as Eros Enagonios or as Agon, a combined personification of the boy Eros and the boy athlete (fig. 5.12). But he is more likely to be simply an Eros.[69] By 1926 the statue had been restored

[65] See Ridgway, RC, pp. 9–10, with references, and Bernard Andreae, "Statuetten eines sitzenden Knäbleins," in Das Wrack, 1:365–74. Another remarkably similar marble figure, in a private collection, probably belongs to the same series: Bothmer, ed., Glories of the Past, p. 236, no. 171.

[66] See the original publication of the wreck (Werner Fuchs, Der Schiffsfund von Mahdia [Tübingen, 1963]), and Gisela Hellenkemper Salies, ed., "Der Schiffsfund von Mahdia," BJb 192 (1992): 507–36. The wreck has now been thoroughly reinvestigated in Das Wrack. For a comparison of this ship's cargo with that of the Antikythera ship, see Nikolaus Himmelmann, "Mahdia und Antikythera," in Das Wrack, 2:849–55.

[67] Frank Willer, "Zur Herstellungstechnik der Herme," in Das Wrack, 2:968 and pl. 34.1.

[68] For the inscription, see Fuchs, Der Schiffsfund von Mahdia, p. 13, pl. 8. For various types of the bearded Dionysos herm, see Jean Marcadé, "Les trouvailles de la maison dite de l'Hermès, à Délos, I. Sculpture. 1. Tête d'Hermès barbu," BCH 77 (1953): 500–512.

[69] I am grateful to Olga Palagia for bringing her straightforward and compelling identification to my attention. Magdalene Söldner also identifies the youth as Eros: "Der sogenannte Agon," in Das Wrack, 1:399–429.

a *b*

c *d*

5.11. Bronze Dionysos herm signed with the name of Boëthos, probably second century B.C., from the Mahdia ship (wrecked in the 80s or 70s B.C. and discovered in 1907). H 1.03 m. (*d*) Before restoration in 1992/1993. Tunis, Bardo Museum F 107. See also figs. 5.13, 7.3, and pl. 7. Courtesy of Rheinisches Landesmuseum, Bonn. Photos H. Lilienthal.

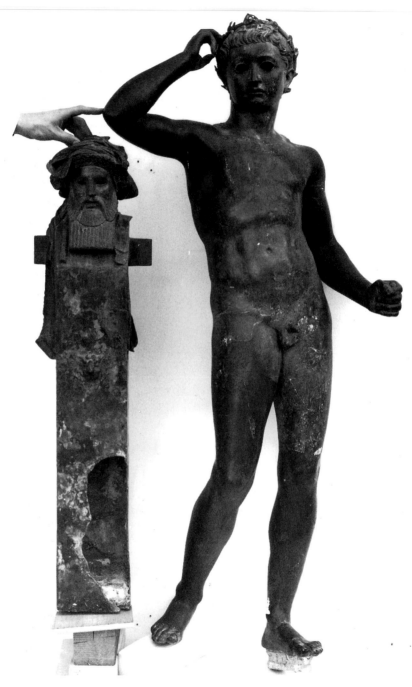

a

5.12. Lifesize bronze statue of a boyish Eros, perhaps second century B.C., from the Mahdia ship (wrecked in the 80s or 70s B.C. and discovered in 1907). H ca. 1.36 m. (*a*) Before restoration of 1994, with the Dionysos herm signed by Boëthos; (*b*) after restoration of 1994. Tunis, Bardo Museum F 106. Courtesy of Rheinisches Landesmuseum, Bonn. Photos H. Lilienthal.

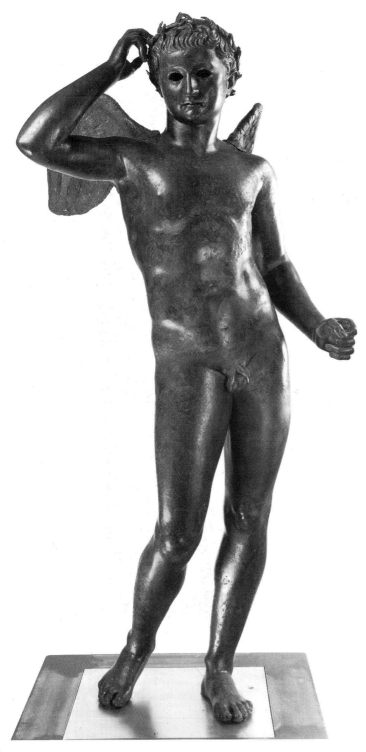

b

so that his right elbow could rest on the turbaned head of Dionysos, and he was almost universally attributed, along with the herm, to Boëthos.[70]

Both statue and herm have lead dowels for attachment to stone bases, a feature that implies both bronzes may have been installed at one time, before being loaded for shipping. In fact, as noted above, one side of the herm is bent in such a way as to make it easy to visualize how it was pried up from its base. But beyond this weak link, there is no evidence that the Dionysos herm and the statue ever belonged together. The two bronzes, moreover, are composed of different alloys.[71] This alone would not normally be of any great significance, but in this case we shall see that the Mahdia herm has the same alloy as a very similar herm in the J. Paul Getty Museum.

Occasionally, marble statues lean on herms: one early example is the fourth-century B.C. statue of Sisyphos II from the Daochos monument at Delphi (fig. 3.1e). The drapery belongs to the statue, not to the herm, and it falls over the statue's arm, perhaps bunching up on top of the herm.[72] In bronze, no such support is needed, given the far greater tensile strength of the medium. Indeed, in order for the right elbow of the Eros to meet the head of the Mahdia herm, the right foot must be raised, and that is how it was originally restored,[73] even though there was no evidence for such a position. Without the raised foot, the youth is not tall enough to have leaned on the herm. Nor is there any mark either beneath the right elbow of the statue or on top of the head of the herm to suggest that the two were ever in contact with each other. The right arm of the Eros was never supported: it was simply raised so that he could finger his wreath, a gesture that is not unusual for Classical bronze

[70] For this restoration, see the original publication by Fuchs, *Der Schiffsfund von Mahdia*, drawing on p. 12. Early on, however, Henri Lechat discussed only the herm in connection with Boëthos: "Notes archéologiques," *REA* 12 (1910): 361–63.

[71] The metal of both was analyzed in 1993 by X-ray fluorescence spectroscopy, and the alloys are similar but not identical. Herm: Cu 70%, Sn > 9%, Pb 20%. Youth: Cu 64%, Sn 14%, Pb 22%. I am grateful to G. Eggert for supplying these data. For evidence about how the herm might have been pried loose, see Willer, "Zur Herstellungstechnik der Herme," 2:968 and pl. 34.1.

[72] For herms used as statue supports, see Fritz Muthmann, *Statuenstützen und dekoratives Beiwerk an griechischen und römischen Bildwerken* (Heidelberg, 1951). For the Daochos monument (330s B.C.) in the Delphi Museum, see Smith, *HS*, p. 52 and figs. 44.1–2; for illustration of Sisyphos II's herm, Marcadé, "Tête d'Hermès barbu," p. 503, fig. 8. Marble herm supports: Athenian Agora S 33 (second century A.D.) and S 2144 ("Roman Period"), in Harrison, *Agora* 11, pp. 162–65, nos. 210–11; Sardis NOEX 70.15 (late Hellenistic or first century A.D.), in Nancy H. Ramage, "Draped Herm from Sardis," *HSCP* 78 (1974): 253–56, and Nancy H. Ramage and G. M. A. Hanfmann, *Sculpture from Sardis: The Finds through 1975* (Cambridge, 1978), p. 107, no. 110, fig. 236; Side Museum inv. 266 ("Antonine," after original by Kephisodotos), in Jalé Inan, *Roman Sculpture in Side* (Ankara, 1975), pp. 65–72, no. 19. Terra-cotta representation of Aphrodite leaning on a herm: statuette from Myrina, British Museum C 528, H 0.226 m. ("Greek . . . of the finer and later periods"), in H. B. Walters, *Catalogue of the Terracottas* (London, 1903), p. 244.

[73] See Fuchs, *Der Schiffsfund von Mahdia*, pp. 12–14, with fig. on p. 12 and pl. 2. For additional illustrations and for comparisons, see Charles Picard, "Boethos de Calchedon et l'Agon de bronze du Musée du Bardo," *Karthago* 3 (1951/52): 83–116. The statue has recently been dismantled and restored again, using modern technology and materials: Frank Willer, "Die Restaurierung des 'Agon,'" in *Das Wrack*, 2:971–84.

youths and that can be seen, for example, in the bronze lifesize statue of a young victor in the J. Paul Getty Museum.[74]

It was entirely on the basis of the hypothetical restoration that *both* the statue and the herm were attributed to Boëthos, and this attribution has been universally accepted. Because most scholars are more interested in the statue than in the herm, they tend to refer to the winged youth as being a work by Boëthos without even mentioning the herm, and the statue has actually been described as bearing "the dotted signature of Boëthos of Chalcedon."[75] Useful as it might be to have a signed statue by a known artist, the fact is that the *herm* is inscribed, not the Eros.

The faint inscription on the right arm-boss of the Mahdia herm is certainly its most remarkable feature (fig. 5.13). It reads:

ΒΟΗΘΟΣ ΚΑΛΧΗΔΟΝΙΟΣ ΕΠΟΙΕΙ

Boëthos of Kalchedon made it.

To be sure, statue bases are often inscribed with artists' names, but it is rare, to say the least, for a large-scale Classical sculpture in either bronze or marble to have the name of an artist or founder written directly on it.[76] In this case, the dotted letters of the inscription were cut into the wax working model for the bronze.

Not much is known about this Boëthos, but a brief outline of his works can be pieced together from the literary testimonia. He lived during the second century B.C. and came

[74] The Getty youth: J. Paul Getty Museum, no. 77.AB.30; pres. H 1.51 m. See Jiri Frel, *The Getty Bronze* (Malibu, Calif., 1978). The date of this statue is open to debate.

[75] Jean Charbonneaux, *Greek Bronzes*, trans. K. Watson (New York, 1962), p. 130. In this case, though, Charbonneaux adds that the statue is "leaning on a herm of Dionysos." For a more recent example of the attribution of the statue to Boëthos, see J. J. Pollitt, *Art of the Hellenistic Age* (New Haven, 1986), p. 140. Recent research on the two bronzes has shown that they were made in quite different ways and that the lead dowels are of different composition. For technical differences between the Dionysos herm and the Eros, see Willer, "Zur Herstellungstechnik der Herme," pp. 959–70, and idem, "Die Restaurierung des 'Agon,'" pp. 981–84. For the lead, see Friedrich Begemann and Sigrid Schmitt-Strecker, "Das Blei von Schiff und Ladung: Seine Isotopie und mögliche Herkunft," in *Das Wrack*, 2:1073–76.

[76] Here are a few examples of inscribed statues. The colossal marble Farnese Herakles from the Baths of Caracalla in Rome (ca. A.D. 211–17) is inscribed in Greek on the rock beneath the club: "Glykon the Athenian made it" (Naples, Archaeological Museum, inv. 6001; H 3.17 m. Left hand and forearm restored). A bronze bust (with arm bosses) representing the head of the Doryphoros by Polykleitos, from the Villa dei Papiri in Herculaneum, is inscribed in Greek on the front at the bottom: "Apollonios, the son of Archios, the Athenian, made it" (Naples, Archaeological Museum, inv. 4885; H 0.54 m.). Two larger-than-lifesize bronze statues from the ancient city of Nakhlat al-Hamra in southern Arabia, dating to the late third or early fourth century A.D., are inscribed across the chest in South Arabic script with the names of the late-third-century or early-fourth-century A.D. dedicators. One of the statues has additional inscriptions on both knees: on the left knee, in Greek, "Phokas made it"; on the right one, in South Arabic, "Lahay amm finished it" (Sana National Museum; both heavily restored. Present H ca. 2.37–2.38 m.). See Konrad Weidemann, *Könige aus dem Yemen: Zwei spätantike Bronzestatuen* (Mainz, 1983).

5.13. Inscription ("Boëthos of Kalchedon made it") on the right arm-boss of the Mahdia herm. See also figs. 5.11, 7.3, and pl. 7. Courtesy of Rheinisches Landes-museum, Bonn. Photo H. Lilienthal.

from the Greek city of Kalchedon, across from Byzantion on the Sea of Marmara, but evidently he traveled to Rhodes and Delos, where he had commissions for sculpture. Besides the bronze herm, two stone statue bases bear inscriptions with the name of Boë-thos. One of these statue bases is from Delos, and it records that Boëthos, son of Athanaion, made the portrait of Antiochos IV (175–164 B.C.) that originally belonged on the base. The other inscription, on a statue base from Lindos in Rhodes, gives only the name of Boëthos, the son of Athanaion, from Kalchedon. In the first century B.C., Cicero mentions a man whom Verres robbed of a beautiful silver hydria by Boëthos.[77] The name Boëthos is also inscribed on a cameo bearing the image of a figure that has been identified as Philoktetes, but this Boëthos could be another artist of a different date.[78]

Pliny states twice that Boëthos was best known for his metalwork, and on one occasion Pliny adds that the same artist also sculpted a baby strangling a goose.[79] Although there is a

[77] Cicero, *In Verrem* 2.4.14.

[78] For the ancient references to Boëthos, see Overbeck 302, nos. 1596–1600; Pollitt, *Greece*, pp. 115–16; and A. Rumpf, "Boethoi," *ÖJh* 39 (1952): 86–89. For the statue bases from Delos and Rhodes, see Jean Marcadé, *Recueil des signatures de sculpteurs grecs* (Paris, 1957), vol. 2, no. 28. For general discussion of the problems associated with this artist, see L. Laurenzi, "Boethos (1), (2), (3), (4), (5), (6)," in *EAA* (1959), 2:118–22; Richter, *SSG*, p. 236; and Pollitt, *Hellenistic Age*, pp. 128, 140–41, 269.

[79] *NH* 34.84, 33.155.

mime by Hero(n)das about two women discussing sculptures in the Sanctuary of Asklepios on Kos, one of which is a stone boy strangling a goose, the third-century date of this poet does not allow us to assign the group to Boëthos.[80] Apparently this was a popular subject, and there are two common variations on the theme: one with the child standing, the other with him seated.[81] Both types were often repeated and revised. In the one, an enthusiastic baby with legs planted far apart grabs a passing goose by the neck as if to try to turn it in the opposite direction from that in which it is headed. Three figures like this were found in a second-century A.D. villa alongside the Via Appia outside Rome (fig. 5.14 *a–c*). All three appear to be very much the same, with the exception, perhaps, of differences that could have been introduced by the modern restorers. The villa in which the three figures were installed was owned by the brothers Condianus and Maximus Quintilius, who used the statues as fountainheads (the three geese were channeled so as to spout water from their beaks).[82] The seated baby with the "goose" makes a clumsy contrast to the standing one. Here a baby timidly tries to hang on to a duck by encircling its ruffled body with one arm and grasping its neck with the other hand; instead of focusing on the duck, though, he turns his head up and away from it (fig. 5.14 *d*).[83] We may never know whether some version of either of these two basic types was conceived by Boëthos, or whether he simply produced one example of this popular and enduring type. Apparently, the seated nude gilded child by Boëthos that Pausanias saw in the Heraion at Olympia was another statue altogether, without a goose.[84]

It is worthy of note that the image of a splay-legged standing baby wrestling with a goose

[80] Herondas 4.20–34.

[81] See Pollitt, *Hellenistic Age*, pp. 128–29, figs. 132–33. For the standing version, see Bober/Rubinstein 233–34, nos. 200–201. The argument for there having been a well-known Boëthos of the second century B.C., and a continuing family workshop, has recently been presented by Andreas Linfert, "Boethoi," in *Das Wrack*, 2:831–47.

[82] See Richard Neudecker, *Die Skulpturen-Ausstattung römischer Villen in Italien* (Mainz, 1988), pp. 191–97, no. 39.19 *a–c*, pl. 10.

[83] There is an example of the same type from the villa of Poppaea at Oplontis, which was destroyed in the eruption of Vesuvius in A.D. 79. This baby with duck belonged on a fountain; water issued from the beak of the duck. See Stefan De Caro, "The Sculptures of the Villa of Poppaea at Oplontis: A Preliminary Report," in *Ancient Roman Villa Gardens*, Dumbarton Oaks Colloquium on the History of Landscape Architecture 10 (Washington, D.C., 1987), pp. 94–96, no. 10, with citation of additional examples in the Vatican and in the Hermitage. Yet another example of this type, from Ephesos, is in the Kunsthistorisches Museum in Vienna, for which see Fowler's discussion of this subject as a possible burlesque of the labors of Herakles or as a parallel to the baby Herakles strangling the snakes that Hera sent to kill him: *The Hellenistic Aesthetic*, pp. 50–52 with fig. 36. Since we do not know whether Boëthos made a baby with a goose or, if he did, what it looked like, this marble boy with duck is not likely to be either a "copy . . . of a second-century B.C. original" or "one of the many variants on the theme of the celebrated 'Boy with the Goose' by Boëthos" (De Caro, "Sculptures," p. 94). Furthermore, the other sculptures of the baby-with-duck type should not be called "replicas of the Oplontis statue" (p. 96) but, rather, representatives of a sculptural series or edition. There is also an Etruscan version of the seated baby playing with a pet or a toy, two bronze examples of which are in the Vatican, Museo Gregoriano Etrusco inv. 12.207 and 12.108. See Otto J. Brendel, *Etruscan Art* (New York, 1978), p. 430 and fig. 327 (12.207), and *The Vatican Collections*, pp. 198–99, no. 119 (12.108).

[84] Pausanias 5.17.4.

a

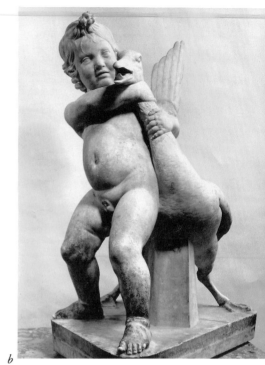

b

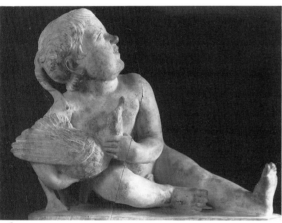

c

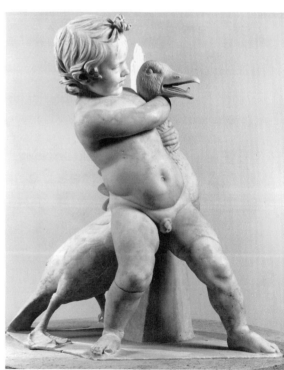

5.14. Lifesize marble statues of a baby grabbing a goose or a
duck, all restored. (*a–c*) Standing with goose, from a second-
century A.D. villa outside Rome. (*a*) Rome, Vatican Museums,
Galleria dei Candelabri IV 66/194. Courtesy of the Vatican
Museums. (*b*) Paris, Louvre MA 40. Courtesy of the Louvre,
Musées Nationaux, Paris. (*c*) Munich, Glyptothek no. 268.
Courtesy of Staatliche Antikensammlungen und Glyptothek,
Munich. (*d*) Seated with duck. Rome, Villa Borghese room 3,
no. 106. Courtesy of Deutsches Archäologisches Institut,
Rome, Inst. Neg. 6664.

d

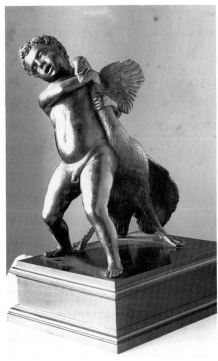

a b

5.15. (*a*) Andrea Riccio's bronze statuette of a boy with goose, early sixteenth century. H 0.196
m. Vienna, Kunsthistorisches Museum KK 5518. Courtesy of Kunsthistorisches Museum, Vienna.
(*b*) Georg Raphael Donner's *Putto with Fish*, 1741, in lindenwood. H 0.385 m. Berlin, Staatliche
Museen, Skulpturensammlung M 229. Courtesy of Skulpturensammlung, Staatliche Museen zu
Berlin, Preussischer Kulturbesitz.

was revived during the Renaissance (fig. 5.15*a*), and that a dolphin, a fish, a goat, or some
other creature might be substituted for the goose. This versatile image has enjoyed continu-
ing popularity. Two good examples of later variations on the original theme can be found in
Georg Raphael Donner's lindenwood *Putto with Fish*, made in 1741 (fig. 5.15*b*), and in the
Laughing Boy and Goat made by Attilio Piccirilli in 1936. Piccirilli carved the group in
marble and had two more cast, one in bronze and the other in lead.[85] The theme of a baby
struggling playfully with an animal, bird, or fish remains popular. Today, in shops and
catalogs that sell outdoor sculpture, particularly fountain ornaments, one can find such
images, although usually these figures have devolved to the status of anonymous works.

We can, of course, include the bronze Dionysos herm from Mahdia in our list of works
by Boëthos, but we must subtract the statue of Eros. The herm has attracted relatively little
scholarly attention, unlike the statue of the winged youth, perhaps because we tend to

[85] Janis Conner and Joel Rosenkranz, *Rediscoveries in American Sculpture: Studio Works, 1893–1939* (Austin,
1989), p. 148 and the fig. on p. 149. The lead version is in Brookgreen Gardens, South Carolina (H ca. 0.79 m.).

dismiss herms as being less interesting than "actual sculptures." Nonetheless, they were among the most common public and private images to be erected during Classical antiquity. Relatively few types were made, and there is little variation within a given type. The turbaned Dionysos is a rather flamboyant variant on the familiar herms from the Classical period, and it was no doubt produced to suit the sophisticated tastes of the later Greco-Roman clientele, for whom such a herm could have made an elegant ornament for a courtyard or garden.

The herm from the Mahdia shipwreck is of the usual form, consisting of a shaft, a head, arm-bosses, and genitals (fig. 5.11 and pl. 7). But the head—that of Dionysos—has an unusually elaborate stylized beard and a fanciful turban. The eyes were originally inset, and the lips are slightly parted, yet there is little indication of expression in the face. The mustache, however, curves gracefully around the mouth to meet seven outward-curving locks on each cheek. Beneath the lower lip, there is a spade-shaped grouping of ten vertical locks; and the lowest layer of the beard consists of fourteen more vertical locks, thickly massed and corkscrew-shaped, cut straight across the bottom. Across the forehead are three rows of stylized snailshell curls, angled outward like the brim of a hat and reaching from ear to ear.[86]

The turban resembles those still worn today in North Africa and in the Near and Middle East, but it is far more extravagant than a real turban could be, for the wrapping is somewhat fanciful.[87] Loosely bound ribbons are piled on top of the head in broad loops, and trailing ends escape below. The effect is lively and naturalistic, but this turban is not realistic: a single ribbon is wide in some places and narrow elsewhere; ribbons appear and disappear at random. Of course, there is no need for continuity in an imaginary turban.

One can also see traces of a wreath that was once entwined with the turban, including two ivy leaves over the right side of the forehead.[88] The hair, exposed in two places on the top and back of the head, is defined by cursorily drawn crossed lines. Four corkscrew curls hang down the back of the shaft; beside them, a broad ribbon loops out of the turban. In front, two long corkscrew curls emerge from the turban and fall neatly down the slanting top of the herm shaft. The one on the left side disappears beneath a wide ribbon, which has escaped from the back of the turban, and loops forward over the top of the shaft, falling to a break below the base of the beard. Two broad ribbons on the left side of the shaft were once interrupted by a circular object that evidently hung over the left arm-boss, fitting a shallow depression in the shaft.[89] On the right side of the turban, another broad ribbon escapes, twists three times above the boss, and drops in front of it, the lower end curling up.

[86] The exact count may seem of little interest here, but we shall see below that it has technical significance.

[87] I am grateful to Diana Buitron-Oliver for showing me pictures of these modern turbans. Such turbans are also mentioned by A. Driss, *Treasures of the Bardo* (Tunis, 1966), p. 34; and, in a 1994 catalog from the J. Peterman Company, *Owner's Manual No. 33a*, a similar turban is advertized, pre-tied, and dubbed the "Afghan Rebel Hat" (p. 49).

[88] This was noted early by Lechat, "Notes archéologiques," p. 361n2.

[89] I am grateful to Frank Willer for pointing out this feature to me and for suggesting that a wreath may have

Who is this exotic Dionysos? During the first century B.C., when the Mahdia herm was lost at sea, no doubt on its way to a buyer, stories of the god's travels in the east had already taken hold in popular culture. Late in that century, Strabo cites the philosopher Megasthenes (ca. 350–290 B.C.) for the information that Dionysos was praised in India. People show a kind of wild grapevine, which grows only in India, as evidence that the god has been there, says Strabo, and he adds ivy, laurel, myrtle, the boxwood, and other evergreens to the list of plants associated with Dionysos.[90] Elsewhere, Strabo asserts that the only two gods worshiped by the Arabians are Zeus and Dionysos, because they provide the most important needs in life.[91] When the Hellenistic world became the Roman world, a close parallel for Dionysos was Liber Pater: a mature bearded deity who was likewise associated with fertility and with wine.

There are quite a few Dionysos or Liber Pater heads on statues and on herms, young and old, with vine leaves encircling the head. But the Dionysos herm from the Mahdia shipwreck is not a common type, and there are relatively few close parallels. Three gems and a marble disk bear representations of similar Dionysos herms. As for actual herms, we have two small terra-cotta hermlike busts, two marble heads (one, at least, from a herm) of Dionysos, and, finally, the second bronze herm, which is the closest parallel of them all. Unfortunately, the only parallels with remotely reliable dates are a gem signed by Aspasios, who is usually dated to the first century B.C. or the first century A.D., and one of the marble heads, which must be before 79 A.D. (since it comes from Pompeii).

The first gem, a three-layered cameo, shows a youth watering four horses at a well, in the presence of a person in Phrygian costume, who is kneeling and drinking (fig. 5.16). The scene has been identified as representing Troilos and Polyxena, the children of Priam and Hecuba, before the attack by Achilles. Behind the group stands a Dionysos herm, whose ribbon turban, wreath, and straight sidelocks are distinctly visible. Whatever the scene is, the herm is probably there because it places the event in its eastern context, outside the walls of Troy.[92]

The second gem, of red jasper, shows the top of a herm shaft crowned with the head of Dionysos, his turban intertwined with a vine wreath (fig. 5.17). Two loops of the turban escape; the beard and sidelocks are curly. The herm shaft is inscribed with the name of Aspasios, a gem cutter whose works are usually dated between the Hellenistic and Augustan periods.[93] The relief on the marble disk also shows a Dionysos herm in three-quarter view

hung over the boss. A parallel for this is the fifth-century B.C. Athenian herm base whose inscription bears a reference to two wreaths or crowns borne by the herm. See Athenian Agora I 5484 (n. 63 above) and Harrison, *Agora* 11, pp. 121–22.

[90] Strabo 15.1.58.

[91] Strabo 16.1.11. See also Carlo Gasparri, "Dionysos," in *LIMC* 3.1:442.

[92] Three-layered sardonyx cameo: Furtwängler, *AG*, 2:264, no. 58.7. G. M. A. Richter posits "a famous original" in *Ancient Italy* (Ann Arbor, 1955), p. 69 and fig. 219.

[93] Red jasper gem: Furtwängler, *AG*, 1:236, pl. 49.15; also Richter, *Ancient Italy*, p. 69, fig. 218. For what may be an ancient copy of this gem, see Furtwängler, *AG*, 2:195, pl. 41.4; and for another red jasper signed by Aspasios,

5.16. Sardonyx cameo of a scene outside Troy, showing a turbaned Dionysos herm in background. Paris, Cabinet des Médailles, Chabouillet no. 106. Courtesy of Bibliothèque Nationale de France Paris.

with curly beard and sidelocks—and, again, a vine wreath entwined with the turban, from which one loop escapes to fold over the top of the shaft (fig. 5.18).[94]

The third gem, an amethyst ringstone, bears the same kind of head in three-quarter view, but the beard is shorter and more tightly curled, and a human chest replaces the herm shaft (fig. 5.19). There are curly sidelocks, but there is no turban: instead, wavy hair is bound by a fillet, a vine leaf is placed over each ear, and a strip of cloth loops down onto the shoulder.[95]

but decorated with a profile view of the Athena Parthenos, see Furtwängler, *AG*, 1:236, pl. 49.12, well illustrated in *The Oxford History of Classical Art*, ed. John Boardman (Oxford, 1993), p. 119, fig. 106 c. The two ringlets falling over Athena's right shoulder are cut in the same way as the sidelocks on the gem showing the herm signed by Aspasios. For a discussion of Aspasios, see Adolf Furtwängler, "Studien über die Gemmen mit Künstlerin-schriften: Aspasios," *JdI* 4 (1889): 46–49, and G. M. A. Richter, "Aspasios I and II," in Mylonas, ed., *Studies Presented to David Moore Robinson*, 1:720–23, pls. 85–86.

[94] See Richter, *Ancient Italy*, p. 69, who suggests that all the herms of this type are derived from a famous fifth-century B.C. original.

[95] Amethyst ringstone: See G. M. A. Richter, *Catalogue of Engraved Gems—Greek, Etruscan, and Roman, Metropolitan Museum of Art* (Rome, 1956), pp. 76–77, no. 322, pl. 43 (from a "Greek prototype of the second half of the fifth century").

5.17. Red jasper gem showing head of turbaned Dionysos and top of herm shaft, signed by Aspasios. H ca. 0.023 m. London, British Museum no. 1814.7–4.1529 (Dalton 701). Copyright British Museum.

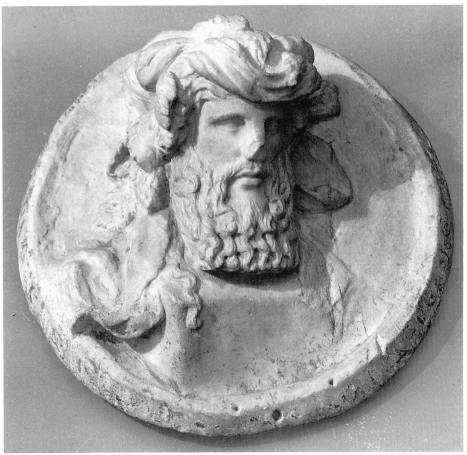

5.18. Marble disk with turbaned Dionysos herm in relief. Diam 0.21 m. New York, Metropolitan Museum of Art no. 26.60.27. Courtesy of Metropolitan Museum of Art.

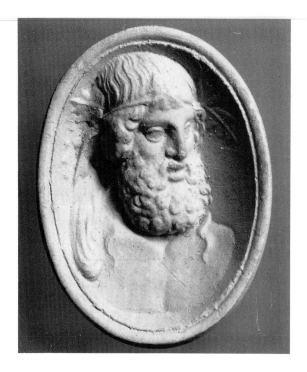

5.19. Amethyst ringstone showing turbaned Dionysos. H 0.021 m. New York, Metropolitan Museum of Art no. 49.21.1. Courtesy of Metropolitan Museum of Art.

The terra-cotta herms are essentially the same (fig. 5.20). They come from a group of terra-cottas in the Townley Collection that are reputed to have been found in a Roman well near Rome's Porta Latina. They were identified as "terminal head[s] of Liber Pater, the Indian or Bearded Bacchus, crowned with vine leaves," and the unusually long bosses were said to "show the ancient mode of joining a number of herms together as a fence or boundary."[96]

A battered marble head of Dionysos, evidently from a herm, was found in Vaison-la-Romaine, ancient Vasio, a Roman town in southern Gaul (fig. 5.21). The head has the same kind of floppy turban as the Mahdia bronze, but this turban seems to descend further over the triple row of forehead curls. The mustache and beard also look the same; but the eyes and the mouth may be wider, the ends of the mustache curl up somewhat more jauntily, and the base of the beard is broken.[97]

[96] *The British Museum. The Townley Gallery.* Library of Entertaining Knowledge (London, 1836), 1:82; also 1:75, 83, 85. See also Taylor Combe, *A Description of the Collection of Ancient Terracottas in the British Museum* (London, 1810), pp. 2–3 (no. 3), 38 (no. 75).

[97] I have not seen this head. It is cited by Emile Espérandieu, *Recueil général des bas-reliefs, statues et bustes de la Gaule romaine* (Paris, 1910), 3:389, no. 2577 (in the Musée Calvet, no. 113; pres. H 0.24 m.). See also Lechat, "Notes archéologiques," p. 361n2 (who calls both the Mahdia head and the Vaison head exact copies of the same model, which he believes must have been crowned with a vine), and Picard, "Boethos de Calchedon," p. 99, fig. 12.

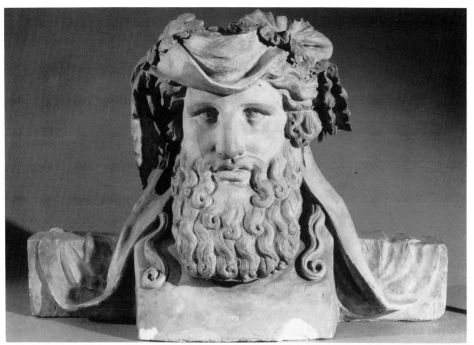

a

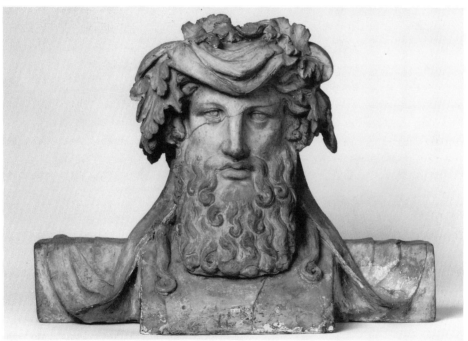

b

5.20. Terra-cotta Liber Pater herms, said to have been found in a Roman well near the Porta Latina of Rome in 1765. H ca. 0.400 m., W ca. 0.534 m. London, British Museum D 431 and 432. Townley Collection. Copyright British Museum.

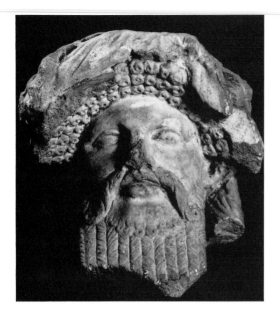

5.21. Marble turbaned Dionysos head from the Roman town at Vaison (Vasio). H 0.25 m. Avignon, Musée Calvet inv. H.113. Gift from the Marquis de Taulignan, 1849. Courtesy of Musée Calvet, Avignon.

Although the marble head from Pompeii bears an uncanny resemblance to the Mahdia bronze herm, the Pompeii head may be a relief and not part of a herm (fig. 5.22). Its measurements seem to correspond closely to those of the bronze herm, and the face looks just like the bronze one.[98] Both heads have a triple row of snailshell curls over the forehead, as well as the same nose, mouth, mustache, beard, and tubular sidelocks. The marble Dionysos, however, wears no turban, only a vine wreath, and the leaves flop so far over the face that they are anchored in a few places by marble struts.

All of these images are clearly very similar to one another, but they are not just alike. Moreover, they vary in size, medium, and details, as well as in authorship. We cannot simply call them copies of a single prototype. There are enough differences among them that we might categorize them simply as a genre or as variations on the theme of the Dionysos who has returned from India, wearing one or more of his eastern attributes. As for the Pompeii head and the Mahdia herm, if the measurements do indeed match, then we may have two heads that are based at least in part on one original model. We can imagine a client choosing a particular Dionysos from a range of possibilities displayed in a workshop. But can the bronze Mahdia herm and the marble Pompeii head actually be from a single

[98] See M. Pagano, "Ermetta di Bacco," in *Rediscovering Pompeii* (Rome, 1990), pp. 264–65, 267, no. 186; also *Riscoprire Pompei* (Rome, 1993), p. 226, no. 123. I have not had an opportunity to examine this head, so I am not certain that it is a relief; nor have I been able to check how closely its measurements correspond with those of the Mahdia herm. The measurements given for the Pompeii head are as follows: H 0.275 m., L 0.220 m., th 0.160 m. The height of the Mahdia herm from the top of the head to the top of the shaft is 0.290 m. According to the catalog description, the back of the marble head is undetailed, except for holes which could have been used to attach it to a stand or a support.

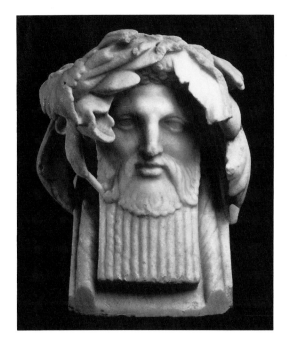

5.22. Marble wreathed Dionysos head (either a relief or a herm), first century A.D., excavated beside a pool within the peristyle of a house at Pompeii. H 0.275 m. Pompeii inv. 2914. Courtesy of "L'Erma" di Bretschneider.

workshop, one that produced works in both bronze and marble, or were they made from two sets of molds that had been taken to different workshops for production? The latter seems more likely.

We know that the Mahdia herm was lost at sea in the 80s or 70s B.C., and that the Pompeii head was buried during the eruption of Vesuvius in 79 A.D., but we do not know when the two pieces were actually made, and we have only the signature of the second-century B.C. artist Boëthos dotted into one working model. The hundred and sixty years separating their destruction dates, the different materials, and the unrelated findspots raise the possibility that molds taken from one original model might have been used over quite a long stretch of time to make either marbles or bronzes, perhaps in different places.[99] We can say, at least, that Boëthos made and finished the wax working model from which the bronze Mahdia herm was cast, because he signed the working model. He would have done this in about the middle of the second century B.C., perhaps sixty to seventy-five years before the Mahdia shipwreck.

The bronze Dionysos herm in the Getty Museum raises different questions from those

[99] A similar conclusion might be drawn with respect to marble figures intended to sit around the rims of fountains: the same seated babies have been found in the first-century B.C. Mahdia cargo and in the first-century A.D. villa at Sperlonga. For a summary of the problem and illustrations, see Brunilde S. Ridgway, "Greek Antecedents of Garden Sculpture," in *Ancient Roman Gardens*, Dumbarton Oaks Colloquium on the History of Landscape Architecture 7 (Washington, D.C., 1981), p. 14 and figs. 5–7. Also see above, figs. 5.14*a–c*.

surrounding the other works in this genre, for it is almost exactly like the Mahdia herm—in alloy, in measurements, and in appearance (figs. 5.23, 7.4, and pl. 8). Purchased in 1979 for the J. Paul Getty Museum, it has been described as an ancient "replica" of the Mahdia herm, having "summary" and imprecise execution and lacking in "artistic achievement."[100] This herm still fits into a stepped bronze base, with which it stands a total of 1.05 meters in height, just barely taller than the Mahdia herm.[101]

The alloys of the two herms are much closer to each other than the alloy of the Mahdia herm is to that of the Eros, and the alloy of the Mahdia herm was unknown when the Getty herm was purchased.[102] The two herms have everywhere almost the same dimensions, with minimal variation, and neither one measures consistently larger or smaller than the other. This means that they are both based on the same original model, from which piece molds were taken and used to produce wax working models. These working models, however, were worked over in quite different ways before casting. The most extensive changes were those made to the Mahdia herm's turban, for which wax was added to allow for additional embellishments. Otherwise, both herms are rather thin and even casts, as would be expected well before the second century B.C., when Boëthos was working.

Superficially, the herms look different because their surfaces are in different condition. The Mahdia herm is rough, its details indistinct: heavily corroded when found in 1907, it was cleaned overzealously. The features of the Getty herm are still clear; it is more angular, primarily because the bronze is in far better condition. It has a large hole in the top of the head, but the white of the left eye (made of bone or ivory) survives, held in place by an envelope of sheet copper that was open at the outside, the finished edges having been cut to resemble eyelashes. Most of the differences in detail between the two heads are minor. Both have the same curls, the same mustaches and beards, the same turbans. But the features were marked more cursorily in the wax working model for the Getty herm. The hair on top of the head, for instance, rather than being marked by neatly incised lines, was simply scored with a spatulate blade. The bronze of the Mahdia turban is thicker where details were added in the wax working model. Its gracefully twisting loops and curling ribbons are left undetailed on the Getty herm, or are abbreviated, and the long corkscrew sidelocks are omitted altogether. The Getty herm, a thin and even casting, was produced from the working model more or less as it came out of the master molds, whereas the Mahdia herm was finished with care: wax was added and worked into additional flourishes, and the

[100] Marion True, curator of antiquities at the Getty Museum, who has kindly allowed me to study the Getty herm, informed me in a letter of April 13, 1992, that the bronze herm had first been offered to the museum in 1971, but that Bernard Ashmole had condemned it as a forgery. Eight years later, the herm was purchased by the museum: Jiri Frel, "Bronze Herm," *The J. Paul Getty Museum Journal* 8 (1980): 96.

[101] Without its base, the Getty herm measures 0.948 m. in height. The height of the Mahdia herm is ca. 1 m.

[102] Getty herm: Cu 70%, Sn 13%, Pb 17%. Mahdia herm: Cu 70%, Sn > 9%, Pb 20%. For the Mahdia Eros, see n. 71 above. Both of the herms also have relatively high traces of cobalt. The Mahdia bronzes were analyzed in 1993 by X-ray fluorescence analysis; the Getty herm was analyzed in 1989 by atomic absorption spectrometry. Although the use of different techniques can affect the results, the fact that the alloy of the Mahdia bronzes was not known until 1993 puts a stop to any speculation that the Getty herm might be a modern forgery.

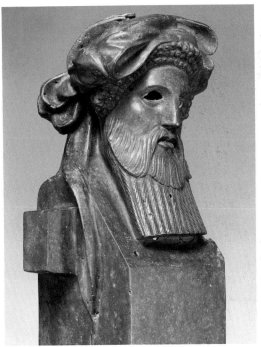

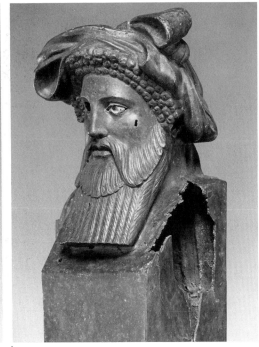

a

b

c

5.23. Bronze Dionysos herm, purchased in 1979. H
1.03 m. Collection of the J. Paul Getty Museum no.
79.AB.138, Malibu, Calif. See also fig. 7.4 and pl. 8.

wreath of vine leaves was interwoven with the folds of the turban. Furthermore, Boëthos signed the wax. Since the left arm-boss has broken off the Getty herm, it is impossible to tell whether this bronze was also signed. Otherwise, the working models for both herms were constructed in essentially the same way: the shaft was made of four narrow rectangular wax slabs;[103] the wax Dionysos head was attached to the shaft; then the wax herm was cored and stabilized with chaplets or, in the case of the Getty herm, with hollow vertical reeds or sticks; and finally the whole was cast in one piece.

The two herms belong to a single ancient series of bronzes, but one of them is finished in more detail than the other. The question remains whether Boëthos made the original model for this type of Dionysos herm, or whether he only produced the signed copy recovered from the Mahdia shipwreck. Whichever it was, the Mahdia herm was surely made during the second century B.C. Why was it worked over so carefully? Was it cast for a particularly discriminating client?

As just noted, we do not know whether the Getty herm was also signed. Nor do we know when this herm was made. We might wonder, too, how long the original model for the Dionysos herm remained in use. Since the Getty herm is a simple reproduction of the original model, should we assume that it was produced later? Maybe it was simply a cheaper copy. And why are the alloys of the two herms so much alike? Perhaps they both came from one workshop; or perhaps this was the alloy normally used for casting herms. Did the client have a choice? So far, we can only guess.

Dorothy Kent Hill, in a paper delivered in 1979, showed great perspicacity when she concluded with these words: "I am not ready to assert that there was an ancient mail-order house, and that from a catalogue one could select a subject, in marble or in bronze, large or small, perforated as a fountain or not. But for our purposes, as we try to recreate Roman gardens after many centuries and perhaps feel some of their calm and beauty, might it not be useful to make such a catalogue?"[104] We have begun to put together that catalog. When completed, it will no doubt help us understand the inherent fallacy in trying to apply a chronological framework to Classical sculpture from periods in which more than one style was being produced. Sculptors could and did combine styles, and they could do so while making a single work. Thus "Greek" was in no sense replaced by "Roman." Instead, the sculptures produced within the contexts of these two intermingling world cultures existed as an interlocking continuum. There has always been disagreement over how to distinguish styles and how to assign dates to those styles. This may no longer be a relevant exercise as we come to recognize the long-lived dominance of certain images, either essentially the same or variations on a theme.

[103] For a detailed and illustrated description of how the two herms were made, see Willer, "Die Restaurierung des 'Agon,'" and idem, "Zur Herstellungstechnik der Herme," pp. 953–58, 959–70, with pls. 33–34.

[104] Dorothy Kent Hill, "Some Sculpture from Roman Domestic Gardens," in *Ancient Roman Gardens*, p. 94.

TORSOS

In 1987, I was asked to write an entry for the Macmillan *Dictionary of Art* entitled
"Greek Molding and Casting." Shortly thereafter, I learned from Christa Landwehr
that she had been asked to write a similar entry, only hers was to be "Roman Molding
and Casting." Puzzled, we discussed our two assignments, hoping that we had not
both written the same thing. After all, both entries were to be about molding and casting,
and we agreed that, so far as we knew, Greek and Roman bronzes cannot be distinguished
by their production techniques. We exchanged entries, and immediately learned that we
had no reason to worry. Although we both had written about what seemed to be the same
topic, each of us had considered the subject from an entirely different vantage point.

Landwehr wrote about the first-century B.C. plaster casts that were found in 1954 at the
site of Baiae, on the Campanian coast of Italy. At least some of those casts match extant
marble sculptures. Some of them, in fact, match marbles of which we have more than one
example, such as the Sciarra and Mattei Amazons, the Athena Velletri, and the Aristogeiton
from the Tyrannicides group that stood in the Athenian Agora. Although we have only part
of the face of Aristogeiton, the plaster preserves traces of the engraved hairs of the beard,
and these are so delicate that they must reproduce the hairs as they were cut into the wax
working model for a bronze. This cast, like a few of the other fragments, was produced
from a mold taken from a bronze and was used to make a reproduction. In this case, we are
familiar with the "original" that someone had chosen to have reproduced, probably as
decoration for a villa in the region of Baiae.[1] Thus, the archaeological evidence from Baiae
expands our understanding of Lucian's comment that the statue of Hermes in the Athenian
Agora was "covered over with pitch because of being molded every day by the sculptors."[2]

[1] Christa Landwehr, *Griechische Meisterwerke in römischen Abgüssen* (Frankfurt, 1982); eadem, *Die antiken Gipsabgüsse aus Baiae: Griechische Bronzestatuen in Abgüssen römischer Zeit* (Berlin, 1985). The major points in *Gipsabgüsse* are summarized in Ridgway, *RC*, p. 35n7.

[2] Lucian, *Zeus tragoidos* 33.

We can even visualize the collections of the people whom Juvenal scorns in one of his early-second-century A.D. satires. He begins by voicing his disdain for people who imitate the upstanding family of the Curii but who live their lives as if they were enjoying a continuing round of Bacchanalia. These people are ignorant, he says, even though their homes may be filled with plaster casts of the Stoic philosopher Chrysippos; for to them the most perfect individual is someone who has a portrait of Aristotle or of the wiseman Pittakos of Mytilene, or who has an original image of the Stoic Kleanthes.[3]

My own dictionary entry concerned the use of the lost-wax process to cast bronzes during antiquity. I described how master molds were taken from a model, how a wax working model was made from the master molds, how the wax was cored and invested, and, finally, how the bronze was cast. The entry had nothing to do with who made the model and who made the finished bronze, nor with the point that, normally, bronze casting is and always has been a collaborative effort between sculptor and founder. Nor did I discuss the fact that lost-wax casting is a process by which an original model can be reproduced any number of times. We shall treat these last two subjects together here, for they are interrelated and informative about the general problem of chronology.

What was the relative importance of artist and founder? Who was really responsible for what we see? What are the implications of the lost-wax process itself with regard to ancient sculpture in bronze? If a cast bronze is not unique, but is instead one of a series of bronzes, like an "edition" of prints, how will this affect our estimation of the Classical work, and of its value? If a bronze is one in a series, should we call it a copy instead of an original? Should we not now begin to think in terms of series or editions of Classical sculpture, as has been done systematically with nineteenth- and twentieth-century sculptures, works that are repeated, not unique, and yet are still seen as works of art?

Today we tend to think of a single artist as being responsible for a work of art. Most of us, for example, would not think to dispute the Hirshhorn Museum's attribution of its colossal bronze statue of Balzac to Auguste Rodin. It is certainly true that Rodin worked on various versions of this *Monument to Balzac* between 1891 and 1898. But it was Henri Lebossé, Rodin's founder and collaborator, who enlarged the work to its present scale, finished it, and cast it in bronze.

This particular bronze Balzac is far from being the only one of its kind. In fact, it was not cast until 1965/1966, although its model had been created more than sixty years earlier. How should we date it? Is the bronze in any sense an "original" by Rodin? Is it even part of an "original edition," since it was cast long after the deaths of both sculptor and founder? If it is simply a "copy," does it really belong in a museum?[4]

Similar questions would certainly have applied to statues that were produced during antiquity, although little in the way of a public record survives today. We know that potter

[3] Juvenal, *Satire* 2.4–7.

[4] For a fascinating discussion of these questions, and for the argument that the value of such a work should be based simply on the agreement made between artist and purchaser, see Jean Chatelain, "An Original in Sculpture," in *Rodin Rediscovered*, ed. Albert E. Elsen (Washington, D.C., 1981), pp. 275–82.

and painter were commonly distinguished in vase painting, and the same may have been true with respect to architect and builder. From the start, bronze statuary seems to have been a two-part operation. By the first century A.D., the introduction of large-scale bronze casting to Greece was being attributed to two early Samians, Rhoikos and Theodoros.[5] Whether or not these particular men were actually responsible for this advancement, large-scale bronzes were certainly being cast in Greece by the sixth century B.C. The fact that the names are linked suggests that it was usual for two men to be involved in the process.[6]

Kritios and Nesiotes jointly signed several statue bases in early-fifth-century Athens, making no allusion to distinct roles. On the well-known Berlin Foundry Cup of about the same date, six people are shown in a foundry, working on at least two casting projects—the joining and finishing of two statues (figs. 1.12, 2.17).[7] Four of the people are mature, bearded men, and they are occupied at tasks that suggest expertise and authority: two of them are finishing a statue; the third is joining the pieces of another statue; and the fourth is stoking the fire in a furnace. The other two workers are beardless youths, clearly acting under the supervision of the man at the furnace: one boy is pumping the bellows; the other is standing by the furnace, watching the fire stoker.

The Riace Bronzes surely belonged together, and they are likely to have been part of a larger group of statues. On occasion, they have, for stylistic reasons, been attributed to two different fifth-century artists, including among the candidates Onatas, Phidias, and Polykleitos (fig. 2.18).[8] There are also literary references to groups of Classical statues in which different figures were made by different artists. It is easy to understand why such a cooperative effort would be necessary for a monument like one at Delphi which commemorated the Spartan victory at Aigospotamoi in 404 B.C.: that monument consisted of no fewer than thirty-six statues, made by nine different artists![9] Tisander, whom Pausanias credited with having made eleven of the statues, is otherwise unknown to us.

Hellenistic Rhodes provides specific information on the nature of collaboration among bronze artists. There are on Rhodes more than two hundred forty signed statue bases dating from about the fourth century B.C. to the beginning of the first century A.D. The inscriptions document 120 artists, eight workshops, and numerous collaborations (most within families, but some with foreigners). A few of these inscriptions refer specifically to a division of labor, in which one man sculpted (*epoise*) and the other cast (*echalkourgese*).[10]

[5] *NH* 34.83; followed by Pausanias 8.14.8, 9.41.1, 10.38.6

[6] For an interesting discussion of the development of the literary tradition about Rhoikos and Theodoros, see Virginia C. Goodlett, "The Non-Collaboration between Rhoikos and Theodoros" (abstract), *AJA* 93 (1989): 254.

[7] Berlin, Antikensammlung F 2294. See Mattusch, *GBS*, pp. 101–7, with references, and, more recently, Zimmer, *Bronzegusswerkstätten*, pp. 132, 152–53.

[8] For a summary of attributions and references, see Mattusch, *GBS*, p. 207.

[9] Pausanias 10.9.6–10. For discussion of the nature of fifth-century B.C. groups made by known artists, see Mattusch, *GBS*, pp. 119–43.

[10] For a thorough discussion, see Virginia C. Goodlett, "Rhodian Sculpture Workshops," *AJA* 95 (1991): 669–81. For additional references to these sculptors and founders, see Gloria Merker, *The Hellenistic Sculpture of Rhodes* (Göteborg, 1977), p. 16, and A. J. B. Wace, *An Approach to Greek Sculpture* (Cambridge, 1935), p. 10. For a description of a Hellenistic foundry on Rhodes, see Zimmer, *Bronzegusswerkstätten*, pp. 91–97.

Such collaboration is not surprising in a busy cosmopolitan center like Rhodes, with its vast numbers of sculptural commissions. Sculpture was a big industry on Rhodes. Indeed, in his day Pliny repeated the information from Mucianus, who had been the consul in Rhodes, that there were still three thousand bronze statues there.[11] On the Rhodian statue bases, the sculptor is named before the founder, but that is no indication of relative importance; after all, the order reflects the sequence of events within the production process.

The very use of the lost-wax process promotes a division of labor, for the roles of sculptor and founder can be as distinct as those of potter and painter in vase painting. Today, sculptors do sometimes cast their own bronzes, but this is quite rare: studios and foundries require different equipment, and artists may not have the technical experience that founders need. Nonetheless, as we have seen from Rodin's Balzac, the artist usually receives credit for the finished bronze.

It is not unusual nowadays to see an advertisement offering us "an extraordinary collecting opportunity," a work by some unknown "award-winning artist." The proffered "masterpiece" will be "individually hand-numbered" or "individually hand-finished" (by some unknown hand). This is a "Limited Edition." Perhaps only a few thousand are being made; or perhaps the edition "will be closed forever after 45 firing days." Nonetheless, a subject, which has been "brilliantly captured in bronze," actually "bears the artist's mark." And because the company making this offer will be "using the 'lost wax' method, no two sculptures are exactly alike."[12] This was certainly true in antiquity: the Riace Bronzes are a good illustration of the modern selling point. As we saw in chapter 3, those two bronzes were based on a single basic model; the work done to finish the waxes, however, was so extensive that the statues look very different from each other.

Even modern reproductions are sometimes produced in "limited editions," a term intended to impart to the works an aura of authenticity. Thus an "edition limited to 100" copies of the Riace Bronzes can be bought from one company. Unfortunately, even in bronze, these "exquisitely beautiful portraits of men sustained by inner faith as they face life" lose something when reduced to a height of thirty inches.[13] We must remember, too, that here we are dealing with the reception of ancient art by a modern audience. Were words like "original" and "copy" even relevant to the viewers of public sculpture in ancient Greece?

Reduced reproductions were common in antiquity, as they are now. Most often, they were made of some inexpensive material like clay, which was easily pressed into a matrix, baked, and painted or even gilded.[14] Such figurines could be "cast" in large enough quantities ("editions") to satisfy many buyers. Usually, the well-known works from which these rough copies issue are only nominally, if at all, recognizable in the surviving terra-cottas.

[11] *NH* 34.36.

[12] These phrases are taken from advertisements in *Parade* Sunday magazine for The Franklin Mint and The Hamilton Collection.

[13] *The Eleganza Collection: Museum Quality Reproductions of Sculptural Masterpieces*, 4th rev. ed. (Seattle, 1992), pp. 106–7.

[14] Modern parallels might be drawn with such materials as painted bonded stone and bonded marble.

During the 330s B.C., in Corinth, fifteen or sixteen terra-cotta figurines were thrown away together. Included in the group are statuettes of draped women, an Aphrodite, two reclining males, a comic actor, a female dancer, a winged boy, a grotesque, a jointed doll, a few heads, an unidentifiable animal, and a bearded man with a curiously bent leg.[15] This last figurine is a miniature version of Myron's satyr marveling at the flutes (fig. 6.1a–b).[16]

The satyr's precarious pose is just like that of the marble and painted reproductions of Myron's statue, a kind of comic version of contrapposto.[17] He is making an exaggerated step backward onto his left foot, and that leg is bent; the right leg was stuck straight out in front of him for balance. The right arm was raised to show astonishment, and the left arm was pulled back and down. The satyr is looking down toward his feet, with his head bent so far forward that a tousled beard splays out across his chest. His mouth is hidden by the sumptuous beard. A pug nose, fleshy features, and beady left eye are preserved. Even though this is a much-reduced copy, the complete statuette would have borne a clear resemblance to the statue by Myron that it "copied."

We know that Myron made his statue of the satyr in the first half of the fifth century B.C. Presumably, the statuette was made after Myron's work had achieved its renown. Was that renown achieved right away? Or was an order for the statuette placed by someone who had seen the original Marsyas years later? Does that mean the statuette was made late in the fifth century or in the fourth century? If a delay in making copies was usual, how could we ever date this figurine or any other copy?

The statuettes discarded with the Marsyas correspond to a wide range of dates. A pivoting dancer with a tambourine wears a clinging chiton, but the skirt swirling behind her has heavy folds.[18] Was this statuette made in the late fifth century B.C.? The legs of another figurine appear to be naked, but they are framed by fluttering tubular folds (fig. 6.1c). This statuette resembles the Nike at Olympia that Paionios of Mende made in the 420s B.C. And a half-draped Aphrodite, who once leaned with her left arm on a support, fits the type of Aphrodite at her toilet that first became fashionable in the fourth century B.C. (fig. 6.1d).[19]

So, looking individually at this group of stylistically disparate statuettes, we would assign them very different dates, ranging over a hundred years or more. It seems very unlikely that

[15] Charles K. Williams II and Joan E. Fisher, "Corinth, 1971: Forum Area," *Hesperia* 41 (1972): 153; idem, "Corinth, 1975: Forum Southwest," *Hesperia* 45 (1976): 116–23. The terra-cottas are otherwise unpublished. I am grateful to Charles K. Williams II for allowing me to work on them.

[16] Richard S. Mason originally identified the figurine as the satyr Marsyas. Pliny mentions this statue: *NH* 34.57. For two well-known statues of Marsyas in the Vatican Museums, see Christiane Vorster, *Museo Gregoriano Profano: Römische Skulpturen des späten Hellenismus und der Kaiserzeit* (Mainz, 1993), 1:21–25, nos. 3 (inv. 9974, statue without arms, found on the Esquiline Hill in 1823) and 4 (inv. 9975, torso, probably Domitianic in date, found at Castel Gandolfo in 1932).

[17] See, e.g., the marble Vatican Marsyas (formerly in the Lateran) and a red-figure vase in Berlin (Antikensammlung F 2418). For illustrations, see Richter, *SSG*, figs. 621, 625, and *Antikenmuseum Berlin: Die ausgestellten Werke* (Berlin, 1988), p. 126, fig. 9.3.6.

[18] Corinth MF-71-11; pres. H 0.095 m.

[19] For a survey of Aphrodites at Corinth, see Mary Ellen Carr Soles, "Aphrodite at Corinth: A Study of the Sculptural Types" (Ph.D. diss., Yale University, 1976).

6.1. Three terra-cotta figurines, 330s B.C., from a deposit in the Southwest Forum area at ancient Corinth. Courtesy of American School of Classical Studies at Athens: Corinth Excavations. (*a–b*) Myron's satyr marveling at the flutes. Max. pres. H 0.165 m. Corinth MF 71-31. (*c*) Woman wearing transparent drapery with tubular folds behind. Preserved from waist to ankles; max. pres. H 0.139 m. Corinth MF 71-42. (*d*) Aphrodite at her toilet. Max. pres. H 0.151 m. Corinth MF 71-36.

a collection of statuettes would have been formed over such a long period of time, unless they had once served as offerings in a sanctuary. Yet by no means do all of them appear to be dedicatory figurines. They are far more likely to have been someone's private collection. If that is the case, they were probably made over a shorter period. Thus, to return to the satyr, if it was not made in the first half of the fifth century, like the statue that we recognize it to have been copied from, then it could have been made at any time before it was discarded in the 330s B.C. Even though in this case we can suggest a rough *terminus post quem*, all we really know for certain is its destruction date. Indeed, trying to assign a stylistic date to any of these discarded statuettes may not be truly relevant, and may actually mislead us as we attempt to understand the group as a distinct whole.

Because of the small number of works that we can define as extant Greek originals, the study of Greek sculpture has focused on what we have called, indiscriminately, Roman "copies." For obvious reasons, full-size marble "copies" of statues have received far more attention than small terra-cottas like the satyr from Corinth. Christa Landwehr's dictionary entry was about the extraordinary plaster reproductions of statues that were meant to be used to make such copies. These plasters were made from molds that had been taken directly from "original" statues, at least some of which were well enough known for us to recognize them in the plaster casts. Margarete Bieber has surveyed the history of scholarship on copies as such and has considered the complicated relationships between what we call "copies" and their Greek models, or the "originals."[20] If, however, we search for a "copy" that is simply that—what Brunilde Ridgway calls a "mechanical and exact duplication of a piece of sculpture in all its details and exact dimensions"—then "very few items, whether Greek or Roman, qualify for the title."[21] If we confine that definition to bronzes, the numbers shrink even more.

We have two lifesize bronze torsos that are unquestionably direct copies of other ancient bronzes. Unfortunately, neither of these torsos can be dated by context. Not surprisingly, moreover, neither of the models appears to be extant.

The Florence Torso

Scholars have always found the lifesize bronze torso in the Archaeological Museum of Florence to be problematic, and it has not received a great deal of attention (fig. 6.2). The well-muscled torso was found at Livorno, an important port city on the Ligurian Sea, just south of Pisa.[22] The date and circumstances of its discovery are unknown to me, but the torso may have come from the sea: the whitish material inside seems to be marine encrustation.[23]

[20] Bieber, *Ancient Copies*, pp. 1–9.

[21] Ridgway, *RC*, p. 6.

[22] See G. M. A. Richter, *Kouroi*, 3d ed. (New York, 1970), p. 150, no. 195.

[23] See Florence Archaeological Museum (Sezione Didattica, Soprintendenza Archeologica per la Toscana), "Room XIII: Male Torso" (Florence, n.d.); also Edilberto Formigli, "The Bronze Torso in the Museo Archeologico, Florence: Greek Original or Roman Copy?" *AJA* 85 (1981): 78n6.

a

b

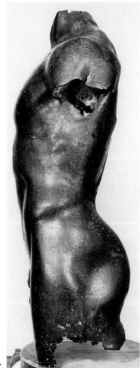

c

6.2. Bronze Florence torso, perhaps from the Ligurian Sea and known since the late nineteenth century. Arrow to reproduced patch. Lifesize, max. pres. H 0.94 m. Florence, Museo Archeologico inv. 1638. Courtesy of Soprintendenza Archeologica di Firenze.

As preserved, the bronze consists of the neck, shoulders, torso, and upper thighs of a nude standing youth. He seems almost to be drawing in his breath to emphasize the naturalistic, well-developed musculature. The stance is strictly frontal, but the right shoulder is inclined forward, showing that the right arm was extended; the left arm was at his side. His weight was on the left leg, for the left hip is slightly raised.[24] The flexed neck muscles make it just possible that the head turned slightly to the right. The pose can thus be reconstructed as a mirror image of the type of the Doryphoros, with the exception of the head, which here seems to turn toward the raised right arm instead of away from it.

The break at the neck lies close to the original edge of the casting, and parts of that edge are preserved. In back, the head was fitted to the neck along the hairline; in front, the join followed the junction of the throat and neck. The ledge at the top of the neck for fixing the head is more or less complete. The arms, too, are broken at approximately the point of the original edges; the pieces were attached along a horizontal line by fusion welding.[25] The nipples, once inlaid, are gone. The pubic triangle, with neat rows of curlicued locks, was inset from within and attached with hard (bronze) solder. The penis, too, was once soldered into place. No doubt the legs were cast separately and joined at some point along the thighs.[26]

In 1892, August Kalkmann called the Florence torso a Greek original from the late sixth or early fifth century, drawing a parallel with the pedimental sculptures from Aegina. In 1893, Adolf Furtwängler eschewed Aegina, attributing the torso to the workshop of Kritios and Nesiotes. Four years later, though, Walter Amelung had reverted to Kalkmann's idea that the torso was contemporary with the pedimental sculptures from Aegina. And in 1912, L. A. Milani also stuck with Kalkmann's date, although he did not go so far as to mention Aegina.[27]

Then, in 1927, Kurt Kluge demoted the bronze torso in Florence to the ranks of copy, calling it a Roman overcast of a Greek statue. In 1933, Stanley Casson agreed. But then in 1935 Ernst Homann-Wedeking suggested that the torso was Italic-Ionic, with a date of, perhaps, 470 B.C. Karl Schefold liked that date, but not the place: he thought the torso was Attic. Two reviewers of Schefold's book disagreed with him, returning to Kluge's idea of thirty-five years earlier that it was an overcast. Felix Eckstein put the torso in the middle of the fifth century or later, and suggested that it might be an Etruscan overcast of an early Classical statue; and R. V. Nichols, who also called it an overcast, had heard that it might be Renaissance in date, but he did not say whose idea that was.[28]

[24] But see Richter, *Kouroi*, p. 150: "Weight on right leg, and left leg slightly advanced; nevertheless left hip is placed slightly higher than right."

[25] The line of the join is illustrated in Formigli, "The Bronze Torso," pl. 16, fig. 4.

[26] For examples of separately cast genitals, thighs, and buttocks, see Cynthia Jones Eiseman and B. S. Ridgway, *The Porticello Shipwreck: A Mediterranean Merchant Vessel of 415–385 B.C.* (College Station, Tex., 1987), pp. 80–86, nos. S9–S11, and figs. 5.52–5.69.

[27] A. Kalkmann, "Archäische Bronze-Figur des Louvre," *JdI* 7 (1892): 132n9; Adolf Furtwängler, *Meisterwerke der griechischen Plastik* (Berlin, 1893), p. 676n1; Walter Amelung, *Führer durch die Antiken in Florenz* (Munich, 1897), pp. 275–76, no. 269; L. A. Milani, *Il R. Museo Archeologico di Firenze* (Florence, 1912), 1:174.

[28] Kurt Kluge, *Die Antiken Grossbronzen: Die Antike Erzgestaltung*, ed. K. Kluge and K. Lehmann-Hartleben

In the 1968 guidebook to the Florence Archaeological Museum, the bronze torso became, once again, just a Roman copy of a Greek statue from the fifth century B.C. Gisela Richter, on the other hand, still seemed to hope that it might, after all, be a Greek original of between 485 and 460 B.C. At least, she did not call it a copy; but she may have been somewhat dubious, because she listed it right before three works that she thought *were* copies.[29]

This is where the argument stood when I first looked at the Florence torso in the 1970s. It is a thin-walled bronze, cast by the indirect lost-wax process.[30] The metal of the Florence torso had been analyzed and was found to consist of roughly 87 percent copper and 12 percent tin.[31] The inner surface of the bronze bears traces that show how a thin layer of wax was applied within the master molds: a long bronze drip runs vertically down the left buttock; and a spatulate instrument marked the lower abdomen.[32]

The torso was in need of major repairs after casting. There are many cracks and breaks in the lower back, and because the bronze in this section is less than 0.001 meter thick, the cracks almost certainly occurred during casting. No signs of the repairs survive. A large irregular portion of the upper back is completely cut away. Was this intentional? Maybe the hole was cut out because this area of the back was hopelessly cracked and broken. Kluge suggested that the hole might have been fitted with a large patch.[33] At any rate, the statue was probably erected in a location where the flawed back would have been hidden from close scrutiny.

The usual method of repairing a smaller casting flaw, one caused by a bubble in the molten bronze, was to cut out a rectangular depression around the flaw and fill the depression with a bronze patch. Fewer than ten conventional patches (square or rectangular) can be seen: three in the region of the right pelvic muscle; one on the back of the left thigh; and three or so on the back. But, on the left front of the left thigh, there is a faint pentagon,[34] within which there is a rectangular hole, probably concealed at one time by a patch. The pentagon, however, which at first resembles a patch like those commonly seen on some late Roman bronzes, cannot be a patch and have another patch on top of it.

(Berlin, 1927), 1:117n2; Stanley Casson, *The Technique of Early Greek Sculpture* (Oxford, 1933), p. 162n2; Ernst Homann-Wedeking, "Torsen," *AM* 60/61 (1935/36): 216n5; Karl Schefold, *Meisterwerke griechischer Kunst* (Basel, 1960), pp. 56, 216, no. 238; Felix Eckstein, review of Schefold, *Meisterwerke*, in *Gnomon* 33 (1961): 404; R. V. Nicholls, review of Schefold, *Meisterwerke*, in *JHS* 82 (1962): 204.

[29] A. de Agostino, *The Archaeological Museum of Florence* (Florence, 1968), p. 27; Richter, *Kouroi*, p. 148.

[30] Thickness ca. 0.003 m., less at the left upper thigh and around the large hole in the upper back.

[31] Cited in Formigli, "The Bronze Torso," p. 78n10, and in M. Leoni, "Observations on Ancient Bronze Casting," in *The Horses of San Marco, Venice*, trans. J. and V. Wilton-Ely (London, 1979), p. 181, table 1. The alloy was evidently analyzed by B. Bearzi, "Il bronzo nella antichità," *La Fonderia Italiana* 15.2 (1966): 66, table 2: "Analisi di alcuni bronzi rinascimentali." This torso is the only one in Bearzi's list of ten "Renaissance"(!) bronzes that does not have lead recorded in the alloy, and it is one of five that have no zinc. Both lead and zinc are normal components of alloys dating to the Renaissance.

[32] Width of blade 0.004 m.

[33] Kluge, *Grossbronzen*, p. 117.

[34] Max. dim. 0.040 m. See fig. 6.2*a* (*arrow*).

Instead, the faintly marked pentagon is the outline of a patch that has been reproduced. The *actual* patch was on the bronze from which molds were taken to make the (too thin) wax model for this torso. Thus, we can safely identify the Florence torso as a copy.[35]

Edilberto Formigli disagreed, calling the small rectangular hole within the pentagon a corroded spot, not a hole for a patch, and adding that the impression of a patch that had been picked up in the wax being used to replicate a statue would surely have been taken off before casting. Formigli's primary purpose was to prove that the torso was not a failed casting, or "waster," but part of a statue that had been finished—which was certainly the case, given the fact that its parts had been joined and its flaws had been patched.[36]

Discussion of the Florence torso has slacked off in recent years: at least, no new theories have been proffered. Martin Robertson has not committed himself to an opinion, P. C. Bol seems to favor a date no earlier than the late Hellenistic period, Ridgway believes that the torso is a Roman copy, as does Formigli, and the Florence Archeological Museum distributes a flyer with that identification.[37] In other words, there are no recent objections to calling the Florence torso a "copy," and most of us seem to be willing to leave the torso in that broad and nebulous category. The torso, at any rate, has not lately been called "Greek" or "Italic" or "Renaissance."

If we are satisfied with the conclusion that the torso is a "Roman copy," why is this so? Those who identified the torso as a "Greek original" felt constrained to try dating it by its style, but they could not agree. There has been no such discussion among those who have called it a "Roman copy." Evidently, it does not matter to most whether a copy is of the first century B.C. or of the second century A.D. If we knew more of the circumstances of the torso's discovery, perhaps we could learn something about when it was lost and under what conditions, and whether it was new or old at that time.

No one would disagree that the type—the standing nude youth—is Greek, and that this naturalistic version originated during the first quarter of the fifth century B.C. This bronze torso looks more or less like a mirror image of the Doryphoros, which, of course, we know only from marble copies. As for the alloy, if the analysis is accurate and the bronze in fact contains no lead,[38] then this torso may have been cast in Greece, where tin bronzes were normal, whereas bronzes cast in Italy during antiquity typically contain lead, whenever they were made. But we still do not know *when* this torso would have been cast, and of course we would like to date and identify the statue from which it was copied.

Consideration of stylistic issues generally seems to occur at the expense of technical matters, even though the latter provide objective information. Such has been the case with

[35] See C. C. Mattusch, "The Bronze Torso in Florence: An Exact Copy of a Fifth-Century B.C. Greek Original," *AJA* 82 (1978): 101–4.

[36] Formigli, "The Bronze Torso," pp. 77–79.

[37] Robertson, *HGA*, p. 195; Bol, *Grossplastik*, p. 85 with n. 10; Ridgway, *RC*, p. 33; Edilberto Formigli, in conversation (Vienna, 1986); Florence Archaeological Museum, "Room XIII: Male Torso" (I last picked up a copy of this flyer in 1992; see n. 23 above).

[38] See n. 31 above.

the Florence torso. Still, it is definitely a reproduction. Moreover, since we can actually see (because of the patch) that this bronze was cast directly from another bronze, we can be certain that it was intended to be a precise, full-scale copy of another statue. But perhaps it is not quite so easy to distinguish the evidence on this bronze, perhaps the cast pentagonal patch is not obvious enough to forestall future disagreements over whether we are actually looking at a bronze that was produced in molds taken off another statue. Here, unfortunately, we have no intermediary plasters like those that were found at Baiae, for they were not needed in this process: only the master molds taken from the first statue were required.

The Metropolitan Torso

A second lifesize bronze torso very clearly reproduces patches from the bronze statue of which it is a copy (fig. 6.3).[39] Robertson fittingly describes the Metropolitan torso as being "of similar character" to the Florence torso, "but very ruined."[40] Richter reported the purchase but not the origin of the Metropolitan torso in 1923. By that time, the bronze had been cleaned and heavily restored by the Parisian M. L. André, and was on display in the Classical Wing of the Metropolitan Museum.[41] Today, the torso is not on display, and few even know it exists.

The Metropolitan torso is that of another nude youth, this one preserved from just below the hips to the base of the neck, missing the entire right side. In order to prepare the torso for exhibition, the rib cage was resprung and secured by metal straps and braces, screwed through from the outside. Some of the uneven edges are not broken, but look as if they may have been smoothed by remelting. In fact, along the break at the bottom of the left side, where there is a cast reproduction of part of a patch, the "broken" edge also appears cast, and additional metal seems to have run inside the statue at the break. The groin is now partly concave, and damaged areas around the navel and just below the nipples have been filled with what looks like plaster.

On the exterior, particularly in the region of the buttocks, the surface seems to have been brushed. This could well be a result of the early cleaning. A patch on the right buttock, marked by an oval-to-circular irregular outline, may be modern: I do not know of any ancient parallels. It is also hard to explain a large butterfly-shaped patch below the left armhole: the bronze walls are very thin here, with no sign of what was being patched; and parts of two sides of the patch can be seen projecting on the interior. Yet the torso has many patches that are definitely not modern, and it is these patches that give the bronze its special importance for the study of ancient technology.

Very little can be said of the figure's original pose. The left hip may have been slightly raised, and it is now, as restored, between 0.01 and 0.02 meter higher than the right one.

[39] I am grateful to Joan R. Mertens and to Carlos A. Picón for allowing me to study this bronze.
[40] Robertson, *HGA*, p. 195.
[41] G. M. A. Richter, "A Greek Bronze Torso," *BMMA* 18 (1923): 32–33.

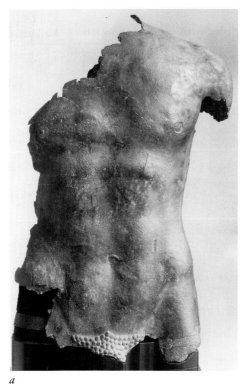

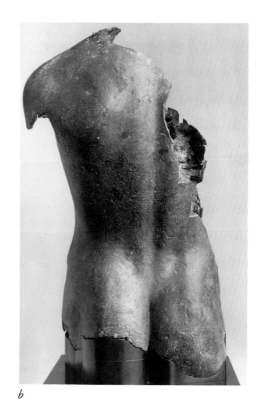

a

b

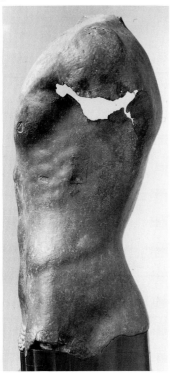

6.3. Bronze Metropolitan torso, of uncertain origin and restored in Paris before 1920. Lifesize, max. pres. H ca. 0.71 m. New York, Metropolitan Museum of Art inv. 20.194. Courtesy of Metropolitan Museum of Art, Rogers Fund, 1920.

c

We may assume that the weight was borne primarily on the left foot. The delicately defined left shoulder looks pulled back, but the backbone seems to curve to the right. Both sides of the pelvis are dented. Because the right shoulder is missing entirely and the left arm is gone up to the shoulder, it is impossible to envision the original positions of the arms.

The figure is slight, characterized by the soft modeling we might see in a boy who is not yet fully developed. The upper back is smooth, as if in a relaxed position. The backbone, marked by a deep, smoothly modeled crease, has a strong S-curve. The chest apparently shows the same lack of emphasis on muscle tension as the back; owing to uncertainty about the accuracy of the restoration, though, we might simply note that there are three horizontal divisions on the abdomen.[42] The inset right nipple is still in place; the left one is lost. The navel consists of two arcs above and one below. This carefully marked navel contrasts markedly with the simple circle and shallow central line on the Florence torso. The latter looks almost as if it was simply punched into the otherwise highly plastic abdomen. Unlike the navel, the rows of small, plain, roughly circular pubic curls of the Metropolitan torso, arcing to a central point, seem surprisingly abstract. The pubic hairs bear no sign of coldworking. The edge that curves around where the penis, now missing, was inset is apparently the only actually finished edge that survives on this bronze.

The metal is thinner than that of the Florence torso, ranging from 0.002 to 0.005 meter in thickness. Most of the inside is covered with a thin layer of lead and with gravelly encrustation, but there are no recognizable marine inclusions. It is difficult to see much of the inner surface of the bronze. That surface, however, was fairly smooth: the crease of the buttocks and backbone is as clearly visible on the inside as on the outside. The bronze becomes slightly thicker at the pubes. At the base of the pubes, as noted above, there is a short finished edge which curved around an inset penis.[43]

Where the inside surface of the bronze is clean, a few drip marks are visible, and one can see impressions made by a spatulate instrument. Both reproduce the surface of the wax during its application to the inside of the master molds. The occasional seamlike projections, known as "flashing," indicate where molten bronze, replacing the wax, oozed into cracks in the clay core. This is a common feature: had the clay core material been slightly more liquid when it was poured, it would have filled the interior of the finished wax model more thoroughly; but it would also have been harder to dry out, and the steam from wet clay might cause an explosion during the pour. One more point of interest inside the statue is a glob of bronze, splattered within the surviving base of the neck: this is hard solder, which splashed when the separately cast head was being attached just above the present break.

[42] Richter noted that "in front . . . it is a little caved in, and the modeling here is somewhat confused in consequence" (ibid., p. 32).

[43] I am grateful to Henry Lie for telling me about the lead lining the interior of the torso. This feature has been noted on a growing number of large bronzes that were cast in pieces. For references and bibliography, see Susan C. Jones, "The Toledo Bronze Youth and East Mediterranean Bronze Workshops," *Journal of Roman Archaeology* 7 (1994): 243–56. For a close parallel for the inset penis, see Olympia Br. 11954: Bol, *Grossplastik*, p. 109, no. 96, pl. 17.

The left side of the statue's back came out of the investment mold without flaws. Elsewhere, however, the statue was repaired with numerous butterfly patches, some of them very large, their sides reaching as much as 0.053 meter in length. A row of butterfly patches follows the diagonal break up the right side of the back: evidently the statue cracked here during casting; later, it broke along the same weak line where it had been repaired.

What, at first glance, look like holes where patches have fallen out are not necessarily what they seem. Quite a few of them are actually casts of the holes for patches that were already missing from the statue that was copied: the holes are not as sharply marked as they would be if they had been cut into this bronze. Instead, their bottoms are not flat, but rough, as if the holes might have been partly filled with some material when the statue was molded. Also, the edges of these reproduced patch holes are not sharp, but smooth; the sides of these rectangular holes range in length from approximately 0.009 to 0.030 meter. At the top of the left leg, just below the iliac crest, are three cast patches; and half a dozen more can be found on the left side of the chest. By the break on the right side of the chest, just above a hole for a patch, is the cast edge of a partly loosened patch, the rest of which did not reproduce. In contrast, the holes actually cut *into this bronze* to patch it are flat-bottomed and of an even depth, between 0.001 and 0.002 meter, and the actual patches are between 0.010 and 0.020 meter on a side.

The Metropolitan torso is definitely an overcast of another bronze, one that had stood long enough for some of its patches to have fallen out. The holes corresponding to the missing patches were picked up in the overcast. Although the Metropolitan bronze had been seriously flawed during casting, it was saved and repaired for installation. The large ingot-shaped patches with which it was repaired bespeak a much later date of production than does its early-fifth-century B.C. style. A similar array of patches of all shapes and sizes can be seen on the colossal gilded-bronze Hercules in the Conservatori Palace in Rome.[44] This statue of Hercules may have come from the Forum Boarium, and probably dates no earlier than the third century A.D. We might wonder whether patches on the Metropolitan torso were concealed when the statue was prepared for installation—either the ingot-shaped patches, associated with the production of the torso, or the smaller ones reproducing the repairs to the bronze from which this one was copied. If any were concealed, with what material? One more technical feature is of interest: at the top of the left leg are oval marks that look like a fusion weld, but there is no sign inside the bronze that pieces were joined at this point.

Probably because it is not on exhibition, the Metropolitan torso has rarely been pub-

[44] See Haskell/Penny 227–29, no. 45, and, more recently, Olga Palagia, "Two Statues of Hercules in the Forum Boarium in Rome," *OJA* 9 (1990): 51–69, with discussion of the scholarship on this statue and with extensive bibliography. Palagia dates the Conservatori Hercules to the late first or early second century A.D., although she once dated it to the third century A.D. ("Herakles," in *LIMC*, vol. 4, no. 421), which agrees with W. A. Oddy's tentative proposal that fire gilding seems not to have been done until the third century ("Gilding: An Outline of the Technological History of the Plating of Gold onto Silver or Copper in the Old World," *Endeavour*, n.s. 15.1 [1991]: 29–33). See also chap. 1, pp. 28–29, above.

lished. For purely stylistic reasons, Richter placed the torso in the late Archaic period, dating it to about 480 B.C., and she tentatively associated it with the works of Kritios and Nesiotes.[45] It is not included in her book on kouroi; however, she dates the youth from Selinus, a bronze with the same slender build and with the soft musculature of a boy, between 485 and 460 B.C. Like the Metropolitan torso, it too was heavily restored, but the work on this statue was definitely done during antiquity.[46] The Selinus Youth is recognized as an original but provincial work. A comparison might also be made with the marble Omphalos Apollo, the original version of which can be assigned to the early fifth century B.C.

We may agree, then, that the Metropolitan torso is in the style of the early fifth century B.C., but that its date of production appears to have been later. We still do not know exactly when or why it was cast, or for whom, nor have we any idea of its origin.

The Vani Torso

The Vani bronze presents a similar picture, but one that is in some ways much more complete. The issues that this torso illustrates have to do with the persistence of popular styles in sculpture and with regional differences in technique. We have a rough idea of the torso's date, but its style is not what we would naturally associate with that date. Its highly unusual technique and its alloy may be explained by its provenance.

In Classical mythology, Colchis, the region to the east of the Black Sea, was where the Argonauts found the golden fleece. Throughout antiquity, Colchis occupied a strategic position on east–west trade routes. The Greeks were sailing in the Black Sea by the eighth century B.C. and had reached Colchis by the sixth century. They settled here as traders, for Colchis was rich in gold and iron, as well as in timber, hemp, fabrics, wax, and resin.

The modern town of Vani lies inland from the Black Sea, south of the River Rioni. During antiquity, many ironworking sites dotted the area, and local burials are particularly rich in both iron and gold artifacts. The ancient city prospered from at least the seventh century to the first century B.C., and trade was particularly strong with Athens during the fifth and fourth centuries. Thereafter, from the third to the first century B.C., Athenian ties were replaced by strong contacts with southern Black Sea cities, with Rhodes, and with cities in Asia Minor. Throughout this period, Greek influence was strong: Greek writing was used; Greek cults were introduced; and Greek styles of buildings, including new fortification walls and city gates, were built. By the late third century or the early second century, there were large city walls, temples, altars, and sacrificial areas. The city was partly destroyed in approximately 180 B.C. The last building phase at Vani began in the second half of the second century B.C., when the city gates were repaired and new temples and altars were built. The final destruction came soon after, in the late 80s B.C., during the

[45] Richter, "A Greek Bronze Torso," p. 33 (Kritios and Nesiotes); Metropolitan Museum of Art, *Handbook of the Greek Collection* (Cambridge, Mass., 1953), p. 66.

[46] See Mattusch, *GBS*, pp. 135–38, with bibliography.

Mithridatic Wars, when Mithridates VI (Eupator) lost to Rome the regions both south and east of the Black Sea.[47]

A foundry that had been installed at one side of the wide central terrace of Vani, sometime during the second or first century, was excavated in 1990. This foundry was a makeshift operation, consisting of an oval casting pit built of tiles and stones; in the center of the floor, a burned area surrounded a mold base made of stones packed with clay. Five meters away, another burned area may mark the location of the metallurgical furnace. All the debris from the foundry was saved: clay props used in baking the molds; two large clay-mold fragments and a sizable number of smaller ones; two large clay funnels, part of a clay y-gate, and one clay vent; about twenty fragments of bronze; numerous bronze drips of all sizes; lots of vitrified clay; four pieces of bronze slag; and various other pieces of bronze waste. The site also yielded numerous smooth black pebbles, each with one more-or-less flattened surface: it was suggested by the excavators that the pebbles might have been used to polish the bronzes. Since I have found the same pebbles in large numbers all along the eastern shore of the Black Sea, however, I assume that they are common to the region: they are basanite, a smooth, fine-grained, black or dark siliceous stone, a variety of quartz or jasper.[48]

Two large deposits of bronze were made on the same central terrace at Vani during the 80s B.C.: they contained fragments of many statues, which were probably destined for remelting in the nearby foundry in use at that time. Many of the pieces surely belonged to different statues, for they represent a wide range of styles, subjects, and techniques. A quick survey of the five cases of best-preserved fragments, on display in the museum, reveals that an amazingly vast array of bronze statues must have stood in the city of Vani during its last phase of occupancy. Many of them are unquestionably Hellenistic in style. Evidently, they had all been broken up during the 80s and were to be remelted for weapons.

The only recognizably larger-than-lifesize bronze is represented by part of a hand: three loosely extended fingers of about twice lifesize. They are hollow-cast, whereas the fingers of lifesize statues are normally solid bronze. Among the identifiable large fragments from lifesize bronzes are the following: a curly lock of hair; two eyelash plates; an extraordinarily thick-walled neck (ca. 0.05 m. thick), the inside of which has splashes of metal from a metallurgical join; a magnificently naturalistic hand, veins bulging, grabbing a lock of hair; a bent forefinger; a large slab of layered drapery from a standing figure; flaps and tassles from a cuirass; a section of tasseled hem; two horses' hooves; thirteen bits of hair and fur, including part of a beard; and two pigs'(?) ears.

[47] For a summary of the literary sources and of the archaeological evidence, see Otar Lordkipanidze, "The Greeks in Colchis," in *The Greeks in the Black Sea*, ed. Marianna Koromila (Athens, 1991), pp. 190–97. I thank Lordkipanidze for inviting me to visit Vani in 1989, and for facilitating my study in the museum and at the site. I am particularly grateful to Marina Pirtskhalava for showing me the foundry remains, the many statue fragments, and the material related to the Vani bronze both at the site and in the storerooms.

[48] I am grateful to Sarah G. Morris for this identification, and for sending me a full-page magazine advertisement for "The Golden Touchstone Compact" (Estée Lauder) in which the pebbles are illustrated.

There are also pieces of smaller statues: two pudgy arms, about two-thirds lifesize; a highly naturalistic foot, the toes grabbing for purchase, about half lifesize; the thigh and knee of a standing figure, with a metallurgical join just below the knee, broken below that, about one-quarter lifesize; and a miniature foot, only about 0.02 meter long, but hollow-cast, a display of remarkable skill in the foundry. There are tiny pieces, too: a wing(?); fur; parts of two snakes; a human ear, hair, flesh, and drapery; a table leg; three different bronze reliefs; and a piece of a Greek inscription, with what appear to be fourth-century letter forms, citing restrictions for entry into a sanctuary.

About twenty-five of the statue fragments have preserved dimensions of 0.10 meter or more. Some of the pieces contain holes where small rectangular patches were once inserted. Also found were about a hundred actual patches, all rectangular, and none with a maximum dimension greater than 0.018 meter. There were also gilded statues: five fragments are gilded, as are two small patches.

The most important bronze found in the context of the first-century destruction is part of a lifesize statue of a youth (fig. 6.4 and plate 9). The Vani torso, excavated in 1988, is preserved from lower thigh to mid-neck, and includes the shoulders and the arms to mid-biceps. A few non–joining fragments were also found, including the right ankle and heel as well as part of one leg.[49]

The Vani bronze was in pretty good condition at the time of its discovery. The genitals had broken off, however, and a crack extends from the resulting hole up to the right hip. The nipples are now simply neat round holes (ca. 0.001–0.002 m. deep), but they were once inlaid. Tool marks around the shoulder blades suggest that the statue was violently dispatched. There are also dents above the navel on the right, on the upper right thigh, in the center of the right buttock, on the lower left buttock, and in the center of the right shoulder blade. Scratches reveal the yellow base metal that we would expect of an alloy with a high tin content. The exterior has a fine green patina, except for silvery gray areas on both sides. The shine is a result of the statue's having been coated with wax. Beeswax mixed with bronze powder to match the patina of the bronze was used to make some further repairs. The wax mixture was used to fill cracks in the left thigh around the groin and on the right side of the torso, as well as to cover a few modern scratches. What look like dark-green

49 Fragment of right heel and ankle: Vani Museum no. 07:1-89/205. Max. H 0.128 m. Part of a finished edge (W ca. 0.010 m.) is preserved on the underside of the foot, which rested flat on the ground. The whole foot was hollow up to the edge. Part of leg: Vani Museum no. 07:1-89/202. Max. pres. dim. 0.145 m. At least two other tiny fragments of bronze must also have been part of this statue: they have the same thickness, the same patina, and apparently the same alloy. For the preliminary publication of the statue, see O. Lordkipanidze, "A New Find in Vani" (English summary), *Journal of Ancient History* [= *Vestnik Drevney Istorii*] 190.3 (1989): 182. Michail Yu. Treister and Gocha R. Tsetskhladze kindly gave me offprints and translations of this article. Treister told me an interesting story about the excavation of the bronze. When the statue was discovered, the former Communist party secretary in Vani, a great supporter of local archaeology, called for an ambulance, thinking that this would be the best way to remove the statue from the ground and transport it to the dig house. The ambulance arrived quickly, with life-support equipment at the ready. When the ambulance attendants learned that this was not a real person, only a statue, they spat on the ground. I am also grateful to Marina Mizandari for her assistance and for discussions that we have had about the statue.

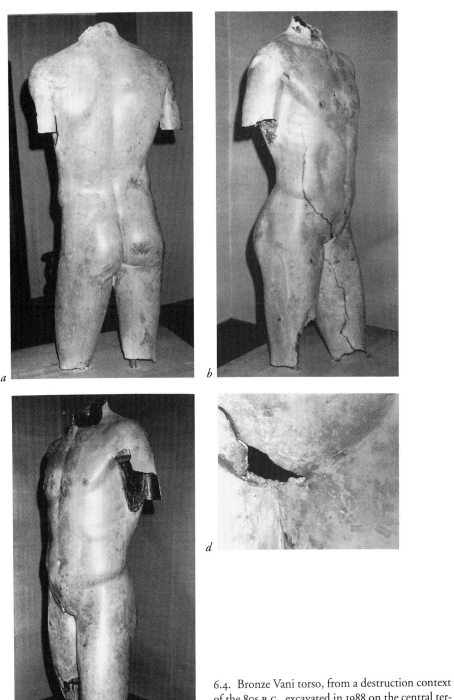

a

b

c

d

6.4. Bronze Vani torso, from a destruction context of the 80s B.C., excavated in 1988 on the central terrace of the ancient site at Vani. Lifesize, max. pres. H ca. 1.01 m. Detail of groin, with diagonal scratches for pubic hair. Vani Museum. See also plate 9. Photos courtesy of Michail Yu. Treister.

patches are really only patch holes that have been filled with wax to replace lost ancient patches. In fact, though, wax could also have been used during antiquity to make certain repairs in bronzes. In general, the metal appears to be in stable condition, with only a couple of small bright-green spots of active corrosion on the interior. The entire inside is brown and shiny—quite unlike the outside surface of the bronze—and looks as if it was varnished during the restoration process.

This statue represents the familiar type of a nude youth: he stands on his right foot, with the right hip raised and the left leg advanced. Both arms hung at the sides, and there are two small wrinkles in the flesh of each armpit. The torso is lean and naturalistic; five ribs are finely marked on either side, and there is a small fold of skin above the navel. The curve of the back is not pronounced, so the figure's stance is quite upright. The thighs are long and slender.

An early version of this type of figure is the marble Kritios Boy from the Athenian Akropolis: it has the same slender, youthful physique, the same naturalistic modeling, and the same stance, but with the right leg forward instead of the left one (fig. 6.5).[50] Numerous nude youths in the tradition of the fifth century provide further stylistic parallels.[51] In fact, the popularity of the type was such that its continuity can be traced through the Roman period. A group of slightly smaller bronze statues—such as the youths from Volubilis and from Pompeii, and the youth in Toledo—also serve as interesting examples of the persistence of this type.[52]

The Vani torso has one distinct stylistic feature that sets it well apart from these parallels and that probably points to local production. At the same time, this feature illustrates for us the naturalistic Colchian convention for representing a boy at puberty. The delicate pubic hairs are no more than short, straight diagonal lines—drawn so shallowly in the wax that they are now almost invisible. These lines (fig. 6.4d) are a realistic rendering of the sparse hairs of a pubescent boy. In its precise rendering of a boy who is just coming of age, the Vani statue is totally unlike the familiar Greek and Roman statues either of athletes, which have

[50] See Jeffrey M. Hurwit, "The Kritios Boy: Discovery, Reconstruction, and Date," *AJA* 93 (1989): 41–80, and, for new photographs, *The Greek Miracle: Classical Sculpture from the Dawn of Democracy*, ed. Diana Buitron-Oliver (Washington, D.C., 1992), pp. 86–89.

[51] Of many good examples, three in Rome's Terme Museum might be cited: the Hermes Ludovisi; a basalt statue from the Palatine; and a torso of Parian marble. See E. Paribeni, *Museo Nazionale Romano: Sculture greche del V secolo, originali e repliche* (Rome, 1953), pp. 26, 31, 34, nos. 28, 36, 42. Otar Lordkipanidze's preliminary stylistic observations are as follows, in what may be a poor translation: "Stylistic analysis suggests that the statue is a very old work of Hellenistic classicism, [a work] that copies sculpture of a severe style" ("A New Find in Vani," p. 182).

[52] Volubilis Youth: Morocco, Museum of Rabat, inv. V.62; H. 1.40 m. See C. Boube-Piccot, *Les bronzes antiques du Maroc* (Rabat, 1969), 1:153–56, no. 167, and (in vol. 2) pls. 78–85. Pompeii Youth: from the atrium of the House of the Ephebe, also called the House of P. C. Tegete, 1925. Naples, Museo Nazionale inv. 143753; H 1.49 m. See *Le collezioni del Museo Nazionale di Napoli* (Rome, 1989), p. 146, no. 252. Toledo Museum of Art: inv. 66.1; H 1.43 m. See C. Vermeule, *Polykleitos* (Boston, 1969), pp. 23–29 and 46–47nn10–11, pls. 20a–20f, and idem, *Greek and Roman Sculpture in America* (Malibu, Calif., 1981), pp. 50–51. Also Jones, "The Toledo Bronze." For the type, see C. Maderna-Lauter, "Polyklet in Rom," in *Polyklet: Der Bildhauer der griechischen Klassik* (Mainz, 1990), pp. 328–92, esp. 357–65.

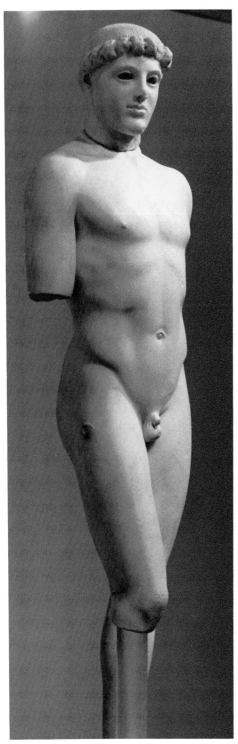

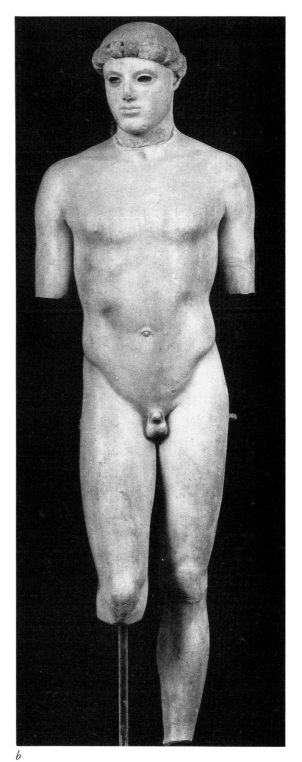

a *b*

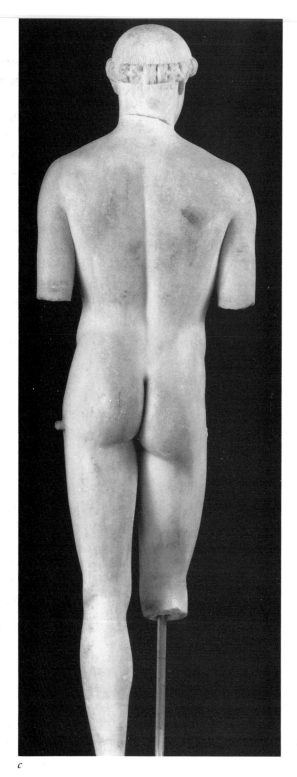

c

6.5. Marble Kritios Boy, from a context of the first half of the fifth century B.C., excavated during the 1860s on the Athenian Akropolis. Just under lifesize, max. pres. H 1.17 m. Athens, Akropolis Museum no. 698. (*a*) Photo courtesy of Jeffrey M. Hurwit, 1987. (*b–c*) Courtesy of Ministry of Culture, Athens.

masses of stylized pubic curls, or of youths, which have no pubes at all.[53] By this curious feature alone, the Vani bronze demonstrates that particular traits, regional or otherwise, may deviate from the modern notion of a fixed or homogeneous style governing an entire work. This realization can easily disrupt the traditional academic construct of a stylistic development that is closely linked to chronology.

The Vani bronze has other idiosyncrasies, from which it seems reasonable to conclude that the statue was not imported from Greece but was made locally, no doubt in Vani itself. The alloy of the statue consists of 88 percent copper, 10 percent tin, and 1.5 percent lead, with traces of silver, iron, and arsenic. The content of the alloy evidently reflects the nature of the metal resources that were available in Colchis.

Some unusual technical features may also be local peculiarities. Torso and legs insofar as they are preserved were cast in one piece. Fragments of an iron armature, square in section and about 0.01 meter thick, were found inside the statue, surrounded by two layers of fine clay core material. The armature consisted of a vertical rod, within the torso, and two attached rods running diagonally into the legs. The neck has a jagged broken edge just above the collarbone, except in back, where the break at mid-neck follows more or less the original edge; a row of small holes for patches remains from the original finishing of the welded join. Thus, the head was attached at approximately the hairline in back, perhaps lower than that in front, but it is difficult to be sure. Both upper arms hung straight down, and there is no inside to the left bicep: instead, there is a large oval opening in the left side where the arm was attached. As often happens to bronzes, the arms broke off below their original joins, leaving those joins intact. The joins curve upward, unlike the straight horizontal joins that are commonly found on statues from Greece. A linked series of narrow gray ovals along the joins are the marks of fusion welding; the color suggests that the weld metal contained a higher percentage of lead than the statue itself. This composition would have simplified the process; for the more lead (or tin) in the metal, the lower the melting point.[54]

The Vani statue is of very irregular thickness, ranging from approximately 0.004 meter at the break in the right thigh to 0.010 meter or more at the groin, and apparently about the same where the legs join. Inside, the indentation of the spine and the shape of the chest are visible, but both are very irregular, having been built up a great deal in the wax. Numerous drips, pours, and toolmarks from the working of the wax are reproduced on the inside of the bronze. In general, it looks as if a painstaking process was used to produce the very fine

[53] It may be useful to recall that the fully mature Belvedere Apollo has no pubic hair at all (see chap. 5 above).

[54] The melting points of both lead and tin are far below that of copper: Cu = 1,083°C; Pb = 327.4°C; Sn = 231.9°C. For examples of fusion welding on Roman bronzes, and for good descriptions and illustrations of the process, see Heather Lechtman and Arthur Steinberg, "Bronze Joining: A Study in Ancient Technology," in *Art and Technology* (Cambridge, Mass., 1970), pp. 5–35; Arthur Steinberg, "Joining Methods on Large Bronze Statues: Some Experiments in Ancient Technology," in *Application of Science in Examination of Works of Art*, ed. William J. Young (Boston, 1973), pp. 103–38. Cornelius Vermeule identified as a "ribbon, chain, or garland" similar traces of fusion welding on the Roman statue of a young athlete in Toledo: *Polykleitos*, p. 27.

detail on the outside of the statue. The arms are much thicker and more irregular inside the shoulders than they are inside the biceps, suggesting that the shoulders were built up in the wax. There is also some roughening inside in the area of the weld metal. The inside of the right leg is smoother than the inside of the left leg.

Thus it is clear that the wax was not simply taken from a mold of an original model and used as it was: instead, more wax was added, so that it could be worked over to produce the desired final model. A bronze cast from such a model is a unique product, but if the casting fails for any reason, that model is irretrievably lost. In fact, the more irregular the thickness of the wax, the more risky the casting, and the more likely it is to be flawed.

Perhaps that is why there are at least thirty-four patches still in place on the left thigh alone. They are all rectangular and small, ranging from 0.005 by 0.007 meter to 0.010 by 0.020 meter in size. A large crack extending diagonally down the right buttock has patches of all sizes, inserted so tightly that they remain practically invisible even today. A crack on the crease at the bottom of the right buttock was repaired with a row of six patches, the largest one measuring 0.007 by 0.013 meter. Another interesting grouping on the right buttock consists of a patch measuring 0.014 by 0.021 meter with two smaller patches meeting two of its corners: one, 0.005 by 0.007 meter, just touches it; the other, 0.005 by 0.011 meter, is inserted across one corner of the large patch. Other patches are visible in the right armpit, below the navel, in the front of the right thigh, and on the back of the left thigh.[55]

Repairs were also made by fusion welding: these are the irregularly shaped gray splotches on and below the right buttock, on the back at the right side of the waist, and on the right bicep just below the original welded join. Their gray color indicates that the welded repairs were made with metal of a higher lead content than that of the statue itself—again, for the benefit of the lower melting point. One badly cracked area on the lower-right area of the back was repaired with a combination of patching and fusion welding.

Our examination of the technique of the Vani bronze allows us to identify the statue as an original, for the wax served as the model. There was, of course, a model or a prototype from which molds were taken to produce a wax. But that model had relatively little to do with the finished statue. Large amounts of wax were brushed, poured, and worked into the master molds, allowing for extensive remodeling of certain areas in the wax. Only after the wax had been worked over extensively was the statue ready for casting in bronze. Such careful attention to the wax must have been the specific responsibility of the artist. Let us imagine that the first version of the model was viewed as a basic pattern to be followed, perhaps as a guide to size, pose, and relative proportions. Perhaps this particular artist

[55] Armpit, on one of the wrinkles: dim. 0.005 × 0.005 m. Circa 0.075 m. below the navel: dim. 0.006 × 0.007 m.; filled with wax during modern restoration. Front of right thigh: dim. 0.005 × 0.014 m.; filled with wax during modern restoration. Back of left thigh: dim. 0.007 × 0.010 m. The flaw was cut away completely before the patch was inserted; a crack running directly across the patch occurred sometime after the casting flaw was repaired.

always proceeded this way. The method may even have been general practice in Vani, or in one or more of the local workshops.

The real problem with the Vani torso is a stylistic one. Indeed, if our technical observations did not conflict with our stylistic analysis, by showing us that the statue is a unique casting, the problem might be avoided altogether. Many of us would surely like to date the statue to the fifth century B.C. Given the first-century B.C. context of the bronze's discovery, though, others of us would say that it must be a copy. For our tendency in the study of ancient sculpture has been to limit our terminology to the terms "original" and "copy." This has certainly been a convenience, and many sculptures do indeed fit, at least roughly, into one or the other of these categories. But the Vani bronze does not.

Vani's richest period began in the second half of the third century B.C. City walls, temples, altars, and sacrificial areas were built, with construction focusing on the central terrace. In 180 B.C. the city was partly ruined, but it was rebuilt between the second half of the second century and the early first century. The city gates were repaired, and new temples and altars were built. Then, in the 80s, Vani was destroyed. Apparently the statues that stood in the area of the central terrace were torn down and smashed. What was left of them was dumped on the central terrace, not far from the foundry in which other bronzes were being remelted, surely for the production of weaponry. By chance, the statue of the youth suffered far less damage than any of the other bronzes that have so far been found.

We have no evidence that Vani was a particularly grand city during the early fifth century B.C., and what we do know of the city's history makes it quite unlikely that this statue survived for four hundred years before it was smashed. Therefore, we cannot safely assign the production of the Vani bronze to the date that its style seems to suggest. It is far more likely that the Vani bronze and the others found with it were cast during the city's final period. This is the period when the city was most extensively embellished, particularly in the area of the central terrace where this statue was found. It is most reasonable to assign the casting of the Vani bronze and of the many other pieces of statuary found with it to a date somewhere in the second century B.C. Indeed, some of these bronzes, such as the hand grabbing someone's hair, and the tensed foot with curling toes, are demonstrably Hellenistic in style.

We must conclude, then, that the Vani bronze was cast in a style that had been introduced in Greece some four hundred years previously. We know that the type of the Vani bronze remained popular for hundreds of years from the time of its first appearance. We know, too, that there had always been Greeks living in Vani. Did one of them commission this statue? If so, the composition of the alloy suggests that the statue was not imported but was made locally. The unusual pubic hairs are not of a kind that we know Greek artists to have made. Would a Greek artist have been satisfied with them? The statue was also produced in a way that seems very unusual for a time when the demand for bronzes was as great as it was during the late Hellenistic period—a way that required the active participation of the artist until the point of investment and casting. Indeed, the evidence points to

one conclusion: the Vani bronze youth was made in Vani during the Hellenistic period; it was modeled by a Colchian artist emulating a style that was first popularized in fifth-century Greece; and it was cast by a Colchian founder using the rich resources and sophisticated technology of his own part of the world. Thus we can picture this Classical figure standing on the central terrace at Vani alongside statues of many different styles, some of them even engaged in violent actions. These statues were not necessarily later in date, although to preserve stylistic dating as we know it, we might well wish that to be so.

We need only turn to fifth-century Athens to find a precedent for the simultaneous production of bronzes having styles to which we are accustomed to assign different dates. As noted before, the Berlin Foundry Cup, which was made in the early fifth century B.C., shows us that even then it was already possible for more than one style of statue to exist at the same time. The painter of that kylix shows us two statues in production: one, a colossus, represents a stiff striding warrior about to strike in the Archaic tradition; the other, lifesize, represents a naturalistic athlete springing into action in the latest style, that of the early fifth century.[56] Whether or not the two statues are meant to be seen as being produced in one workshop, they do coexist on one vase, decorated by one artist. Moreover, the two statues are shown to be of two distinct styles—styles that we would be inclined to assign to different dates.

Of the three standing youths that we have examined here, two can be proved to have been copied directly from other bronzes, and one is unique. Stylistically, they all belong to the Greek world of the first half of the fifth century B.C. But this approach tells us only where and when the *type* began. We have no context at all for two of the youths. Although we have been accustomed to accepting the notion of regional differences in ancient sculpture, such differences have always related to style.[57] Now we have the Vani bronze, a work whose style resembles works that originated in mainland Greece during the fifth century B.C., but whose context is centuries later and whose technique is decidedly non-Greek.

The Vani bronze, having a destruction context, provides the best answers to the problems of dating. Made in the second century B.C., it was neither old-fashioned nor stylistically provincial. Its style, which had first been introduced in early-fifth-century Greece, was still popular, and it was popular in many places. The figure of a nude standing youth, produced in many versions, was current throughout antiquity. Any one of those versions might be cast at any time, depending on the wishes of the buyer. The Vani torso tells us little by its style. Instead, it is best understood in the light of its being a product of second-century B.C. Colchis. It was not a copy, and although its style may be derivative of an earlier period, the Vani bronze is a unique casting, one that was produced in Colchis—from local materials, by local techniques, and for a local audience.

[56] Berlin, Antikensammlung F 2294. For discussion and bibliography, see C. C. Mattusch, "The Berlin Foundry Cup: The Casting of Greek Bronze Statuary in the Early Fifth Century B.C.," *AJA* 84 (1980): 442–44.

[57] The Selinus Youth is a good example here. See above, n. 46.

CHAPTER SEVEN

TOOLS OF THE TRADE

Repetition is characteristic of Greek art from the ninth century B.C. onward. The first images that appear in Geometric vase painting are, like the earlier decorative elements, repeated over and over again on a single vase—birds, horses, humans, chariots. To vary a given figure, the artist might simply turn it around, making a mirror image or heraldic composition (fig. 1.1). The types of images appearing in vase painting were the same ones used for small-scale bronze votive offerings. An appropriate type was treated like a formula, variations being perhaps more incidental than intentional.

On a large scale, too, conventional types (rather than the physical properties of any particular medium) drove production. Thus the kouros appears in both marble and bronze, even though the blocklike style of the kouros made it unnecessary to use a medium as flexible as bronze (figs. 1.3, 1.6). Bronze's flexibility, however, and its color, eventually gave it an edge over marble as the primary medium for freestanding sculpture, for it was obviously well suited for producing statues of athletes in action. Once the convention had been established, however, bronze was widely used for all sorts of freestanding commemorative statues, whether or not the pose required the flexibility inherent in the bronze.

In the fifth century B.C., as before, equivalent types and styles appear in vase painting and in sculpture. On the Berlin Foundry Cup, we see a "statue" of a striding attacking warrior, Archaic in style but of a type that remained popular throughout the fifth century (fig. 2.17 b). This "statue" is flanked by two partly draped standing men (figs. 1.12 b, 2.12), of a type that we often see in vase painting (figs. 2.10, 2.11) but that is also used to represent a group of men on the Parthenon frieze (fig. 2.7); it is a type used for freestanding statues as well. On the other side of the cup is a "statue" of the athletic type (fig. 2.17 a), more naturalistic in style than the striding attacking warrior. Both figures are meant to be understood as being made of bronze, and we could easily argue that in both cases the gestures and stances are best suited to that medium.

How important is the medium to a work of sculpture? In a sculpture workshop in Carrara, a man is carving a colossal white-marble statue of a seated nude woman (fig. 7.1). Actually he is copying a full-size plaster model of the figure. The measurements of the plaster have been transferred to the block, and the marble has already received the general configuration of the statue, even though the raised measuring points are still in place. The carver reduces the marble to its final proportions. His job depends in large part on the accuracy of his eye, for he looks at the plaster model every few seconds, then turns to his carving. When he has worked the stone down to the same size as the plaster model, he will probably turn it over to a polisher, who will finish the statue.

How does the role of the artist compare to that of the stonecarver? The artist brings to the workshop a small clay model for a statue. A technician makes a full-size model, perhaps with the help or guidance of the artist, and the artist approves the finished model. A block of stone is measured and cut from this model. The completed sculpture is also, of course, subject to the artist's scrutiny.

The role of the artist is essentially the same when the work is to be produced in bronze rather than in marble. The technology, however, requires different skills and different equipment. It seems that the artists of Classical antiquity often intervened to individualize the wax working model, so that each finished bronze could be significantly different from the other bronzes in the same series.

Today we tend to rank the artist above the technician, giving the latter only secondary importance in the creation of a piece of sculpture and attaching a certain mystique to the artist's creative process. Yet this modern distinction between craft and creativity is not suggested by the word *technē*, which the Greeks used to describe the entire process—the art, the skill, and the craft of production. It is extraordinarily instructive for a layperson to watch the activities in a bronze foundry or in a marble-carving shop. Doing so makes it absolutely clear that the success of the finished sculpture can depend as much on the skill of the bronze founder or the stonecarver as it does on that of the artist making the original model.

The medium is simply a matter of choice—by the technician, the artist, or the buyer. Today, an artist may have several versions of a work made: there may be a few bronzes, not all with the same patina, a marble or two, and a restricted number of reduced versions of an image. The impetus for this kind of mass production is market demand. Each version can be signed by the artist and by the founder; and when we see, for example, a large bronze labeled as Rodin's *Monument to Balzac*, we think of it as Rodin's work, even if he was not involved in the production of this particular version of the original idea. In the Fonderia Chiurazzi, the entire staff poses proudly in front of their masterpiece, a full-size bronze Laokoon, magnificently patinated and prominently signed with the name of Chiurazzi (figs. 4.7, 4.8).

Turning again to the ancient world, we have found that one can apply this practice to the production of sculpture meant for the decoration of private houses and gardens. The

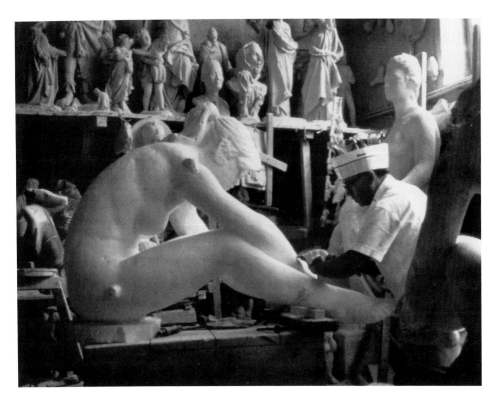

7.1. Carver working on a marble statue and guided by raised measuring points, plaster model at far right. Carrara, sculpture workshop. Photo courtesy of Mary B. Hollinshead.

literary testimonia about Lysippos and Lysistratos suggest that the market grew rapidly during the fourth century B.C. Plentiful evidence is also provided by the works themselves, some of which were lost in transit to Italy, where there was a burgeoning demand for sculpture of all kinds. By the first century B.C., the art market was flourishing.[1] In the sort of sculpture that was produced then, and that continued to be produced until at least the later first century A.D., we see the rejuvenation of some earlier types alongside the sustained popularity of other types over an extended period of time. The general style of a sculpture created during this period may be Archaic, like the Apollo from Pompeii (pl. 5), or Classical, like the three bronze torsos shown in figures 6.2, 6.3, 6.4 and pl. 9. Or an entirely new idea may be generated, like the sleeping Eros, in a style we would not hesitate to call "Hellenistic" (figs. 5.8–5.10 and pl. 4). Our difficulty in assigning a specific date to such a

[1] Four articles in *Das Wrack* deal specifically with the evidence concerning the artistic tastes and market demand of Republican and early Imperial Rome: Hartmut Galsterer, "Kunstraub und Kunsthandel im republikanischen Rom," 2:857–66; Gerhard Zimmer, "Republikanisches Kunstverständnis: Cicero gegen Verres," 2:867–74; Tonio Hölscher, "Hellenistische Kunst und römische Aristokratie," 2:875–88; and Chrystina Häuber, " '. . . endlich lebe ich wie ein Mensch': Zu domus, horti und villae in Rom," 2:911–26.

work stems from the fact that a type does not depend on a single original or on a particular artist, the two identifying points that scholars often seek. For once such a type became popular, it could be produced over a long period of time. The variations on a single type might be infinite, as in the case of the sleeping Eros, or they might be limited, as with the running Hypnos, where the chief variation seems to be that the body used is sometimes that of a baby, sometimes that of an adolescent (figs. 5.4–5.7). The Dionysos herm also fits neatly into such a framework, for we have examples of two bronzes and one marble based on the same model and, therefore, probably coming at some point from the same workshop (figs. 5.11, 5.13, 5.22, 5.23, 7.3, 7.4, and pls. 7 and 8). At the same time, there were various other versions of the same general type, made to different scales and in different media, that were certainly products of other workshops (figs. 5.16–5.21). We need not look for a single original turbaned Dionysos.

We may be surprised to learn that, in the fifth century B.C., an Etruscan family owned two red-figure vases that looked just alike (figs. 2.1 and 2.2). These are not chance companions, nor are they of poor quality. Indeed, they are fine Attic pelikai, each with the same unusual subjects, and with complex, skillfully executed compositions. As each composition is a type, so are the individual elements within each composition. Two onlookers frame each of the four compositions, all approximately alike, although four face to the right and four face to the left, mirror images of each other. One vase does not reproduce the other; instead, these are repetitions, either of canonical types or of types directed to a particular market.

The artist could easily draw the same figure over and over again, working by eye. He might change the position of an arm a little bit, or the fold of a cloak, but he repeated the same general outlines of the figure. This is an easy exercise, with predictable results. The more often a specific figure or configuration is represented, the more familiar it becomes, and the more easily it is read by the viewer. The figures on these vases are part of a visual language—easily written, easily understood, and based on repetition. We can imagine that one family would have owned two examples of the same vase for the same reasons that two examples of the same sculpture have been found in one household. The same principle applied to public sculpture, where types were repeated for the sake of familiarity. Some of the best-known types were the nude warrior, standing or striding, and the simply draped standing onlooker, perhaps best described as a general reference to the presence of the Athenian people by way of their tribal heroes.

The artist decorating the two red-figure vases worked freehand, repeating himself each time he made a new vase in the same series. Bronze, of course, is reproducible, so an artist working in that medium makes a series of like figures in a very different way from someone who makes several drawings of the same figure. Is that how bronzes were recognized in antiquity—as reproductions of originals? Surely an artist did not choose to work in bronze because it is reproducible. But is a bronze a reproduction?

When a dentist casts a gold crown, he concentrates his skills on making an exact copy of

the impression he has taken from the tooth. To make the model, he uses very hard wax, which will not give at all when it is lifted from the die (mold) that he has taken of the tooth. Nor can there be any shrinkage. The crown must fit. This is a very different job from casting sculpture, where a few millimeters do not matter. Skill to the dentist means making no mistakes, because he must make an *exact* copy.

Today's sculptors, like most dentists, usually turn over a model to technicians for production. A sculptor may have the expertise to produce a work, but might not have an appropriate workshop or the right equipment. It is to a sculptor's advantage, however, to be involved in production, for the sculptor then has greater artistic control over the completed sculptures. Different choices may be made for each version of a work completed. These choices can include variations in size, joining, surface details, color, and texture. They may also extend to having one version made of bronze, another of marble.

The artist may simply choose the medium, then ask skilled craftsmen to make a sculpture to certain specifications. Technically, bronze might be described as a more exactly reproducible medium than marble, because using molds is a way of making a direct copy. With both media, though, the difficulties faced in completing a statue are far more likely to occur during production than during the work's conception.

During the production of the Riace Bronzes (fig. 2.18), one or more artists assumed a major role in individualizing the wax working models, with the result that the two bronzes are markedly different from each other. Because bronze is a reproducible medium, the artist(s) did not need to work separately on each of the wax models; by doing so, however, creativity became part of the process of production. There are, as a result, variations in the heads, in the musculature, and in the position of the legs. The work on the wax need not be done personally by the one whom we call the artist, as distinct from the craftsman or technician. Ideally, a single individual might be familiar with all aspects of creation and production, as could have been the case with the makers of the Riace Bronzes. Otherwise, the artist and the technician can be true collaborators, as was the case with Auguste Rodin and Henri Lebossé. It is in this kind of merging or linkage of tasks that we shall probably find the best meaning for the word *technē*.

So many men may be involved in the completion of a sculpture like the Laokoon, Pliny tells us, that no single individual can be given credit for the work (*NH* 36.37). Similarly, the marble Farnese Herakles, which is usually associated with a bronze statue by Lysippos, bears the signature of Glykon the Athenian, the person who so skillfully carved that sculpture (fig. 7.2). No doubt the same meaning should be applied to the signed bronze herm from the Mahdia shipwreck. The basic model for a turbaned Dionysos was in fairly wide circulation, appearing in a variety of contexts and media. Boëthos of Kalchedon altered the standard wax working model for this image by enlarging the loops of the turban and adding a wreath of vine leaves (figs. 5.11, 5.13, 7.3, and pl. 7). Then he signed the wax. Aspasios likewise signed a gem with the same herm on it, no doubt because this is a fine example of his lapidary skill (fig. 5.17). And so today a bronze group of the Laokoon bears

7.2. Signature of Glykon the Athenian on the rock on which the Farnese Herakles rests his club. Naples, National Museum. Photo by C. C. Mattusch.

an inscription with the name of Chiurazzi, the foundry that produced the work (fig. 4.8), even though we know that Pliny attributes just such a group to Hagesandros, Polydoros, and Athenodoros of Rhodes, noting, by the way, their skill in carving it from one block of marble (*NH* 36.37). We must conclude that the skill needed to produce a particular work merited a signature in antiquity, as is the case today. It is only the modern interest in famous artists that has led us to assume that the name written on a sculpture ought to be that of the person who first conceived of a particular work or even, more generally, a certain type of image or subject, like the baby strangling a goose or a duck (figs. 5.14, 5.15).

We have referred more than once to Lucian's second-century A.D. passage about a statue of Hermes that stood by the Painted Stoa in the Athenian Agora: the statue is "covered over with pitch because of being molded every day by the sculptors" (*Zeus tragoidos* 33). Skilled workers were taking casts of a well-known statue in order to make copies of it, in workshops all across the Mediterranean world. On a smaller scale (and less site-specific, though very similar) are the modern souvenir stands of Rome. Beside the Pantheon, the Trevi Fountain, and the Vatican Museums, some of the most popular statuettes "reproduce" the Capitoline Wolf (Rome), the Augustus from Prima Porta (Rome), Michelangelo's David (Florence), a slenderized Venus de Milo (Paris), and Leonardo's painting of the Last Supper (Milan). All of these statuettes are available in either bonded marble or metal, and in several sizes. Some of them bear the name of the maker.

One turbaned head of Dionysos, a bronze herm, came from a shipwreck that is dated rather closely to the 80s B.C. (figs. 5.11, 5.13, 7.3, and pl. 7). A second such head, this one in marble, comes from Pompeii, giving it a very specific destruction date of A.D. 79 (fig. 5.22). These fixed points make it difficult to assign a date to the bronze Dionysos herm for which we have no context but which is unquestionably an ancient work (figs. 5.23, 7.4, and pl. 8). All three come from the same series, but we are forced to admit that this last herm could have been produced at any time over a period of at least a hundred and sixty years. Perhaps

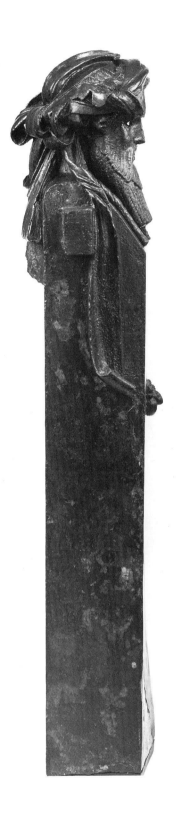

7.3. Bronze Dionysos herm signed with the name of Boëthos, probably second century B.C., from the Mahdia ship (wrecked in the 80s B.C. and discovered in 1907). H 1.03 m. After restoration in 1992/1993. Tunis, Bardo Museum F 107. See also figs. 5.11, 5.13, and pl. 7. Courtesy of Rheinisches Landesmuseum, Bonn. Photo H. Lilienthal.

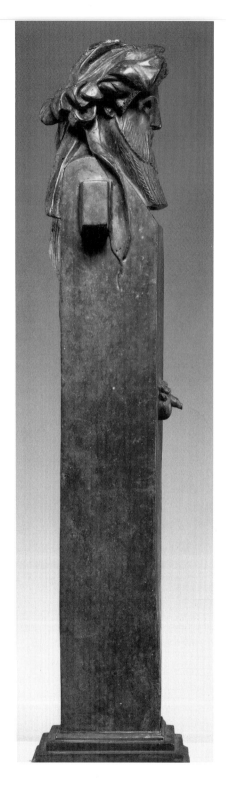

7.4. Bronze Dionysos herm, ancient but of uncertain date, purchased in 1979. H 1.03 m. Collection of the J. Paul Getty Museum no. 79.AB.138, Malibu, Calif. See also fig. 5.23 and pl. 8.

it is not important to assign dates to works whose popularity was so long-lived. It may not even be a useful exercise to call one work "Greek" and another "Roman," for both represent the Mediterranean world during its largest and richest phase, when it was most diffuse and most fully integrated. This was a period when there was great interest in works of art of all types, when works from earlier periods not only were being collected, but were also influencing new Hellenistic creations. Styles from different periods coexisted; what we think of as "older" styles could be called on at any time for reuse, imitated or reworked, and placed in new and, perhaps to us, unexpected private contexts. It should not surprise us that so many of the bronze statues that survive today come from ancient cargo ships, wrecked near Antikythera, Artemision, and Mahdia at around the beginning of the first century B.C. The statues that those ships carried were popular images and types, and those images and types did not fade from the scene simply because the ships in which these particular examples were being carried were wrecked. That the traditions continued can be seen at every site for which statuary was being created—for example, the burgeoning towns and the rich villas along the Bay of Naples. We can see the interests and influence of patrons in the most familiar types, in the range of scale and the medium, and in the adaptation of sculptural types to a variety of functions.

If we look at some of the popular metal figurines sold nowadays in Athenian shops, we can see that there is still today no need for homogeneity in date (fig. 7.5). Nor are the reproductions true to the medium of the "original." Here, as in modern Rome, it is familiarity that sells an object. If there are a dozen diskos throwers on a shelf, few of us mind that a bronze Diskobolos by Myron no longer exists, or that the ancient "copies" of this statue are to be found in Italy, not in Greece. Stylized bronze Athenian owls, patinated black, stand beside shiny brass, not marble, Cycladic figurines. Bronze rearing horses, striding lions, Classical helmets, and generic images of Athena are mingled with "copies" in different sizes of the famous statue of the Artemision god. We can choose our favorite patina.

The three ancient Dionysos heads, one in marble and two in bronze, are all based on the same original model. Was there only one such model, and was it the property of one workshop? This seems unlikely, for it would mean that one and the same workshop produced marbles, bronzes, and gems. More likely, several examples of the basic model were in circulation for a long period of time, and these models were available for use by various workshops, in different places. The same principle applies to the Piombino Apollo (pl. 6), the work of a first-century B.C. Rhodian artist, and to its twin from Pompeii (pl. 5). So, too, with various popular sculptural subjects, such as the sleeping Eros or the baby with a goose, although both these familiar types had a range of variants, that of the Eros being so wide that no two are just alike. Thus far, not a single example of these two commercially successful types has been found to bear a maker's signature.

A specific type, like the turbaned Dionysos, can exist on several levels: it can be of high quality, or of lesser quality; it can be made in different sizes, and in different materials. We

7.5. Souvenir shop on Pandros-sos Street, Athens. Photo by C. C. Mattusch.

have two in a series of bronzes, a parallel series in marble, a related series in terra-cotta, and a few gems which, though individualized works, represent the same type of figure. All of these examples are distinct from overcasts or reproductions of particular bronzes. An overcast may be reworked, like the artificially patinated modern head of "Berenice" once said to be from Perinthos (figs. 4.2, 4.4). The intention in the case of this "Berenice," with its "broken" edge, was evidently to deceive a buyer, one who would not know about the similar head from Herculaneum. In fact, scholars also have been deceived, even though we *did* know about the Herculaneum bronze.

It could be very useful to look again at the "original" from which this copy or forgery was made. The bronze head of "Berenice" was found in 1756 (figs. 4.1, 4.3). It was restored right away, like all the other Herculaneum bronzes, in order to be presentable to the public eye.

7.6. Detail showing restored nose and neck of marble Artemis of Versailles, known to have been at Fontainebleau in 1586. H 2 m. Paris, Louvre MA 589. See also fig. 5.2. Courtesy of the Louvre, Musées Nationaux, Paris.

By the 1750s, the Artemis of Versailles had been known for almost two hundred years, and she had been restored at least once. As we see her today, she has been restored yet again, at least in part. Unfortunately, detailed records of early restorations were not often kept. Will it be possible to determine when the nose was restored? And why is it that the restored nose on "Berenice" (fig. 4.3*a*) is so much like the restored nose on the Artemis of Versailles (fig. 7.6)? Is the profile of either of these statues, the bronze or the marble, in any sense based on an antique model, or will we come to understand it instead as a profile that was admired during the eighteenth and nineteenth centuries?

How in fact do we usually look at antique statues today? Are we using all the evidence that we have about these statues? Let us take for an example the Delphi Charioteer, which, unlike the Belvedere Apollo, is still held in high regard (fig. 7.7). And how could it not be so? The Charioteer is indisputably a "Greek bronze original": it is without modern additions, and it is one of only about a dozen large-scale ancient bronzes to have been found in Greek soil. Indeed, more is known of this statue's history than of almost any other Classical bronze.

7.7. Upper part of the bronze Delphi Charioteer as originally seen ca. 474 B.C., discovered in 1896. H 1.8 m. Delphi Museum nos. 3484, 3450. Courtesy of Ecole Française d'Archéologie, Athens.

From what is preserved of the inscribed base, we know that the statue belonged to a chariot group that was erected by Polyzalos of Gela. The group commemorated one of his two Pythian chariot victories, which occurred in 478 and 474 B.C. To date, no one has quarreled with the evidence that the statue group was made during the 470s.

About one hundred years after it was erected, the bronze victory chariot of Polyzalos was destroyed by the earthquakes of 373 B.C. Some of the pieces were dumped in the fill behind the Ischegaon Wall, which was built at that time to contain landslides. This site was excavated in 1896, and the pieces found included the Charioteer, a boy's arm, three horses' legs and one tail, and a few pieces of harness and chariot.

In 1941, Roland Hampe published *Der Wagenlenker von Delphi*, and in it he included detailed drawings of how the entire chariot group might have looked. François Chamoux's *L'Aurige de Delphes* appeared in 1955 (*Fouilles de Delphes*, vol. 4.5). He discussed the base for the group, the various bronzes, and the casting technique and style of the Charioteer. Otherwise, scholars have focused almost exclusively on the style of the Charioteer, treating the statue as if it were meant to be seen alone—as, of course, it is exhibited in the Delphi Museum.

If we look through fifteen readily available works on Greek art and Greek sculpture that include illustrations of the Delphi Charioteer, we will not be surprised to find that they all show the full statue from the front. Rhys Carpenter, in his *Greek Sculpture* (1960), departs from the canon in that he also includes a side view of the statue. A few other books have two illustrations of the bronze, and the second view is inevitably a close-up of the head, which shows well from the front or in profile. Indeed, it is only in Lullies and Hirmer's *Greek Sculpture* (1957, rev. 1960), which provides four photographs of the Charioteer, that we see a

view of the upper part of the statue (in support of the statement in the text that he stood inside a chariot).

Why do the modern descriptions and analyses of this well-known statue so often concentrate on the columnar skirt and the naturalistic feet? Why have we practically forgotten to consider the chariot and the horses which once formed the bulk of this large monument?

If we put the Charioteer back in a chariot, and continue to look at him from the front, as we seem to prefer, we will see glimpses of his chiton through the framework of the chariot, and only his head and shoulders will rise unobstructed above the heads of the two central horses in his hitch of four. The statue's face will be about two and a half meters from the ground, or about three feet above our own eye level. If we move a bit to our left, we may notice the statue's slightly downturned gaze. But, no matter where we stand, those features on which we have usually fastened our attention—the long, immobile skirt and the poised feet—are invisible. From the sides, however, our sense of the whole group will be greatly expanded, even though our view of the Charioteer will not be so interesting as we have been led to expect by the textbooks. We must remember that his original role was not what we have made of it today. Instead, to the Classical viewer, he was simply one of the parts of a whole chariot group, and it was undoubtedly the size and value of the group that was intended to attract the attention of visitors to Delphi.

Admirers and purchasers of statuary in the ancient world were probably no more interested in how these works were physically made than are most viewers today. But those who are interested in whether a work is an "original" will find that the technique is actually more revealing than the style. When we look at the strikingly different faces and hair of the Riace Bronzes, we can see that the original model for each was separately and painstakingly worked over, making each statue unique (fig. 2.18). The differences between the bodies are far more difficult to discern. Indeed, they are too much alike for the similarities to be coincidental. These are canonical examples of a popular type of image—one that was immediately recognizable to viewers because of the close similarities among its many representations. It is also a type that did not change noticeably over time. As a result, we find that we cannot agree on a date for disembodied torsos. What does that suggest about the ancient view of such works? We have received them as art, and as such we have tried to ascertain whether or not they are originals, which is surely not how they were recognized in the Classical world by the people who saw them standing in public places.

When we consider the commissions of today—the sculptures seen in the garden or the cemetery, outside the sports arena or the government building—we can easily see that tastes have changed very little since antiquity. Favorite types of statues from the Classical world seem very like some of the most popular imagery in today's world. There are still many places in which to find an abundance of representational statues of athletes, sleeping babies, infants struggling with fish or goats or geese, victorious goddesses, chaste huntresses. Even that rather odd type of image, the herm, continues its life in the modern world, being used

7.8. Heroes of Rome beside the monument of Giuseppe Garibaldi. Larger-than-lifesize marble busts on hermlike shafts. Gianiculum Hill, Rome. Photo courtesy of Mary B. Hollinshead.

to support both a series of marble portraits of the proud defenders of Rome (fig. 7.8) and a colossal bronze bust of Christopher Columbus in front of the public library in Bryn Mawr, Pennsylvania (fig. 7.9).

7.9. Colossal bronze bust of Christopher Columbus on marble herm-like shaft. H ca. 3.5 m. Dedicated October 12, 1952. Ludington Public Library, Lancaster Avenue, Bryn Mawr, Pennsylvania. Photo by C. C. Mattusch.

INDEX

Page numbers in italics indicate illustrations. The color plates follow page 140.

inscriptions (*cont.*)
 preference regarding, 21; on portrait statues, 73; remaining, after statues are gone, 38, 45, 90, 127; type of sculpture more important than, ix, 65; work meriting, 222
investment, 12, 15–16
Ionian tribes, 40
iron, 27, 213
Izmir, 110; female head from, 102, *103*, 110, *111*, 112, 114–16, 121; veiled woman statue from, 11–12, *14*

J. Paul Getty Museum (Malibu, California), 117, 174, 175, 187, 224
Janson, H. W., 146
Jocasta statue, 27
joiners, 18
joins, 16, 118–19, 131, 135, 199, 213. *See also* bronze-casting: in pieces; fusion welding; solder
Jucker, Hans, 110, 112, 114
Julius II (pope), 144
Juvenal, 192

Kalchedon, 110
Kalkmann, August, 199
Kekrops (Athenian tribal hero), 45, 52–54, *54, 55*
Kephalos, 53, *55*
Kephisodotos (artist), 135
Kimon, 39–44, 46, 47, 52, 169
Kleanthes (Stoic), 192
Kleisthenes, 39–40
Kleobis and Biton (Delphi), 4, *5,* 8, 149
Kleoitos, 26
Kluge, Kurt, 112, 199, 200
Kodros (Athenian tribal hero), 45, 46
Kopien und Umbildungen griechischer Statuen (Lippold), 151
Kos, 176
kouros (kouroi): Apollo as, 107, 109, 113, 129, *130,* 131, 137, 138; as common Greek type, 4–9, *5–7, 9,* 21, *23,* 76, 217; from Samos, 21, *23,* 149, *150*
Kritios (artist), 40, 61, 62, 193, 199, 206. *See also* Kritios Boy
Kritios Boy (Athenian Akropolis), 210, *211, 212*
Kroisos (King of Lydia), 20, 28

La Coste-Messelière, Pierre, 112
Landwehr, Christa, 191, 197
Laokoon group, 119, *120,* 121, 145, 218, 221–22
Last Supper painting (Leonardo), 222
Laughing Boy and Goat (Piccirilli), 179
Laurenzi, Luciano, 82
La Vega, Francesco, 107
Lawrence, A. W., 152
lead: in bronze alloys, 32–33, 128, 137, 201, 213; goose and baby statues in, 179; in patches, 214; for patination, 26

Learchos, 27
Lebossé, Henri, 192, 221
Leochares (artist), 146, 148, 152
Leonardo da Vinci (artist), 222
Leos (Athenian tribal hero), 45, 52, 54
Liber Pater, 181, 184, *185. See also* Dionysos
Libyan head (British Museum), 25, 80, *81,* 82–83, 87, 94
lions, 8, 158, 160
Lippold, Georg, 151
literary testimonia: on Artemis of Versailles, 148; on artistic collaboration on bronzes, 193; on artist's identity, x, 175–76; on Eponymous Heroes of Athens, 50; on figure types, 65; on gilded Nikai, 121; on herms, 168; on Hypnos, 152, 158, 160; lack of, for sleeping Eros, 163; on Lysippos, 76, 97, 219; to missing statues, 38–40; on patination of bronzes, 26–27. *See also* inscriptions
Livorno, 197
Livy, 34, 128
lost-wax casting process: description of, 10–12, 15–17, 192; division of labor in, 194; Egyptian use of, 4, 9; indirect, 72, 200; as reproducible procedure, 18, 37; sculpture made from, 8
Louvre Museum, 146, 148
Lucian, 72, 191, 222
Luculli, 34
Lullies, Reinhard, 82, 145, 228
Lysander, 65
Lysippos of Sikyon (artist), 68–73, 76, 80, 94, 97–100; Alexander the Great statues by, 28, 68, 70, 76, 124; fallen heroes statues by, 65, 68; gilded bronzes by, 28; Herakles statue by, 106, 221
Lysistratos of Sikyon (Lysippos's brother), 69, 71–72, 82, 94, 219

Macedonia, 69
Macmillan Dictionary of Art, 191, 192, 197
Mahdia shipwreck bronzes, 225; herms among, 170, *171,* 174, *176,* 181, 184, 187–88, 190, 222, *223, plate 7;* original color of, 27
Marathon battle, 40, 43–47
marble: Apollo Patroos in, 135, *136;* Artemis of Versailles in, 146, *147,* 148, *227;* Athena statues in, 135, 138; Belvedere Apollo in, 141, *142, 143,* 145; Dionysos heads of, 184, 186, *186,* 187, *187,* 222, 225–26; Dionysos herm on disk of, 181–82, *183;* Doryphoros in, 201; goose and baby statues in, 179; Hypnos in, 155, *156, 157;* kouroi in, *5–7;* Kritios Boy in, 210, *211, 212;* Laokoon in, 222; not Lysippos's medium, 73; Omphalos Apollo in, 206; plaster casts for statues in, 191; powder of, in restoration, 104; as sculptural medium, 4, 187, 217; seated woman statue in, 218, *219;* sleeping Eros in, *162,* 166; statues of, as imitations of bronze originals, 141–51, 197
Marcus Scaurus, 33

market demand: for popular sculptural types, 166, 218–19, 222, 225; for votive figures, 1

masks (tragic), 129, 136, 137

master molds, 10, 14, 18, 19

Mastrokostas, Euthymios, 129

Mattei Athena, 135

medium: choice of, in sculpture, x, 28, 217–18, 221; of Egyptian sculpture, 2, 4; study of, ix; variety in, with sculptural types, 8, 160, 161, 181–87, 195, 222, 225–26. *See also* bronze; clay; marble; metal; terracotta

Megasthenes, 181

Meidias Painter, 121

Meletos, 70

Mengs, Anton Raphael, 145

mercury gilding, 29n, 124

metal (as sculptural medium), 1, 3. *See also* bronze; gold; silver

Metellus, 68

Metropolitan Museum (New York): bronze torso in, 202–6, *203,* 219, 229; *Handbook* of, 163; sleeping Eros in, 161, 163, *164,* 165, *167, plate 5*

Michelangelo, 166, 222

Mikon (artist), 42–43

Milani, L. A., 199

military heroes (statues of), 4, 21, 38, 46, 76, *77–79,* 220. *See also* Eponymous Heroes of Athens; Riace bronzes

Milman, Henry Hart, 145

Miltiades (Kimon's father), 40, 43, 45, 46, 64, 65

Mithridates Eupator of Pontos, 96, 136, 207

models (for bronze-casting): clay, 10, 71; evidence of, *15,* 115–16, 165, 188, 200, 204, 213–14; reuse of, 18, 21, 190, 221, 229; similar, in different workshops, 187; wax, 2, 10, 14–15, 18, 37, 72, 79, 83, 87, 94, 98, 99, 116, 117, 121, 124, 125, 149, 187, 192, 218, 221, 222. *See also* original work; serial production

models (for marble sculpture), 218

Monnot, P. E., 166

Montorsoli, Giovanni Angelo, 142, 144, 146

Monument to Balzac (Rodin), 192, 194, 218

Mucianus, 34, 194

Mummius, 34

Museo del Prado (Madrid), 155

Museo Ercolanese (Portici), 104

Museo Nazionale (Naples), 105

Mycerinus, 2

Myron (artist), 96, 195, 225

Naples female head, 102, *103,* 107, *108,* 109, *111,* 112–16, 226

National Archaeological Museum of Athens, 30–31, 102, 110, 141

Naukratis, 2–3

Neleus/Philaios/Phileus (Athenian tribal hero), 45, 46

Nero, 28, 124, 144, 155

Nesiotes (artist), 40, 62, 193, 199, 206

Nichols, R. V., 199

Nike (Nikai): gilded, 28, 121–22, 127; at Olympia, 195

North African bronze head (Cyrene), 25, 80, *81,* 82–83, 87

nude standing youth. *See* kouros (kouroi)

Odysseus, 88

Oineus, 45, 46, 52, 54, *58*

Olbia marble lions, 8

olive oil, 29, 148

Olympia: boxer's head from, 84, *85,* 86–87, 93, 94, 113; charioteer statuettes from, 18, *19,* 21, 150; gilded statues in, 177; griffins from, *20,* 21; kouros from, 8, *9,* 10; Nike at, 195; number of statues in, 34, 68; Pausanias on statues in, 65; Temple of Zeus at, 28, 84; Zeus statue in, 47

Onatas (artist), 193

Orientalizing period, ix, xi, 19–21, 35

original work: artist's model as, 10; *vs.* copies, x, 72–73, 79–80, 99–100, 105–6, 112–21, 135–36, 141–60, 163, 165, 188, 190, 191–92, 194–95, 197, 199–202, 214–15; definitions of, 138–40, 149; evidence of, 213–16; *vs.* restorations, 104–7, 121; Roman copies allegedly based on, 145–46, 148, 149, 151, 155, 190, 197, 199–202, 225; sculptural types not dependent on, 220, 225, 229; and serial production, x. *See also* reproduction

Ovid, 158

owners, 68; choice of sculptural media by, 21, 225; dating of statues by identifying, 90, 92; of goose and baby statues, 177; of similar vases, 36–37, 220

Paderni, Camillo, 104, 105, 107

Paionios of Mende, 195

Pamphilos (artist), 69

Pan and Aphrodite statue, 38

Pandion (Athenian tribal hero), 45, 52–54, *54, 55*

Papadimitriou, Ioannis, 129

patches, 16; on Antikythera philosopher's head, 93; in Colchis bronze fragments, 208, 210, 213, 214; on Cyrene head, 83; on Florence torso, 200–202; on Metropolitan torso, 202–5; shapes of ancient, 118. *See also* repairs

patination. *See* bronze: colors of; repatination

Pausanias, 33, 61, 65, 84, 135; on Artemis in Antikyra, 148; on artists, 193; on Eponymous Heroes of Athens statues, 38, 45–46, 52; on gilded statues, 28, 127, 179; on herms, 168; on Hypnos, 158, 160; on inlays, 26; on monument to Miltiades, 40; on paintings of Trojan War, 53–54; on re-naming of statues, 64; on use of pitch, 29

Peace of Kallias, 44

Peisistratids, 39

Peisistratos of Athens, 40, 94

Triptolemos Painter, 53

Troilos and Polyxena, 181

types: long-term popularity of, 52–53, 138–40, 148, 151, 160, 161, 165–66, 170, 177, 179, 181–87, 190, 206, 210, 215–16, 219–22, 225–29; not dependent on original work or artist, 220; revivals of, 166, 179, 222, 225; use of, in sculpture of antiquity, ix–xi, 1, 4, 8, 21–22, 34, 39, 46–48, 52, 53–54, 58–62, 76, 80, 137–38, 180, 217, 220–22, 225–29

Tyrannicides: paintings of, *60, 61;* statues of, 29, 40, 51–52, 58–62, *59,* 127, 151, 191

Urlichs, Hans Ludwig, 148

Valenziani, Tommaso, 104

Vanderpool, Eugene, 129

Vani torso, 206–16, *209,* 219, 229, *plate 9*

vase paintings: Apollo and Artemis on, 24, 137, *plate 2;* collaboration on production of, 192–94; Eponymous Heroes of Athens on, 53–58, *54–56, 58,* 217; Eros on, 121, *123;* repetition on, 35–37, *36, 37,* 217, 220; similarities between sculpture and, 217; of Tyrannicides, 58, 60, *60, 61,* 62

Vatican Museums, 141

Vatin, Claude, 45–46

veiled woman statue (Izmir), 11–12, *14*

Venus, Mars, and Amor (Piero di Cosimo), 166

Venus de Milo, 117, 222

Verres, 96, 176

Villa dei Papiri. *See* Herculaneum Bronzes

Virgil, 158

Volubilis Youth, 210

votive offerings, ix, 1, 8, 21, 150, 197, 217

Wagenlenker von Delphi, Der (Hampe), 228

Waking Child (Monnot), 166

Waldstein, Charles, 106–7

Wall of Triarius, 96

Walters, H. B., 82, 148

Walters Art Gallery statue of boy, 114, *115*

warriors. *See* military heroes

wax: beeswax, 10; for repairs, 210; working models of, in bronze work, 2, 10, 14–15, 18, 37, 72, 79, 83, 87, 94, 98, 99, 116, 117, 121, 124, 125, 149, 187, 192, 218, 221, 222

Waywell, Geoffrey, 135

Weber, Karl, 107

welding, 33, 199, 205, 213, 214

wells: statues found in, 125, 127, 128; terra-cotta herms found in, 184

Winckelmann, Johann Joachim, 105, 144–45

winged boy statue (Mahdia shipwreck), 170, 172, *172, 173,* 174–75, 179–80, 188

wood (as sculptural medium), 28

Wooden Horse statue, 45

Xenophon, 70

Zeus, 35–36, 53, *55,* 181

zinc, 116